MADE IN MEXICO

TRACKING GLOBALIZATION

ROBERT J. FOSTER, EDITOR

Editorial advisory board
Mohammed Bamyeh
Lisa Cartwright
Randall Halle

Made in Mexico

ZAPOTEC WEAVERS
AND THE
GLOBAL ETHNIC
ART MARKET

W. Warner Wood

INDIANA UNIVERSITY PRESS
BLOOMINGTON AND INDIANAPOLIS

Published with the generous support of the
Natural History Museum of Los Angeles County

This book is a publication of

Indiana University Press
601 North Morton Street
Bloomington, IN 47404-3797 USA

http://iupress.indiana.edu

Telephone orders 800-842-6796
Fax orders 812-855-7931
Orders by e-mail iuporder@indiana.edu

The paper used in this publication meets the minimum
requirements of American National Standard for
Information Sciences—Permanence of Paper for
Printed Library Materials, ANSI Z39.48-1984.

Manufactured in the United States of America

Library of Congress Cataloging-in-Publication Data

Wood, W. Warner.
 Made in Mexico : Zapotec weavers and the global
ethnic art market / W. Warner Wood.
 p. cm.—(Tracking globalization)
 Includes bibliographical references and index.
 ISBN 978-0-253-35154-8 (cl : alk. paper)—ISBN
 978-0-253-21986-2 (pbk : alk. paper) 1. Zapotec
textile fabrics—Marketing. 2. Zapotec weavers—
Social conditions. 3. Textile industry—Mexico.
4. Ethnic art—Mexico—Marketing.
5. Art and globalization. I. Title.

F1221.Z3W66 2008
306.4'7—dc22 2007049057

1 2 3 4 5 13 12 11 10 09 08

For my parents

The work is laid out in the mind of
the maker . . . technical difficulties may
arise that compel him to alter his intentions.
Such instances . . . are highly instructive,
because they throw a strong light upon the
mental processes of the workman.

Franz Boas, *Primitive Art*

CONTENTS

ACKNOWLEDGMENTS

A project of this sort, lasting nearly two decades and following me through several institutions and stages in my career, makes for a long list of people and organizations to acknowledge—in fact, far too many to fully recognize here.

I could never hope, for example, to individually thank all the people who helped to shape this project and who supported me throughout its very long trajectory by listening, reading, commenting on, or writing about the work I have produced on Zapotec weaving since I first visited Oaxaca in June 1988. That first trip would not have been possible, though, had it not been for the financial support provided by a University of Illinois, Department of Anthropology, Summer Field Research Grant and a Tinker Title V Grant through the UIUC Center for Latin American Studies. Subsequent fieldwork in Oaxaca, the American Southwest, and the U.S.-Mexico border area was supported through the following grants and fellowships: a Foreign Language and Area Studies (FLAS) Summer Fellowship (1990); a Fulbright IIE Garcia-Robles Fellowship and a University of Illinois Graduate College Dissertation Research Grant (1991–94); a University of Illinois Faculty Research Board Grant (1998); and Natural History Museum of Los Angeles County Alliance Board Awards (2001 and 2002). An Ethel-Jane Bunting Foundation, School for American Research, Summer Scholar Fellowship (2003) supported an important period of writing the manuscript. And color photos of Zapotec textiles could not have been included in the manuscript without the very generous support of the Los Angeles Ethnic Arts Council (2004) and the Natural History Museum of Los Angeles County (2005), as well as the hard work of Daniel Watson, Chris Coleman, and a host of student interns and volunteers.

I would also like to extend my gratitude to a number of individuals for their help and participation in this project. Rosario Herrera-Navanjo, of Central Washington University, designed a perfect map. In my five years at the Natural History Museum of Los Angeles County, I benefited from both the good friendship and collegiality of several people, including Dan Danzig, Ken Johnson, Ángel Valdés, and Scott Van Kueren, all of whom have since left the institution. My conversations with all of you have shaped my thinking about this project in profound ways. Jayne Howell, whom I met during my very first trip to Oaxaca, has subsequently proved to be kind and supportive beyond measure, especially while I lived close by in Southern California. In fact, several colleagues whose work is also focused on Oaxaca deserve mention for having shaped my work and responded to my ideas and writing in stimulating and productive ways, including Ronda Brulotte, Michael Chibnik, Jeffrey Cohen, Jorge Hernandez-Diaz, Michael Kearney, Martha Rees, Laurel Smith, Lynn Stephen, Lois Wasserspring, and Ron Waterbury. This book has also been tremendously improved by the thoughtful suggestions and critique of the three anonymous reviewers for Indiana University Press.

In June and July 2003, I was fortunate enough to have an absolutely critical period of reflection, writing, and intense editing of this manuscript at the School for American Research in Santa Fe, New Mexico. My interaction with the staff at SAR (especially Kathy Whitaker), the wider SAR family, and my fellow resident scholars (Linda Cordell, Gelya Frank, Charlie Hale, David Grant Noble, Nancy Scheper-Hughes, and Lucy Fowler Williams) have had a significant impact on my thinking about Zapotec weaving practices as well as on the general contours of this book.

Between the University of Illinois and the Natural History Museum of Los Angeles County, while I taught as an adjunct professor or lecturer at a number of campuses in the Baltimore, Maryland–Washington, D.C., area, the very generous support of the Johns Hopkins University Department of Anthropology (with which I was affiliated as a visiting scholar) came at a formative point in my thinking about globalization and Zapotec weavers. I made lasting friendships in Charles Village (and the "CVP") and have greatly benefited from getting to know Sarah Hill, Jim Mokhiber, and Carol Pech, among many others. The thinking of a number of scholars who have passed through the Johns Hopkins campus and the university's Global Studies Center is strongly felt in many of the ideas that ground this work.

Several people who were faculty members in the Department of Anthropology at the University of Illinois, Urbana-Champaign while I was there deserve mention for their guidance and support, including Edward

Bruner, Jacquetta Hill, William Kelleher, Janet Keller, and Alejandro Lugo. Also, many thanks to Enrique Mayer, who insisted early on that I learn something about *arte popular* in Mexico and that I read what Mexican anthropologists had to say about it. The insightful and supportive comments and suggestions of Alma Gottlieb and all the students in her writing seminar came at a time when many of the ideas that have made it into this book, and with which I was then just beginning to grapple, were swimming willy-nilly in my head—thanks to you all (and especially Rosa De Jorio) for taking an interest in my stories. Walter Little, a fellow UIUC alumnus, is a friend and colleague whom I count myself very lucky to have gotten to know.

In Mexico, everyone at the offices of the Comision México-Estados Unidos para el Intercambio Educativo y Cultural, especially Ellin Emilsson, was most supportive. In Oaxaca, many thanks to Dra. Ma. de los Angeles Romero Frizzi, the coordinator of the Centro de Investigaciones y Estudios Superiores en Antropología Social (CIESAS) at the time of my fieldwork (and to the staff at the Biblioteca de CIESAS) for making my affiliation with CIESAS both enjoyable and productive, as well as to Gudrun Dohrmann, who graciously made every resource at the Cecil R. Welte Library available. In Teotitlán del Valle and Santa Ana del Valle (and Santa Ana, California), as well as in Díaz Ordaz, there are simply too many people who have supported my work (many of whom should remain anonymous) to thank every one individually. Thank you all, *Ben*e rini dich za*a*—without your trust and patience I could never have finished what I set out to do. There are also a number of businesspeople, mostly from the Southwestern U.S. but from other places as well, who talked with me (sometimes, no doubt, against their better judgment) about their work selling Zapotec textiles—I have tried my best to tell your stories as you told them to me without betraying your confidences. Finally, there are several people whose work has played a very important part in the success of this book. Elia, Enrique, and Violeta Bautista, Paul Bravmann, Jorge Cruz, and Nayely Gonzalez all worked tirelessly transcribing the interviews, lectures, and tours upon which so much of this is based, and their hard work has brought the words of those I interviewed to life on the page.

There are three people, however, who stand out in this crowd and without whom this project would never have come to completion: first, Lic. Antonio Mendoza Ruiz, my sometimes field assistant, sometimes mentor, and sometimes harshest critic, but always my good friend; second, Lolly Marcum, in whose shadow I came to know Oaxaca and who, when I arrived,

never failed to offer whatever time, energy, and personal resource I needed; and third, my life partner, Lori Foulke, to whom I owe the greatest debt. She has unquestionably been the single most important and supportive influence in seeing this project to its completion (twice).

As is customary, I accept full responsibility for any errors and omissions.

MADE IN MEXICO

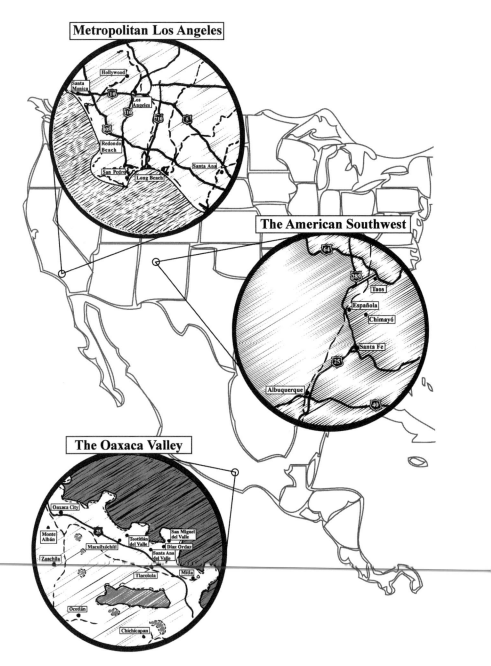

Metropolitan Los Angeles

Hollywood
Santa Monica
Los Angeles
10
110
710
5
105
Redondo Beach
San Pedro
Long Beach
Santa Ana

The American Southwest

64
285
Taos
Española
Chimayó
Santa Fe
25
Albuquerque
40

The Oaxaca Valley

Oaxaca City
Monte Albán
25
Macuilxóchitl
Teotitlán del Valle
San Miguel del Valle
Díaz Ordaz
Santa Ana del Valle
Zaachila
Tlacolula
Mitla
Ocotlán
Chichicapan

Metropolitan Los Angeles, the American Southwest, and the Oaxaca Valley (not to scale)

INTRODUCTION

Locating Mexico and Zapotec Weavers

I remember thinking to myself that evenings in Los Angeles are the perfect time for a drive in the car with the windows down. It is a bit of a truism to say that Los Angeles is a car city, but in a car you really do get a sense of the life of the city moving around you that you cannot get in any other way. At least that is what I was telling myself, sitting there behind the wheel, as I came to the realization that I had just started something I was not all that comfortable with—perhaps I would find a moment of catharsis on my drive home though the city, windows down in the cool evening air.

I was in a restaurant parking lot in Koreatown on Olympic Boulevard, near the heart—well, one of the many hearts—of the city. The restaurant had once been known for its Korean barbeque. The green-tiled roof, red-painted beams, brass lanterns, and other architectural elements seemed now, however, oddly inappropriate, considering that the current tenants run a very successful restaurant named for a cultural festival, featuring folk costumes, dances, and music, that is held every July in Oaxaca, Mexico—the Guelaguetza (the name of the place is pronounced wa-HA-ka; that of the restaurant, GAY-la-GET-tza).

So . . . I was sitting in my car, behind a Mexican restaurant originally constructed as a Korean barbeque, in Los Angeles, California. And I was thinking about Zapotec textiles and the people I know who make them as I pulled out onto Olympic Boulevard to begin my drive home.

1

I was thinking about them, and Oaxacan crafts more broadly, because I had just met with a dozen or so people who would form the core of a tour group I would be taking to Oaxaca in a few weeks in my capacity as a curator at the Natural History Museum of Los Angeles County (NHMLAC). I had been employed at the museum just a few weeks when I was asked to lead the tour. The itinerary was already set, I was told. All I had to do was give the tour-goers the sense that they were traveling with an expert who was sharing special insights—it would be easy, I was told.

As I drove home from the Guelaguetza Restaurant wondering how I was going to get through the tour, it began to dawn on me that the itinerary was the problem. What the museum's travel office had billed to the membership as a "cultural tour" to Oaxaca, Mexico, during the "Day of the Dead celebration," featuring explorations of "local folklore" and "emerging young artists" with the museum's expert on culture—their "museum curator of anthropology"—was, in fact, not the kind of tour that I, their "cultural expert," would ever put together. Given the way the tour had been set up, I would need to work against its itinerary if I wanted to insert just a few nuggets of insight into the lives and work of Oaxacan craft makers as I had come to understand them.

A museum travel office staff member had made all the arrangements for that night's pre-tour dinner, and introduced me to the group of future travelers as an "expert on Zapotec weavings." Several people present were already reading and learning about Oaxaca and its history and crafts, and asked me several questions about Zapotec textiles as the evening wore on. They were what I now, several years later, recognize as the usual questions one gets from an interested public: In which communities are the textiles made? What do their designs mean? Who makes them and how? And, of course, the twin questions: Is it hard to do? Does it take long to learn how to weave? These are exactly the kinds of questions that had formed the core of my own research, and even though answering such questions is what really interested me about traveling with a tour group to Oaxaca, I could not answer them for these people (or show them the answers on the trip), because the tour itinerary had been planned for me.

So it was not the tour *per se*, or the people, that was causing me so much angst. I had no problem with the idea of leading a tour and the people that I had met had been wonderful during our talk and dinner—so excited, and with such great questions, that I could tell I was really going to enjoy getting to know them. But I found myself thinking that I was not going to be able, for example, to take them to nearby Orange County to meet Antonio Mendoza

and his brother as they busily prepared for the county fair. Antonio's brother comes up from their family's home in Teotitlán del Valle, Oaxaca (simply Teotitlán hereafter), just before the fair every year and brings several boxes of textiles—they give weaving demonstrations and, with luck, sell most of the textiles from their booth at the fair. Nor was I going to be able to take them to Boston, Massachusetts, to get to know Andra Fischgrund Stanton. She had recently published her book, *The Zapotec Weavers of Teotitlán del Valle* (1999), and had owned and operated her own gift shop in Boston for nearly a decade—the book is prominently displayed alongside her inventory of Zapotec textiles and is used to establish her authority as well as the authenticity of the textiles she sells. Even more disappointingly, we would not be visiting the Oaxacan village of Díaz Ordaz, where Tomas Martínez and his brother put in long days at the two looms Tomas has set up in a roughly constructed lean-to on the side of his one-room, dirt-floored house. The only chance I would have of introducing tour-goers to Tomas would come at his temporary stall in the main plaza of the state capital during the Day of the Dead celebrations—one of only a few opportunities for him to circumvent the middlemen from the nearby town of Teotitlán who control access to the lucrative tourist market.

Perhaps most disappointing of all to me was that those on tour with me would not be in Díaz Ordaz late in the evening, when Tomas's brother would be gone and he would continue working alone. By the light of a single dim bulb that dangles from wires strung overhead, over the loom's frame, Tomas works most nights, hunched over, straining to see. But those on the tour with me would not have the opportunity to learn how he quits weaving only when his eyes refuse to focus any longer, nor that he picks up again early in the morning, hoping to weave perhaps four to six inches more before breakfast. In short, the hard work of weaving (and of learning to weave) would remain invisible to them on the tour.

So many important parts of the story of how Zapotec weavings (and weavers) are made take place outside of Oaxaca and in places in Oaxaca where tours do not typically go, and I was not going to be able to show (or even introduce) those parts to the very inquisitive and engaged people with whom I would be traveling. What a disappointing (and somewhat aggravating) way to begin my work as a museum curator! Given the opportunity, I thought to myself, I would put together a *very* different kind of tour.

What would my idealized tour look like? The short answer is that it would look a lot like this book. The itinerary for the tour that I would have organized would allow my group to encounter the places and people featured in

the pages that follow. That trip would begin not upon arrival in Oaxaca, but, as this book does, in the Guelaguetza Restaurant in Los Angeles, before moving on through spaces in Southern California, the American Southwest, and Oaxaca, among others. It would offer a unique examination of the global forces which shape the everyday working lives of Zapotec weavers and others crafting Zapotec textiles—the many people (like Antonio and his brother, Andrea, and Tomas and his brother) who create not only the material items but an entire assemblage of ideas, images, and associations that shape their meaning for producers and consumers alike. That first stop in a Koreatown Oaxacan restaurant in Los Angeles would be very important, as it would be there that I would introduce the group to the idea that a tour of Oaxacan crafts would be a tour not *to Oaxaca,* but to those places both inside and outside of Oaxaca where many of the craft items that are labeled MADE IN MEXICO are produced, marketed, and consumed.

The Museum Cultural Tour of Oaxacan Crafts—First Stop, Koreatown

In my tour, that dinner and talk at the Guelaguetza Restaurant in Koreatown would have been the first stop on the itinerary, not a pre-tour informational meeting. It would be a necessary first stop, because it offers important insights into the cultural logic that is a driving force behind interest in and appreciation for Mexican crafts—including Zapotec textiles. Much of what makes the restaurant an appealing place for both the Los Angeles Oaxacan community and others grows from a larger complex of ideas and images that also make Zapotec textiles appealing. I would start my tour with an introduction to these ideas and their history . . . and, of course, a wonderful dinner of Oaxacan dishes.

While the design of the Guelaguetza Restaurant's exterior reflects its history as a Korean barbeque, the interior is another matter. It is filled with the sights, sounds, smells, and tastes of Oaxaca. It can be a little overwhelming, especially if one is not prepared for the onslaught—a regular cacophony of bright colors, sounds, and pungent aromas.

The main dining room has a stage and sound system with a floor-to-ceiling photographic mural as a backdrop depicting the ruins of a colonial monastery near the Oaxacan district capital of Zaachila. Black-and-white photos of rural market and village life from the early twentieth century dot brightly painted walls, and Oaxacan craft items are strategically placed in

niches and archways throughout. Overhead are hung colorful cut-paper (*papel picado*) banners, a marimba band serenades diners, and brightly colored tablecloths lend a further festive touch to the scene. Near the front entrance, a variety of Oaxacan products, from ceramics, basketry, and embroidered clothing to foods like fried grasshoppers (*chapolines*), *pan dulce* (sweet bread), and packaged *mole* sauces, are available for sale.

We shall explore in more detail later how such sights, smells, and tastes have become markers of Mexico. At this point, we should simply note that what at first sight may seem like a madcap cacophony is, in fact, a baroque composition of carefully chosen items that are widely known as markers of Mexico and Oaxaca. The interior of the restaurant is actually painstakingly orchestrated and not simply a hodgepodge of "things Mexican" thrown together. In fact, every detail of the restaurant's interior, as well as its name, has a history as a marker of national and regional identity (what in Mexico is called *patrimonio cultural,* cultural patrimony), of *lo mexicano* (that which is Mexican).

For the museum's pre-tour dinner and presentation, several tables and a screen for my slides were set up in a more secluded section near the back of the restaurant. Given the itinerary of the tour and the purpose of the dinner and my talk that evening, I showed slides I had taken over the previous fifteen years of people at work in Oaxacan villages known for different kinds of crafts. I also showed slides of archaeological ruins, of rural Oaxacan outdoor markets, and of people selling a variety of crafts at them. And I explained that, as an ethnographer, I had gone to Oaxaca intent on learning how the social setting within which Zapotec weavers work shapes their weaving skills and knowledge.

I had been doing this, I went on, since the late 1980s, and had spent lengthy periods (as long as twenty months at a stretch) living in Teotitlán, working in the workshops alongside weavers, and conducting life history interviews with them. Like most craft producers in Oaxaca, I explained, the weavers I worked with live in rural indigenous communities where villages tend to specialize in one craft or another. Many Zapotec weavers live in one of four specific communities and are linked together in a complex network of subcontracting relationships between families both within and between communities. I emphasized how this system of subcontracted textile production then articulates with the outdoor markets seen in the slide show.

There has been a great deal of anthropological interest in what is called Oaxaca's "cyclical market system," I went on to explain. Some scholars see these daily markets that move from community to community throughout

the week, with the main market held on Saturday in the state capital, as vestiges of a pre-Hispanic system of exchange. On the other hand, some emphasize how they work as a social and economic mechanism through which partially self-sufficient small-scale farmers and crafters maintain a position that is both in the wider capitalist market economy and, at the same time, tangential to it.

Of course, any discussion of the basic whos, wheres, and hows of Zapotec textiles would be incomplete without some mention of the loom, the textiles themselves, and the wool yarn that is used to make them. Here again, my talk focused on Oaxaca's cyclical outdoor markets and their linkages to, and discontinuities with, the pre-Hispanic era. The textiles made by Zapotec weavers from these communities are formally described by textile experts as woolen tapestry-weave textiles, meaning that they are flat-weave (as opposed to knotted or tufted) textiles in which the woolen weft yarn forms the "face," or visible surface—and hence, by extension, the textile's design. Most ordinary people would probably recognize them to be *serapes*. The loom used to make them, local (Oaxacan) oral history has it, was introduced by the Spanish in the mid-1500s and is found throughout the Americas, from Hispano settlements in the American Southwest to highland communities throughout the Andes in Peru and Bolivia. In essence, it is a sixteenth-century European technology that was introduced wherever Spanish settlers also introduced sheep herding. People in the four weaving communities of Teotitlán, Santa Ana del Valle, San Miguel del Valle, and Díaz Ordaz have never owned sheep in large numbers, but customarily purchase raw wool and wool yarn at several of the cyclical markets, from sheep herders and yarn spinners who live in the mountains around the weavers' communities.

Some scholars have noted that, unlike the cotton thread and back-strap loom used in many indigenous communities throughout the Americas, the material and loom used by Zapotec weavers are European in origin and their textile tradition is therefore, strictly speaking, not purely indigenous. On the other hand, I pointed out, they have been using this "new" technology and material for somewhere in the neighborhood of 450 years—how long do they take to qualify as indigenous (and, by extension, authentic) items? I went on to say, as I moved into the final portion of my talk and began showing slide after slide of the many different Zapotec textiles held in the NHM-LAC's collection, that the same difficulty exists in evaluating the textile patterns woven by the Zapotec. They are well known for making textiles that feature the geometric patterns found on the archaeological ruins throughout Oaxaca and elsewhere in Mexico, but they also weave a wide variety of col-

orful and fantastic patterns whose inspiration lies far outside Mexico. These are the many textiles that "experts" of all stripes will tell you are "inauthentic" and not worth purchasing—even as a simple souvenir.

"How completely and utterly uninspired and uninsightful," I remember thinking as I sat in my car, in the restaurant parking lot, after the talk. Uninspiring, and what is worse, not at all an unusual way of orienting tourists to the subject of Zapotec weavers—and Oaxacan crafts more generally. "That's not what people need to know about the lives of Zapotec weavers!" I thought to myself. I wanted those going with me on the tour to see the Zapotec as real people, with real families and real financial issues, not as caricaturish, "exotic" peasant farmers and weavers living in quaint rural villages. That is, not as "noble savages," "primitive others," and so on, but as the everyday kind of people who might be (and no doubt were) working in that restaurant's kitchen preparing my listeners' meal—but as those who also had this fascinating history of making beautiful textiles. So . . . I sat there concerned that I had started off on the wrong foot and would not have many opportunities to make things right.

If the Guelaguetza Restaurant had been the first stop on the tour, I would have used that moment in the restaurant to reflect upon why we place so much emphasis on linkages with patterns, materials, and technologies from the pre-Hispanic era. And here is the connection to the Guelaguetza Restaurant and my way into this subject through the restaurant itself—we emphasize such linkages not only when we evaluate crafts, but also when we consider Mexican cuisine. In other words, I would have used the tour stop to talk with those traveling with me about both the cultural history of the sights, sounds, smells, and tastes of the interior of the restaurant and the uses to which they had recently been put.

Why should continuities and discontinuities with pre-Hispanic patterns be an issue at all? Who cares, or more exactly, why do we care (and we do)? Jeffrey Pilcher shows that the meanings of food in Mexico, the associations between food and social class, region, and ethnicity, have shifted over time. The current enshrinement of corn tortillas, tamales, tacos, and so on as the core of traditional Mexican food, which is evident in the Guelaguetza Restaurant's menu, has its origins in the 1930s, when post-revolutionary Mexico went through a period of intense reflection and debate about what it meant to be Mexican. Pilcher calls this the "tortilla discourse," meaning that a common way (what some authors call a "discursive trope") developed of narratively framing how people talk about corn, *masa* (cornmeal dough), tortillas, tamales, and the various sauces used to give them flavor and spice. These

foods had previously been denigrated as the not very nutritious staples of the diet of Mexico's rural indigenous population—as things that Mexico's leadership needed to wean the populace from, replacing them with the European grain, wheat, if Mexico were to modernize. During this period of reflection and debate, however, more and more people came to see these corn-based foods not only as nutritious but as a symbol of national culture. Mexico's upper classes "appropriated tamales for themselves, transforming a basic element of popular culture into a symbol of national unity."[1]

This reflection and debate occurred as part of a wider revaluation of things pre-Hispanic and indigenous that was, in turn, part of one of the great nation-building projects of the mid-twentieth century. Many Mexican artists (including Diego Rivera and Miguel Covarrubias) and Mexican anthropologists (such as Alfanso Caso and Manuel Gamio) were instrumental in developing a new sense of Mexico's relation to its own past, explicitly taking up the issue in their work.[2] Although there were competing images of *lo mexicano,* for many politicians, intellectuals, and artists the phrase meant "things Mexican" that looked not to Europe and European history, culture, and thought for direction, but to the "Americas"—more specifically, to the non-Anglo-Saxon America of José Martí's well-known essay "Nuestra América" ("Our America") and, especially, to Mexico's own pre-Hispanic civilizations.[3] Rivera and like-minded artists and intellectuals saw the rural indigenous Mexicans, their traditions, their aesthetic expressions, and the very communities in which they lived (often situated atop the ruins of pre-Hispanic settlements) as the living remnants of—and a direct link to—Mexico's pre-Hispanic past. Ethnographers were also very public figures during this period of Mexican history, and they championed anthropology and the tools of the ethnographer for their ability to bring scientific rigor to the programs through which Mexico was attempting to build a national identity and create itself anew.

Craft items of the sort displayed throughout the interior of the Guelaguetza Restaurant were among those aspects of rural indigenous culture most intensely scrutinized by anthropologists, and a well-developed literature now supports the idea that the work of anthropologists in this period is largely responsible for the way we judge the worth of such items as "authentic indigenous" material culture. Ethnographers worked alongside artists, writers, and politicians to help craft this new sense of what it meant to be Mexican (and what things were *truly* Mexican), helping the new nation to find safe ways of imagining its relation to its native/indigenous peoples and their cultures—an army of people whom Mexican anthropologist Néstor García

Canclini has described as those who "jointly manage our money and our dreams, those who exchange our reality for fetishes."[4] In the case of the Guelaguetza Restaurant, then, the food served in it, the items used to decorate it, and even, as we are about to see, its name are all a part of this managed, fetishized reality. They are all, in a very real sense, made important to us through this cultural space of Mexican cultural patrimony that so many people helped to create. They are all MADE IN MEXICO.

Deborah Poole has traced the historical development of the Guelaguetza cultural festival in her work on "type photos," race, and dress in Oaxaca in the late nineteenth and twentieth centuries. Type photos were a popular and highly structured way in which European colonials represented racial and cultural difference, and Poole outlines how this representational form traveled to Mexico and was used by Oaxacan elites to work through their "lingering concern with documenting and administering the diversity of racial types in their state."[5]

The Guelaguetza festival has its origin in the 1932 Homenaje Racial (Homage to Race) pageant, in which female representatives (ambassadors) and their entourages from throughout the state "functioned as a visual technology for promoting an idea of a unified Oaxacan identity based on a sort of menu of feminine costumes and types" that later came to include a repertoire of folk dances.[6] Concern with documenting and finding a way of representing Oaxacan identity in its diversity of racial "types" (and folk or indigenous costumes and dances) took hold in Oaxaca just as Mexico was struggling to define itself as a nation. For the state's authorities, then, the Guelaguetza became a way to find a space and rationale for Oaxaca's traditions among the forms of Mexican cultural patrimony that were now recognized and considered appropriate (a way to discover how *lo oaxaqueño* made its own unique contribution to *lo mexicano*) at the same time that the festival also came to mark the high point of the summer tourist season. Over the past several decades, Oaxaca's performative technology of diversity has been promoted to visitors as a means of touring and consuming Oaxacans' contribution to Mexican cultural patrimony—the cultural diversity of its indigenous populations.

Meanwhile, for the past several years, the Guelaguetza has been performed at several venues in Southern California, including the Los Angeles Sports Arena, just across Exposition Park from the NHMLAC. Predominantly Oaxacan crowds varying in size from approximately ten thousand (in 2002) to four thousand (in 2006) enjoy a day of food, crafts, and costumed folk dances much as crowds of mostly foreign tourists do in Oaxaca each

July. In 2006 both the consul general of Mexico in Los Angeles and the mayor of Los Angeles spoke to the crowd at a time of heightened tension over pending U.S. federal immigration reform. Their message was exactly what Poole might have predicted—that Oaxaca and the Guelaguetza festival should be taken as shining examples of how cultural diversity should be expressed and can work to unite instead of divide a population (whether that population be in the southern Mexican state of Oaxaca or Southern California).

Were the timing a little different, I might have begun the museum's tour at this event (or, better, made it the second stop), as a way of emphasizing to the group the idea that to tour Oaxacan crafters and crafts is to tour those places inside and outside of Oaxaca where the legitimacy of Mexican craft items is produced, marketed, and consumed at the same time that the actual items (and their makers) are as well. In his work on pageants of another sort (Belizean beauty pageants), Richard Wilk argues that such events frame identity and difference in limited ways along set dimensions that create a transnational structure "celebrating some kinds of difference and submerging others," and he calls such structures "global systems of common difference." Had I taken my tour group to the Los Angeles Guelaguetza festival from the Guelaguetza Restaurant, I would have emphasized how the pageantry of different forms of indigenous dance and costume works with a similar limited set of narrative frames (like Pilcher's tortilla discourse) that structure the way they are experienced and understood by people in these two places in Southern California. Were one to track those narratives across the globe at other events, I would suggest to them, taking stock of the places and circumstances where they are encountered, one would be moving through and creating a network of the kind of cultural spaces that I think a tour of Oaxacan crafts ought to visit.[7]

While Wilk most often uses the structural metaphors of networks and circuits to argue that such contests offer important insights into the relation between the local and the global, he closes his essay on Belizean beauty pageants by noting that they also "create *communities* of fans and contestants that are very real, and are no more imaginary than the lineages and tribes that anthropologists have traditionally studied."[8] Taking my tour group to the Guelaguetza Restaurant and Guelaguetza festival in Los Angeles would be beginning the tour in a community that is every bit as real as the Oaxacan villages traditionally visited by tourists interested in Zapotec weaving. As the museum's cultural expert, once back on the tour bus and on our way to the next stop, I would emphasize to them that they had just made their first

two stops in that community and that the remainder of the tour would explore several such places that can be thought of as forming a kind of dispersed or translocal community.

Locating a Global Ethnography of Mexican Indigenous Artisans

So just where is my alternative museum cultural tour headed? The short answer is that my tour is global—it is a tour of globalization through the medium of Zapotec textiles (and weavers). While I will lay out the tour's itinerary below, it is important at this juncture to indicate what I mean by the term "globalization" and its importance for understanding the whos, wheres, and hows of a "locally produced" product like Zapotec textiles.

A vast anthropological (and, more broadly, social science) literature focuses on both the term itself and on the various debates about how globalization is changing our lives—much too vast a literature to review here, when it would do little to move the narrative forward. There are, however, a number of scholars who are looking at the things (material, symbolic, and biological) in our lives, at commodities as varied as food products, body parts, art, and other expressive cultural forms, in an effort to develop more focused accounts of what globalization is, how it works, and what it means to our daily lives. Here again Richard Wilk's work in Belize is informative—and provocative. In a continuation of his line of thinking about beauty pageants and global systems of common difference, he has more recently turned to an analysis of the historical development of "authentic" Belizean food, offering a radical take on globalization debates:

> Could it be that there is something about globalization itself that produces local culture, and promotes the constant formation of new forms of [the] local . . . ? Maybe the very diversity we have always presumed was a remnant of a time before globalization is not a survival, but a contemporary of the sweeping forces that have brought modern capitalism to every part of the planet?[9]

Wilk couples his position on local cultural difference with an equally interesting stance on globalization, arguing that, in essence, the technological changes in communication and transport that lie at the heart of most definitions of what is driving globalization are nothing new. And that is not to say that globalization is not real, only that there have been other dramatic technological shifts that drove changes in people's lives at other historical junctures as well. He notes, for example, that pundits of various sorts predicted

dire consequences for cultural traditions in the nineteenth century, fearing that steam-powered travel, the telegraph, and the economic ties that stitched together geographically dispersed empires would either wipe clean the cultural diversity of the world or transform it utterly, as the push of global forces met the staying power of local traditions. Of course, neither of these predictions fairly characterizes the history of the past two centuries—reality is much messier.

Today's debates about globalization and cultural difference also tend toward these two extremes. Wilk's point is that we may just find that messy reality is better explained not by thinking of older local traditions as responding to global flows (regardless of whether or not the local traditions "win" or "lose" to the global imperial forces) but by dropping the frame altogether (and the linear conception of history that it is built upon) and thinking of globalization in the plural and as something that is local. Drawing on Jonathan Friedman's ideas on globalization and identity, Wilk argues that it is our very conceptualization of space as either local or global, our use of this dichotomy, that has been the problem. Subsequent authors have taken up this position. They suggest that we might better understand local expressive cultural forms, from music to food to crafts, as "widespread and common forms of contest for the exercise of power over what to produce, consume, watch, read, and write."[10]

This ethnography (and tour) takes those insights into globalization and the local lives people live in global space as a starting point for developing an ethnographic account of how people become Zapotec weavers while making textiles. People from the rural Oaxacan villages where Zapotec textiles are, at least in part, made inhabit a "world" that is "a pageant of diversity with its differences neatly organized and selected," although, in the case of this and other forms of expressive material culture, "exposition of diversity" would be the more apt phrase.[11]

For this reason, this story must also move through the spaces where culture and identity are selected and created, in much the same way that Zapotec textiles are crafted and "authenticated." Thus, this study cannot be organized only around the Oaxacan communities where many Zapotec weavers live, but must be more broadly oriented around the spaces where Zapotec textiles (as both material and symbolic objects) are produced as a distinct part of this "exposition of diversity." This set of spaces is in fact a series of spaces created as a locality—that is, as a place—through the practices of Zapotec weavers and others from a continuous global space.[12] This organization, in turn, will emphasize how the symbolic economy of common difference

surrounding Zapotec textile production and consumption informs the capitalist economy and vice versa, creating images of the Zapotec in terms of pre-Hispanic traits, which, in turn, shape the production of Zapotec textiles. It will emphasize how images and narratives influence production, the movements of products in the global economy, and the articulation of these economic circuits with the household workshops of Zapotec weavers.

Yet these spaces are also inhabited by those who work to make indigenous Mexican craft items into objects of fetishized desire, according to García Canclini. Wilk points to some of those spaces when he emphasizes that a host of people working in state bureaucracies, NGOs, university departments, museums, and so on contribute to the work of the artisans, musicians, cooks, and others who craft the cultural forms of common difference that make up the global pageantry of diversity. In their work they are "following paths already well worn by generations of historians, anthropologists, and folklorists."[13] Because of the particular history of Mexico, anthropologists and the ethnographies they produce will feature prominently in my description of this community. Placing the work of ethnographers squarely within Mexico's mid-century project to create a national cultural patrimony that included its indigenous populations (albeit only certain, "safe" portions of those populations and their cultures) has begun to reveal why this should be, and serves as a point of departure for this ethnography (and my imaginary tour) as we begin to explore those spaces crafted out of global space by the practices of making Zapotec textiles and artisans.[14]

Location, Practice, and the "Problem of Context"

In contrast to the approach developed so far in this introduction, this ethnography (and tour) might have opened with a more straightforward passage along the following lines: "Zapotec textiles are made in the community of Teotitlán, an indigenous *municipio* (municipality) of approximately nine thousand inhabitants located . . ." and so forth. A very large number of ethnographies set in Mexico have been framed in this manner, and tours frequently orient people to Oaxacan crafts in terms of the "villages" they are said to "come from" (much as I did in my talk at the Guelaguetza Restaurant). That kind of bracketing off would locate both this project and Zapotec textile production within an overly narrow set of geographic confines, whether they were the *municipio* of Teotitlán, a set of Oaxacan *pueblos,* towns, or villages, or even, more expansively, a "culture area" such as Mesoamerica.[15]

This study, however, reframes the ethnographic project to include the work of García Canclini's "image makers." It points to ethnographers themselves and others who inform our understanding of and appreciation for Zapotec textiles. In other words, Zapotec textiles and weavers come from another place—one which includes those villages that Oaxacan crafts are so frequently attributed to, but other places as well. These other spaces, this community, is not a community or location that literally exists as a place and is "gone to" but one that comes into being through the social practice of people, and it is every bit as real as those places we think of as occupying a particular geographic space.

Arjun Appadurai's writing on the creation of "locality" is informative on this issue. In *Modernity at Large,* he writes that the "ethnographic project is in a peculiar way isomorphic with the very knowledges it seeks to discover and document," and notes that ethnographers have typically taken the location of their work to be the ground, not the figure, when in fact it is both simultaneously. As a consequence, ethnography and ethnographers have been complicit in the work of location. Anthropology has been an accomplice or collaborator in creating the social spaces it is sometimes unproblematically assumed to be describing. He suggests that the "problem of context" is to conceive how localities might "at the same time require and produce contexts." In other words, the conceptual dilemma is how to understand the social and cultural spaces through which Zapotec textile practices are both embodied and put into practice(s) as a part of the ethnographic enterprise itself, and how they are also important to establishing the places or localities to which the ethnography goes.[16]

Appadurai uses the term "neighborhood" to describe this notion of locality, "the actually existing social forms in which locality, as a dimension or value, is variably realized." So conceived, neighborhoods are settings that can generate context and "might exceed existing" demarcations.[17] Conceptually, then, localities are simultaneously setting and generative of setting, but only under certain circumstances and at particular historical junctures. One might well ask, are ethnographers (and tourists) only occasionally complicit? Relatedly, is ground also figure only at special moments? Neighborhood as setting, and as conceived by Appadurai, accommodates changes in setting and makes use of its context-generative dimension at specific moments when, presumably, this dimension is activated. A strong theory of the context-generative dimension of locality, on the other hand, must treat each and every moment as generative.

How then to preserve Appadurai's insight into the simultaneity of locality? And, further, how then to write the social and cultural spaces through which both we (as ethnographers and tourists) and those we study (and visit) move as figure and ground simultaneously, both requiring and producing context? Treating the setting of this ethnography as produced through the practices of ethnographers, tourists, Mexican artists, and so on marks a reflexive shift that begins to suggest answers to these two related questions in the context of Zapotec weavers and their textiles.

We will return to the second of these questions toward the end of this introduction. As for the issue of the simultaneity of locality, a conception of context more in keeping with the implications of the shift I have described begins, quite straightforwardly, with the assertion that the context of any practice grows out of such a practice. I begin here to craft a framework where context is both setting and generative of setting, asserting that each and every practice is context-generative. Where Appadurai sees the context-generative dimension of locality as something to be activated, this ethnography will highlight how every action makes assertions about the generation of context. Where Appadurai sees that the context-generative dimension of locality may sometimes suggest changes in the existing demarcations of a locality, in this account the limits of locality are the product of multiple simultaneous suggestions that vie with other suggestions to define how a locality is demarcated. In short, the context-generative dimension of locality is not activated; it is always present and asserted with sometimes greater or lesser success. Further, and to jump a bit ahead of myself, the degree to which an assertion about context is successful is a question of power.

Many studies of craft production in Mexico and around the world have been community studies, and our understanding of the lives of countless rural villagers is a product of the highly nuanced, thick-descriptive accounts that these community-focused research programs helped to create. But a focus on the multiple spaces created in practice that make up the community of people crafting Zapotec textiles allows for a different sort of "community study," one focusing on all of those engaged in the material and symbolic creation of Zapotec textiles. Rather than assuming that the bounded limits of geographic space define the geopolitical limits of the community, this kind of community study allows the social, cultural, and spatial geography of the community to emerge as a product of the lives and practices of those engaged in the making of Zapotec textiles.[18] This type of community study frames its inquiry into the creation of Zapotec weavers and weavings in

response to the lived spaces of Zapotec weavers, localities made a part of this community by the ever-changing relations of production under late capitalism, the spaces formed in practice by those who create García Canclini's fetishized realities and by a host of others.

The Research Site: A "Community of Practice"

Although the community study has long been a dominant form in the ethnographic genre, I borrow the phrase "community of practice" from the work of Jean Lave and Etienne Wenger. Lave and Wenger describe the community of practice as a "set of relations among persons, activity, and world, over time and in relation with other tangential and overlapping communities of practice." They employ the phrase to highlight the "relational interdependency" of the activities in which people engage, the social and cultural worlds created through such practice, and the people themselves, who, to no small degree, also create themselves through their practice.[19]

They also position their work as part of the "turn to practice" in the social sciences, described by Sherry Ortner as a turn to the things "people do," and the "relationship" between those practices and larger systemic "entities."[20] However, Lave and Wenger's focus also takes its impetus from another source—Vygotskian activity theory. Lave and Wenger are most concerned with understanding learning as "legitimate peripheral participation" in communities of practice and thus as an inherent part of participation in social practice more generally.[21] Learning, so conceived, is less a matter of exposure to and acquisition of "information" or "knowledge" (as it is almost paradigmatically assumed to be in research programs as diverse as educational pedagogy and cognitive science) than it is the embodiment of social structure. Central to a Vygotskian approach to knowledge and practice is the idea that the development of the mind is essentially a disciplinary process, less the *imparting of knowledge* than the *imposition of ways of knowing* that are inculcated through participation in the social world. It is worth exploring the origins of such a radically conceived notion of, and approach to, "learning" in greater detail.

The theory of action founded by Lev Vygotsky (what is sometimes referred to as the Cultural-Historical School) was developed in Russia in the early 1900s, and it has been described as a "sociocultural approach to mind." Vygotsky was quite theoretically eclectic, having begun his career outside the realms of the psychological profession in art criticism, and he continued

throughout his short life to read widely and critically in a number of disciplines. As a result of his broad interests and intellectual mastery, there are several "Vygotskys" influencing psychological, anthropological, and educational research, as well as other social science research programs focusing on "knowledge and practice" or "activity."[22]

Vygotsky developed several key concepts for understanding how human mental "development," in its broadest sense, is related to social life. Arguably, the most important is that any mental process will be the "internalized" version of a pre-existing social process or cultural form. Some of Vygotsky's most widely acknowledged work was in the area of child education, where he wrote extensively about the processes of internalization of speech and resultant transformation of social knowledge.[23]

Unfortunately, Vygotsky's early death left a number of issues critical to his work largely unexplored. For instance, in his continual reference to the "social," he paid only sporadic attention to what the proper unit of analysis might be. Although his writings make explicit that the social context of an activity must be understood in its historical, cultural, and politico-economic senses, his research does not clearly state how this is to be done. Most of his research was conducted in the laboratory setting and although Vygotsky was, without question, aware of the limits of the experimental situation, he never approached this issue systematically.

Much current debate among those working from a Vygotskian perspective seeks to address the problem of how to incorporate the social. This is the "problem of context"—what Vygotsky referred to as the "problem of the environment." Lave and Wenger have proposed that the wider social setting of a particular practice be conceived in terms of the totality of such practices—what they call a community of practice. Further, they envision the structure and limits of such communities of practice (at least where learning is concerned) in terms of "power" and "conditions of legitimacy," two closely related issues. Unfortunately, despite the centrality of the concept to their analysis, they offer no substantive treatment of it. As they themselves admit, "the concept of 'community of practice' is left largely as an intuitive notion, which serves a purpose here but which requires a more rigorous treatment."[24]

Their insight into the role of power and legitimacy where the structure and possibility of learning are concerned will, in this ethnography, be generalized and applied to the overall structure of the "community" under study. This way of framing the problem of context treats the overall shape and

structure of communities of practice in terms of assertions about, and claims to, legitimacy for the product of those practices as well as the practices themselves. This move has the benefit of resolving two conceptual issues simultaneously. First, it changes the concept of a community of practice from an intuitive notion guiding the study of learning situations to an empirical question to be resolved through research. Second, it resolves the question posed earlier about who determines which practices are "similar" or "like" for a setting conceived in terms of a totality of practices. Quite succinctly, every practice makes claims about legitimacy and hence assertions about the limits of any community of practice.

Essentially, the limits of the community of practice are constantly being created and destroyed, by each and every practice. The social structure of such a community, then, is a consequence of the totality of relations between competing claims about membership. The limits or boundaries of a community so conceived are set through claims to membership which are, in turn, a part of the structure of the practice itself. Locality is, as a consequence, continually asserted through every practice, and every practice is context-generative in two senses. First, it literally creates social spaces as people engage in a practice, and second, legitimacy claims embedded in the practice itself set limits on the spaces that make up communities of practice. Carved out of a continuous global space, then, are the practiced spaces that implicate other practices as "like" (or "unlike") through assertions about membership or inclusion with other such spaces.

This conception of the context of practice has clear parallels with the work of another well-known "practice theorist," Pierre Bourdieu. Bourdieu used the term "field" to refer to the structure of the space of practices at the same time inscribing and, consequently, asserting particular practices over others.[25] He framed his studies of the French literary world in terms of conditions of legitimacy, marking out a "field of cultural production." In Bourdieu's phraseology, the field of cultural production consists of sets of historical relations between positions, anchored in forms of power, all working to define and legitimate competing material and symbolic cultural products. The boundaries and structure of the field of cultural production are created in "conflicts over definition," and

> struggles over definition (or classification) have boundaries at stake (between genres and disciplines, or between modes of production inside the same genre) and, therefore, hierarchies. To define boundaries, defend them and control entries is to defend the established order in the field.[26]

Similarly, the network of practiced spaces associated with crafting Zapotec textiles has a social structure I conceive in terms of a field of positions marked out in conflicts over definition: the definition of what constitutes a Zapotec textile, a Zapotec weaver, and "legitimate" or "authentic" Zapotec weaving practices. These spaces both provide the setting for the study and generate the context of this ethnography. The social structure of this community of practice, its overall shape or topography and its limits or boundaries, is a field of positions on, and competing definitions of, what constitutes a Zapotec textile (including the positions and definitions asserted by anthropologists). This community of practice study, then, will move through (or tour) and explore those cultural spaces engendered through the practices which create Zapotec textiles materially and symbolically—that is to say, the practiced spaces of the actual material production of Zapotec textiles, and also those spaces through which Zapotec textiles are produced as objects understood to be aspects of expressive culture.

Framing this study around the concept of a community of practice suggests that it must include all practiced spaces through which such assertions are put forth—the practices of those who inform the attitudes expressed in museums, galleries, and texts (including this one), as well as in government policy and commercial enterprise. These are spaces from which those who, as García Canclini pointed out, create our fetishized realities also inform our attitudes toward Zapotec textiles (e.g., concerning the "authenticity" of certain practices and products) and their producers. They are practiced spaces where the conditions for legitimacy are argued over and, to a greater and lesser extent, are set for the Zapotec, who lack the literary or educational pedigree ("cultural capital," in Bourdieu's framework) to have their assertions carry much weight.

Zapotec Weavers and Their Bodily Techniques: MADE IN MEXICO

Describing the effects of culture and society on the ways the body moves through social and cultural space, Marcel Mauss wrote that bodily techniques are quite literally the "ways in which from society to society men know how to use their bodies." The ways that the body engages in the most basic activities, such as walking or eating, form a locus where social, psychological, and physiological processes meet to transform and inform one another—a "triple consideration," according to Mauss. Such bodily orientations and practices register a "social idiosyncrasy." They are, in a sense, quite

un-"natural" or crafted, as they are "assembled for the individual not by himself alone but by all his education, by the whole society to which he belongs, in the place he occupies in it."[27]

To take the example of walking (as does Mauss), one's gait and the swing of the arm are shaped by society as well as by one's place in it. That is, they are not solely "natural" consequences of the necessities of bipedal locomotion, but are also shaped by the particulars of a person's place in a social world. This study examines how this is also the case for Zapotec weavers and their work at the loom—their weaving practices. The turn of a wrist at the loom, the way a leg moves from one pedal to another, the tip of a finger as it pushes a length of yarn into position (to say nothing of how the weaver approaches a particular design), all register a social idiosyncrasy and are in this sense crafted, or "assembled."

This invocation of Mauss's seminal essay, however, is more than a simple acknowledgment of what many take to be the beginning of a sociological approach to studying the body as created in society. Mauss's notion of bodily techniques is of particular importance because, anticipating Foucault's notion of "anatomo-politics" (around which much current debate and research are focused), he also suggested that bodily techniques are a locus of discipline.

> We are everywhere faced with physio-psycho-sociological assemblages of series of action . . . [which] are more or less habitual and more or less ancient in the life of the individual and . . . [which] are assembled by and for social authority.[28]

From this perspective, learning to walk or eat is a disciplinary process in which the use of the body is shaped by social structure, and the way people walk or eat registers (or contains traces of) their place in the social order. It is in this sense that bodily techniques are crafted.

Yet Mauss also contends that bodily techniques are "assembled for social authority"; in other words, they are not only shaped by power relations, but are also a locus for the imposition of power over other bodies, practices, spaces, and events. Bodily techniques are a site of agency and political struggle (broadly conceived). They are not simply determined by society but also shape society and, because of this, make assertions about social order at the same time as they are shaped by it.[29]

Mauss's notion of bodily techniques, then, ties together several strands of the framework for understanding Zapotec weaving practices developed in

this discussion. First, his emphasis on activities such as walking and eating (in contrast to most studies of learning, which focus on "cognitive" skills like mathematics and "critical thinking") offers a point of departure for a focus on "manual skills." Second, his focus on disciplinarity intersects nicely with Lave and Wenger's Vygotskian approach to learning. Lave and Wenger's emphasis on conditions of legitimacy as structuring participatory patterns finds a parallel in Mauss's contention that bodily techniques are a locus of discipline (*by* social authority). Finally, his conception of bodily techniques also suggests that the practical manual skills of Zapotec weavers are not simply determined by the social order in which they are embedded, but may shape that social order as well (*for* social authority). For an orientation toward "context" conceived in terms of practiced space, Mauss's work opens a theoretical space for a non-overdetermined treatment of the relation between practice and social structure. In this approach to the creation of social order, seemingly mundane manual activities may be among the catalysts exerting and imposing structures of power in communities of practice.

Crafting Zapotec weavers, then, describes learning as a process of embodying social practice. A Maussian formulation of the interrelation between Zapotec weaving practices, Zapotec bodily orientation toward everyday practical activities (a kind of "posture"), and society entails a triple consideration of bodily techniques: a simultaneous focus upon bodily postures in weaving, weaving practices, and the social spaces in which those bodily postures and practices are embedded. These bodily techniques are one nexus created by and for social authority: the contestations of conditions of legitimacy and the limits of the practiced space in which such contestations may take place. Understanding the social idiosyncrasy registered in the bodily techniques of Zapotec weavers as they work at the loom, however, requires moving beyond the bounds of the Oaxacan communities where most Zapotec weavers live and out into the multiple spaces where Zapotec textiles as material and symbolic products are created: those spaces make up the community of practice of which the production of Zapotec textiles (and the crafting of Zapotec weavers) is a part. This study will move through those spaces where the social idiosyncrasy of the practices of Zapotec weavers is crafted as Zapotec textiles are also produced.

In an important sense, Zapotec weavers and textiles are made in all the far-flung social and cultural spaces in which we find things labeled MADE IN MEXICO. That phrase, implicating those spaces where the romance of indigenous Mexico is figured in relation to the pre-Hispanic, points to the spaces beyond the municipalities of Teotitlán, Santa Ana, San Miguel, and

Díaz Ordaz from which our understanding of Zapotec weavers and the product of their labor is given shape. Mexico's Zapotec weavers, I argue, learn to weave and work in a global space at the same time as their weaving practices shape it. While referring to the "country of origin" of Zapotec textiles, the phrase "Made in Mexico" also refers to the spaces making up a translocal (and transnational) community of practice—the Zapotec weaving community. This ethnography (our "ideal" museum cultural tour) will move through those spaces and others as it takes account of what and how Zapotec artisans learn when they learn to weave as they craft Zapotec textiles.

Given the tenor of this study, its focus on the constructed nature of the realities in which we live (what García Canclini has called reality's "managedness"), something needs to be said of this study's use of the word "Zapotec." Because we have come to associate the textiles made in Teotitlán and other spaces with an indigenous identity, this study is also about how and where arguments over definitions of "Zapotec" occur. Use of the term "Zapotec" to describe the weavers whose work figures so prominently in this study, as well as the product of their labor (Zapotec textiles), should not be understood as an unproblematic reference to any group of people, their ethnicity or race, nor to a set of features or techniques of the textiles they make. Such use points to a part of the managed reality to which García Canclini alluded, and this study is in large part an effort to document and describe that process.

In some respects, we are once again faced with ethnography's duplicity in the creation of locality, but, where Zapotec weavers and textiles are concerned, also with the creation (or, better, crafting) of identity. Just as ethnography has sometimes been duplicitous in the creation of locality, ethnographers have also been, from time to time, complicit in the creation of identity. We have sometimes taken the identity of the people among whom we work, as we have taken locality, to be the ground for our studies, not the figure, when, as Appadurai would likely suggest, it is both simultaneously. Here, again, the ethnographic project has been isomorphic with the very identities it has sought to discover and document. Further paralleling Appadurai's argument, I would suggest that the problem is how to conceive of ethnic identity as both requiring and producing identity.

Following our conception of locality as both requiring and producing context, I also think that it is most productive (in this context at least) to consider the ways that each and every practice asserting Zapotec identity helps to create Zapotec identity anew, and is one instance in a field of such practices. This is the case for all such practices, including those crafted in

this study, because, as Bourdieu reminds us, to produce effects, that is, to make assertions about identity through one's practices, is already to exist in the field of identity-making practices—or in this case, in the spaces MADE IN MEXICO.

The Itinerary

We turn now to the second issue to emerge from Appadurai's insight into the simultaneity of context: how to write the social spaces through which both we as ethnographers and those we study move as figure and ground simultaneously. George Marcus has suggested that one means of writing and researching the increasingly de-localized life worlds emerging in the early twenty-first century is to move the reader through the multiple spaces created by the subjects of our research and by ourselves in the course of our research. He terms such ethnographies multi-sited—ethnographies that are, at the same time, *in* and *of* the world system. He describes multi-sited ethnography as

> designed around chains, paths, threads, conjunctions, or juxtapositions of location in which the ethnographer establishes some form of literal, physical presence, with an explicit, posited logic of association or connection among sites . . . through (preplanned or opportunistic) movement and of tracing within different settings of a complex cultural phenomenon.[30]

Marcus outlines six "following" strategies for tracing such connections, such as "follow the people," "follow the thing," and "follow the metaphor." This ethnography as "tour" engages the global in the same way. In effect, the global emerges as a product of networks of multiple locales as we tour those spaces where crafts (and especially Zapotec textiles) labeled MADE IN MEXICO are produced, marketed, and consumed. This multi-sited ethnography therefore maintains the local focus of traditional research and writing strategies, but drops the narrative structure and holism that come with place-focused ethnography. In their place, a different narrative structure and sense of holism are established as readers are moved through differently connected cultural spaces—but cultural spaces that, nonetheless, are connected and form a larger entity.[31]

At the same time, such a methodological and writing strategy for a community of practice study need not be global or, for that matter, transnational, because these are, after all, empirical and historical questions. The degree to

which a particular study takes a global breadth depends, for example, upon where one follows the textile, weaver, tourist, design, yarn, and so on. In fact, Marcus's multi-sited strategy is useful to this study not because it can deal with increasingly globalized or de-localized lives, but because it focuses on the crafted (or managed) nature of the larger systems and sees the transnational as essentially the product of the multiple practices of people in multiple spaces. This kind of field methodological and writing strategy is doubly important to a community of practice study. First, it lends itself to a focus on the things people do and make as a consequence of its "follow the . . ." strategy. Secondly, it fixes the researcher's gaze on the intersection of what one might call local actors and larger social entities, or what Ortner referred to as "systems." Such a focus offers a methodological grounding for what Ortner has argued must be the focus of any "unified theory of practice"—namely, the simultaneous consideration of how practice makes and may modify the system.[32]

William Roseberry has commented on the usefulness of such an approach in discussing Max Gluckman's ideas about "community" and "social fields" in his work in Zululand. Framing Gluckman's work in terms of the local and the global (and holding parallels to Wilk's way of framing global and local relations), Roseberry notes that conceiving of social context in terms of a translocal field of relations enabled Gluckman to put local places into a network of other local places in which the historical and social specificity of practice in particular locales informs and shapes other locales in the social field. As a consequence, "the local is global, in this view, but the global can only be understood as always and necessarily local."[33] Such an approach creates a methodological possibility of (and a mode of representation appropriate to) a strong theory of the context-generative dimension of locality. These ideas structure the basic writing strategy of this ethnography. This ethnographic account of how Zapotec weavers and textiles become what and who they are is built around following (or "touring") the connections created in practice in a social field I write of metaphorically using the phrase MADE IN MEXICO.

In the same essay, Roseberry notes that the point of such an approach is not to "displace" earlier work but to build on it through dialogue. This work takes an ethnographic form well developed by researchers working in Oaxaca, elsewhere in Mexico, and beyond—the community study—and adapts it to the translocal (and in some cases transnational) working lives of people who once lived a much more geographically circumscribed exis-

tence. Relatedly, Fernando Coronil has noted that the point of critiquing "modernist assumptions" (such as that communities and lives are closed and bounded) ought not to be to produce a "proliferation of disjointed vignettes and stories" but to weave together glimpses into the lives of those with whom we work, revealing something of the complexity of the wider social and cultural contexts of their lives—he emphasizes that "fragmentations, ambiguity, and disjuncture are features of complex systems, rather than their opposite."[34]

The basic two-part framework around which this study is organized finds its origin in the intellectual wake of Lev Vygotsky. Vygotsky's ideas about the appropriation and transformation of social knowledge (or what has here been referred to as the disciplining of bodily techniques) frame my orientation to this problem, as well as my sense of what needs to be considered in contextualizing or locating Zapotec weaving practices. Following Vygotsky's suggestion, this study proceeds from the social to the psychological plane—from the Zapotec weaving community to the bodily practices of Zapotec weavers, and from the "who, where, and what does it mean?" questions to the "how are they made?" and "is it hard?" questions.

Part 1, "Constructing and Consuming the Zapotec," follows some of those involved in making, promoting, selling, and consuming Zapotec textiles, investigating what they say and the images they employ. In the first chapter ("*¡Viva Oaxaca, No Hay Otro!*"), instead of arriving in "the village" with the ethnographer, we encounter the town, the people who live there, and the textiles they make through the narrative practices of someone describing them for a primarily American audience. Beginning with an ethnographic vignette set in a craft gallery in the state capital of Oaxaca and a presentation given by a professional craft purchaser from the U.S., the discussion traces the historical development of images and descriptions of Teotitlán, the people who live there, and the textiles that they make.

Chapter 2 ("Touring Zapotec Weavers, or the Bug in the Rug") focuses on a tour of Teotitlán based, in part, on recorded tours. The idea is to experience Teotitlán through the words of a tour guide and the eyes of tourists. Through this means, the locality of Teotitlán, those who live there, and the things they make are all created in practice (and introduced in the ethnography) by the tour guide, the Zapotec family that hosts the weaving demonstration, and the tourists themselves. The discussion focuses on the use of cochineal (an insect, *Dactypolius coccus,* from which dye is made)—the bug in

the rug, and, I argue, the source of ambivalence, among tourists and tour guide, about the control Zapotec weavers exert over the "secret" knowledge of how to cultivate and effectively use this highly valued (both monetarily and symbolically) natural resource.

When Zapotec textiles are sold in the American Southwest (and a very large number of them are), they run headlong into the Southwestern Native American art market's own narrative construction of authenticity. United States law and a host of experts all work to define any textile produced outside the United States (including in Mexico) as not authentically Native American but "counterfeit" or "fake." In chapter 3, I use D. H. Lawrence's phrase "land of enchantment" to refer to the cultural spaces in which authenticity in the Santa Fe Native American art market (and the exclusion of Zapotec textiles from it) is constructed. The discussion enters into this material through the life histories of those who make a living by buying Zapotec textiles in Oaxaca and selling them in Santa Fe. Their work in Oaxaca is juxtaposed to the work they do in accommodating the narrative construction of authenticity in Santa Fe in order to sell Zapotec textiles as "Native American."

The discussion that concludes part 1 ("The Zapotec Industry") opens with a reflection on the people, places, and practices behind the making of a video about a weaving cooperative in Teotitlán and is illustrated by color photos of textiles and of the people and places explored in part 1. Scholars studying indigenous video in Mexico have suggested that it is created in a complex, transnational space where the interests and practices of NGOs, large institutions (like universities and museums), indigenous intellectuals, and local communities intersect to form a cultural space on which ethnographic analyses ought to focus. I use their argument to point out that this ethnography has been moving through a sampling of similar cultural spaces where Zapotec weavers and textiles are created—parts of the weaving community around Zapotec textile production with a corresponding "field of power" conceived in terms of competing assertions about authenticity.

Part 2, "Crafting Textiles and Weavers," moves from that wider social space where Zapotec textiles are crafted as symbolic objects, as objects of consumptive desire, into the working lives and, ultimately, the hands and feet of Zapotec weavers at work at the loom—to the "how are they made?" and "is it hard?" questions posed by those who accompanied me to on the tour to Oaxaca. Chapter 4 ("The Zapotec Textile Production Complex") begins by moving into the home and workshop spaces of Zapotec weavers through an ethnographic vignette set in the community of Santa Ana that also serves as a vehicle for exploring the ethnographic literature describing

and analyzing Zapotec textile production. Key features I omit from this initial description enable a critical reflection on the fact that such spaces are typically not a part of ethnographies in which the manufacture of Zapotec textiles is discussed and analyzed.

Chapter 5 ("We Learn to Weave by Weaving") provides an intimate and detailed account of the changing lives of Zapotec weavers that is primarily based on personal histories recorded between 1993 and 2003. This descriptive account is largely organized around Jean Lave's ideas about "legitimate peripheral participation"[35] and a young weaver's statement that in Teotitlán they "learn to weave by weaving," and ends by focusing on what learning to weave by working at weaving implies about the skills weavers acquire, their exposure to new color palettes and designs, and so on.

How and what weaving skills develop as the artisan works at the loom and the effect this process of "learning to weave by weaving" has on skills in, and knowledge of, weaving are the focus of chapter 6, "To Learn Weaving, MADE IN MEXICO." There I argue (borrowing from Donna Haraway) that becoming a Zapotec weaver is an "accumulation strategy."[36] Like Mauss, Haraway and David Harvey emphasize that the body, together with the ways people come to move and use their bodies, is a disciplinary process in which social divisions shape bodily orientations to and engagement in practice. For his part, Harvey emphasizes that capitalism exerts its own set of contradictory pulls that are manifest in and on the bodies and the working practices of laborers. While this final substantive chapter begins with an account of how the life trajectories of Zapotec weavers move through the wider social space where the authenticity of Zapotec textiles (and weavers) is crafted, the balance of the discussion focuses on how those contradictory pulls identified by Harvey work on Zapotec weavers at the loom.

The discussion that concludes part 2 ("Crafting Zapotec Weaving Practices") opens with a detailed account of the problems that a young Zapotec weaver had in reproducing a Navajo Yei figure textile and reflects on the impact that exporting Navajo look-alike textiles has on the development of the skills and knowledge associated with Zapotec textile production. As they did in the concluding discussion in part 1, color photos of Zapotec textiles and of the people and places explored in chapters 4, 5, and 6 illustrate this discussion and review of part 2's wider argument—that the success of Zapotec weavers stems from their ability to translate designs into blocks of color and then weave them in those terms.

That detailed examination of Zapotec "Navajo" bodily techniques and practical weaving knowledge serves as a final reflection on how the framework

developed in this study (a translocal "community of practice study") trans-
forms and redeploys the community study form in a global era, rearticulating
the strengths of up-close, thick-descriptive ethnography while responding to
the increasingly transnational lives of those with whom we work as ethnogra-
phers. A thick-descriptive account of Zapotec weavers' repertoire of bodily
techniques and practical weaving knowledge emerges as this ethnography
moves through the community of practice where Zapotec textiles and arti-
sans are simultaneously MADE IN MEXICO.

CONSTRUCTING

AND CONSUMING

THE ZAPOTEC

[A]ny function in the child's cultural
development appears twice . . . it
appears on the social plane, and then
on the psychological plane.

—*Lev Vygotsky*

¡Viva Oaxaca, No Hay Otro!

"¡Viva Oaxaca, no hay Otro!" Long live Oaxaca, there is no other; these are the first words from the mouth of Lynn Youngstrum, a professional rug buyer from Kansas who has been coming to the state of Oaxaca and Teotitlán for over twenty years, buying rugs, and reselling them in the United States.[1] We are in a gift shop/gallery in the state capital, Oaxaca de Juárez (or Oaxaca City); the shop's owners are from Teotitlán. She is giving a talk on the weavings of Teotitlán and the culture of the community. Lynn is consistent and adept as her presentation creates—through example, anecdote, and slide—the ways in which Oaxaca, the textile tradition of Teotitlán, and the people who make the textiles are all remnants of another time and a distinct way of life. She establishes her authority as she demonstrates to the crowd of about thirty people (most of whom are tourists from the United States) her intimate knowledge of the weavers themselves, a few of whom are in the audience.

The gallery is located on a street named Macedonia Alcala, which is generally referred to as "La Avenida Turistica," in downtown Oaxaca City, running from the Zocalo, or town square, to the north and ending five blocks later in front of the largest cathedral in the city, Santo Domingo. La Avenida is lined with a multitude of gift shops, two museums, and three parks (if one includes the Zocalo), and most of those who visit Oaxaca City as tourists never venture very far from this one five-block section of the city except for excursions into the nearby countryside to visit archaeological ruins and craft-producing

communities. Everything that could or would draw the tourist to Oaxaca (except the beaches) can be found in this small section of the city: Mexico's pre-Hispanic past, the Spanish colonial period, and the indigenous Mexico of today—a mix of the pre-Hispanic and colonial past. The Mexican federal and Oaxacan state governments have gone to great lengths to control the proportions and elements of these three periods that greet those who travel to Oaxaca. Many streets in and around the tourist center of the city have been, or are in the process of being, repaved with the large green stone blocks common to much of colonial Oaxaca's architecture—and sometimes simply with poured cement molded and tinted to look like the large stone blocks. The buildings lining the streets evoke the same sense of colonial history, and strictly enforced building codes ensure that they do.

It is in this setting that Lynn gives her lecture. It is a setting meant to hearken back to a lost era: an era in which life was slower, less congested, and less concerned with the necessities of daily living. Lynn begins her lecture by emphasizing these points. Oaxaca, she stresses, is a region living in the past, and the inhabitants of Teotitlán are the people that time forgot, the descendants, indeed the living remnants, of the pre-Hispanic civilizations that prospered in and around the present-day city of Oaxaca.

This chapter traces the emergence and development of the words and narrative used by Lynn in her lecture and their more recent use on Internet sites where Zapotec textiles are sold. These narrative strategies that aid in the sale of Zapotec textiles have their origin in mid-twentieth century travel literature. They figure Zapotec textiles, the techniques and organization of their manufacture, and the Zapotec themselves as the living remnants of a distant past. Exploring the origin and development of such discursive practices reveals similarities with the work of European colonial travel writers, who described their encounter with the "other" in ways that made their (European) presence an innocent happenstance, while asserting their power to create accounts of others.

William Roseberry notes that such discursive constructions are a reflection, and do the work, of hegemonic power, not by creating a "shared ideology" but rather by offering a "common material and meaningful framework for living through, talking about, and acting upon social orders." Those who sell Zapotec textiles create frameworks (narrative, pictorial, etc.) that give meaning to the textiles and work to secure the sellers' "innocence." Yet their accounts are part of a radically unequal encounter between Zapotec weavers and mainly U.S.-based entrepreneurs, who control knowledge about and access to the most lucrative markets for Zapotec textiles.[2]

Tracing the historical development of how the Zapotec and their textiles are imagined will offer a glimpse into the whos and wheres of these stories, revealing connections to institutions and their locations. These are some of the localities in which those who shape our conceptions of Zapotec weavers and textiles live and work. The organization of their accounts will also begin to reveal the topography of the field of power relations informing what counts as a Zapotec textile—the social structure of the Zapotec weaving community. Finally, this discussion explores how the words and narrative introduced here have recently been taken up by the Zapotec themselves. Just as scholars have found that colonial subjects eventually took up European conventions for representing themselves, the Zapotec have more recently begun producing autoethnographic accounts of their community's "tradition" of textile production on the Internet. These accounts write U.S.-based entrepreneurs out of Zapotec textile production at the same time that the Zapotec compete with U.S.-based entrepreneurs to market and sell their textiles on the Internet. Roseberry cautions that even discursive constructions that are resistant to hegemonic power "*must* adopt the forms and languages of domination in order to be registered or heard."[3]

The Zapotec Other: Contours

Colorful weavings and paintings line the adobe walls of the room in which Lynn lectures. Massive, intricately carved wooden doors open out onto La Avenida Turistica, where a mix of tourists and locals pass by, shopping, taking after-dinner strolls, or heading home after work in the cool evening air. Through a set of doors on the other side of the room is a courtyard with adobe walls, still damp from the afternoon rains. Under the balcony, young men are hard at work weaving. Short young men stand hunched over unfinished weavings, seemingly encased for display in the massive wooden frames that make up the Spanish-style treadle looms they are using. They work silently, shoulders bent, heads down. The looms creak as they press one pedal and then the other while passing yarn from one hand to the other in a rhythm broken only by a glance upward, an outstretched arm, and then the thump of the beater as it is pulled down, pushing the wool yarn into place—another fraction of a centimeter of a single Zapotec weaving is finished.

Lynn—who wears sandals, a long, flowing, brightly flowered skirt, and a white blouse—is a little nervous and paces back and forth while she introduces herself and explains how she got started selling Zapotec textiles. She begins by describing herself as an independent go-getter who came to Oaxaca

with nothing but a few dollars, the idea that she wanted to be her own boss, and the suspicion that she might be able to make a living by taking Zapotec weavings back to the U.S. and reselling them there. After her introductory remarks, she moves toward the back of the room to the slide projector, takes her seat behind it, projects the first slide, and begins reading in a slow deliberate voice from a script she has prepared:

> ¡Viva Oaxaca. NO HAY OTRO! Long live Oaxaca. THERE IS NO OTHER. It is one of those clichés which is profoundly true: OAXACA IS UNIQUE. Once across the border in the state of Oaxaca, you are in another country altogether—Mesoamerica. All of this region was once a cultural unit . . . the home of an ancient and marvelous civilization. In Oaxaca, the presence of this antiquity is still felt. The high cultures of this region began, it is believed, in the area centering in Oaxaca and radiated out until finally they touched Peru in the south and the Ohio and Mississippi valleys in the north. Owing to its central position, Oaxaca has always been the clearinghouse for the arts and the ideas of Mesoamerica and its people still show their cosmopolitan heritage. Because of its valleys, Oaxaca was the first great cultural crossroads of the continent, and because of its mountains, the atmosphere of the classic days has been preserved.

This passage from the beginning of her lecture frames Oaxaca, a southern state in the country of Mexico, as different or "unique" because it was once a cultural center but is now inaccessible. As a consequence, ancient cultural traditions and customs have been "preserved." These preserved cultural patterns can be dated to a specific era, Lynn goes on to tell her audience, and this happenstance has implications for Zapotec weavings and other craft items produced in the rural communities of Oaxaca:

> The best way to arrive at a picture of Oaxaca as a whole is to describe it as a country still living in a medieval system of production and exchange. This system not only works well, but gives Oaxaca its rich variety and charm. For here is the greatest array of popular arts in all of Mexico. The machine with its noise is absent; instead you see a whole country of people working silently and busily, making something functional and attractive to use and to sell.

Not only the "machine," but industry and the industrial mode of production are absent from the Oaxaca that Lynn creates. Instead, Lynn emphasizes, families are the center of the production and sale of Zapotec textiles, and she punctuates each sentence with a slide:

Factories break up family life, which is far more important than any money earned . . . the family is the producing unit. It feeds itself and works at the community specialty. Each handicraft, such as weaving textiles, making dresses, or pottery, is a village specialty, but there is no community factory. Simply a collection of busy homes, which turn out the local product. Then these products are exchanged between communities in the classic way, at markets and fairs.

While showing the audience a slide of a young Zapotec man holding a textile, she reminds the audience that a distinct relationship between the textile's producer and the consumer also is a product of Oaxaca's otherworldliness:

> The weaver makes the rug with his or her own hands and sells it directly to the customer. He or she is identified with his rugs and the rugs are identified with Teotitlán, and this has always been so.

And just as family members, not factory workers, are the locus of productive economic activity, the home, not the factory, takes on significance as a marker of distinction.

> Most of the homes are fenced from the dusty road by a living green wall of organ cactus. The side of the house opening onto the road is usually windowless, so that one must open the gate to get an idea of what is inside. The houses are made of adobe blocks, roofed with red tiles. These form two sides of a big patio and have wide verandahs where the spinning and the weaving can be done comfortably while shaded from the sun.

As her talk draws to a close, Lynn links her central theme that Oaxaca exists in a previous era (and what she has characterized as domestic, as opposed to factory, relations of production) to Zapotec children and their involvement with textile production. While showing her final set of slides, including images of crude little textiles still attached to the rungs of chairs, on which they were woven by the children of the family from whom she buys her textiles, Lynn concludes,

> The machine and the modern mechanisms of business do not enter into the Oaxacan picture. In Oaxaca, almost all the people, including children, are working at home. The tasks are not complicated or far above the children's heads, but are crafts, like weaving and pottery making, which appeal to a child and in which they can play some simple part. The point is that children are allowed to participate and to be useful. So that this education is not a matter of learning through contrived tasks and games, rather skills which they will later

apply to real life are learned by cleaning wool or patting clay as an actual part of the family industry . . . Zapotec children romp and play like children anywhere, but what fascinates them is work. And they are allowed to work as much as they like.

Having set herself up as a self-styled and self-educated expert through her forty-minute presentation, Lynn moves from the region to the home, from the present to the past, and from the United States to a people and land from "the past" that lies just across the border. A specific logic permeates the words and narrative with which she has chosen to represent the community of Teotitlán, the textiles made there, and the people who make them. Furthermore, these narrative constructions are part of a more general pattern— the modes through which Europeans have represented the rest of the world and its people to themselves as well as to Europeans.

Mary Louise Pratt's framework for understanding the connections among the spaces from which such images, and the narrative strategies employed in published "travel accounts" and elsewhere, are created offers a point of departure for this discussion. She developed two terms for understanding these encounters and the resultant published accounts of "others": "anti-conquest" and "autoethnography." Anti-conquest describes the way in which Europeans often write the colonial encounter out of their "travel accounts" while at the same time asserting and creating European hegemony anew. This narrative strategy, Pratt argues, builds upon "older imperial rhetorics" having their origin in colonial exploration and conquest. Autoethnography describes efforts by "colonial subjects . . . to represent themselves in ways that *engage with* the colonizer's own terms." Such texts are partial appropriations of the "idioms of the conqueror" and, to sometimes greater or lesser extents, are woven into "indigenous modes." Both narrative strategies work through, and are developed within, the unequal social relations that are integral to the colonial encounter.[4]

Pratt's analytical framework focuses upon how cultural agents, when they find themselves in social spaces also inhabited by people they identify as different from themselves, actively construct representations that mediate their realities. The construction and uses of images of the colonial "other," Thomas reminds us, are historical phenomena shaded by the prior uses and meanings of similar constructions, in turn given shape and meaning within another historically specific context. All images and stories are "strategic reformulations and revaluations," as he puts it, which are a part of a "series of projects that incorporate representations, narratives, and practical efforts." In some

instances, such reformulations work to create the "primitive other" through an inversionary logic that makes indigenous peoples the polar opposite of the supposedly advanced society of the colonial metropole. What's more, in some "settler" societies this logic takes particular forms, so that "an interest in the primitive . . . attributes an exemplary status to simple or archaic ways of life" and "revalues its rudimentary character as something to be upheld." At the same time, indigenous culture is reduced to "terms that complement white society's absences: against the alienation of modernity are 'intimate connections' that constitute 'roots, origins, and identity.'"[5]

In all cases, however, the logic of the narrative constructions framing the "other" is a product of the practices of agents creating subjectivities for themselves and others in specific localities at specific times. Exploring the historical development of the words and narrative strategies Lynn employed in her lecture reveals a genealogy—a "pedigree" or record of descent—of the mode in which she casts the Zapotec, their weavings, and how they are made. The stories she uses are reformulated from previous ones, then reworked and revalued within a particular social circumstance, most recently that of the Internet sites where Zapotec textiles are sold.

The Zapotec Other: Origins and Genealogy

The Teotitlán that Lynn creates in her lecture is idyllic in many ways. Families live in harmony in a quiet little community nestled in the foothills of the Sierra de Juárez Mountains in sunny southern Mexico. Parents and children work together (but not too hard) in the comfort of their own homes. And everyone in the community makes the same thing—all cheerfully competitive but with such strong traditions of community and family cohesiveness that, surprisingly, everyone gets along just fine. It is a world that is closer to the earth. Some people farm, while others tend goats and cattle. Everywhere the sound of chickens, turkeys, and pigs can be heard as one walks down the cobblestone or dirt streets. A group of young boys fly by, chasing and kicking a ball, and two men greet one another, the younger of the two bowing down and nearly kissing the older man's hand as he takes it as a show of respect.

The church and town hall lie in the center of town on the foundations of pre-Hispanic ruins and are surrounded by two markets (one for weavings and one for food and other necessities) as well as a newly built museum dedicated to the glorious pre-Hispanic past of this once great community and its textile tradition. The church (*templo*) is the centerpiece, the largest and tallest

building in the small town. It might be indistinguishable from any other church in rural Mexico were it not for the pieces of carved stone from the archaeological ruins upon which it was built embedded in its walls. The streets are bordered by brick, cement, and adobe walls and by cactus. Doors are often left ajar, and open onto central patios that are a hodgepodge of dirt, cement, and brick surrounded by bougainvillea growing up adobe walls. Teotitlán is a compendium of sights, smells, and sounds, with one exception: the rhythmic sound of the looms (not the people) hard at work.

Lynn wove these images together, just as I have done here, creating an idyllic setting which at the time of her lecture I found strangely inappropriate, having just driven into Oaxaca City from Teotitlán. The community that I had just left seemed to me like a dust-bowl landscape of cement and brick walls where one could not escape the stench of the acid and chemical dye baths. In this other Teotitlán, the pounding of weavers working at the looms echoed through the hollow cement and brick walls from house to house, day and night in an unending machine-like rhythm. Sons fought with their fathers over how the money they earned weaving should be spent. The entire town was deeply divided over whether the space in the new museum dedicated to a celebration of its heritage should be allocated to local merchants eager to attract the attention of passing tourists or to a display which would cement the authenticity of its craft in centuries of tradition.

The images of Teotitlán that Lynn created are not new; in fact, neither are the other images which figure Teotitlán as a maquiladora-like zone of sweatshops. My intention here is not to argue that any of these images are right or wrong, but rather to introduce the ways in which Teotitlán is fabricated as "different" through visitors' accounts of what the place is like. As Hayden White observes, every text leaves some things out, such that every description is a partial one.[6] The absences in Lynn's description, and in others as well, are patterned and consistent with some earlier descriptions of Teotitlán and those who weave textiles there. The point is not to berate a text's supposed deficiencies in exposition or description, but to analyze how a particular pattern of absences is related to the social context in which the description emerged.

Three themes run through Lynn's talk: the people and their culture, the organization of production, and the weavings. Within each of these themes, she moves from the general to the specific and from the present to the past (and a supposed past that is Oaxaca's present). She first establishes Oaxaca, the state, as exotic and other ("in the state of Oaxaca, you are in another country altogether"). Then she establishes Oaxaca as the center of a past

great civilization whose "presence . . . is still felt." This "ancient and marvelous civilization," which was a center for "the arts," "has been preserved" because of a mountainous geography that has "isolated" its people, for whom "nothing has essentially changed."

As she grows more specific, idyllic images of family life and family production, from which "the machine and the modern mechanisms of business" are absent, create a space where "the weaver makes the rug with his or her own hands and sells it directly to the customer. He or she is identified with his rugs and the rugs are identified with Teotitlán, and this has always been so." The rugs themselves, in spite of the fact that the wool and the looms were introduced by the Spanish, also are part of the legacy of "antiquity."

The temporal dimensions of these connections are constructed through negation. This temporal negation is accomplished by establishing the people of Oaxaca as an "other" connected to and, to a great extent, still living in the past—people who reside outside of the steady march ("progress") of Western civilization. By establishing the people and their culture ("a country still living in a medieval system of production and exchange"), the family-centered production process ("which has scarcely changed since the Spanish Conquest, for no part of the weaving craft is mechanical"), and the weavings themselves as lying outside the historical progress of the rest of the world, Lynn creates a place—a static, non-evolving place—which exists in the past.

This is not to assert that what Lynn says is wholly untrue. Much of what she describes can be found in Teotitlán: families working at home using medieval technologies, cactus fences, and children playing at weaving are all present. However, I felt that there were large omissions and gaps in the Teotitlán that Lynn created for her audience and presumably for a number of other audiences throughout the United States.[7] She does not mention the long hours that young children spend at the loom weaving, nor does she mention the modern cement-block and red-brick architecture springing up throughout the community—few families build with adobe bricks these days. Finally, her omission of a fully mechanized yarn factory in the community, which has done most of the yarn spinning there since the mid-1980s, is especially telling.

These omissions and the vocabulary that Lynn uses to create her Teotitlán link her to, and at the same time distinguish her from, a long and illustrious line of explorers, colonial administrators, travel writers, journalists, and anthropologists. It is a line that extends from Alexander von Humboldt and A. F. Bandelier, both of whom visited the ruins of Mitla (an archaeological site fifteen kilometers from Teotitlán) in the 1880s, to Jan Morris, a well-recognized

travel writer, who wrote in 1992 that the Zocalo in Oaxaca City "was like a benign hallucination" and that the very name Oaxaca evoked a "queer combination of breathiness and romance." Morris mentioned Teotitlán and attributed the high quality of the textiles produced there to "the inherited skills of the indigenes."[8]

The attitude toward Mexico's indigenous population expressed in Lynn's lecture and alluded to in Morris's comment suggests that the historical specificity and coherency of an entire constellation of ideas about indigenous Mexicans have developed in concert with notions about Mexican cultural patrimony. Within this ideological apparatus, a particular way of understanding textile production in Teotitlán has developed as well. In fact, piecing together this attitude toward Zapotec weavers and its development in Mexico undermines the apparent benignity of Morris's remark about the "inherited skills" of Zapotec weavers—what other well-known writers (including Octavio Paz) have termed an "innate" proclivity for artistic expression among Mexico's indigenous population.[9]

On the other hand, not every visitor to Teotitlán has been immediately struck by the beauty, born of simplicity, of Zapotec textiles and the people who make them. Frederick A. Ober, for instance, who visited Teotitlán in the early 1880s, wrote in his travel account that the "people of the community were clad in rags and were very dirty, while the children roamed around with no covering to their nakedness but their hats, and some of these even were brimless." In fact, Ober, who, like von Humboldt and Bandelier, made an excursion to the archaeological ruins at Mitla, never comments in any way upon the textiles woven in Teotitlán. He takes care to describe the carved stone monuments he and his party were shown while in Teotitlán, as well as the uncouth characters they encountered, but concludes only that the "traditions of this place are well preserved, and though the people are inhospitable, an archaeologist of perseverance could pass a most profitable season among the hills and in the valley."[10]

As Ober's account suggests, Teotitlán had by the 1880s been established as a stop on excursions to the archaeological site of Mitla and other points of interest—a status it retains to this day. Interest in Teotitlán at that time, however, was predicated upon different assumptions about its connection to the pre-Hispanic past than those expressed by Lynn. Ober had no interest in the locals, how they lived, or what they made. He seems to have given little thought to the pre-Hispanic "vestiges" still extant in this community, which are central to more recent descriptions of Teotitlán. Ober and his party were in Teotitlán because it is built on archaeological ruins.

In 1927, when *National Geographic* published several pieces on Oaxaca, its description of Teotitlán, its textile industry, and its weavers included many of the images that appear in Lynn's lecture. Teotitlán, we are told, "where . . . the Spirit of the Shadows spoke to the men of old, is the place where the serapes are made. One gets a glimpse of the old-time communal life in such communities." Later we learn that a Zapotec Indian "wove them, on a hand loom that is common to every primitive people, in the cool shadow of the portico of his little hut, by the side of which, under the peach trees, a little stream tinkled in a stone-lined ditch."[11]

In 1939 Catherine Oglesby, expanding upon and giving greater coherency to these images of an idyllic community of craftsmen, wrote that Teotitlán

> lies near the community of Mitla, dusty, quiet, basking in the sun. Each little patio is fenced with twelve-foot spires of organ cactus, and one enters through a narrow break in the fierce fence into a courtyard where pigs and chickens search for food and into a second patio where the wife spins, the children card, and the littlest baby sleeps. In a hut in the third courtyard, two crude looms are set up, mute testimony of the Indian's invariable communism . . . He started to weave, his nimble bronze fingers sending the gay-colored balls of yarn back and forth with incredible speed.[12]

Here we find many of the elements and images that Lynn stressed in her lecture. A tiny community sweltering in the noonday sun. "Dusty" little streets lined with "organ cactus" fences. Secluded little patios where the entire family works together in harmony—proof of the "Indian's invariable communism."

These images find perhaps their fullest expression in the work of Helen Augur. Nearly eighty years after Ober's visit, Augur devoted an entire chapter of her widely read travel account, *Zapotec,* to Teotitlán, its people, and the textiles they make. Before focusing on the weavers of Teotitlán, however, Augur sets the stage by framing southern Mexico and the state of Oaxaca as still existing in the aura of a bygone age.

> Viva Oaxaca, no hay otro. It is one of those clichés which is profoundly true; Oaxaca is unique . . . Once across the Oaxaca border, you are in another country altogether: . . . The high cultures of Middle America began, it is believed, in the region centering in Oaxaca and radiated out until finally they touched Peru in the south and the Ohio and Mississippi valleys in the north.

In words that Lynn would appropriate nearly forty years later, Augur creates Oaxaca as a region that lies outside history.

> Owing to its central position, Oaxaca has always been the clearinghouse for the arts and ideas of Middle America, and its people still show their cosmopolitan heritage. Because of its valleys Oaxaca was the first great cultural crossroads of the continent, and because of its mountains the atmosphere of the classic days has been preserved.

As Augur goes on to state, and Lynn to parrot, this area has, as a result of its imagined geographic isolation, resided in a space located outside of historical progress. This notion is of central importance to their characterization of the uniqueness of Oaxacan craft production, which exists outside the confines of modernity:

> The best way to arrive at a picture of Oaxaca as a whole is to describe it as a country still living in a medieval system of production and exchange. . . . The machine is absent, with its noise and drive; instead you see a whole country of people working silently and busily away making something sound and attractive to use and to sell . . . the family is the producing unit; it feeds itself and works at the community specialty. Each handicraft . . . is a community specialty, but there is no community factory, simply a collection of busy homes which turn out the local product. Then these productions are exchanged between communities in the classic way at markets and fairs.[13]

Material production in Oaxaca is understood here to be the "inverse" of a sometimes unmentioned, but often strongly implied, "modern" system. It is distinguished from a system of material production that is characterized by repetition and uniformity, the inverse of Oaxaca's "rich variety and charm," and by machine-based assembly-line production that takes place in factories (as opposed to Oaxaca, where "the family is the producing unit" and its members work "silently and busily"). A modern system of material production is organized into and run by global corporations, instead of "simply a collection of busy homes," and sells its products through chain stores or in shopping malls, whereas in Oaxaca products are "exchanged between communities in the classic way at markets and fairs." Here we see quite specifically how production in Oaxaca is understood to be the inverse of what it is implied to be "over the border" in the United States.

Not very surprisingly, Augur wrote that the weaver's

> home is fenced from the dusty lane by a living green wall, and the side of the house giving on the lane is windowless, so that one must open the gate to get any idea of what is inside. The house of adobe blocks roofed with red tiles is L-shaped, forming two sides of the big patio, and has a wide verandah where the spinning and weaving can be done comfortably, outdoors but shaded from the sun.

Augur also stresses the same points that Lynn did in her account of Zapotec weavers, the way they make textiles, and sell them.

> Don Leopoldo Torres makes the serape with his own hands and sells it direct to the customer. He is identified with his serapes, and the serapes are identified with Teotitlán, and this has always been so . . . the machine and the mechanism of commerce do not enter the Oaxaca picture. Don Leopoldo's ancestors, in the day when Teotitlán was the old Zapotec capital, wove fine mantles for kings and high priests, and when they tired of weaving they took the mountain road down into Central America to a certain great religious fair, where the weavings of their town were in great demand. Nothing has essentially changed.[14]

Here, the inversionary logic Augur uses to make sense of Oaxaca more generally is applied specifically to Teotitlán and the weavers themselves. Augur goes on to place the women of Teotitlán into this utopian vision at the sides of their husbands, carding and spinning wool in familial bliss. Finally, like Lynn, Augur lends the finishing touches to this Edenic (and patriarchal) scene by inserting children who work happily alongside their parents:

> All the people are working at home, not on complicated tasks which are far above the children's heads, but on crafts like weaving or pottery making which appeal to a child and in which he can play some simple part. The point is that he is *allowed* to participate, to be useful, so that his education as a child is not a matter of learning, through contrived tasks and games, skills which he will later apply to real life, but learning to clean wool or pat clay as an actual part of the family industry. Zapotec children will romp and play like children anywhere, but what really fascinates them is work, and they are allowed to work as much as they like.[15]

In his *Marvelous Possessions,* Stephen Greenblatt describes the explorer Sir John Mandeville as "an unredeemable fraud: not only were his rare moments

of accuracy stolen, but even his lies were plagiarized from others." His discussion of Mandeville may hold important insights with which to piece together the sources of Lynn's imagery. Mandeville's acts of plagiarism were part of what Greenblatt describes as a circulation of images that worked together as an act of "taking possession" of others. He argues that Mandeville's book is just an "extreme version" of the act of taking possession of other people, their land, their bodies, and their possessions, through representing them to others and to oneself. It is such a complete act of taking possession that even Mandeville's words are those of another person. Mandeville's language, writes Greenblatt,

> betokens not material existence as such but a circulation of signs that makes material existence meaningful, comprehensible, resonant. *Mandeville's Travels,* and the textual phenomenon we call Mandeville himself, is stitched together out of bits and pieces of human experience, most of them pieces that had passed like well-thumbed coins or rather like old banknotes through many hands.[16]

The images Lynn creates for her audience have a history that can be similarly characterized. Her representations of Teotitlán, its weavers, and the textiles they make have been woven together from other authors' representations (most notably Augur's) and have passed from written account to slideshow.

Between the publication of Ober's 1884 travel account and Corey's 1927 piece for *National Geographic,* Mexico began to actively promote, both to Mexicans and to visitors, a sense of national cultural patrimony that emphasized Mexico's unique cultural hybridity, its combination of the pre-Hispanic and the European. This shift placed those described by ethnographers working in Mexico—the rural indigenous Mexicans—at the center of Mexico's new sense of self.

Among those traveling and guiding travelers in Mexico, an interest in Teotitlán as a rubble deposit of pre-Hispanic antiquities seems to have been transformed into an interest in the people of Teotitlán and the product of their labor that is rooted in their connection to the pre-Hispanic ruins among which they made their homes. This interest was expressed first in the 1927 *National Geographic* article, expanded on by Oglesby, and given its fullest expression in Augur's 1954 travel account. Mexican intellectuals (especially anthropologists) seem to have helped steer this shift. Notable among those Augur thanks for helping her make sense of her Oaxacan experience is, for example, the well-known Mexican anthropologist Alfonso

Caso, who Augur writes "illuminate[d] many problems about ancient Oaxaca."[17]

Nearly forty years later, Lynn directly appropriated Augur's work: not just the images but also Augur's diction and phrasing. Lynn is a business-woman, and her livelihood as a buyer and seller of Mexican craft items has influenced her reshaping and reappropriation of the narrative construction of the Zapotec other.

The circumstances (social, cultural, and economic) of this encounter manifest themselves in Lynn's account and, in spite of their startling similar-ities, her narrative and Augur's have profound differences. Lynn's images of Teotitlán, its weavers, and the textiles that they make differ from Augur's in significant ways. First, Augur describes what she understands to be "adulter-ated" or tourist-influenced textiles, while Lynn does not. For example, Au-gur describes how some weavers make things for tourists but concludes that most in Teotitlán have not succumbed to the pressures of this market.

Of late years they have stopped dyeing with plant juices and buy their dyes in the Oaxaca market, which means that chemical as well as vegetable colors are used. But the Teotitlán palette is conservative, and only a few families have transgressed tradition by turning out gaudy-colored serapes for the *turistas*.[18]

Lynn, on the other hand, in one of only a few moments of originality in the slideshow, says that the textiles are "all wool" and that the patterns are taken from the "geometric designs of the nearby pyramids." She also describes how "natural dyes" are used and connects them to the pre-Hispanic era by speak-ing of "the subtle, natural beauty of the ancient dyes." Augur creates a Teotit-lán into which the outside world sometimes penetrates—a Teotitlán that is visited by tourists and whose textiles and weavers are influenced by them. Lynn's Teotitlán is a sanitized one where Zapotec weavers live lives beyond the pale. Only Lynn visits this remote location and brings back the pristine spoils of her visit for the benefit of those back home in the United States.

A second significant difference between the two accounts is that Augur describes a Teotitlán of her present, the 1950s, while Lynn describes a Teotitlán that existed only in the past. When Augur visited Teotitlán, fewer tourists came and there were more organ cactus fences, comparatively more adobe buildings, no U.S.-based entrepreneurs buying textiles for resale in the United States, and no yarn factory. Lynn's description is dated, as all de-scriptions are, but it dates to another period and describes a place that, as I commented earlier, I did not think currently existed. In fact, it is a Teotitlán

that never existed for Lynn at all, given that she went there for the first time in the 1980s, when both U.S.-based entrepreneurs (like her) and Teotitlán's yarn factory were already present.

The differences between these two accounts may be traced directly to the projects in which Lynn and Augur are involved. Augur, as a travel writer, is primarily concerned to describe a place that she has visited and that others may visit, but that is somehow very different from the United States. Lynn, on the other hand, is primarily concerned with developing an interest in the textiles produced in Teotitlán so that people in the United States will purchase them, preferably from her. Lynn's representations of Teotitlán, Zapotec textiles, and Zapotec artisans are, in effect, mechanisms making her the sole conduit through which consumers' desire for authentic Zapotec culture (with a close, almost mystical connection to nature) may be satisfied. In describing Teotitlán without being present, Lynn effectively creates, for her audience of prospective clients, a Teotitlán where her work and that of other U.S.-based entrepreneurs who buy and sell Zapotec textiles in Mexico and the United States may not enter the picture—or, more accurately, has not yet entered the picture.

The Zapotec Cyberspace Other: Contours, Origins, and Genealogy

Lynn's lecture offers an excellent example of how images of Teotitlán, the weavings produced there, and the weavers who make them are circulated, revamped, or altered, and then put to new uses.

Having directly appropriated Augur's 1954 description in 1992, she created Teotitlán, its people, and textile production as she never experienced them. This is an act of descriptive denial—denial of Teotitlán's location in history and the world economy, and denial of her own economic power in relation to Zapotec weavers (she cannot enter her picture of Teotitlán because she has not yet arrived). This act of descriptive denial appropriates and accentuates specific images of Teotitlán and creates a nonexistent place, a place that someone visiting Teotitlán might not locate. This makes Lynn the sole means through which the textiles produced there may be consumed—a narrative practice with structural parallels to the discursive "imperial" trope Pratt terms "anti-conquest."

The anti-conquest-like trope shaping the narrative construction of the Zapotec other secures Lynn's innocence by describing her out of the social and economic scene at the same time that it secures her power to create representations of the Zapotec, their community, and the textiles they make. It is an "anti-commerce" trope that removes Lynn (and others like her) from

the scene, together with most traces of the commercial relations of which she is a part. U.S.-based entrepreneurs work alongside Zapotec weavers while simultaneously using this anti-commerce trope to obfuscate their position in the network of people involved in making Zapotec textiles. Admitting their considerable involvement in the making of Zapotec textiles would undermine, in consumers' minds, the legitimacy or "authenticity" of their product.

Reappropriated representations of Teotitlán, the people who live and work there, and the textiles they make continue to circulate in new and innovative ways, especially on the Internet. In 1996, fewer than twenty websites existed on which one could purchase Zapotec textiles; today there are countless more. The vast majority of them were created and maintained as a part of the businesses of U.S.-based entrepreneurs who, like Lynn, both coordinate the production of textiles and buy finished textiles in Teotitlán, reselling them at the retail and wholesale levels in the United States.[19]

In addition to inviting visitors to view and purchase Zapotec textiles online, such websites typically include several pages devoted to providing "information" to prospective consumers, and these pages are organized around narrative constructions similar to those developed in earlier travel literature. Today, Zapotec textiles also appear in online auctions (on eBay, for example) and on the websites of retail and wholesale establishments selling ethnic or Third World arts and crafts more generally; such websites often simply display items for sale and provide little or no "information" about the Zapotec and their textiles. Finally, the Zapotec themselves have begun to market their own textiles on the Internet and, as Pratt describes, to autoethnographically appropriate the same discursive strategies and anti-commerce trope.

On the Internet, Oaxaca is figured as a once important cultural center now sheltered from the modern world as a consequence of the mountain ranges which surround it, as it was in Lynn's lecture and more generally in travel literature. In 1997 the website of Mexico's Ministry of Tourism (and tourism is Mexico's largest industry) described Oaxaca as follows:

> Speaking of Oaxaca brings a faraway look and wistful smile to the faces of those who have fallen under its spell. The city sits serenely in a dramatic valley, high in a rugged mountain range, and has been declared a national monument by UNESCO . . . [It] had been important long before Cortes . . . as a religious and cultural center for some of Mexico's pre-Columbian Indian cultures.[20]

Images of Oaxaca as remote, picturesque, and inhabited by the living remnants of Mexico's pre-Hispanic past are reproduced on multiple web pages.

Similar discursive strategies inform understandings of Oaxaca on the web-sites of U.S.-based entrepreneurs. As one site explained in 1996:

> Oaxaca is a valley state located in the southern part of Mexico. Among the in-habitants of this valley surrounded by the towering summits of the Sierra Madre del Sur are the Zapotec Indians . . . Patterns found in Zapotec weav-ings complement the heritage of these people. Consistent with most traditional Indian themes, arrows portray hunting and zigzag lines reflect lightning.[21]

On this site, one could view a variety of Zapotec textiles, learn about the place where they are made as well as those who make them (and the "mean-ing" of Zapotec design elements), place an order, and have the textile mailed to one's house.

On the Internet, narrative constructions of the Zapotec and their textiles continue to emphasize their remote, inaccessible location and their connec-tion to the pre-Hispanic cultures of Mexico.

> The Zapotec have continuously inhabited the valley of Oaxaca for 3,500 years and their weaving tradition is one of the oldest in the New World. Tradition-ally, their weavings have been used mainly for domestic clothing and religious purposes. Despite the antiquity of the Zapotec tradition, however, their prod-ucts have only been available to the U.S. market for thirty years. Each piece is made of hand-spun Churro Wool from the mountains of Chiapas in southern Mexico.[22]

In addition to these familiar themes, the absence of modern machinery also is a staple feature of Internet descriptions of how Zapotec textiles are made in Teotitlán:

> Located high in the Sierra Madre mountain range, a ten hour drive south of Mexico City, the isolated communities of the Zapotecs are steeped in the rich mysteries of their culture. Life hasn't changed much here in the past cen-tury . . . They are one of the last cultures in the world to complete the entire weaving process without the benefits of automation or modern science.[23]

> The Zapotec Indians live and weave in a community high in the mountains be-tween Mexico City and Guatemala . . . virtually isolated for thousands of years . . . [and] one of the last remaining cultures in the world to complete the entire weaving process without the benefit of automation or modern science.[24]

Obviously, particular ways of describing the Zapotec continue to be passed like well-thumbed banknotes, as Greenblatt noted, from website to website. The same (characteristically patriarchal) discursive construction of Zapotec families also enters into and structures these texts, albeit in limited ways. More typical of Internet depictions of family cohesiveness are brief and lavishly illustrated descriptions of the "steps" in the weaving process. In most cases, women and children dutifully support the work of male weavers by tending sheep, cleaning and processing wool, and spinning yarn:

> Forays are made to a remote Zapotec community in the mountains, where for generations, women have been spinning and carding wool using the ancient drop-spindle method. Because nothing has come between the fleece and human fingers, all the natural oils remain in the yarn.[25]

> Craftsmanship is a heritage passed on through an oral tradition within each family group—there are no books to study. Youths learn by working with the elders, and are expected to pass on their acquired knowledge in the same fashion. From the earliest age, children learn the responsibility of tending the sheep from which the women of the family will later card and spin the wool into yarn.[26]

Such sites construct U.S.-based entrepreneurs and their "forays" as the sole conduit through which the nearly direct relationship between the "remote" Zapotec weavers and their patron may be maintained (with the help of the Internet). Again, "descriptive denial" is the most apt way of describing these constructions. Just as the colonial encounter was written out of the imperial travel account (as Pratt shows), the anti-commerce trope writes out of these accounts the central role played by U.S.-based entrepreneurs (who maintain many of these websites) in the commercial relations between those making Zapotec textiles and those buying and reselling them.

On the Internet a domesticated work environment is also created through narratives of children tending nonexistent sheep herds (there have never been large sheep herds in Teotitlán) and Zapotec women spinning wool yarn (yarn is purchased already spun from the community mill). Here again the anti-commerce trope frames a Teotitlán the authors of these sites have never visited, and, in truth, could never visit. The Teotitlán inhabited by the shepherd sons of master weavers tending flocks of sheep in the hills surrounding their remote community was *never* there—not at any time.

These discursive constructions also inform the ways the Zapotec have more recently begun to construct an identity for consumption by potential clients on the Internet. Today a few Zapotec weavers from Teotitlán have websites where one may purchase a Zapotec textile. Those who have created a web presence for themselves (and there are indications that they have been "helped" to create themselves for the Internet by businesspeople like Lynn) have appropriated the same narrative constructions that first emerged in American travel writing about Mexico in the period following the Mexican revolution and that have subsequently been pilfered and recrafted by U.S.-based entrepreneurs.

For example, sheep figure prominently in Zapotec weavers' Internet descriptions of how they make textiles, just as they do on the websites of U.S.-based entrepreneurs: "first the sheep is shaved and the wool is washed out at the nearest river." A connection to the pre-Hispanic civilizations of Oaxaca is also stressed, just as it is on the websites of U.S.-based entrepreneurs: "the history of Teotitlán as a weaving population has been established from as far as the pre-Hispanic era." Finally, these narrative elements work together (with an emphasis on the non-mechanical nature of Zapotec textile production) to help lend the textiles themselves an air of distinction: "these wool rugs, each one hand-made, represent a weaving tradition going back five hundred years."[27]

The autoethnographic Internet texts of Zapotec weavers, then, take their structure and narrative strategies from a variety of antecedents. As Pratt reminds us, "western modes of representation" inform the language of autoethnographic texts—from biographies to oral histories and testimonials. The point here is not that Zapotec weavers simply appropriate the language and images that U.S.-based entrepreneurs have developed, but that they must accommodate, in their representations of their own lives and culture, an already established vocabulary and set of images. Roseberry framed an approach to the relations between power and representational strategies in keeping with our dual focus on practice and agency on the one hand, and the "managedness" of social and cultural realities on the other: "To the extent that a dominant order establishes not consent but prescribed forms for expressing both acceptance and discontent, it has established a common discursive framework."[28]

A symbolic logic locating the Zapotec, their textiles, and their techniques of manufacture in the past frames all of these constructions of Zapotec weavers and the textiles, from *National Geographic* to the World Wide Web. Although derived from the language of mid-twentieth century travel writing, this discourse is crafted by its authors and is particular to the encounter

between those weaving Zapotec textiles and those buying them in Teotitlán, then reselling them to consumers in the United States and now on the Internet.

Zapotec weavers who attempt to create an Internet identity for themselves by appropriating the same interpretive framework (representational strategy) employed by U.S.-based entrepreneurs write out of their descriptions of life and textile production in Teotitlán not only their encounters with tourists but, to a large degree, themselves as well. On one such website discussing "Zapotec history, culture, and archaeology," little space is devoted to those who live and work in Teotitlán today. All it can say is "today, most of the 300,000 Zapotecs are Catholic, and live either in the Isthmus of Tehuantepec or the mountain communities of the Oaxaca Valley."[29]

This chapter has outlined the historical development of published narratives regarding the Zapotec, their environment, and their culture, tracing shifting emphases and omissions. While the early accounts by adventurers and explorers focused on the material ruins and relics dotting the natural environment around Teotitlán, later accounts focused on the Zapotec people as living relics. In accounts written by the Zapotec themselves, the authors are present only as the relics of a bygone age now in ruins but also available for purchase by credit card online.

Through this chapter, we have also gained an initial glimpse at the symbolic logic structuring the field of power relations around the Zapotec weaving community, which is marked out in conflicts over the definition of what constitutes a Zapotec textile, a Zapotec weaver, and authentic Zapotec weaving practices. Where authenticity is concerned, an important structural element of this field of power relations is the centrality of notions about the timelessness of rural Zapotec life and its correspondingly close connection to an imagined pre-Hispanic condition. Both of these notions are also closely tied to the idea that a region that was once an important trade juncture is now relatively isolated from the modern world by its mountainous geography. The idea that Oaxaca is the backward but once important "countryside" to the modern world's "city" is another manifestation of this basic frame, and it is played out in the tours to, and weaving demonstrations given in, the homes of Zapotec weavers.

In the next chapter, we will move into and introduce the domestic spaces of Zapotec weavers in Teotitlán through a tour and weaving demonstration. Through these, we will examine some of the ways that the autoethnographic constructions of the Zapotec themselves, even where they resist

power, also adopt the vocabulary and images of domination as the Zapotec work to have their own interests and voices registered or heard.

In chapter 3 we will explore more fully how, beginning in the 1980s, Lynn Youngstrum and U.S.-based entrepreneurs like her began to play a more central role in the production and marketing of Zapotec textiles. Many weavers in Teotitlán work with business owners from the United States, helping them to organize transnational production and supply chains. Such a relationship is often the weaver's economic mainstay; it is much more lucrative than selling textiles to tourists, more lucrative even than arranging for large bus tours to come to the community for a weaving demonstration and to purchase textiles.[30] Lynn and her fellow entrepreneurs, then, are an extremely important part of Teotitlán's commercial life. The narrative frames crafted from a previous language of travel by these businesspeople work to secure their innocence by writing their presence out of the unequal commercial relations that characterize Zapotec textile production in the "era of late capitalism."[31]

Touring Zapotec Weavers, or the Bug in the Rug

Of the relation between the English city and countryside, Raymond Williams writes that the "city eats what its country neighbours have grown."[1] Williams's well-known study traces how perceptions of, and attitudes toward, both the country and the city as expressed in English literature shifted as England's agricultural (and later industrial) economy transformed over several centuries. Images of the country as a congeries of utopian rural communities, a productive natural resource, or unbridled "green nature," and their inverse, images of the city as a mass of moving bodies, decadent and decayed, or, alternatively, as an industrious and productive metropolis, were all present in English popular and literary discourse.

This chapter explores a similar circumstance, in which Mexico is both fascinated by and ambivalent about rural Oaxacan indigenous artisans and, by extension, the products they produce. The "country" and indigenous Oaxacan "country folk" are framed in terms of secrecy and unlimited (albeit untapped) natural wealth. Paralleling Williams's insight, the Mexican city wishes to eat what its country neighbors have grown as well as the knowledge of how to grow it. In Oaxaca, however, how to coax wealth from the countryside is kept secret by its indigenous population. The city is therefore ambivalent toward them—rural indigenous Oaxacans are fascinating, but they are also suspect, because they keep secret the ways of exploiting this natural wealth. When Mexican nationals tour the Zapotec weaving community of Teotitlán, their ambivalence is manifest in discussions of

natural dyeing materials and techniques, especially the cochineal insect—the "bug in the rug."[2]

The ambivalent feelings of Mexican tourists toward Zapotec weavers who employ cochineal as a dye agent, however, are not simply a product of the touristic experience. Indeed, historians argue that in the region of southern Mexico that is now the Mexican state of Oaxaca, Spanish colonial ambivalence toward the indigenous population was a product of economic uncertainty.[3] That ambivalence grew directly from the Spaniards' preoccupation with indigenous control of access to arable land and the unpredictability of the supply of (mostly rural and indigenous) labor for the various businesses of Spanish colonists (who lived almost exclusively in the colonial regional metropolis of Antequera, now the state capital of Oaxaca). Mexican "elites" have often "flaunted their internationalism while simultaneously embracing a rural culture," as a part of post-revolutionary cultural nationalism, and coupling that habit with this history of ambivalence reveals a particularly Oaxacan structure for the feelings held toward the surrounding rural indigenous population.[4] Those attitudes, intimately tied to colonial Oaxacan relations between the country and the city, are, in turn, of tremendous importance for understanding the touristic encounter as experienced by Mexicans traveling to indigenous communities in the Oaxacan countryside with tour guides from Oaxaca City.

I borrow Raymond Williams's term "structure of feeling" to describe the historically informed attitude of ambivalence emergent in the touristic encounter described here. I do so in an attempt to theorize lived experience (the "actively lived and felt") in its moment (of "impulse" or "restraint" or lack thereof) in a way that overcomes the shortcomings of analyses of society and culture, which Williams has written about extensively.[5] In this chapter, this "moment in present" process, at the same time structured by the past and which slips through (or rather between) social and cultural analyses, will enable an analysis of a single impulsive act that occurred during a touristic encounter.

A shortcoming similar to the one noted by Williams might be seen in recent ethnographic analyses—and ethnographies of "tourism" are no exception. The meaning of the very word "tourism" is slippery; Chris Rojek and John Urry have recently defined it as a "complex set of social discourses and practices" associated with the movement of people, things, and ideas. As with anthropology more generally, ethnographies of tourism typically either embrace textual analysis, taking a "discursive" approach to social and cultural analysis and treating discursive constructions as already formed structures

revealed through analysis, or they reject such approaches in favor of "real ethnography."[6] Those doing "real ethnography" look at "real people," not "texts." The resulting analyses of the "lived experience" of "real people" often appear to be set in the present, and social structure figures only as the setting or backdrop to the study, if at all. As Williams pointed out, the result is an analysis of lived experience divorced from historical and cultural context or a textual analysis of dead discursive structures. Given Rojek and Urry's definition, this is especially troublesome for ethnographers working in "touristic settings."

In the touristic encounter, the ethnographer finds Williams's "undeniable experience of the present" in process and, at the same time, informed by social (and often narrative) structures of the kind explored in the introduction and chapter 1. Such an ethnographic setting requires an account of how those structures inform present experience at the same time that they are reformulated by it. An ethnographic account of the touristic encounter must take account of how narrative constructions (such as those that tourists take with them on tour) are shaped by the touristic experience—texts are, after all, crafted by people. These will be accounts of real people of the sort studied by ethnographers who reject the "discursive turn," on the ground, forming new discursive constructions by reformulating existing ones and, in the process, making sense of their experiences.

In current anthropological debates, then, this discussion and description take a middle road, coupling textual analysis with a "thick descriptive" ethnographic focus on a guided group tour to the Zapotec weaving community of Teotitlán. It focuses on the practices of real people in the process of making and using narrative structures. Such an approach, a historically grounded and discursively informed ethnographic description, argues for a non-reductive focus on an ethnographic present where a relatively pre-structured present is being formed and restructured by the people living it. In the case of the "actively lived and felt" touristic encounter examined here, this approach works toward understanding a single unrestrained impulsive act (and a corresponding structure of feeling) that has a precedent in Oaxacan colonial relations between the country and the city.

The Bug in a Zapotec Weaving Demonstration

Many people who visit Teotitlán and buy textiles there are introduced to the people of the community and their craft through a tour; both individual and group tours visit Teotitlán frequently.[7] Group tours, like the one described

here, usually leave from one of the major hotels in Oaxaca City, include between a dozen and twenty participants, and last between three and five hours. The composition of tour groups varies from month to month and season to season throughout the year. The tour group examined here is composed almost entirely of tourists from Mexico City (the nation's capital) and Monterey (an industrial city in northern Mexico).

Upon leaving the hotel, the tour bus meanders down narrow streets, past parks and large churches, while the driver attempts to navigate traffic that moves at a snail's pace, until it reaches the Pan-American Highway and exits the city. The tour guide, Isaac, begins his presentation almost immediately. He introduces certain key themes and terms which lay the groundwork for his framing of how to appreciate indigenous crafts. As the bus passes several churches, he points out that the churches and religions in the city are different from the "pre-Hispanic rites and rituals" one finds in the surrounding countryside:

> In a few places like Mitla and Monte Alban [two nearby archaeological sites], it is still possible to see one of these rituals. Of course they are performed in secret.

Pre-Hispanic survivals and secrecy will be referred to frequently. Isaac will stress that the weavers of Teotitlán (and hence the textiles that they produce) have a special connection to the pre-Hispanic past and a secret knowledge connected to pre-Hispanic culture.

There is a casual air as the tourists talk amongst themselves while the bus speeds down the highway and out toward the surrounding countryside. The tour guide continues:

> The kind of architecture that the Zapotecs developed here in Mitla is a profound symbol of their sacred numbers, magical colors, and other beliefs . . . They never gave away the secrets of its construction to the conquistadors: when it was constructed, with what, how it was cut. That is, the material that comes from the mountains nearly twenty kilometers around behind the site itself.

He uses the archaeological ruins to frame what will come later in the tour. The people who built them followed a logic and methods that are "secret," with meanings that were and are sacred to them. Later in the tour, he will use this same set of concepts to frame the textiles of Teotitlán.

As the bus passes bottling plants, bus stops, and a gas station, a sign marking the border between the city and the surrounding countryside reads, "Bien viaje, regreso pronto!" Isaac's monologue also marks this transition, as he moves on to the people of the country and their "traditions." In this mobile lecture, delivered as the tour bus moves out onto the undulating plane of the surrounding valley, we see quite clearly the narrative structure through which Isaac frames Oaxaca, its peoples, and their activities.

> Those who have been to Mitla can also tell you that there is a beautiful spot called Santa María del Tule in which we have a large tree, which is considered to be the widest in the world, and it's called "El Huehuete." In the past, families traveled an entire day to go to places like El Tule and now you can get there in ten or fifteen minutes. We have lost many of our provincial traditions or customs, they are disappearing—progress has put an end to a few beautiful things that we have had for a very long time.

Oaxaca is imaged as a place that exists simultaneously in the past and in the present. Oaxaca City, its peoples, and its customs exist in the present. They are modern and changing and, most importantly, they are encroaching upon that which is meant to be unchanging and pre-historic—the peoples, places, things, and customs of the country, all thought to be vestiges of the pre-Hispanic world. Our tour guide uses Santa María del Tule, at the border between city and country, to represent these two competing forces. The bus hits the first of a series of speed bumps marking its passage through El Tule, and everyone moves to the left side of the bus, taking photos and straining to see what ought to be enormous as the bus motors by.

It is September and the end of the rainy season. The cornfields are lush, green and gold with the colors of mature corn stalks, and in many areas the surrounding mountains dominate the landscape. As our tour bus creeps slowly into foothills that punctuate the rolling plain of the valley, Isaac continues.

> Here, again, we can see part of the Sierra Madre Oriental Mountains to the left and you can see that it's raining in the mountains. Oaxaca has many different climates. For example, up there in the mountains it is almost always raining . . . the Mije, which is the people that live in the mountains up there, were never conquered by the Spanish. The Mije know the mountains like the back of their hand and up there horses aren't any good because there aren't, well, any flat spots, really . . . They continue to carry out certain rituals that they don't permit us to see. They are secret rituals in which only the Mije leaders in each

place take part . . . So they continue with their beliefs, their traditions, and their cures. They have shamans, but they won't let us see how they cure, the orations that they do. They would say that they go to doctors like we do but it's not true. Well, then, as I said before, there is a great deal of mysticism, in many regions where that which is truly Oaxacan remains intact.

The Mije are here set apart both in space (they live in the inaccessible mountains) and in time (they live outside the march of history, in the margins where "tradition" continues). Their culture is framed as having been preserved as a result of their geographic and chronological isolation. Further, they maintain their "traditions" and keep them secret from outsiders. From this perspective, culture is a static entity which, when it comes into contact with other traditions or cultures, may be lost forever. As a result, change or innovation is impossible, and hence the worthiness and authenticity of religious ritual and craft production are judged according to the same logic.

For the remainder of the twenty-minute trip to Teotitlán, Isaac performs a continuous monologue on subjects ranging from a locally made liquor called *mescal* and the cultivation of the agave cactus from which it is produced to what goes on at a rural wedding celebration. As the tour bus nears the turn-off to Teotitlán, however, Isaac shifts his discussion to topics more directly related to the weaving and dyeing demonstration to come. And the themes of the pre-Hispanic and secrecy reappear, invoked again in relation to the people and textiles of Teotitlán.

Now I feel that it is necessary to say that we are going to a private home and that everyone uses their homes to work. It is not only a home but, at the same time, a workshop, and it is a place to exhibit and sell their work. In other words, they live, work, and sell in the same place. And as a result, you will find that the objects for sale there are of a higher quality, less commercial, then what you will find in any market in the state—especially in Oaxaca City.

The difference—we are going to see an impressive difference in price—is that here they work in pure wool while with the commercial tapestries it is a wool/acrylic blend. It's not pure wool. Also the colors are . . . synthetic colors and the colors that they use here, where we are going in Teotitlán, are natural colors. They are going to demonstrate with, for example, cochineal that makes the color red. The Japanese have been thinking of exporting cochineal as the colorant for red lipstick in order to have a natural colorant, one that isn't harmful to people.

. . . These are secrets that in Oaxaca City when we buy a blouse, or runner, or shawl we don't know what is involved in making something like this from the start. Many times we say, "They are very expensive," but really, crafts in Mexico aren't expensive. There's a lot of work involved, really, for the artisan in order to sell his products.

The same themes that are stressed here in this prelude to the coming demonstration will structure the demonstration itself: secrecy and difference. During the demonstration, these two themes will work together to create a framework for understanding the textiles produced in Teotitlán and the single workshop that this tour group will visit. Like all tour guides in Teotitlán, Isaac is working on commission; the owner of this workshop will pay him 20–35 percent of what the tourists he brings spend.[8] In the demonstration to come, Isaac will try to impress upon the group that the workshop they are visiting offers better workmanship, design, and materials than any other, as well as than the town markets.

In this prelude to the demonstration, Isaac has already begun his task. He supports his comment that this workshop's textiles are less "commercial" and of a "higher quality" than those found elsewhere by asserting the quality of workmanship, purity of wool, and use of natural dye agents. The demonstration and tour are not intended only to frame Zapotec textiles and weavers in terms of the pre-Hispanic and secrecy and to offer a description of how a textile from Teotitlán is produced, but also to encourage those on the tour to purchase textiles from weavers with whom Isaac has a working relationship and from whom he is certain to receive his commission.

About five kilometers off the highway, up a narrow blacktop road running toward the surrounding mountains, the bus enters the community. Isaac continues to prepare his tour group for the demonstration to come.

The entire family works, they are the ones that card and operate the looms, and the women card and wash the wool—from carding to spinning are their jobs . . . and selling too. And the children, the young ones, they shepherd the animals in the fields . . . everyone works, everyone has a job . . . It is a picturesque village. When one goes to the towns one finds, principally in the markets, that they buy and sell by barter, for example. In the little guidebooks that you can buy, they say that the market in Oaxaca continues to be a traditional market . . . It's a lie. That's not what they were like twenty years ago. Now when we arrive at a traditional market, one in a village, we will see that when two people from the same place greet one another, the younger one kisses the hand of the older

person. The younger one kisses the hand of the older one in a gesture of respect. In Oaxaca City, one doesn't see the customs anymore . . . the folklore. They also continue to have barter in the villages, not in Oaxaca City.

Isaac's statement that the markets in Oaxaca are not "traditional" because they are different from "what they were like twenty years ago" is perhaps the clearest and most succinct expression of the logic that makes sense of craft production in Mexico. In this logic, an item is authentic only if it is made with materials and by methods that are assumed not to have changed.

The paved road running from the highway to Teotitlán is lined with houses spaced ever closer together until, when one finally approaches town, they appear side by side, flanking the dusty little road. Many of the houses have signs, hanging in front or painted on a wall, inviting anyone passing by to come in and look over the textiles there. The signs boast "100% wool," "100% handmade," "original designs," and "wholesale prices." The entrance to the town itself is marked by a large metal billboard inviting everyone to visit the textile market in the plaza.

The houses lacking signs simply have textiles hung on the walls or in the doorway. Oftentimes, people stand in the doorways, beckoning the passing vehicles with their outstretched arms, shouting at the passengers. Apart from the signs of prosperity and the peddling along this stretch of road, however, Teotitlán seems outwardly to have changed little more than other rural Oaxacan communities, in spite of its success and renown for selling woolen textiles. Until the late 1990s Teotitlán, like most communities in southern Mexico, had only one paved road, and large multi-story homes were rare. Even now, if one ventures around a corner or two and down a side street or footpath, one-story adobe houses are common.

Once in the community, the tour bus stops on the side of the road in front of a house. The tourists begin to file out of the bus, through the front door, and into the courtyard and workshop. Having been ushered into a central patio area, they find themselves surrounded on all sides by one-story walls (some adobe, some brick) punctuated by doorways and windows. Hanging from the walls, roof, and opened windows are an array of textiles. They are colorful and vary in size; some have geometric stepped designs, some have central diamond-shaped motifs, and others feature pre-Hispanic-looking figures in profile. The patio area is unpaved in the center, with a number of trees and bushes, green and lush from the daily rainfall. This central area is encircled by a patchwork ring of concrete and brick perhaps seven feet in width, except for a small recessed area near the

front entrance completely paved in brick, where the tour group is now standing.

Here there are a number of crudely built wooden chairs, while textiles and skeins of wool yarn hang from the walls on hastily made wire hooks. The chairs face toward the center of the patio, where a spinning wheel, a small cane basket full of raw, fluffy wool, and two carding paddles are placed on a reed mat, to which two Zapotec women move while motioning for the tour group to take their seats. The younger one kneels on the reed mat and begins to card the wool while the older woman takes her place standing at the spinning wheel.[9] To the left and near a wall in this recessed area are several looms, and a young man stands next to one, poised for his part of the demonstration.

The spinning and wool-carding portion of the demonstration begins:

> Here you can see the first phase of the process, which is carding the wool. This wool is already clean, it has been washed . . . You can see that it is the natural color, it's white . . . Natural wool comes in white and also in black and by mixing them you get the color gray—gray is also a natural color. This runner [pointing to a nearby textile] demonstrates . . . natural colors. Here [pointing to several other textiles] we see a few of the designs from Mitla. For the persons that have been there, they represent two forces, negative against positive, that drive our cultures, which you can see at Mitla with these symbols that the people there were manipulating. Just like we had in El Valle Azteca [near Mexico City] with the two forces of the two serpents that are day and night, the two forces maintain the equilibrium of the days.
>
> Here at the spinning wheel, you can see how to begin to spin the wool into yarn. This is the way that it's done and that's why we say that it is very labor-intensive work to finish pieces like this one [pointing to another textile], which has in the center the Zapotec diamond. We have ones like this in natural colors and others more complicated, like this one, which is bigger. Around the border you can see the forms from Mitla—here on the border in natural colors.

Isaac connects textiles produced today in Teotitlán to the pre-Hispanic era, saying that the designs are taken from pre-Hispanic architecture and have a sacred meaning. We learn that the step-fret patterns common at the archaeological site of Mitla are a sacred symbol and a reenactment of the "two forces: negative against positive" which "drive" the cultures of the Valley of Mexico to the north, where Mexico City is located and where many in the tour group live as well.

Carlos, the head of the household, has developed an international reputation as a master dyer and is often referred to as the only weaver from Teotitlán

who still uses natural and vegetal dyes, most notably cochineal. Through having read travel pieces and books about collecting Mexican crafts, many of those who visit Teotitlán know of Carlos and his incredible knowledge of pre-Hispanic dyeing techniques.[10] Some of the tour group, however, seem to be a bit confused about what cochineal is, and they begin to ask questions about how the insect is used and the mechanics of the dyeing process. Isaac answers,

> Yes, you boil it and you put in the fixative . . . and cochineal . . . cochineal is this, this small insect that lives on the nopal cactus. You shouldn't think that they are little animals that walk around . . . No, that's not what they are. Right now I'll show you what they are. They're like little fluffy pieces of cotton that are attached to the nopal paddles. One takes them in massive quantities, dries them, and then grinds them so the red comes out. They say that the Japanese are now thinking of exporting this to produce colors . . . vegetal colors for lipstick or to produce sweets . . .
>
> This gives us the color red. Cochineal is expensive. It's expensive because it is very difficult to collect this little insect that is destroyed by the wind, the blowing of the wind, and the rain. How much does a kilo of cochineal cost? A kilo of cochineal costs 500,000 pesos [approximately US $166 in 1992]. Just imagine how much for such and such a quantity of wool.

Several in the tour group have had their interest piqued by the expense of using cochineal as a colorant and they begin asking more probing questions. One woman asks how much cochineal is required to color six kilos of wool and Isaac turns, looking for Carlos, who left through a doorway a few moments earlier. Unable to locate Carlos, Isaac turns to Tomás (Carlos's son), pointing toward a large quantity of ground cochineal that sits on a grinding stone for the demonstration, and asks if it would take about that much. Tomás (who is still standing at the loom waiting to play his part) answers "No," so Isaac asks if it might not be "more like this amount," pointing at a much smaller pile of indigo. Tomás answers affirmatively that it would be about that much. Isaac adds that only the female cochineal insect is harvested, so many more insects must be raised than can be used.

The tour group is then ushered over to a large cauldron of steaming water that sits precariously over an open fire near the back of the central patio. Several of the tourists approach the cauldron and begin to lean over to see its contents but are pushed back by the heat. Carlos appears again, chuckles at their surprise, and shakes red, ground cochineal from a ceramic bowl into the steaming water as the tourists banter back and forth about the heat. From a safe distance, the tourists surround the steaming cauldron while he squeezes

several limes over the mixture before throwing the entire fruit in. As he shakes more cochineal into the cauldron and begins stirring with a large stick that has been stained a pinkish red from use, a woman appears at his side with three long skeins of wool. Carlos takes a break from his stirring and, with a glance around at the crowd to let them know that they should pay attention to what he is doing, lays the skeins on top of the simmering water. The crowd goes silent and leans in toward the pot as Carlos uses the stick to push the wool under the surface of the water and begins stirring. After a minute or two, he lifts the wool back up to the surface with the stick, picking at the tangled mass of pink yarn. He pinches the steaming wool between his thumb and index finger before turning it over and pushing it back down.

This goes on for several minutes, until the yarn no longer loses its color when he pinches it. One last stir with the stick and Carlos lifts the tangled mass from the water, holding the other end of the stick to the ground with his foot to prop the dyed wool yarn over the cauldron as it drips. The crowd gasps in awe at the transformation and applauds enthusiastically at Carlos and the now bright pink wool. Isaac adds that not only is cochineal a natural dye agent, but it also resists fading. A couple of the tourists approach Carlos and the dyed wool, pinching it for themselves and remarking on the heat and hard sweaty work of dying wool by hand over an open fire.

The carding, spinning, and dyeing part of the demonstration is now drawing to a close, and our guide asks the elderly woman who has been patiently spinning wool into yarn throughout Carlos's demonstration to say a few words in Zapotec. The woman obliges and then paraphrases in Spanish: "Welcome everyone to our house. Here we are demonstrating how one cards, spins, combines colors, and weaves a serape." Everyone applauds. Carlos ushers the group over to the loom, where Tomás begins weaving, and on the way shows the group a paddle of a nopal cactus that has white, fluffy specks on it. Isaac tells them,

This is the cochineal. When the Spanish came they held large tracts of land and they cultivated cochineal because . . . because it was a highly profitable undertaking for them. When they exported it to other countries, the other countries asked what this colorant was—the Spanish said that it was roots, that it was leaves, that it was other things but not this. So the Spanish cultivated a lot of cochineal but they didn't do it like our little portion here. Why? Because they didn't know what these people here knew about the wind and the rain, all of those things so that they [the Zapotec] could cultivate a great deal of cochineal in a very small area—this is the famous cochineal.

Tour group members pull out their cameras and snap photo after photo of this small white insect that, according to Isaac, even the Spanish could not learn to exploit as efficiently as the Zapotec. The "famous cochineal" will undoubtedly evade their camera lenses as well, and appear to their friends and relatives back home to be only tiny white specks on the cactus.

Many in the tour group are clearly impressed by Carlos and his use of traditional dyes like cochineal. As a consequence of widespread and concerted efforts to link rural popular culture to Mexico's "ancient civilizations," Mexican crafts are widely understood to stand apart from other products because of their and their makers' relation to pre-Hispanic culture. From this perspective, the secret and sacred knowledge of the great past civilizations of Mexico lives on in the lives and practices of the indigenous population—but it is a knowledge, according to Isaac, that is being steadily eroded as these people abandon their "traditions." Isaac's comments about Carlos's efforts to maintain this knowledge and prevent it from being forgotten frame this weaving workshop as distinct from others the tourists might have access to. As a consequence, that which is produced in this workshop (the workshop of Don Carlos) alone, more than the products of any other workshop in Teotitlán, more than anything sold in a market stall or by a street vendor, preserves and embodies that knowledge. Don Carlos alone is responsible for maintaining it because he alone has rescued its fading memory from the steady march of progress. Isaac ushers everyone over to Carlos's son, Tomás, and the loom:

> Good! Well, let's go over to the looms because . . . Here in the photo [of a textile on the frame of the loom] you can see the job that Tomás is working on right now.

Everyone watches Tomás weave in silence for a few minutes. They take photos and move around the loom, trying to get a better view of what he is doing. Some stay for quite some time, taking photos and asking questions of Tomás. Others lose interest rather quickly and wander off to the stacks of textiles set up on benches along the nearby walls. Isaac, Carlos, and several family members follow them over, inviting them to look through the piles and encouraging those who find something of interest to unfold it and lay it out on the tile floor. As the tourists look through the piles, Isaac and the others ask what sort of design and color combinations most interest them, helpfully pulling out similar textiles. The tourists ask questions of Isaac, the others, and Tomás, who ushers the remaining tourists over to what has be-

come a rather chaotic scene. Textiles are strewn all over the floor and tourists bump and jostle one another, rifling through the stacked textiles as well as those on the floor. They ask about prices, whether the red is from cochineal and the blue from indigo. Isaac and the others answer, pointing out that one or another textile costs more because of the complicated nature of the design and consequent time involved in weaving it, or that parts of one or another textile are dyed red with cochineal and for that reason it is much more expensive. Many of the tourists begin to purchase textiles—some with Mexican pesos and others by credit card.

At the same time as the others have shifted their attention to the textiles and are making purchases, one tourist from the group backs away, heading back toward the area where the wool yarn and dye agents are still scattered about the floor. There is no one in this part of the patio, except for the anthropologists on the balcony above who have been videotaping the demonstration at the request of the family. The middle-aged woman checks over her shoulder and then reaches down and takes a small handful of cochineal, stuffing it into her handbag as she backs away across the patio and rejoins the group.

After the demonstration, as the tourists are ushered back into the bus, no one seems to notice that Isaac remains behind in the house for a few moments to collect his percentage of the sales—something he negotiated before the start of the demonstration. From Teotitlán, the tour is off to the nearby community of Tlacochahuaya, where they will visit a rural Catholic church, the interior of which features murals by "indigenous painters." At this, their last destination before returning to the city, they will be asked to refrain from taking photos. Because of concerns about camera flashes harming the murals and because of the "secret" ritual knowledge and beliefs that are said to be represented pictorially on the country church's interior walls and ceiling, Isaac emphasizes that any attempt to photograph the murals will be dealt with severely—the film will be taken by the townspeople, who maintain the church, and destroyed.

How can we understand the tourist's act of taking the cochineal? First, we must place cochineal's importance as a marker of authenticity for indigenous crafts in Mexico within the context of the tour itself. An examination of the situational construction of what cochineal means to Mexicans touring Zapotec workshops reveals how multiple narratives are brought to and remade in the touristic encounter. I argue that Mexican tourists literally tour the nation, creating for themselves their own version of nation in postcolonial Mexico.

As Isaac guides this group from the city to the county, he strongly suggests a particular interpretation of their experience. He tells them that the Mexican state of Oaxaca exists simultaneously in the present (in its metropolitan center) and the past (in the surrounding rural hinterland). To move between the Oaxacan city and countryside, then, is to move from Mexico's present to its pre-Hispanic past. Indigenous crafts occupy a special place in Mexico's well-developed sense of national cultural patrimony, which is especially important for understanding the place of cochineal in guided tours of the homes of Zapotec weavers. Two general features of Isaac's framing of his tour are particularly important in this regard. Isaac suggests, first, that Oaxaca's countryside is littered with the remnants of authentically Mexican civilizations that are now in ruins; and second, that indigenous Mexicans (understood to be the living descendants of Mexico's pre-Hispanic civilizations) still hold knowledge passed down to them that has been kept "secret" first from Spanish colonists and now from outsiders. The general organization of his monologue gives concrete form to this relation. Discussions of indigenous cultural practices, for example, are bracketed by mention of some aspect of pre-Hispanic civilization (usually as evidenced in the architecture of archaeologically reconstructed Zapotec settlements). Framing discussion of religious ritual, shamanic curing, or dyeing techniques and technologies in this way suggests a direct relation between pre-Hispanic Mexican practices and those of indigenous Mexicans today. The authenticity of indigenous culture today (including craft production) is then judged against a pre-Hispanic standard.

Together, these two points structure Isaac's framing of how to understand the value of indigenous crafts as well as the special place held by cochineal as a dye agent (and Don Carlos as an expert dyer). Cochineal holds special significance because of its associations with an asserted pre-Hispanic condition. The emphasis placed on cochineal's cost, the difficulty of using it, and the "secrecy" surrounding its cultivation are all important to understanding the social context of one tourist's impulse to stuff a handful into her purse.

Isaac's framing of the commercial value of cochineal also highlights another important aspect of the construction of cochineal's worth—Japanese interest in using cochineal commercially as a natural colorant. This revaluation of cochineal emphasizes its continued (even reinvigorated) commercial worth. In fact, cochineal's reemerging value as a dye agent not just for textiles but also for food is a theme that has more recently been circulated well beyond guided tours to Teotitlán. In an article entitled "Can Tiny Red Bugs Mean Gold for Mexico?" the *Wall Street Journal* discusses current attempts to

reestablish cochineal cultivation as an industry. Emphasizing the "ancient glory" of the colonial industry and the efforts of a Oaxacan "ranch" owner (a "regular Juanito Appleseed"), the piece intimates that if the methods and technologies of efficiently raising and harvesting cochineal can be rescued from the past and brought into the present, then great riches will follow.[11] The actions of the tourist who took the cochineal may be similarly interpreted— she took her small cache of cochineal from the past to the present when the tour group returned to the city from the countryside, thereby re-creating its worth for modern Mexicans.

Nation, Tourism, and Craft in Mexico

As a large number of thinkers and writers have noted, Mexico has a well-developed discourse which explores what is known as *ser del mexicano* ("the essence of the Mexican") or *lo mexicano.* This theme, and the related cultural and political debates concerning what is "truly Mexican," have a history extending back well before the Mexican Revolution. The place of the indigenous populations (as well as the crafts they produce) in the Mexican national consciousness has been central to it, especially during the post-revolutionary period. Views have ranged from the political right's proposed programs of forced assimilation, designed to eliminate the "Indian problem," to leftist indigenist romanticization of a supposedly morally and physically superior indigenous population.[12] The mainstream of *lo mexicano* thought, however, has emphasized Mexico's hybrid identity, adhering closely to Mexican politician and writer José Vasconcelos's conception of *la raza cósmica* (the cosmic race). That version of *lo mexicano* emphasizes the contributions of both the indigenous and Iberian cultural and "biological" legacy by celebrating the hybridization or mixture (*mestizaje*) of both "races": it promotes the *mestizo* as the true Mexican.

Nor has the debate been solely academic, as various positions frequently reach a broader audience. For example, in one of his most widely read books, *The Labyrinth of Solitude,* Octavio Paz found that the essence of Mexico (and Mexicans) lies outside the mechanization of factory production and the rhythm of the assembly line. What is more, he emphasized that the proclivities of Mexicans, including an "innate good taste," are linked to an "ancient heritage."[13] Paz was not alone in linking a uniquely Mexican aesthetic to the country's past "civilizations."

Regardless of their political position, most who have broached the subject have, like Paz, been unable to avoid ascribing certain inherent attributes to

the indigenous population. Diego Rivera, perhaps the best known of the post-revolutionary Mexican muralists, explained his artistic vision and program for public art works in terms of "reviving" an "old art" and of releasing "forces and influences secretly at work in the spirits of the artists themselves." Similarly, Alfonso Caso, one of Mexico's foremost anthropologists, who was involved in the excavations at Monte Albán just outside Oaxaca City, wrote that he saw in "the Indian 'a marvelous intuition for the transformation of the crudest material into beautiful artifacts.' "[14]

Alex Saragoza gives tourism and those who help to produce touristic encounters of the sort examined here a central role in this complex. He argues that a cultural, economic, and political apparatus that arose in the 1940s and that first helped to make mass tourism possible in Mexico cohered around four elements: public and intellectual *lo mexicano* debates; governmental programs designed to rebuild Mexico's colonial and pre-Hispanic monuments and monumental architecture ("ruining ruins" to create authentic "original copies," as Quetzil Castañeda so insightfully puts it); the indigenist discourse; and, finally, an emphasis on rural folk or "vernacular" culture.[15]

This narrative complex had its origins in a cultural industry of the pre-revolutionary Porfiriato period (1876–1911) that worked to link the pre-Hispanic and indigenous Mexico with nationhood for an international audience. Saragoza describes how Mexico's tourism industry developed from this base in the post-revolutionary period and worked to couple pre-Hispanic and indigenous images with images of Mexico as a haven of plush resorts, developing a "presentation of *mexicanidad* (Mexicanness) commingled with a tourism based on sun, beaches, and recreation." This uneasy commingling was the product of not only private business ventures but also a growing state bureaucracy that began to take shape in the late 1930s, during the presidential administration of Lázaro Cárdenas.[16]

In the 1940s and early '50s, Miguel Alemán Valdés, who led the governmental ministry that oversaw tourism and later became president, was instrumental in this shift, presiding over the creation of the Acapulco resort and the completion of the Pan-American Highway. At the same time, the notion that the pre-Hispanic was the root of Mexican identity (and was present in contemporary indigenous Mexico) was given material form and cultural power through governmental institutions and their public programs. The Secretaría de Educación Pública (SEP), whose first director was José Vasconcelos, played a major role in fostering the idea that Mexico's cultural roots were indigenous through a variety of campaigns promoting different expressive folk cultural forms. The Ballet Folklórico, which staged sanitized

regional costumed folk dances, was created in 1952. In 1939 the Instituto Nacional de Antropología e Historia (INAH) was created as a branch of the SEP, with a host of programs filling out the "monumentalist dimension of the state's cultural project." By the 1960s, Mexico's Ministry of Tourism had succeeded in blending the resort and indigenous heritage branches of its program under advertising phrases such as "so modern and yet so foreign" and "so foreign . . . yet so near." Mexico and its indigenous populace could be both exotic (or otherworldly) and, at the same time, safe (not roving *banditos* but quaint potters) and comfortable (a hotel room with all the amenities of home).[17]

It is clear that indigenous art and craft production was an important element in the narratives that were used to develop and promote mass tourism in post-revolutionary Mexico. Victoria Novelo has documented the role of crafts in the complex and very public discussion of what it means to be Mexican, writing that crafts became everything to everyone and were referred to as

> works of art, as a sign of underdevelopment, as a way of improving the situation of underemployed peasant farmers, as a fundamental part of national culture, as a potential way of balancing the commercial deficit of the country, as occupational therapy, etc.[18]

Novelo underscores how different conceptions of *lo mexicano* have privileged certain interpretations of crafts and differently constructed their place in the national space. For instance, those on the political right might easily make craft production a sign of underdevelopment, while those on the left might see it as a means to improve the situation of underemployed peasant farmers, or even as non-European "fine art." Thus, as the political tides and sentiments shift in Mexico at different periods and in different political and ideological quarters (as well as from differing class perspectives), indigenous craft production might take on different meanings. Novelo credits intellectuals (especially archaeologists and ethnographers) with being a major force in creating both the romantic image of craft production that is prevalent today and Mexico's many governmental programs promoting and supporting indigenous crafters. Anthropologists, she argues, provided the basis for the valorization—and governmental support—of indigenous expressive culture.[19]

More recently, Eli Barta has noted that indigenous crafts are a "foundational element" in Mexican cultural patrimony and are viewed as the primary "symbol of the pre-Hispanic roots of the modern Mexican nation."[20]

These symbolic associations are given material (and personal) form in the guided group tour and weaving demonstration, where Zapotec textiles and the use of cochineal and hand-spun woolen yarn are made authentically Mexican by framing them in relation to pre-Hispanic Zapotec civilization.

Following Novelo's insight, we may say that despite the strong links between the pre-Hispanic, rural folk culture, indigenousness, and the Mexican nation that those like Isaac create, Mexican tourists nonetheless bring multiple interpretive frames to their encounters with indigenous craft producers, the items they produce, and the techniques, materials, and technologies they employ. They may see Zapotec weavers, with their textiles and cochineal, as signs of underdevelopment (or potential development), or, just as likely, as producers of non-European fine art. As a consequence, the cochineal is "famous" in different ways, and comes to Zapotec weaving demonstrations with multiple histories of its place in Oaxaca's (and Mexico's) colonial political economy.

The Bug in Colonial Oaxacan Political Economy

Most historians believe that cochineal was enormously important to the Spanish colonial empire and also that its production was enormously exploitative of the indigenous population. This was especially true in Oaxaca, where production peaked in the late 1700s. Spanish colonial authorities tried from early on to control the trade, prohibiting the export of live cochineal and shipping all exports of the highly prized dyestuff through the Spanish ports of Cadiz and Seville. Mystery and confusion surrounded the nature of cochineal, at least partially because of tight control of information about both the insect and the equally "exotic" cacti (nopal and opuntia) on which it lives, all of which were unfamiliar to Europeans. During the colonial period, as today, the insect was generally (and erroneously) referred to as *la grana* (the grain) and was variously described by both Spanish and later non-Spanish European authorities as a worm, fly, fruit (usually a fig), berry, and herb.[21]

Very early on, perhaps as early as the mid-1500s, the collection of a wild variety of cochineal known as *silvestre* and the cultivation of a more highly prized domesticated variety called *fina* or *grana fina* became very important parts of colonial New Spain's export economy. In the mountainous area to the north of Oaxaca (the Sierras Mixteca and Zapoteca), "farming" of the *grana fina* variety expanded rapidly in the late sixteenth century. By the early

1800s, the mountainous region was perhaps the single most important center for cochineal cultivation in the Spanish empire.[22]

The domesticated variety was cultivated over an approximately six-month period. "Pregnant" females were purchased at market and then introduced to the nopal cactus by pinning or tying several small, loosely woven baskets, each containing around twenty-five of the insects, to the paddles of the cactus plant. When the cochineal hatched, they spread over the cactus and attached themselves by inserting specialized parts of their jaws into the plant for feeding. In four to five months, when the insects reached maturity, they were brushed off the cactus, killed, and dried using a variety of methods. The dried insects were then sold to merchants who packaged them for shipment to Europe.

Cochineal exports to Europe fluctuated wildly from year to year, because of the labor-intensive nature of its cultivation and variations in weather. The domesticated variety, which is a stronger dye agent, is extremely vulnerable to rain and wind. In addition, colonial New Spain suffered through a series of epidemics which placed a strain on the indigenous labor pool necessary to see the insects to maturity. Even during the periods of greatest output, cochineal production remained largely a cottage industry, making use of the household labor of indigenous women, children, and the elderly who minded small family "garden" plots of nopal cacti called *nopaleras*. Cochineal farming *haciendas* (large estates) did develop in the eighteenth century, but as Alexander von Humboldt remarked after his travels through the region, "the greatest part of the cochineal which is employed in commerce is . . . produced in small nopaleries belonging to Indians of extreme poverty."[23]

Few Spanish settlers were involved in the actual cultivation of cochineal, and the modest number of large Spanish estates devoted to its cultivation were never very successful. Great fortunes, however, came to those who trafficked and traded in cochineal. The greatest problem facing those seeking to make their fortune with cochineal was getting their hands on it, as Spanish authorities attempted to control both access to and trade in the insect. While the indigenous population responsible for producing cochineal earned little, intermediaries (including local indigenous merchants), controlling larger plots of land and reselling cochineal cultivated by others, "grew rich on the sale of *la grana*."[24]

The enormous value of the cochineal bought and sold during the colonial era and the mystery surrounding its cultivation laid the basis for an aura of awe that still surrounds the dye agent. The "famous cochineal" is

famous both for the wealth it created and for the unusual nature (from a European perspective) of both the insect and plant from which it is produced. Historical treatments of the political economy surrounding colonial Oaxacan cochineal cultivation and marketing, however, reveal multiple competing ways to construct the particulars of why cochineal is famous.

Standard historical treatments of the subject position it as an example *par excellence* of Spanish colonial mistreatment and exploitation of New Spain's indigenous population. Cochineal is famous, from this perspective, because of the wealth extracted in it by Spanish colonials from the largely rural Zapotec population of Oaxaca.[25] But Jeremy Baskes's reinterpretation of the political economy surrounding colonial cochineal cultivation suggests an alternative reading. According to Baskes, the indigenous small-scale cochineal farmers were far from being passive, exploited colonial subjects; many of them took cash loans and then successfully manipulated crown representatives, the courts, and the authorities more generally to avoid repaying them, in what can be seen as colonial "resistance."[26]

Isaac, our tour guide, creates a framework for understanding cochineal's role in Zapotec textile production far different from that offered by either Baskes or more standard historical treatments of the subject. Where historians have found either greedy representatives of the Spanish crown exploiting a rural indigenous population or Zapotec peasants manipulating the system to obtain cash loans that were otherwise hard to come by, Isaac finds prosperous Spanish settlers successfully cultivating cochineal—but less successfully than the indigenous population. In place of exploitation at the hands of greedy colonists and resistance to colonial authority, then, Isaac's version of the place of cochineal in colonial Oaxacan political economy locates its fame in the secret knowledge that made Zapotec small garden plots even more productive than Spanish estates.

Mexican tourists who come to Oaxaca and take guided tours to Teotitlán already know about the famous cochineal. Isaac strongly suggests to them that Zapotec textiles (and especially Zapotec textiles dyed with cochineal) are valuable because they embody secret knowledge passed down to Zapotec weavers as the living descendants of those who built the great pre-Hispanic settlements of ancient Mexico. Through their experience of the tour and weaving demonstration, Mexican tourists create for themselves their own version of why a Zapotec textile is worth owning and, correspondingly, why cochineal is famous. In so doing, they project sentiments onto Zapotec weavers and textiles—and cochineal—which lead them, following Ray-

mond Williams, to consume (and in one particular case, snatch) what their country neighbors have grown.

The Country and Peripheral Latin American City

Writing of associations with the Amazonian jungle, Michael Taussig finds a structure of feeling toward colonial and post-colonial natural environs, as well as their inhabitants, which is quite distinct from that described by Williams in England.

> It is the sentiments colonizing men project onto it [the Amazon jungle] that are decisive in filling their hearts with savagery . . . And what the jungle can accomplish, so much more can its native inhabitants . . . the colonially construed image of the wild Indian was a powerfully ambiguous image.[27]

Fear or dread of, and, at the same time, fascination with and respect for, the indigenous healer (or shaman) in Taussig's South America–based study are part of a radically different structure of feeling. Yet this structure also reveals the ways the Amazonian city, together with its inhabitants, "eats what its country," or in this case jungle, "neighbor has grown," in Raymond Williams's words. Taussig asserts that a symbolic product is the source of this ambiguous attitude: the wild, savage power of the indigenous Amazonian shaman and, more generally, an indigenous population figured simultaneously as wild and as a labor resource.

Following Du Bois's and Fanon's idea that the consciousness of colonized subjects is fractured and "doubled" (seen by themselves through the eyes of the dominant colonizers), Julie Skurski and Fernando Coronil find that in post-colonial Latin American spaces, Williams's country and city trope becomes "doubly articulated." In the Venezuelan popular imagination, the trope of country and city expresses, through "disjunction" and "ambiguity," the "shifting meaning attached to center and periphery, and elite and pueblo, in terms of embedded notions of social and political, and cultural hierarchy." In the Latin American post-colonial situation, the country and city trope "at once assumes, conceals, and recreates the fractures of a colonial legacy." Interpretations will shift from "differing class perspectives," so that the doubly articulated country and city trope carries "conflicting historical memories." It can be either barbarous or civilizing, exalted or denigrated, a locus (and producer) of either anarchic or democratic impulses, etc.[28]

In Oaxaca, a doubly articulated country and city trope also manages simultaneous images of indigenous Oaxacan artisans as keepers of 'secret' knowledge. Their image is particular to both Mexico's own national imaginary and a distinctly Oaxacan colonial history. In the Oaxacan case, the trope of country and city (where both city and country are in the periphery) expresses the shifting meaning attached to indigenous crafts. Victoria Novelo notes that in Mexico, crafts have meant multiple things. In the doubly articulated country and city trope we locate a symbolic logic that makes sense of Novelo's observation. In the case of Zapotec weavers who use cochineal to dye their textiles, the ambiguity and disjunction of the post-colonial Latin American country and city trope is manifest in one tourist's interest in and admiration for Zapotec "secret" knowledge of cochineal even while she takes it.

The act of touring Teotitlán and the workshops of indigenous artisans carries conflicting historical memories that tourists sort through as they reconstruct for themselves a version of Mexican cultural patrimony. To tour Zapotec artisans is to enact Mexico's own foundational nationalist myth. It is to travel into the countryside, back to Mexico's pre-Hispanic foundational past, to locate the essence of *lo mexicano,* and then to return to the colonial city and finally modern Mexico, having rearticulated Mexico's hybrid identity—the relation between past and present and between Indian and Spanish. To tour Zapotec weavers and their textiles, then, is also to assume, conceal, and re-create the fractures of Oaxaca's own colonial legacy, so intimately tied to cochineal production. This is the bug in the rug for Mexican tourists or, following Williams, the present moment in process and precedent that makes sense of one tourist's impulsive moment.

The Bug in Mexican Fascination with Zapotec Textiles

In the words of Gary Ross, a biologist, freelance writer, and avid collector of Zapotec textiles, there is a "bug" behind the fascination with these textiles and their makers. The rural Oaxacan communities where Zapotec textiles are dyed using cochineal are well visited, and such visits frequently include a weaving demonstration. These demonstrations offer tourists from the United States a glimpse into the lives and work of an exoticized, unfamiliar other: the living remnants of pre-Hispanic civilizations commonly thought of as "extinct" and representing a pre-industrial ideal where people live "closer to nature" and produce crafts—a way of life commonly thought of as "lost to progress" in the United States.[29]

Fascination with Mexican indigenous culture and art is manifest in venues ranging from international travel literature to European and United States art and philosophy more generally. This interest has also been profoundly shaped by Mexico's own developing sense of its national cultural patrimony. Mexican plastic arts and ballet—to pick just two examples—were decisively shaped by Mexico's placing of indigenous art and culture at the core of *lo mexicano*.[30] For tourists from the United States, then, the "bug" in their fascination with Zapotec textiles encompasses an attitude that has been profoundly shaped by the assertions of Mexican intellectuals and artists about what constitutes *lo mexicano*. Exposure to these ideas in the art and literature of Mexico, as well as through European and U.S. romantic traditions, has made the traveling public receptive to images of exotic, mysterious, and secret Others while in Mexico.[31]

Writing of the uses to which national governments in Latin America have put the remnants of pre-Hispanic civilization, Erik Camayd-Freixas draws our attention to the distance between "nation and state" in the region. He argues that various national identities are sought out in "foundational pasts" and "ancestry," while the largely "progressivist" state "argues policy on the basis of promise." In the end, such a focus on an idealized, if not utopian, past "becomes a melancholic expression of disillusionment, a compensatory search for the ideal values lost to modernity, but also a sublimation of its very own unconfessed fetishism of progress."[32]

The structure of feeling framing southern Mexico's rural indigenous inhabitants, and ambivalence about their control over secret natural wealth or bounty, are expressions of this longing for values lost to modernity and a simultaneous fetishism of progress. Herein lies the source of the ambiguous sentiments regarding Mexico's own indigenous artisans. It is manifest quite clearly in Mexican fascination with indigenous craft production and most especially in the way that some Mexicans are drawn to Zapotec textiles dyed with cochineal. To understand the historical and cultural origin of the disillusionment described by Camayd-Freixas (the bug in the rug) is to work between present experience and the narrative, structuring frame of the actively lived and felt history informing the touristic experience.

An intertwined set of images and narrative constructions developed in the Mexican post-revolutionary national imaginary have figured a distinct relationship between urban and rural Mexico.[33] Through the tour described here, we have taken a second glimpse at the symbolic logic structuring the field of Zapotec textile production around a binary opposition between the historical present and an ahistorical pre-Hispanic past. To follow Bourdieu, this framing of

excursions into the Oaxacan countryside offers a "space of possibilities" where the rural is made sense of—as Bourdieu puts it, "a finite universe of *freedom under constraints*" where experience is made meaningful.[34] For Mexican nationals, the doubly articulated country and city trope frames such a finite universe for understanding Zapotec textiles and weavers by locating a present that is not yet complete and modern in the urban city (of the periphery) and the past in the indigenous countryside. As the present encroaches on the rural, the countryside's pristine indigenous inhabitants and their culture are debased by modern influences. Such debased Zapotec textiles are, according to our tour guide, Isaac, "commercial" products with a compromised value. The same is true of Zapotec weavers.

THREE

Selling Zapotec Textiles in the "Land of Enchantment"

Today, automobile license plates in the state of New Mexico carry the slogan "Land of Enchantment." In 1924 D. H. Lawrence described the Land of Enchantment after visiting the Hopi pueblo of Hotevilla with Mabel Dodge Luhan, a transplanted East Coast socialite and noted resident of Taos, New Mexico. Lawrence and several thousand other "Americans of all sorts," as he put it, were there to witness a performance of the Snake Dance. Lawrence wrote,

> the Indian, with his long hair and his bits of pottery and blankets and clumsy home-made trinkets, he's a wonderful live toy to play with. More fun than keeping rabbits, and just as harmless. Wonderful, really, hopping round with a snake in his mouth. Lots of fun! Oh the wild west is lots of fun: the Land of Enchantment.[1]

His text drips with sarcasm and was not very well received by Dodge Luhan, a well-known patron and supporter of Native American art and culture.[2] In spite (or perhaps because) of this, it also captures the cultural politics of the Land of Enchantment. Lawrence seems not to have been taken in by the romance of the American Southwest, which he describes as "the great playground of the White American," or by the spectacle of Native American art and culture that drives that romance, both of which have been well described by academics. A number of scholars, for example, have explored the role of the Santa Fe Railway and the Fred Harvey Company, transplanted eastern

United States art patrons like Dodge Luhan, Native American culture, and the community of Santa Fe itself in creating the American Southwest as a region of the United States widely renowned for its natural and cultural beauty—the Land of Enchantment.[3]

My use of this phrase, then, is a deliberate attempt to move away from the more common regional descriptor—the American Southwest or, simply, the Southwest—to a sense of a crafted or constructed place and space, a cultural geography. Bruce D'Arcus emphasizes that its spaces and places do not serve as "reflections of an authentic regional essence," but work to "actively create a very particular vision of . . . enchanted otherness." D'Arcus works from Michael Riley's sense of the Southwest as a "semiotic construction": a place that "relies on a linked construction of ethnicity and place . . . driving its ability to enchant." Riley, D'Arcus, and a number of other scholars have argued that this narrative construction informs cultural politics in the region. D'Arcus writes that while this enchanted space is not the region's real essence, it has real effects on real people in the region. He shows how the otherness of the Land of Enchantment "masks" the fact that it is a construction, but he emphasizes that it is possible to peek beneath the surface and to examine the construction of the Land of Enchantment and its relation to the politics of everyday life.[4]

The presence of Zapotec textiles in the American Southwest also provides opportunities to peek beneath the surface of the enchanted space sought out by so many travelers to the region. While Zapotec textiles are sold to people visiting Teotitlán, very large numbers have also been sold in the American Southwest since the early 1980s, particularly to people visiting the Santa Fe and Taos areas of New Mexico—the *axis mundi* of the Land of Enchantment. In the Land of Enchantment, however, Zapotec textiles can be a hard sell, and their presence is discursively framed by some as an "illegal invasion." This chapter moves through a series of spaces that will demonstrate why this is so and further examine the symbolic logic of the field of power giving structure to, and defining the limits of, the transnational Zapotec weaving community. We begin to explore these spaces through the lives and work of two well-established businessmen, Ross Scottsdale and Brice McCoren, who buy Zapotec textiles in Oaxaca and resell them in the United States.[5] While one uses Southern California as a home base and the other Texas, both have a large number of retail clients in the Santa Fe area. In fact, together they supply nearly all the galleries and gift shops on Santa Fe's central plaza (the commercial heart of the Land of Enchantment) that carry Zapotec textiles. Next,

we examine a gallery owner's development of a line of reproduction Navajo textiles. Moving through the spaces where these Zapotec-produced, "authentic" reproductions of Navajo textiles are crafted will further reveal the details of the working lives and practices of the community of people who have a hand in creating Zapotec textiles. Finally, a brief historical treatment of the traveling exhibit "Indian Handicrafts: The True and the False" will provide one example, chosen from among many, of how the public is schooled in issues of "authenticity" as they relate to Native American art. Together, the work of importers, gallery owners, and even the United States government (through its attempts to legally enforce "authenticity" in Native American art) will demonstrate how certain ethnicities, places, and art forms are constructed as "outside of" the enchanted space.[6]

Ross and Brice, Buyers of Zapotec Textiles

> I guess the start is how I got here [Teotitlán] originally, which was in January of '74, coming down from the California border in a train, and with a friend from Chico State University, where I had just quit my student teaching . . . leaving the education system, realizing something critical was wrong with becoming a teacher when I didn't like school anymore. And I'd seen some beautiful rugs in Newport Beach [California] in a shop prior to 1972 and 1973 and somehow, they really impressed me.

Ross Scottsdale buys Zapotec textiles in Oaxaca and resells them in the United States. He has been coming to Teotitlán for more than thirty years. In 1992 he still found it difficult, despite the fact that he is well spoken, to put into words what drew him to this work. He was in his early forties, very thin and fit-looking thanks to his daily yoga regimen and strict whole-foods diet. Ross was at ease as we sat in a room he rents from a weaving family in Teotitlán. Between long pauses as he carefully chose his words, he described the first Zapotec textiles he ever saw.

> I don't know what it was about them . . . a very fine weave and beautiful colors, and it was a big format, five-by-six-foot serape format. And I . . . when I came down to Mexico I wanted to find that. I didn't know where it came from, or who made it, and as I traveled hitchhiking through Mexico . . . I looked at a lot of weavings, and . . . my AAA tour guide said that there was a weaving center called Teotitlán in the state of Oaxaca, and on my map Teotitlán was . . . below Tehuacan, so I ended up . . . hitchhiking down there, and got there one

evening and . . . no one said there were any rugs there and I couldn't believe them. All there was, was a big jail, and they wanted me to enter the jail. I was a little paranoid . . . [it was] a little spooky. I finally got a clear story by the next day, and . . . I went back up to Tehuacan just before the highway went from Teotitlán del Camino to Oaxaca [City] and came back down to Oaxaca [City] . . . stayed there in Oaxaca [City] for about seven days, and it was the place in 1974 that all the people on the Gringo Trail said was a good destination, that Oaxaca [City] was real peaceful and mellow.[7]

Ross's adventure on the "Gringo Trail" was full of misdirection, miscommunication, and what appeared to him to be a chance of ending up in a Mexican jail. Having mistakenly gone to the other Teotitlán—Teotitlán del Camino (now Teotitlán de Florez Magon), in the northern mountains of Oaxaca near the border with Puebla—Ross took the long route to Oaxaca City in his quest to find the origin of Zapotec textiles. His adventure continued as he made his way to the correct Teotitlán:

I found the Teotitlán bus and took the bumpy road out. It was like an hour-and-twenty-minute drive, and the bus would go from—leave the Pan-American highway up from Maquil [Macuilxochitl] on dirt roads and from Maquil and up the really bumpy road to Teotitlán. On the bus was a gringo, who I talked to briefly, and I went to his house; he was living in Teotitlán, and he was a good introduction to hear a little bit about the village.

I don't remember much of what I talked to him about . . . and I don't recall really too much about what the town looked like, because in these eighteen years the . . . visual transformation, it's been gradual but . . . a major transformation. But I do remember the two men I bought from that day, who are still some of my best friends, and some of the people who I buy a lot of rugs from, one of them is Antonio Ruiz and the other one's Ricardo Mendoza, and I remember the rugs I bought from them. What impressed me most about Antonio's rugs was that he had a big palette of colors, maybe fifteen colors in his Mitla patterns, with stripes of colors, and with an accent color bordering each stripe color, a little, little shadow color.[8] And it was one of the most pleasant things I'd ever seen in tapestry work.

Ross had become more animated and was leaning forward as he spoke.

I bought six rugs from him, and I bought two to four rugs from Ricardo Mendoza, and Antonio's rugs were a hundred pesos each [US$5.00 in 1974], and about eight dollars for Ricardo's work. His serape, five-by-six-foot serape with a fire god, was probably about twenty-two dollars.

I was real pleased with my selection, got back to the bus corner at five-thirty, and the last bus had already left to Oaxaca [City] so I walked back down to this gringo's house, laid out some boards, and we put the rugs down on the boards and covered . . . Antonio's rugs as a mattress and covered myself with Ricardo's blankets as my blanket. It was January, it was pretty cold, and, uh . . . I guess that was a pretty symbolic moment, to be stuck in Teotitlán my first time coming out. I didn't get back to Oaxaca until ten the next morning. It was a good experience.

But it is what Ross was able to do with just a few Zapotec textiles back in the United States that he really wanted to emphasize.

I just spent that one day in Teotitlán. I didn't return, and I hitchhiked back to Mexico City with ten rugs, and my gear, probably about sixty pounds, all wrapped up, and thought a lot about Teotitlán. I loved the rugs, and my first impression was that it was just a nice, quiet, pleasing little place . . . as I recall now. I didn't have anyone's address, or name, or not very many thoughts of returning, but when I got back to the States, I sold them pretty readily, on . . . uh, on a market, like a crafts market in front of the UC San Francisco med center. I just brought them up and hung them on the concrete, or the brick seats in the plaza, and people liked them, and I sold them for like twenty-five dollars.

Originally I was going to bring them back for a friend in Chico who had an import store, so I knew I had a market for what I brought back . . . um, but after carrying them back so far I decided to sell them myself for some money. I was going to sell them to my friend for what they cost me, but I decided that . . . I should try to sell them myself. So I traveled the whole month for . . . traveling expenses included . . . for three hundred dollars, including buying the ten rugs. I would say I lived pretty cheaply in motels for two dollars a night, back then. And selling the rugs sort of paid for the trip, so that started the economic wheels turning.

The experience that Ross described is not an unusual one. His unhappiness with a "normal" life and his quest for independence, travel, and a sense of accomplishment outside of workaday channels in the United States are expressed by others who resell Zapotec textiles in the U.S. Some of the other textile buyers report a satisfaction with working for themselves and, more importantly (or so it would seem), say they began their quest for independence on a whim, almost a lark. Many find it difficult to express the way in which they feel spiritually touched by these textiles. They also describe traveling through Mexico by bus, or sometimes hitchhiking, to get to Oaxaca and finally to Teotitlán, echoing the common description of Oaxaca as isolated and difficult to reach. Other common themes will emerge as well.

Brice McCoren is a very different sort of person from Ross. Physically he is older and heavier, with thinning, light-brown hair. He appears less calm and deliberate in his speech. Brice's words (delivered with a Southern accent) flow in short nervous bursts:

> I, uh, used to be an engineer. I don't have a degree but I'm one of those practical people who can do almost anything by hand. Fix things, you could say. And in 1975, um . . . I was in Florida, jus' workin' my butt off and . . . uh, took a leave of absence. Came down to drive a bus for my parents. Who, ah . . . my stepfather is a professor of languages in Iowa. And anyway, after a month or so in Mexico, I ran into a woman who had a *caseta* in, uh, San Miguel de Allende in northern Mexico and amongst all her things were lots of weavings. And . . . uh, something just like a light bulb went off—I had to know about weavings.
>
> I had a little bit of . . . uh, information supplied by my father 'cause he'd been to Oaxaca and he owned a few of the weavings but I hadn't really seen 'em, or I should say my stepfather, and we just talked about it. But once I saw them it was just something that I needed to know more about. And I took a bus from San Miguel de Allende down to . . . uh, Oaxaca City and went out to the village on a bus that took half a day to catch. In those days—again, this is '75—you'd ask which bus it was and they'd give you a color. Half the time that wasn't right so you'd be out there a long time, which was all a part of what Mexico was about. Slowin' things down . . . and, y'know, being a little more aware.
>
> So I get out to the village and had the name of one particular person . . . uh, Felipe Gonzalez, who lives in Teotitlán, which obviously is a three-thousand-year-old village inhabited by Zapotec Indians, and I just showed up at his house and mentioned who my stepfather was and there was kind of a grin on his face and a sparkle in his eye . . . uh . . . obviously he didn't know that I only had two hundred and eighty bucks, but back in those days that was a heck of a lot of money. The peso was twenty to one, and I ended up buying two cardboard boxes full of rugs and schleppin' them back to the States. The reason I bought the weavings was because . . . um, they talk to you in a way that . . . uh, at least now, seventeen years later, I can kind of relate to it easier. They talk to you in a way that's non-verbal. It's a feeling, it's kind of a texture.

Like Ross, Brice has trouble expressing what first drew him to Zapotec textiles. As he rather awkwardly expresses it, "they talk to you in a . . . nonverbal" way. Brice works his stepfather somewhat awkwardly into the story. His longish silences and sideways glances in the direction of our hostess when his stepfather periodically crops up in the story give me pause.

Our meeting has been arranged by a mutual acquaintance, and we sit in the beautifully decorated living room of her San Felipe del Agua hilltop home. San Felipe del Agua was once a separate town but is now a suburb of Oaxaca City where well-to-do Oaxacans and the wealthiest "snow-birds" from the United States (those who leave their cold homes in the North to winter in sunny, warm Oaxaca) maintain picturesque homes. Our hostess's home, with its thick adobe walls punctuated by scaling bougainvillea plants that artfully fling themselves over the red-tile roof, has a colonial-era feel, much like the gallery and gift shop in which Lynn Youngstrum gave her talk. As I wait for Brice to continue, I look around the room, taking notice of a David Siqueiros charcoal drawing hanging on the wall and silk *rebosos* (shawls) artfully flung for display over the backs of the room's two couches. Brice reminisces,

> It's getting into the village, and in those days it was all adobe and the fences were made outta cactus that bloomed and bougainvillea with five or six different colors, and, coming from Florida and Texas, I had a feeling as to what those things were but to see 'em in a, in a village in that setting and have the turkeys come out and attack you in their funny way is . . . uh, is something that is intrinsic. It's something natural. It's something that's pretty far removed from, I would say, the routine I'd been in. So things just opened and I . . . uh, got all these weavings just because I thought it was something neat to do.
>
> Uh, anyway, I spent my two hundred and eighty-five dollars. I spent the night sleeping on a bed of, y'know, probably . . . I dunno, four or five . . . I took the best weavings that were there and I threw 'em on the floor . . . y'know, like a mattress style, you might say, right in his [Felipe Gonzalez's] house. Right in the same room that he still has. He was one of the first people that had . . . uh, *ladrios,* or bricks, so he had a big room . . . had a window and everything in it. The room is still there. Same color. It's kind of a good feeling to visit him because it's good memories, as much as the village has changed. And . . . so, I bought all these weavings and stayed that night because I missed the bus. And subsequently . . . uh, he was a happy camper because I had bought everything he'd said . . . told me to buy. So that worked out pretty good. I mean, within a certain reason, because after you see some . . . when you first begin you kind of rely on other people and what's nice about the Zapotecs is their honesty . . . uh, of course you have to be honest to know that. But . . . uh, that makes sense to me.

Brice's narrative is striking in its similarity to Ross's. Both were stranded in Teotitlán and slept nestled in Zapotec textiles, both faced the challenge of finding the right bus, and both decided to begin the adventure without really

knowing much about what they were getting into. Lynn Youngstrum defined herself for her gallery audience in much the same way: as a self-taught expert on Mexican folk art, who got started in the business on a whim at the suggestion of a friend.[9] We see that the frame Ross and Brice have used to represent themselves in these interviews is pervasive.

Once Brice makes it back to the U.S. with his purchases, he finds, like Ross and Lynn, that the textiles practically sell themselves.

> So I brought 'em back to . . . uh, Delores Hidalgo, and was helping to drive the bus with the students with my parents back to the states . . . my first . . . uh, weavings I smuggled across the border . . . this was actually my father's idea but I'd agreed to it, so he would just . . . uh, hand 'em to the kids to, y'know, put 'em underneath the benches so it looked like they belonged to each of the students coming back, y'know, with gifts. And then we put 'em all back into the boxes and it was kind of fun, I mean, in a way. Y'know, illegal, but shoot, it wasn't . . . uh, I dunno, it's come a long way since those days. So, y'know, the trip took about three days, maybe four. It wasn't a real fast bus and I came back to Rockport, Texas, which is north . . . uh, of Houston, Corpus Cristi.
>
> They was having an art festival there that weekend. I came in on a Saturday morning . . . and I . . . I take my two boxes and walk up to the, to the . . . uh, art festival and I happened to pick the booth who was the, the famous artist Estelle Astair and . . . uh, asked if I could show these things, and I took 'em outta the box and I put 'em on the ground and she said, "Why, sure, I've sold all my art. You can have half my booth." Basically what happened after that is to me the excitement of what began this quest as a business . . . uh, you could say, in that I just went on a feeling and Sunday afternoon at sundown I'd sold every rug that I bought, y'know, a week before, I didn't have one rug left. And I had, I dunno, I guess $500 in my hand, which, it wasn't the money, it was just the level of . . . uh, the feeling of being able to have a hunch, backed up by a feeling, and then follow through with it and then have someone appreciate it as much as people obviously did. Of course I was selling 'em for probably, y'know, less than keystone [a standard markup], which means not even double my money. But that's because it was love. It was a feeling rather than a business, and . . . uh, not that it's changed that much, but it really hasn't. Even today, y'know . . . and I own thousands of rugs and sell tens of thousands of weavings in our country, America. Um, I still like the idea of giving people deals. And it's intrinsic, I think, from living so many years in Mexico and coming to Oaxaca. So that was the beginning.

I have been told by more than one weaver that Brice actually "inherited" his textile business from his stepfather (keeping the same contacts and relation-

ships with specific weavers that his stepfather had established). This probably helps to explain some of the inconsistencies and incongruities in the role played by his stepfather in his story (as well as his furtive glances in the direction of our hostess, who had known Brice and his family for a number of years), such as the slippage between a stepfather who is a Spanish teacher in Iowa and Brice's successfully dropping his stepfather's name in Teotitlán (he implies that his stepfather did business with Felipe Gonzalez).

Incongruities in others' narratives as well as Brice's, and the parallels between these narratives, point to the possibility that these textile buyers are working at representing themselves to others in very limited and prescribed ways. In other words, Brice did his best to constrain his story and make it fit within a certain frame, one that was both spiritual and picturesque.

That Brice felt it necessary to invent, or at least embellish, his past makes the story all the more interesting. We have no way of knowing whether or not Ross or Lynn, or any other U.S.-based textile buyer, did the same—although I heard a similar "origin story" (complete with the bus ride and sleeping between the textiles in Teotitlán) from one other buyer I interviewed. It does seem clear, however, that these professional textile buyers are trying to represent themselves to others in a storyline (or set of narratives) that is organized to appeal to the sensibilities of potential clients and others who might be interested in or close to the Zapotec textile business. After all, a down-to-earth, caring middleman with an artistic sensibility is more appealing than an opportunistic businessman who runs his business like a business, working to "buy cheap and sell dear."

These stories of adventure and individual initiative offer an interesting point of entry into the business of buying Zapotec textiles for markets in the U.S. What we find in them are images of Mexico as an Eden of productivity in wait, of its indigenous peoples as a domesticated and highly productive work force, and of their folk arts as an intrinsically valuable commodity whose legitimacy, character, and beauty are self-evident. In other words, for enterprising businesspeople like Ross, Brice, and Lynn, Mexico and the indigenous communities of southern Mexico are a promised land full of obedient and tirelessly productive workers waiting for the entrepreneur who is willing to take a gamble, travel through the countryside on a slow bus overloaded with peasants and farm animals, and sleep on dirt floors in the chilly night of the Mexican countryside. All that is required is that the buyer be able to "schlep" the textiles back to "civilization." Furthermore, as will be shown shortly, clients of these textile buyers can purchase a part of this beauty and character at, so the sales pitch goes, an incredibly low price. Just

as the guided tour to Teotitlán described in chapter 2 worked as an allegory for Mexico's own foundational myth of national cultural patrimony (locating the indigenous half of the *mestizo* nation in the countryside and the rural, indigenous population), the common themes of these narratives are an allegory for the United States' own foundational myth. They are personal narratives told on a mythic scale: stories of entrepreneurial spirit and American ingenuity, of imperial desire and manifest destiny, of triumphant individualism and having gone it alone.

Stories like these are easy to come by. They are a pervasive part of the discursive universe that surrounds Zapotec textiles. They are told to anthropologists, journalists, and prospective clients alike. We have seen how these sorts of images of Mexico's indigenous population inform how Mexico is imagined and, more importantly, how the rural population and the crafts they produce are infused with value by those who buy and sell those crafts. And these themes are also an important part of how professional folk art buyers from the U.S. represent themselves and their work to others.

While living in Teotitlán, I came into contact with several professional buyers who visited regularly to buy textiles. These professional buyers, who number fifteen or twenty at the most, purchase textiles in bulk in Teotitlán and sell them in the U.S. For the most part, they work independently and are frequently in direct competition with one another. However, they are not a uniform group. While some have been visiting and buying rugs for close to thirty years, like Ross and Brice, others (like Lynn) began their business in the mid-1980s or later, at the peak of a boom in the Zapotec textile market.

Many of them make buying trips to Oaxaca three or four times a year. During these trips, they visit their contacts in an attempt to get orders together, make arrangements for their shipment to the U.S., and place orders for textiles to be collected on their next visit. Some stay as long as a month at a time, while others stay only a day or two. While most, like Brice, stay in or near Oaxaca City during these trips, others, like Ross, prefer to stay with families in the village. Some visit only those owning shops on the main road into Teotitlán, where they can buy large quantities of textiles, while others work with as many as thirty to forty weaving families. Some of them speak Spanish fluently, while many have little more than a rudimentary vocabulary. They can generally be divided into two groups: those who resell the textiles wholesale, supplying retail establishments throughout the U.S., and those who act as direct buyers for, or in conjunction with, a single gallery or

specialty store that sells Native American and Third World arts and crafts. Many of these galleries and stores are located in the Southwestern U.S. and California.

Zapotec weavers are deeply ambivalent about these buyers. On the positive side, they are seen as a steady source of income and as powerful individuals who should be cultivated for the direct economic benefit of the household. Weavers know that these professional buyers will pay higher prices than will business owners in Oaxaca City, for example. Likewise, they buy more textiles, more frequently, than even the most dedicated collector or enthusiastic tourist. They are also a good source of information about American tastes. Some in Teotitlán use the professional buyers' color and design preferences as a guide to what both professionals and tourists are likely to buy in the future.

On the negative side, weavers speculate that many of the professional buyers used the downturn of the U.S. economy in the early 1990s and the post-9/11 slowdown in world travel and tourism to their financial advantage. These downturns made weavers more dependent on professional textile buyers, and thus allowed the buyers to play one family against another in order to leverage lower prices. As a result, competition between families has intensified and the cohesiveness of the community, and even of extended families, has been jeopardized. Ironically, in many instances these professional buyers are unwittingly undermining the Native American "culture" and "family harmony" that they promote in their sales pitches and represent as timeless and immutable.

Many buyers are acutely aware that some of the people they work with in Teotitlán could export the textiles themselves, and as a result they fiercely guard their trade secrets. In Teotitlán they limit what the weavers and local merchants know about the U.S. market, including such information as how much a weaving sells for in a gallery, where such galleries are located, where ideas for new colors and designs come from, and, most importantly, who their current clients are.[10]

Although the professional U.S. buyers are diverse, the stories examined here indicate how they are united: they efficiently manipulate both their own images and those of the weavers and the weavings they produce. These stories imply that the Zapotec textiles do not sell themselves. The stories Ross and Brice told offer a glimpse into the massive cultural apparatus that is involved in establishing the "intrinsic" value of these textiles—what one might call their legitimacy as objects worthy of collection. In fact, a great

deal of work goes into selling them, and, as we have begun to see, into selling those who sell the textiles.

I am not arguing that those professional buyers from the U.S. who tell stories like the ones presented here are engaging in some sort of conspiracy in a calculated effort to dupe prospective clients. Some of them believe in what they do and, consequently, in the value and beauty of what they sell. At the same time, however, by juxtaposing what they say they do with what they actually do, by exposing the appropriations, purposeful vagaries, and inconsistencies of those who traffic in Zapotec weavings, simply by contextualizing them and making those activities interpretable, we are better prepared to understand Zapotec textiles as products of particular historical and cultural processes: not as ahistorical, essentialized objects that exist outside of time and social space, but as objects created through the daily and sometimes mundane activities of historically and culturally situated individuals. Reaching such an understanding is not an end unto itself or a way of exposing "frauds," but a way of exploring how those with an interest in Zapotec textiles work to construct an interpretive field in which textiles are made into significant cultural objects for consumption. I explore this topic through another story—the story of how one textile, Hearst #235 *Rojo Fuerte,* was created.

Hearst #235 *Rojo Fuerte*

In the American Southwest where Brice, Ross, and other importers sell Zapotec textiles, reaction to those textiles is largely, often vehemently, negative. This negative reaction is due to the fact that many of them are Zapotec reproductions of Navajo designs. Lynn Stephen writes that the 1980s saw a significant increase in the production of "Navajo designs," with textiles "bought by smaller-scale Mexican and U.S. distributors." In a recently published monograph about Navajo weaving, Kathy M'Closkey voices the concerns she and others have about this increase, describing the work of professional Zapotec textile buyers like Ross and Brice (and the weaving of the Zapotec) as "not just a pilfering of pretty designs . . . [but] theft of a way of life" and saying that it "threatens the destruction of activities vital to Navajo culture."[11] A closer, transnational look at the work of people like Ross and Brice will, however, problematize both M'Closkey's and Stephen's interpretations. Following the creation of one such "Navajo knockoff" textile through the multiple sites where it was conceived and created will show that M'Closkey ignores the deleterious effects on the working lives of Zapotec

weavers that their dependence upon, and work for, businesspeople like Ross and Brice can have. Simultaneously, it will become apparent that Stephen's statement that "distributors" like Ross and Brice "bought" textiles glosses over the complexity of who makes such textiles as well as where they, in their totality, are made.

M'Closkey focuses on the website of a single business in Santa Fe, New Mexico, where reproductions of Navajo textiles are sold. She finds the sales pitch offered to the public by this business, Santa Fe Interiors, to be emblematic of the "sophisticated" advertising used to dupe unsuspecting clients. She describes how the owner of Santa Fe Interiors, Michael Wineland, works with Zapotec weavers to produce Navajo patterns from well-known collections using "prespun wool colored with dyes imported from Switzerland."[12] I purchased one such textile while in Teotitlán in 1992, and I later found its design identified as "Hearst #235 *Rojo Fuerte*" on Santa Fe Interiors' website. It is only fitting, then, that the people and places involved in the creation of this textile serve to problematize M'Closkey's and Stephen's accounts and interpretations of how such textiles are crafted as well as Ross's and Brice's characterizations of their work.

The textile I purchased in 1992 (hereafter Hearst #235) is now in the Ethnology Collection of the Natural History Museum of Los Angeles County's Department of Anthropology (accession code F.A.3828.2001-1). Surprisingly, an account of how this textile, with its Navajo pattern, was created does not begin in Teotitlán, or even with Michael Wineland's much-maligned business. Hearst #235 must be understood in relation to another textile, this one in the museum's William Randolph Hearst Collection, that has a nearly identical pattern (accession code A.5141.42-153).

That textile was purchased by Herman Schweizer for the Fred Harvey Company (a major retailer of Native American collectables affiliated with the Santa Fe Railway) in August 1929 and labeled with his item inventory number (A-922) and price code (B-43790).[13] It was subsequently purchased by the well-known publisher William Randolph Hearst, an avid collector who built a large collection of textiles from the American Southwest and Mexico, largely through purchases he made from Schweizer. The records that lay the foundation for the story of A.5141.42-153 and Hearst #235, then, have their roots in the American Southwest at the turn of the century, and are linked with the establishment of the Santa Fe Railway and the opening of the region to travelers from the eastern United States.

In the late 1800s, Frederick Harvey negotiated with the Santa Fe Railway to construct and manage restaurants and hotels on its Western routes. To

entice passengers from their railcars and into Harvey's hotels and restaurants, Schweizer built elaborate "living village" exhibitions, like those at World's Fairs. Under Schweizer's direction, the Indian Department (created in 1901) saw great success; passengers on the railway were a nearly captive audience for the mock villages, inhabited by Navajo weavers (and other Native Americans) who demonstrated their art in simulated "natural environments." On a trip to Chicago, Hearst saw a display of items owned by the Indian Department, and he wrote the Harvey Company expressing interest in purchasing some of them. Schweizer responded in 1905, beginning a nearly four-decade-long relationship through which Hearst purchased a large number of items, including Navajo and Southwestern Hispano (or "Rio Grande") textiles as well as Mexican serapes from Saltillo and Texcoco.[14]

Harvey Co. ledgers indicate that Schweizer purchased A.5141.42-153 in September 1929, from someone named C. E. Chavez, but no information about Chavez was recorded. Chavez may have been a weaver, collector, or merchant of some sort, as Schweizer purchased textiles from a variety of sources. He also bought textiles by the pound from reservation trading posts and had an especially close relationship with Lorenzo Hubbell, owner of the well-known Hubbell Trading Post in Ganado, Arizona. Additionally, he purchased entire collections at auction and from the executors of collectors' estates.

Nancy Blomberg attributes A.5141.42-153 to the late 1880s, noting that its cotton warp would have made it a less-than-ideal item for the serious collector. According to a 1907 letter Schweizer addressed to "All Concerned" and which was distributed to textile dealers, among others, such items were considered "practically worthless" by the Harvey Co. and a danger, no less, to the integrity and quality of the Navajo textile tradition.[15] Hearst's records do not indicate the date he purchased A.5141.42-153, but it is safe to assume that it was sometime before February 1942, when 221 pieces from his textile collection were donated to the Los Angeles Museum of Science, Art, and History, now the Natural History Museum of Los Angeles County.

From March 25 through July 31, 1988, Blomberg, an anthropology curator at the museum, displayed several Hearst textiles in an exhibit titled "Art From the Navajo Loom: The William Randolph Hearst Collection." That same year, in their design shop on Rodeo Drive in Beverly Hills, California, Michael Wineland and Bianca Dresner began to discuss creating a new line of textiles for their business.[16] Michael, like Brice and Ross, had been importing textiles from Oaxaca since the late 1970s and selling them throughout Southern California. He invited Bianca into the business in an attempt to

bring some creativity into what he hoped could become a textile design studio, and she did not disappoint. After learning of Blomberg's exhibit at the museum across town, Bianca pitched to Michael the idea of reproducing (with minor alterations) several of the textiles. The pair thumbed through Blomberg's *Navajo Textiles* and chose a handful of their favorite designs, marking the page numbers and discussing whether and how they might be altered for reproduction. The result was, according to Michael, one of his business's most successful "lines" of textiles—the "Hearst Series," which he described as "inspired" by the photos in Blomberg's book.

While Michael worked with Bianca in a shop on Rodeo Drive to design the textiles they would sell, he worked directly with people in Teotitlán to actually make them. He helped them dye yarn to the correct colors (he also initially paid for the yarn) and, on his behalf, they then distributed the dyed yarn and designs to weavers. In an effort to reduce the time he spent in Oaxaca, in the early 1990s Michael began working through an intermediary based in Oaxaca City who, in turn, worked with a number of families in Teotitlán. The yarn for the Hearst Series textiles was either spun in Teotitlán's mechanized yarn mill (from wool trucked to Oaxaca from the Mexican state of Puebla and elsewhere, an arrangement initiated the early 1980s when the mill was constructed)[17] or purchased from hand spinners in the nearby mountain community of Chichicapan, and was dyed with widely available commercially produced aniline dyes, which many in Teotitlán simply buy at corner stores.

Michael, Bianca, and, more recently, Michael's representative in Oaxaca City did not work directly with those actually weaving the textiles for the Hearst Series. The Zapotec weavers who made Santa Fe Interiors' Hearst Series textiles worked in their own homes for families in Teotitlán, who in turn worked for Michael's representative in Oaxaca City. These families supplied the weavers with dyed yarn and the required designs (often little more than black-and-white photocopies of the illustrations in *Navajo Textiles*, with handwritten notes indicating which color yarn was to be used in which sections of the design) and received the finished products, which might be no more than two or three copies of each design. They paid weavers per finished textile out of the "down payment" Michael's representative in Oaxaca City had made upon placing the order (yarn was often purchased from the mill in Teotitlán under the same arrangement). Early on, Michael made several trips per year to Oaxaca to ensure timely production. Later, this work was done by his representative in Oaxaca City, but he still tried to visit Teotitlán at least "once a year or so" until his business folded in 2005.

I bought Hearst #235 from one of the families in Teotitlán that dyed yarn and contracted Zapotec weavers for Santa Fe Interiors. By the time I made my purchase, four years after the Hearst line of textiles went into production, this family was also selling several of the Hearst Series designs directly to tourists. I knew that the design was based on a Navajo textile, and I purchased it as an example of the sort of textiles produced under what I have elsewhere characterized as transnational relations of post-Fordist production.[18] While conducting fieldwork in Santa Fe, New Mexico, in 1993, I visited Michael's business, where I noticed a very large (perhaps 6′ × 9′) version of this same textile—Hearst #235—hanging on display. More recently (in 2001) in Los Angeles, I learned of its connections to Blomberg's text and the 1988 exhibit of Hearst textiles when I spotted A.5141.42-153 in one of the museum's collection storage areas. A subsequent interview with Michael and visits to the Santa Fe Interiors website have provided further information about the circumstances surrounding the creation of Hearst #235.

The Hearst Series (one of Santa Fe Interiors' "Americana" lines of textiles) was one of Michael's most successful product lines. He described doing more than $1 million worth of business during his "best year" (2000), and said that his Hearst Series textiles had been used to decorate the homes of well-known Hollywood personalities. The website listed Goldie Hawn, Kurt Russell, and Gene Hackman as clients and allowed visitors to browse through textiles in several different product lines and purchase a textile online. The page devoted to the Hearst series described the textiles as the "most powerful of these now extinct designs," which Santa Fe Interiors had "reproduced . . . in the traditional fashion." On this page, I found the design I had purchased identified by the name "Hearst #235"; as it turns out, the textiles in the series were named for the page numbers from Blomberg's book that provided their design inspiration.[19]

The textiles were not described as Zapotec, and Zapotec weavers were not identified as those who made them, on that page of the website. Although many of the galleries and gift shops in the Santa Fe area emphasize the ethnicity of those making Zapotec textiles (presenting their products as an ethnic craft made by a remote Native American people living in a romantic pastoral past), Santa Fe Interiors framed its sales pitch with the notoriety of William Randolph Hearst: "William Randolph Hearst's collection . . . remains most admired in the world." Elsewhere on the website, the relationship between Santa Fe Interiors and the weavers was described as a "collaboration," but the actual community of Teotitlán was never mentioned by name (the weavers lived in an unnamed "small Zapotec Indian village").

Santa Fe Interiors was described as having a "production facility" where "churro wool" from the "mountains of Chiapas" was "washed, carded, hand-spun, and hand-dyed." The designs for the various product lines were described as having been inspired by other well-known collectors and by indigenous cultures from around the globe and "copyrighted" by Santa Fe Interiors. This was a sales strategy that Michael felt avoided many of the difficulties of selling Zapotec textiles (and Zapotec reproductions of Navajo textiles) as Native American craft or art items in the Santa Fe area. During a conversation in 2002, he noted with some amusement that Blomberg had "stormed into" his shop on Rodeo Drive and derided him for the products he and Bianca had developed.

Like Blomberg, M'Closkey apparently sees things somewhat differently than Michael. She quotes Michael's business's website as saying that "Wineland works closely with dozens of Zapotecans of Teotitlán del Valle who are 'reinterpreting long-forgotten nineteenth century Navajo designs.'"[20] Clearly, to describe the Zapotec as "reinterpreting" Navajo designs from William Randolph Hearst's collection is to grant a great deal more creative agency and control of production to the weavers than is warranted. Likewise, Stephen's referring to Michael and other business owners who have product lines manufactured by Zapotec weavers as "distributors" seems inaccurate, in the face of the actual relations among, and activities of, the various parties involved in creating "Navajo knockoffs."

M'Closkey sharply criticizes Stephen, not for having mischaracterized the role that Michael's Santa Fe Interiors and other businesses play in the creation of Navajo knockoffs, but for her "documentation and confirmation of this appropriation without critique." This failure to critique, M'Closkey says, "sanctions an activity that threatens Navajo lifeways."[21] A similar criticism could be leveled at M'Closkey's own documenting of how these activities threaten Zapotec lifeways—for example, by sanctioning their continued exploitation as a cheap, but highly skilled, "offshore" workforce—without also offering a critique that supports the position of Zapotec weavers.

The views expressed by M'Closkey and Blomberg serve this discussion as "sanction" and "critique" simultaneously. They do so by returning the discussion to the issue of the limits and structure of the transnational Zapotec weaving community—returning to a focus on one of the most central and "empirical" issues in this study: the limits of and divisions within the community of people crafting Zapotec textiles. I do so by reading M'Closkey's assertion that to not critique Zapotec appropriation of Navajo textile design is to (implicitly) sanction it as one claim among many about the definitions of

Navajo and Zapotec textiles. Hers is a call for Stephen and others, as Bourdieu would no doubt put it, to take a more explicit position in a struggle over definitions with several boundaries at stake.

Put somewhat differently, M'Closkey's and Blomberg's practices literally both require and produce the context of this ethnography—they are both figure and ground. That is, I wish to frame their practices in terms of how they make claims about membership in the Zapotec weaving community and, as a consequence, about the limits of this study's setting. Recall that the limits of the community of practice are in a continual state of flux as competing assertions about inclusion (or membership) struggle against one another, such that from one position certain practices will be legitimate, while from another they will not. M'Closkey, for her part, could not be clearer about where and by whom a textile that "looks Navajo" may be crafted. What is more, in arguing that Michael's creations are not legitimate works but "copies" of Navajo textiles, M'Closkey also argues that the textiles are not legitimately Zapotec. In short, they are not Navajo because they are not made by the Navajo, and they are not Zapotec because they are made to "look Navajo." From M'Closkey's perspective, in the work of Michael (and others like him) we have found and crossed the limits of the community of persons legitimately crafting Zapotec textiles (and, for that matter, Navajo textiles). In short, M'Closkey is explicitly constructing a boundary as she argues for certain definitions of the authenticity of the motifs featured on Zapotec textiles. She is asserting that Santa Fe Interiors' Hearst Americana series textiles were not legitimate Zapotec textiles and that Michael and those who worked for him were outside the community of people crafting "real" Zapotec textiles.[22]

Michael, on the other hand, was working to define legitimacy somewhat differently. For him (as expressed on the Santa Fe Interiors website and in interviews), the Hearst Series textiles were legitimate reproductions of a well-known collection of "antique" Navajo textiles. They were produced using highly skilled Zapotec labor and were not advertised as "Navajo textiles." At the same time, however, the Native American ("Indian") status of the Zapotec was a part of his sales pitch. Clearly, Michael's was a highly nuanced argument: these are not Navajo textiles, nor are they Zapotec textiles, but rather reproduction textiles created through a collaboration between his company and Zapotec weavers.

M'Closkey's concern that the unsuspecting public might be duped by the "sophisticated" marketing techniques employed on some websites where Native American textiles and Native American knockoff textiles (as well as

knockoff Native American textiles) are sold seems well placed. But the public is not undefended, as a multitude of experts and institutions have weighed in on how to separate the true from the false in Native American craft. We continue to explore the issue of legitimacy and to map the contested and shifting boundaries of the Zapotec weaving community through the practices of those experts and institutions.

The True and the False in the "Land of Enchantment"

From the 1940s through the early 1970s, an exhibit mounted by the Department of the Interior's Indian Arts and Crafts Board (IACB) called "Indian Handicrafts: The True and the False" traveled the United States as part of a widespread effort to promote the arts and crafts of "Indian people" and educate the public about the differences between "real" and "fake" Native American craft items. It featured several glass cases housing craft and art items, from silver jewelry to beadwork and ceramics to textiles. Each set of items was accompanied by a short, informative text describing those telltale signs indicating that an item was either real or fake, and the items were, in turn, labeled as "true" or "false." A pamphlet from the 1950s accompanying the exhibit describes the differences between "authentic" and "imitation" Indian products by summarizing that there is

> the authentic Indian made product, handcrafted or partially handcrafted, created with considerable technical skill and knowledge, and usually composed of native materials of intrinsic value . . . [and] an imitation or copy product, mass produced by machine or manufactured by cheap and relatively unskilled labor on a production line and generally constructed of poor or synthetic materials.

Not surprisingly, the history of the IACB and its predecessors is closely tied to some of the figures and institutions instrumental to crafting the Southwestern United States as an enchanted space.

Susan Meyn's "grassroots" history of the IACB, *More Than Curiosities,* finds that while it was formed as an official governmental body in 1935 in an effort to both promote and regulate commerce in Native American–crafted items, it took up the agenda of earlier organizations such as the New Mexican Association of Indian Affairs (NMAIA, now the Southwestern Association of Indian Affairs, SWAIA)—organizations with direct links to figures such as Mabel Dodge Luhan. In the early 1900s, Dodge Luhan was part of a

growing group of intellectuals and artists who had taken up residence in the Santa Fe area (including John Collier, later the director of the IACB) and who had been energized as a group in 1922 through their opposition to the Bursum Bill, which, had it passed Congress, would have severely undermined Pueblo Indian land and water rights. The group's interests were wide-ranging, and beginning in 1924 the NMAIA designed, built, and toured several exhibits that were to accompany "Indian bazaars" and that were intended to "stimulate a taste for and an appreciation of Indian Art."[23] The IACB's exhibits continued this strategy for educating the wider public in how to appreciate, and purchase, "true" Native American–crafted items.

The Act of Congress that founded the IACB in 1935 also established a number of guidelines for the sale of such items, created a "Board trademark" that would identify and authenticate Indian products, and promulgated penalties for selling both foreign and domestically made "counterfeit" items. Unfortunately, such distinctions could never be consistently applied, much less the penalties enforced, and in 1990, Congress passed the Indian Arts and Crafts Act in another attempt to curb "fraudulent sales." The discussion section of the 1990 act decried how "counterfeit" Indian arts and crafts items were "siphoning an estimated $40 to $80 million from the *genuine* manufacturers markets" on a yearly basis.[24]

The IACB's exhibit and the congressional legislation are only a few of a multitude of interventions on behalf of *true* Indians and *true* Indian arts and crafts. In Santa Fe, those seeking to purchase Native American arts or crafts have been, and continue to be, advised against purchasing "cheap," "machine-made," "Mexican souvenirs" masquerading as Native American items. Newspapers routinely feature articles and guides printed expressly for "Indian Market," a weekend-long event that brings nearly a hundred thousand visitors to Santa Fe annually, warning attendees against being duped by counterfeit Native American art. Articles and sections of books written about collecting Indian art are dedicated to helping spot these "fakes," and in 1998 the market's organizers offered a seminar to help shoppers identify items that "may have been produced not in the United States, but in the Philippines or Mexico."[25]

These interventions have a long history among academics and other experts on Native American material culture. In his 1914 classic on the history, aesthetics, and manufacture of Indian blankets, for example, pioneering expert and collector George Wharton James devoted an entire chapter to the problem of "imitation Navaho blankets." Regarding "Mexican" weavings, he wrote, "it must be remembered that some blankets . . . are made

by Mexicans, and it requires knowledge to differentiate between an Indian blanket and a Mexican blanket." In another book about collecting Native American art, another expert, Don Dedera, highlighted a number of ways to identify Mexican textiles:

> Rugs imported from Mexico in recent years, although done in designs sugges-tive of Navajo weaves, are light to the touch, because lanolin has been removed in cleaning . . . Imitations from Mexico, woven on horizontal looms operated mechanically, are looser of both warp and weft. Navajo edge warps usually are single, buttressed by edging cord. Mexican edge warps are multiple and gener-ally are not reinforced with edging cords.

These authors, like their successors today, seem not to have recognized that some of the Mexican textiles of which they wrote were made by Native Americans living in Mexico.[26]

There was, and is, also little public discussion of how the Navajo have borrowed extensively from both local New Mexican non–Native American textile traditions and from the indigenous and non-indigenous textile tradi-tions of current-day Mexico. Navajo weavers, for example, had exposure to and experimented with design elements common to the Saltillo-style serape of northern Mexico. Also, the influence of reservation trading post owners such as J. Lorenzo Hubbell and J. B. Moore, who introduced Navajo weavers to Oriental textile design at the turn of the century, has not gone unnoticed in works concerned with the history of Navajo textile production, even while such design motifs are widely regarded as "traditional." Navajo weav-ers were also heavily influenced by locally made Rio Grande–style textiles, produced by Hispano (or, following Chavez and his discussion of the myth of the Spanish Southwest, Mexican) weavers who self-identify as Spanish and live along the Rio Grande in southern Colorado and New Mexico. Both Santa Fe and Taos lie close to this river. In the American Southwest, then, different indigenous cultures have often influenced each other's weaving, as have indigenous and European cultures, even while such hybrid, mixed forms have preoccupied artists, anthropologists, and art patrons concerned about purity.[27]

In 1990, the Indian Arts and Crafts Act was reinvigorated and, according to some, given real teeth to enforce the federal laws laid out in 1935. Most significantly, Congress defined who was Indian and made it illegal to market as "Indian" any item made by someone who did not meet its very specific criteria:

1) The term "Indian" means any individual who is a member of an Indian tribe; or . . . is certified as an Indian artisan by an Indian tribe; 2) the terms "Indian product" and "product of a particular Indian tribe or Indian arts and crafts organization" has the meaning given such term in regulations which may be promulgated by the Secretary of the Interior; 3) the term "Indian tribe" means A. any Indian tribe, band, nation, Alaska Native village, or other organized group or community which is recognized as eligible for the special programs and services provided by the United States to Indians because of their status as Indians; B. any Indian group that has been formally recognized as an Indian tribe by a State legislature or by a State commission or similar organization legislatively vested with State tribal recognition authority; and 4) the term "Indian arts and crafts organization" means any legally established arts and crafts marketing organization composed of members of Indian tribes.

In spite of such stepped-up attempts to control what could be legally sold as Indian art, professional textile buyers like Ross, Brice, and Michael brought so many Zapotec textiles to market in the Land of Enchantment in the 1980s and '90s that Zapotec textiles became well recognized as one of the principal culprits in this widely lamented "invasion." In fact, in the spring of 2000, Congressional hearings marking the tenth anniversary of the 1990 Act were dominated by the testimony of experts expounding upon the threat this "onslaught" of fake, foreign-produced "Indian" arts and crafts posed to real Native Americans.

It should be noted, however, that not all concerned parties are equally pleased with the legislation that has been enacted to deal with this situation. The well-known author and Native American activist Ward Churchill recently complained that the "federal government . . . arrogated unto itself . . . the ultimate authority to determine who is/is not entitled to identify themselves as an American Indian . . . usurping and in fact criminalizing the self-determining prerogatives of indigenous peoples." Art historian Margaret Dubin noted that the IACB legislation could also be seen as "part of a larger effort to limit Native people's engagement with modernity by controlling the commodification of their goods" through a "primitivist discourse."[28]

In fact, there is every reason to believe that such legislation is a simple reflection of the cultural politics and social divisions already long at work in the Land of Enchantment. Put another way, in the American Southwest the lower value ascribed by tourists to "Mexican" blankets than to Navajo blankets parallels a well-described regional social hierarchy.

Focusing on Taos, New Mexico, and the development of the community's art colony, for example, researchers have argued that "Mexican" culture has

been viewed by the Anglo population as "dirty," "cheap," "shoddy," and "common," while local Indian culture has often been privileged, understood to be both "quaint" and "noble."[29] According to Sylvia Rodríguez, a tripartite social division—Anglo, Indian, "Mexican"—is based upon culturally defined notions of race and class. She traces Taos's development as an art colony and situates the artists' and tourists' fascination with the Indian as it has developed historically over the last century. Anglo artists began arriving in the region at the turn of the twentieth century for several reasons, including " 'spectacular' natural scenery" and "isolation and rusticity." Taos also "promised the quintessential frontier experience—vast desert-mountain spaces, wild but noble savages, and unlimited personal freedom."[30] Within this "fantastic" environment, a tripartite social division of labor developed early on in which Anglo artists painted, local Indians modeled for them, and those of "Mexican" descent worked as domestics in the homes of Anglo painters.

John Bodine coined the phrase "tri-ethnic trap" to describe the social position of the "Mexican" population of the Santa Fe–Taos area. Rodríguez, building upon his work, noted that in this trap, "Mexicans" are "conquered, dispossessed, dependent, ghettoized, and, above all, witness to the Indian's spiritual and moral elevation above themselves in Anglo eyes." This tripartite social division is a version of a well-documented pattern in which "Mexicans," as well as their cultural products (material and otherwise), are devalued and made to stand as a symbol of poverty. Similarly, "Mexican" immigration, of bodies and products, is framed in terms of a flood, onslaught, or invasion bringing poverty to the United States. John Chávez has written that "Mexicanness" has been so completely devalued that even long-established Mexican settler populations in the Southwestern United States prefer to emphasize their fictitious Castilian or colonial Spanish "blood" and "culture" as a means of accommodating a set of images first developed by Anglo travel writers in the 1880s—a set of images he calls the "myth of the Spanish Southwest."[31]

Within this regional social hierarchy, Zapotec textiles are frequently framed (and now, through the force of federal law, legally defined and labeled) as "Mexican" textiles (and not indigenous or Indian). This practice carries a number of implications for their value in Santa Fe's social hierarchy: it makes them "foreign" and, by logical extension, their appearance in large numbers in the Santa Fe art market an invasion.[32] Within the Land of Enchantment, then, certain populations and their art are made out to be permanent foreigners, and therefore interlopers, in one of the more lucrative parts of the region's economy—the Native American or "Indian" art market.

This is the heart of the market for indigenous arts and crafts in the United States, and it is here that professional textile dealers like Ross and Brice strive to sell Zapotec textiles.

Ross and Brice, Sellers of Zapotec Textiles

How is it that professional textile dealers sell Zapotec Indians producing Navajo designs to tourists vacationing in the American Southwest when all Zapotec textiles must carry a sewn-on label that says MADE IN MEXICO? To avoid, or at least draw attention away from, the negative "Mexican" label (which was not required before the 1990 legislation), they emphasize the "Indianness" and "primitive" culture of the "Zapotec Indians" while obscuring the fact that these particular Indians live in Mexico. Buyers and sellers of Zapotec textiles, like Ross and Brice, work to "educate" the public about the Zapotec and their history as weavers through their sales pitches, elaborate tags, and informational handouts, placards, and displays, while at the same time they do not go out of their way to remind the public that the Zapotec live in Mexico.

Some of the galleries and professional buyers doing business in the Santa Fe–Taos area make a greater effort to do justice to Zapotec history and culture, and others simply do what they can to make Zapotec textiles appear to be Navajo. For example, tags and signs often identify weavings from Teotitlán and other nearby communities in ways that emphasize Zapotec ethnicity and downplay Mexican nationality. Professional textile buyers and gallery owners appeal to and shape tourists' images of the lone craftsman or lone Native American weaver, the family, the production process, and the textiles while drawing attention away from the fact that the weavings come from Mexico. In fact, the communities in Oaxaca where Zapotec textiles are woven (like Teotitlán) are sometimes not named at all in promotional materials, and in some instances, a phonetic spelling of Teotitlán's name in Zapotec is offered instead. The tag attached to the rug itself may name the weaver as well as the design (names often invented by the professional buyer) and state that the rug is 100 percent wool and dyed with natural vegetable dyes (which it frequently is not). The information provided helps to suggest a personal relationship between the consumer, the rug, and, by extension, the native craftsman who "lovingly wove it."

In some instances, informational handouts may be included in the display of the rugs. One such handout, offered by a Santa Fe gallery, informed viewers,

The Zapotec Indians of Zsá Yéah are Native Americans for whom weaving is an outlet for artistic expression which provides a sense of individual pride. What's more, in Zsá Yéah weaving is intimately tied to the family unit, where everyone participates in the production process . . . Finally, the quality of these hand-crafted textiles is testimony to the Zapotec Indians' traditional culture and family cohesion and serves as a reminder of the level of skill possessed by mas-ter craftsmen—a level that has by-and-large been lost to the steady march of "progress" in the United States today.

Such "educational" handouts and elaborate labels, with their emphasis on "tradition," "craftsmanship," "culture," "family," and "Native Americans," re-inforce our images of Indianness in general—images that have been success-fully manipulated in the marketing of arts and crafts in the past.[33] Even more importantly, they do so without locating the Zapotec in Mexico.

When one enters a gallery in Santa Fe, then, the widely described South-western regional tripartite social hierarchy structures the presentation of and the value ascribed to the textiles on display. Many of the more upscale galleries will not sell textiles made in Mexico (that is, by "Mexicans"), while those businesses that do tend to market them as a more affordable alternative to a Navajo textile. In these galleries, local indigenous textiles (primarily Navajo) are displayed on one side of the gallery while Zapotec textiles are displayed on the other side. Local indigenous textiles are hung in windows and displayed in well-lit prominent locations to attract customers, while textiles made by Zapotec Native Americans living in Mexico are frequently found folded in piles in the back, in the basement, or on the second floor, spaces often allocated to sale items or associated with low prices (as in the phrase "bargain basement"). That is, Zapotec textiles are, by and large, mar-keted not as worthy of purchase in their own right, on an equal footing with other Native American art, but as a cheaper substitute for the "real thing."

As they sell Zapotec textiles in the Land of Enchantment, then, Ross, Brice, Michael, and a handful of other businesspeople run headlong into the Southwestern Native American art market's own version of authenticity. As this discussion has moved through the cultural spaces in which that authen-ticity (and the exclusion of Zapotec textiles) is constructed, examining how professional buyers and sellers of Zapotec textiles have accommodated that construction, it has also explored the contestations of the field of Zapotec textile production. The history and present state of those contestations serve to mark the shifting limits or boundaries of the Zapotec weaving commu-nity. In those cultural spaces, where some accept the authenticity of Zapotec

Indians producing Navajo designs to tourists vacationing in the American Southwest while others do not, this ethnography encounters the limits of the community under study.

Building upon the work of a number of scholars who describe the American Southwest as a "region" that is at the same time a discursive construction built around a romantic fascination with the area's indigenous population (in Lawrence's words, the "playground of the White American"), this chapter has examined the position of Zapotec textiles in this cultural space. Michael Riley writes that the notion of the Southwest propounded by these scholars is defined through discourse, while my approach here and elsewhere is to define through practice.[34] That definition by practice works through a host of micro-contestations of what can and cannot legitimately be considered "Indian art" that are instantiated through a host of cultural practices (e.g., the testimony of experts in congressional hearings) that, in turn, help to define the community of people who create Indian art (e.g., through congressional legislation). The social structure of this community is conceived in terms of a field of positions marked out in conflicts over definitions: of what counts as an Indian art object, and of who counts as a Native American artist.

It is worthwhile to bear in mind that all such assertions (the practices of those who inform the attitudes expressed in museums, galleries, and texts— including this one—which in turn inform government policy and commercial enterprise) are a part of the practices (discursive and otherwise) shaping that cultural logic. They work to craft practiced spaces where the conditions for legitimacy are contested and, to a greater or lesser extent, are set for those who, lacking a literary or educational pedigree ("cultural capital," in Bourdieu's framework), have to make their livelihood in a contentious social world where their assertions carry little weight. No Zapotec weaver, nor even anyone familiar with how Zapotec textiles are made, has ever testified in congressional hearings related to the Indian Arts and Crafts Act. Those who work to exclude the Zapotec from legitimate participation simultaneously help to create the cultural space and standards in and through which the "authenticity," the "truth" or "falsity," of Native American art is defined.

Moving between Oaxaca and the American Southwest, this discussion has moved from the cultural spaces where those who craft authentic Zapotec textiles work (the spaces MADE IN MEXICO) to those where authentic Native American art is crafted in the United States (the Land of Enchantment). Attending to where the cultural space MADE IN MEXICO bumps into the Land of Enchantment brings this community study to a kind of border—that space of flux where shifting assertions about inclusion (or

membership) struggle against one another. Were space to permit it, this ethnography might take the discussion to a number of similar spaces of flux and competing assertions about the legitimacy of Zapotec textiles. Given the trajectory of this discussion, however, it is more appropriate to explore only one other space before taking stock of where this ethnography has been and then moving on to examine how Zapotec weavers are, in turn, MADE IN MEXICO.

Seenau Galvain/Sigue la Vida (the title means "life goes on" in Zapotec and Spanish) is a documentary video made by Sarapes, Arte y Tradición ("Sarapes, Art, and Tradition"), a Zapotec weavers' cooperative, describing how textiles are made in Teotitlán, and, for a variety of reasons, it reveals a great deal about the Zapotec weaving community. It might be described as a self-conceived, self-videotaped, and self-produced product of Zapotec weavers from Teotitlán. Yet this description leaves a great deal unsaid about the actual practices and subjects involved in the video's creation. Like Zapotec textiles, the video is the product of an international set of actors working in a transnational network of places to produce what has come to be called "indigenous video." Juan Jose García, a central figure in Mexico's indigenous video movement, recently stated in an interview in *American Anthropologist* (the flagship journal for anthropologists in the United States) that the movement's goal was to "provide native organizations with video equipment and training so they could represent indigenous realities from their own perspective."[1] How, where, and when I first viewed the video (as well as met or heard about those involved in making it) will reveal how its subject matter and production serve as a catalyst for pulling together the divergent ethnographic material presented in chapters 1, 2, and 3.

The Making of *Seenau Galvain* and the Zapotec Industry

In July 2001, I met an anthropologist colleague at a small diner in Oaxaca City, so that she could introduce me to Laurel Smith, a graduate student who was trying to get in touch with some Zapotec weavers for a dissertation project examining the cultural geographies enabling and embodying indigenous video production. The meeting went well, and I introduced Smith to some weavers and their work; she in turn introduced me to the network of people involved in making indigenous

video in Oaxaca. I first watched *Seenau Galvain* and met Juan José García a few days later, in Laurel's apartment on the outskirts of Oaxaca City.

During our conversation, Juan José described how he had been contacted by a weaver from Teotitlán named Fausto Contreras, one of the principal figures in Sarapes, Arte y Tradición, which wanted to make a video about Zapotec textiles and the cooperative's own work.[2] The video that Fausto and the members of the cooperative produced, with Juan José's help, orients the viewer to Teotitlán and the "tradition" of textile production. Narrated in Zapotec by Fausto, with subtitles in Spanish, it tells the story of how commercialized production techniques (by implication, Teotitlán's mechanized yarn mill and the use of commercially produced aniline dyes) have encroached on the weaving tradition, and the efforts of the cooperative's members to "maintain" their "traditional" practices.

The use of cochineal as a natural dye figures prominently in the video. In fact, the video presents the making of Zapotec textiles much as do the weaving demonstrations described in chapter 2. It includes scenes of carding and spinning, an elderly woman grinding cochineal into powder using a *mano* (grinding stone) and *metate* (muller), Fausto and others weaving, and Fausto dyeing wool yarn with cochineal in a large vat. Fausto hoists the yarn out of the boiling water as he describes the added work and expense of using cochineal to dye wool.

Overall, the video emphasizes that many weavers in Teotitlán have given up the use of handspun wool and natural dyes, but that the weavers in the Sarapes co-op are committed to preserving these "traditional techniques." Like Don Carlos and his family (described in chapter 2), the weavers in Sarapes (Fausto, his brothers, and their extended families) are represented as carrying on, and reviving interest in, practices that have been abandoned by most of their fellow weavers. According to an elderly Zapotec gentleman at the close of the video, the Zapotec weave because it is their tradition and their livelihood. They weave, in short, "para que siga la vida" ("so that life goes on"). Members of Sarapes explain in monologues that working for intermediaries brings less money to weavers and that the co-op gives its members a way to sell directly to consumers.[3]

When Fausto contacted him, Juan José was employed by the Centro de Video Indígena Oaxaca (CVI, the Oaxacan Indigenous Video Center), which, in turn, was an offshoot of the Transferencia de Medios Audiovisuales a Comunidades y Organizaciones Indígenas project (TMA, Transfer of Audiovisual Media to Indigenous Communities and Organizations), which was run through the Instituto Nacional Indigenista (INI, National Indigenous In-

stitute). *Seenau Galvain* was made with the help of video producers trained through the TMA program, which had been founded in 1990 at the behest of Arturo Warman, an anthropologist and director of INI, as part of the social-welfare programming of Mexico's then-president, Salinas de Gotari. When I talked with Juan José in July 2001 about his involvement in *Seenau Galvain*, he had begun to organize Ojo de Agua Comunicación (Eye of Water Communication). By the spring of 2002, he was moving away from CVI projects and was devoting all of his efforts to Ojo de Agua. Those affiliated with Ojo de Agua worked closely with both Juan José and Guillermo Monteforte, a Canadian documentarian and long-term resident of Mexico. Monteforte had founded the CVI in 1994 after becoming disillusioned with the INI's TMA program, of which he was also a founding member. Several of the videos made in the CVI/Ojo de Agua period (roughly 1994–present) have seen critical success.[4]

Fausto, his brothers, and their extended families were desperate to gain access to the international market for Zapotec textiles, which was largely controlled by textile buyers from the United States. Fausto had hoped that the video would act as a catalyst (and sales pitch), bringing some recognition (and increased sales) to the members of his co-op. In August 2001, when we spoke again, he felt that the video had not been very successful, and the co-op had been largely abandoned by its members. Although his wife, his brothers' wives, their sisters, and their families had organized a women's co-op that was seeing limited success, Fausto was still struggling to gain access to the most lucrative markets for Zapotec textiles.

Let's briefly consider the people, places, and institutions associated with the production and circulation of this video, which might be glossed as an indigenous account of their weaving craft. First the people: Fausto Contreras, his brothers, their extended families, and the textile buyers from the United States—like Brice McCoren, Ross Scottsdale, and Michael Wineland—whose control of the market the members of Sarapes were trying to circumvent.[5] Juan José and Guillermo Monteforte provided equipment and know-how to Fausto and the other members of Sarapes, and Guillermo and the anthropologist Arturo Warman also brought institutional support to the project. Those institutions included INI and its TMA program, the CVI, and Juan José's Ojo de Agua; they also had links to the Mexican national government and its long-standing post-revolutionary interest in promoting the links between indigenous Mexico and Mexican cultural patrimony. Beyond Mexico, there are the international institutions, from NGOs to the Smithsonian Institution, film festivals, and the other "universities, community

groups, and museums across the Americas" where both the films themselves and workshops about the films and their makers reach the broadest possible audience.[6]

Erica Cusi Wortham correctly points out that, like the crafting of indigenous identities, crafting videos like *Seenau Galvain* is an "entangled social process situated at the complex juncture of state-indigenous relations." At the same time, the people, institutions, and places associated with making *Seenau Galvain* highlight the presence of international commerce, NGOs, museums, the discipline of anthropology, and the Sarapes co-op at that juncture. Jeff Himpele, an ethnographer and documentary film producer whose research has focused on indigenous video centers, puts it somewhat differently: Ojo de Agua is representative of the "nodes of widely dispersed and mobile networks of collaboration" of those crafting such films.[7] Wortham and Himpele (and Laurel Smith) focus on the intersection of practice (in this case, video making) and the social spaces brought into being through that practice (institutions like Ojo de Agua). They describe a group of people who are created as a group in their engagement with indigenous video production—a community of practice whose members craft indigenous video. Similarly, the first half of this ethnography has focused on the intersection of textile-making practices and the spaces they bring into being, exploring the dispersed and mobile network of people, an entire industry of people, collaborating in the making of Zapotec textiles.

Theodor Adorno's notion of the "culture industry" will serve us here as we take stock of where this ethnography has gone. According to Adorno, the phrase "culture industry" allows us to distinguish "a culture that arises spontaneously from the masses" from cultural products that are, in some sense, "tailored for consumption by masses." He warns that the term "industry" "is not to be taken too literally," that he uses it to emphasize the "standardization of the thing itself . . . [and] the rationalization of distribution techniques, but not strictly . . . the production process." Hence the phrase "culture industry" points to, and emphasizes, the ways that cultural products are tailored to meet the consumptive desires of a broad public, and suggests that such a process might be fruitfully thought of as an industry because the product is standardized in its widest material and symbolic sense.[8]

As we explored the narrative strategies used to describe and understand the lives of Zapotec weavers and the product of their labor that have been developed in, for example, travel literature, we glimpsed a part of that standardization in the tailored set of images and descriptive frames em-

ployed by Lynn Youngstrum and others. We traced the historical development of images and descriptions of Teotitlán, the people who live there, and the textiles that they make from travel literature, through journalistic accounts (including those of the *National Geographic*), and, finally, on Internet web pages, and noted that these images and descriptions stress the "preindustrial" nature of indigenous Mexican artisans. Borrowing from Pratt's notion of the "anti-conquest" trope, we analyzed the ways that those who market and sell Zapotec textiles also write themselves out of their accounts—something we termed the "anti-commerce" trope. Finally, borrowing also from Pratt's insights about native autoethnographic accounts, we examined how Zapotec weavers write their thoroughly modern (and, for many, international) lives out of their own Internet accounts of Zapotec weaving.

The video account of Zapotec weaving narrated by Fausto is also tailored to work within the anti-commerce trope that structures such autoethnographic online accounts. For example, when speaking about the use of cochineal, Fausto does not mention its recent uses in high-end tapestries inspired by nineteenth-century serapes from Saltillo in northern Mexico, but rather focuses on its past use to make women's wrap-around dresses. Like Lynn Youngstrum's descriptive denial of her presence in Teotitlán, Fausto's autoethnographic account, tailored to work within a standardized way of talking about Zapotec textiles and weavers, cannot accommodate his own uses of cochineal.

Chapter 2 took this ethnography literally on tour to Teotitlán and its environs. That discussion continued our exploration of and emphasis on the pervasiveness of the tailored images introduced in the previous chapter, as well as their use in a country/city trope figuring the Mexican countryside as the past to urban Mexico's present. For Mexican nationals, such tours are an allegory for Mexico's own foundational myth of national cultural patrimony, locating the indigenous half of the *mestizo* nation in the countryside and the rural, indigenous population. That chapter also focused on Zapotec use and knowledge of cochineal. Cochineal is the bug in the rug and, as we saw, the source of ambivalence about the control Zapotec weavers exert over "secret" knowledge of how to cultivate and effectively use this highly valued resource. It should come as no surprise that the same tailored and standardized narrative about cochineal, its preparation, and its expense is emphasized in Fausto's video.

Of equal interest are those aspects of *Seenau Galvain* that are left unemphasized in Fausto's narrative. I refer here to images and practices that

appear in passing on the screen but about which nothing is said. For example, the opening scene of the video features the same elderly gentleman whose words provide its title: "para que siga la vida." He is shown at work on the loom, first tightening the ratchets holding the textile taut, then weaving, and finally brushing off its surface, at which point the viewer can catch a glimpse of the design it features—a Navajo Yei figure. Chapter 3 explored how, when Zapotec textiles are sold in the American Southwest (and a very large number of them are), they run headlong into the Southwestern Native American art market's own construction of authenticity. Those institutions and people whose work defines "authentic" and "counterfeit" or "fake" Native American items in the United States (such as the Bureau of Indian Affairs' Arts and Crafts Board and Kathy M'Closkey, to pick just two examples) would no doubt find it perplexing that the video opens with a Zapotec weaver reproducing a Navajo design. They do not, by and large, grant legitimacy to such work.

Chapter 3 used D. H. Lawrence's phrase "Land of Enchantment" to refer to the cultural spaces in which authenticity in the Santa Fe Native American art market (and the exclusion of Zapotec textiles) is constructed. This discursive approach allowed us to move beyond the idea that Southwestern culture and cultural politics are coterminous with the literal regional geographic entity of the Southwest. The chapter explored the ethnographic material through the life stories of those who make a living buying Zapotec textiles in Oaxaca and selling them in Santa Fe. It juxtaposed their work in Oaxaca to their accommodations of the discursive construction of authenticity in Santa Fe in order to sell Zapotec textiles as "Native American." In a continuation of the anti-commerce trope introduced in chapter 1, they write themselves out of the accounts of Zapotec textile production they offer to their prospective clients in Santa Fe. The very different versions of what makes an "Indian" textile "authentic" are highlighted by moving between Oaxaca and the American Southwest, attesting to the contested, fragmentary, partial, and in-process nature of the spaces created in the practices of those making such assertions.

Following what is said about Zapotec textiles to the limits of the social spaces where their "authenticity" is agreed upon took this ethnography to the limits of the Zapotec weaving community in which Zapotec weavers learn their craft. To this point, this ethnography has cut a swath through the community of people who craft Zapotec textiles and weavers and has examined how the stories told and images put forth concerning who and what are legitimately Zapotec compete with one another.

Stories like the ones retold in these first three chapters do not live only in the books we own, the tour guides we travel with, and the ethnic art galleries we frequent. Nor are the lives of Zapotec weavers beyond their influence. In all of these stories we have glimpsed Zapotec weavers and weavings. Not only are they the focal point of these stories, but Zapotec weavers were there in the gallery in Oaxaca City for Lynn Youngstrum's lecture, both in the audience and "at the loom." They were in the tour, talking about and demonstrating weaving and selling textiles to the tourists. They are also, from time to time, brought to ethnic art shops in the Santa Fe area to weave on the showroom floor, and, like Fausto Contreras, they may narrate stories that help to shape what counts as authentically Zapotec.

In the chapters that follow, we will see that versions of these stories meet and compete in the workshops and, indeed, at the looms of Zapotec weavers. We have examined how they sometimes complement and at other times struggle with one another's definitions of representation and legitimacy. We have also seen how they come to the villages with professional buyers and tourists, as a kind of cultural baggage, and shape and inform the ways those visitors understand what they see and do while there. Part 2 focuses on the ways such stories work on the lives and weaving practices of the Zapotec.

The Field of Zapotec Textile Production

In *The Field of Cultural Production,* Bourdieu frames his analysis of artistic and literary production in France in terms of competing interests in the struggle to define the artistic and literary work—the social creation of art and literature in France. He identifies the dominant struggle as being over the power to "impose" the "definition of the writer . . . or to put it another way, it is the monopoly of the power to consecrate producers or products." The relation among those who compete to define writers, and consequently what they produce as art, constitutes the "field of cultural production." As the editor of the volume wrote, Bourdieu's analysis of French artistic production is in essence an account of the origin and maintenance of the "multiple mediators which contribute to the works' meaning and sustain the universe of belief which is the cultural field."[9]

Bourdieu finds that in the case of French literary and artistic production, the specific economy of the cultural field is based upon a logic and hierarchy that legitimizes non-economization. He demonstrates how those with a stake in this field of cultural production (e.g., artists, galleries, publishing houses, and academics, as well as various segments of the public) struggle to

define the artist and art. Bourdieu explores how art, the artists, and art's meaning and worth are all permeated with a particular logic of value as a result.

In its most basic form, the field of Zapotec textile production is a sometimes agreed-upon, and at other times contested, social universe (a community of practice) with a resulting social structure made meaningful and distinguishable through principles (or logics) of distinction and hierarchization. In part 1 we have explored several social spaces where the discursive frame working to give shape and meaning to Zapotec textiles informs practice. We saw that specific ideas about the character of indigenous culture (which are to no small degree the creation of anthropologists) have developed since the Mexican revolution and shape the marketing and consumption of Zapotec textiles in a wide variety of circumstances. Those ideas coalesce around the notion that indigenous artisans are the living remnants of the pre-Hispanic civilizations of the area we now call Mexico.

We also saw that the material items, including textiles, produced by Mexico's indigenous artisans are made meaningful and ascribed value (or given legitimacy) through a similar logic. Like those who produce them, these items are thought of as existing outside the march of history, produced in self-sufficient rural communities that are cut off from the modern world and its influence. But these items are made "unadulterated" and "legitimate" through the work of a large and highly dispersed group of participants.

In sum, the field of Zapotec textile production is composed of the totality of the relations among the positions occupied by those who are at work creating Zapotec textiles in both their material and symbolic aspects. It is, to borrow from Bourdieu's analogy of a game, a playing field composed of the relations among those vying for legitimacy and competing with one another to define the terms of legitimacy for the "sport" of consecrating Zapotec textiles and those who make them. The playing field itself (the field of cultural production) is at the same time the historical product of the multiple plays for legitimacy of the multiple agents implicated in this competition.

Further, this structure and the definitions of legitimacy that it consecrates are continually being re-created. Because of this, the topography of the field of Zapotec textile production is continually changing as a product of historical process. In this discussion we have explored how its basic topography is the historical product of Mexican cultural politics (especially the historical development of Mexican notions about pre-Hispanic Mexico's relation to the modern post-revolutionary nation), the uses to which the Mexican government has put indigenous material culture, the history of the

consumption of markers of Native American identity in the U.S. (especially the consumption of those markers in the Southwestern U.S.), and other factors. What remains is to demonstrate how that history informs the practices of those who make Zapotec textiles—to describe how Zapotec weavers come to embody the structural characteristics of the competitive sport of consecrating the producers of the products we call "Zapotec textiles." To that end, in part 2 we will see how stories like those examined in chapters 1, 2, and 3 are also "in the heads and hands," so to speak, of Zapotec weavers. The principles and historical contingencies that structure these stories also help structure Zapotec weavers' knowledge of and about weaving.

Prelude to Part 2

John and Jean Comaroff have written that a truly historically informed anthropology would be "dedicated to exploring the processes that make and transform particular worlds—processes that reciprocally shape subjects and contexts, that allow certain things to be said and done." They remind the reader that such an anthropology, focused as it would be upon the multiple practices through which "collective worlds" are created, would treat those worlds as "domains of contest . . . a confrontation of signs and practices along fault lines of power."[10] Part 1 of this study explored one such collective world—the Zapotec weaving community.

The field of Zapotec textile production maps out the symbolic regularities (the social structure, really) of this community that is responsible for creating Zapotec textiles as objects of desire. Learning to be a Zapotec weaver must, in turn, be understood as a process whereby weavers come to embody the structural logic of the field of Zapotec textile production—the logic through which we grant legitimacy to Zapotec textiles and weavers. As Lave and Wenger so aptly put it, "learning" is a process of "embodying, albeit in transformed ways, the structural characteristics of communities of practice."[11]

However, this is a general claim and therefore deserves the following caveat: the field of Zapotec textile production, as we have constructed it here, is not a uniform, monolithic framework that will stamp its structure on the minds and hands of Zapotec weavers. The field of Zapotec textile production is a representation of the symbolic structure of a community composed of the relations between the multiple positionings of the myriad of agents implicated in the material and symbolic creation of Zapotec textiles—including Zapotec weavers themselves.

Consequently, in constructing "learning to weave" as a process of embodying the structural principles of the field of Zapotec textile production from multiple positions in that field we must, in turn, refocus our analysis on the ways that those who are becoming weavers are granted legitimate peripheral participation in these legitimizing activities. In part 2 we will explore what this framework means to an analysis of the knowledge and skills of Zapotec weavers, investigating topics such as personal history, access to resources, and access to the social roles through which people are granted legitimate participation. In so doing, we will discover that understanding individual patterns of participation and the multiple positions in the field of Zapotec textile production that weavers hold over the course of their lives (their "career trajectories") is the key to understanding how the crafting of Zapotec textiles is, at the same time, the crafting of Zapotec weavers.

Bajo la piedra. The steeples of Teotitlán's church peek out above ancient ruins in the foreground, beneath the rocky crag locals call "brother rock." Teotitlán literally sits *bajo la piedra,* "under the stone," which is the meaning of its Zapotec name, *Xha gui.*

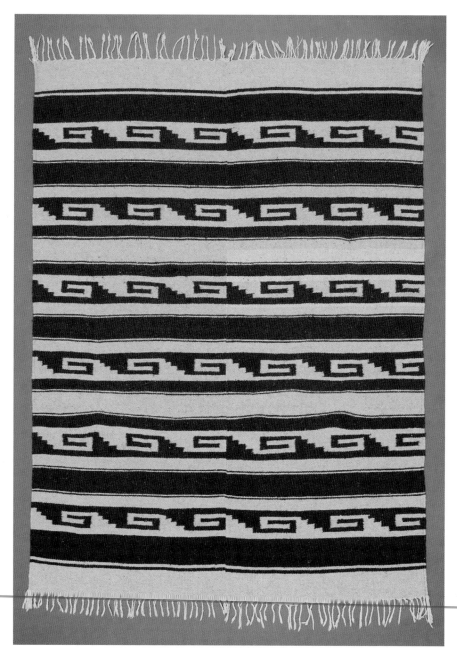

Zapotec *greca* textile. Zapotec weavers are perhaps best known for their *greca* or Greek key motif textiles, inspired by mosaic stonework at the nearby archaeological site of Mitla.

(NHMLAC item F.A.3828.2002-3; image courtesy of the NHMLAC Foundation)

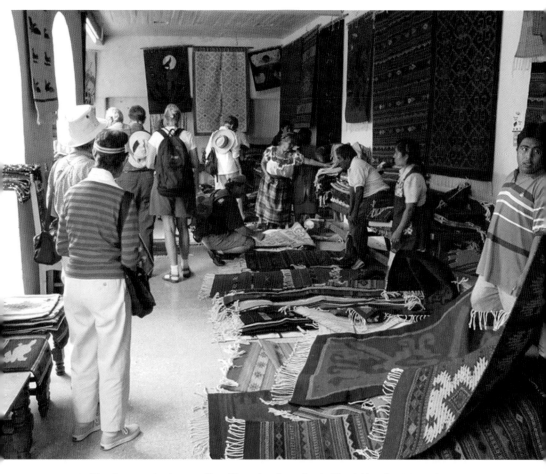

Tourists purchasing textiles. The sale of textiles in Teotitlán after a weaving demonstration can be hectic, as tourists sort through neatly folded piles of textiles, examining each one, and leaving their top choices in their wake with those hosting the demonstration.

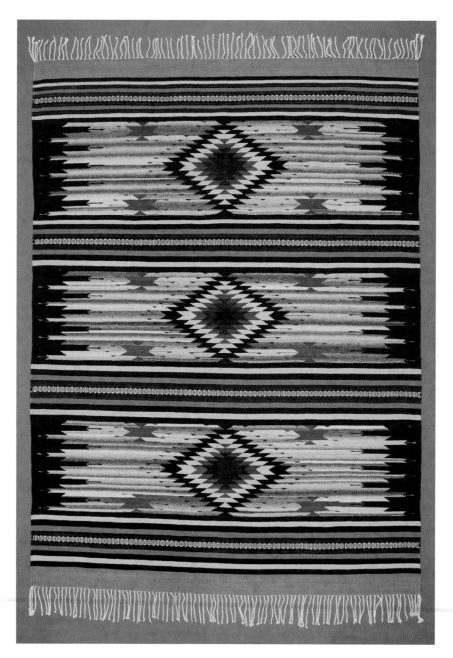

"Zapotec diamond" textile. Textiles featuring what has come to be called the "Zapotec diamond" motif, such as this one, were sold in large numbers throughout the 1980s and early '90s.

(NHMLAC item F.A.3828.2001-2; image courtesy of the NHMLAC Foundation)

The gallery lecture. A lecture on Zapotec textiles in the patio of a Oaxacan gallery, surrounded by thick adobe walls, elaborate ironwork, indigenous handcrafts, and other markers of Oaxaca's colonial and pre-Hispanic past, can have a lasting impression on tourists.

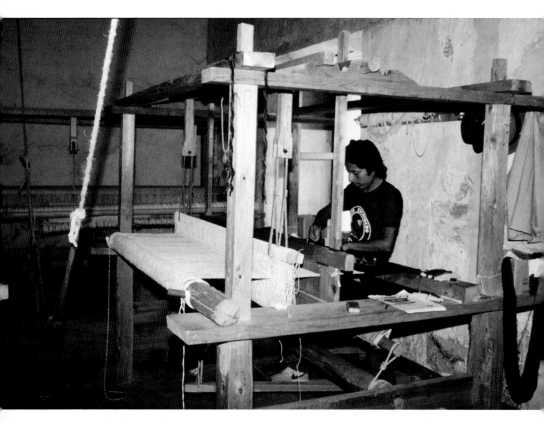

Zapotec weaver at work. Upstairs from the gallery lecture, a weaver from
Teotitlán works by natural light that enters the large room from windows set
in the thick adobe walls while, below, tourists stroll and shop along
"La Avenida Turistica."

Santa Fe–style *greca* textile. In the American Southwest, large numbers of Zapotec textiles featuring a "Santa Fe–style" soft or "pastel" color palette were sold in the 1980s.

(NHMLAC item F.P.4.2003-27; image courtesy of the NHMLAC Foundation)

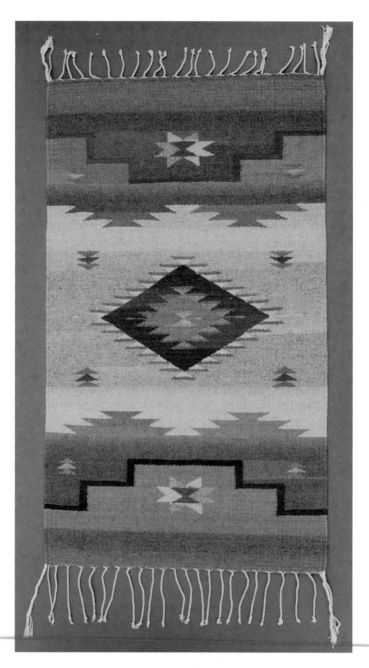

Zapotec Santa Fe–style textile. As textile buyers from the United States began to play a role in designing Zapotec textiles in the 1980s, the familiar layout of horizontal bands separating design fields with diamonds also changed to approach the Santa Fe style, as seen in this textile.

(NHMLAC item F.P.4.2003-30; image courtesy of the NHMLAC Foundation)

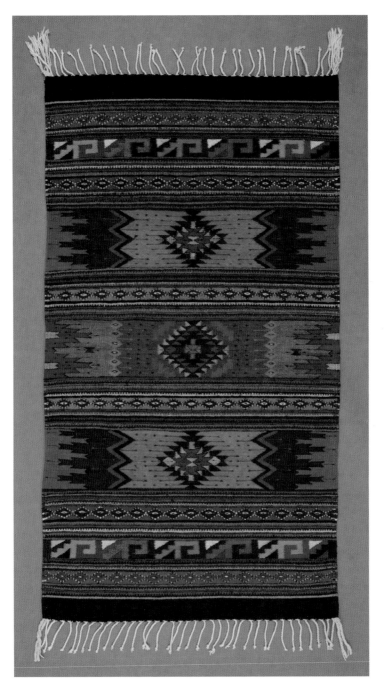

Late 1990s Zapotec textile. By the late 1990s, the pastel colors of
the Santa Fe style, so popular throughout the 1980s, were giving
way to a more intense color palette, as seen in this textile.
(NHMLAC item F.A.3828.2004-11; image courtesy of the NHMLAC Foundation)

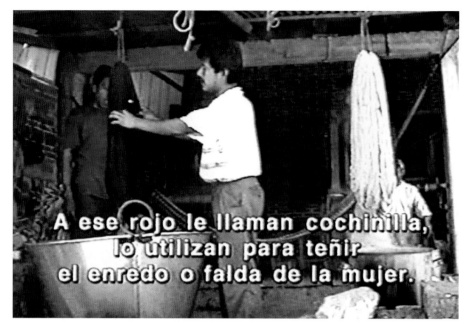

A ese rojo le llaman cochinilla,
lo utilizan para teñir
el enredo o falda de la mujer.

Dyeing with cochineal. Fausto Contreras narrates his own use of the cochineal insect to dye wool yarn for high-end textiles out of his cooperative's video. "This red is called cochineal; it is used to dye women's wraps or skirts." (Still-frame image courtesy of Sarapes, Arte y Tradición)

Touring the Oaxaca Valley. Coming out of the hustle and bustle of Oaxaca City and into the rolling hills and fields of the Valley of Oaxaca, whether traveling by taxi or tour bus, can seem like taking a trip back into Mexico's rural past.

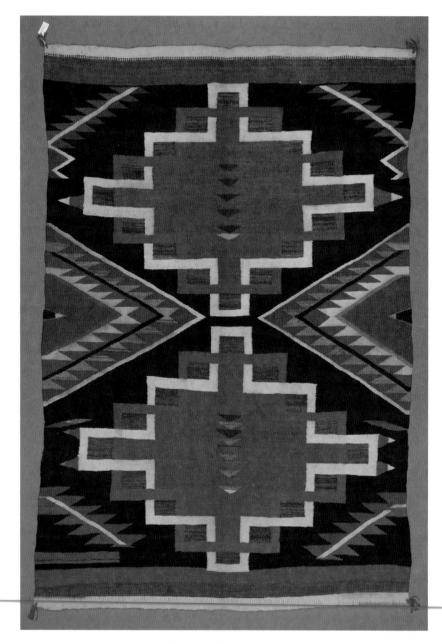

Navajo textile owned by William Randolph Hearst. This textile was purchased by newspaper magnate William Randolph Hearst in 1929 and donated to the Natural History Museum in 1942. It is featured on page 235 of the exhibit catalog, *Navajo Textiles: The William Randolph Hearst Collection*.

(NHMLAC item A.5141.42-153; image courtesy of the NHMLAC Foundation)

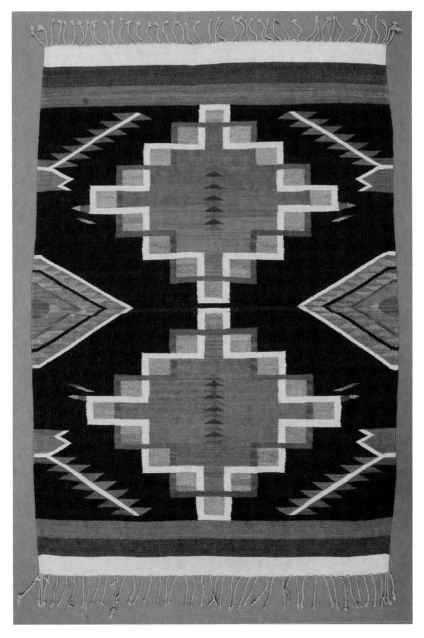

Hearst #235 *Rojo Fuerte*. I purchased this textile in 1993 from a Zapotec
weaver under contract to weave textiles (whose designs were taken directly
from the exhibit catalog for William Randolph Hearst's Navajo textile
collection) for a Santa Fe, New Mexico, gallery.

(NHMLAC item F.A.3828.2001-1; image courtesy of the NHMLAC Foundation)

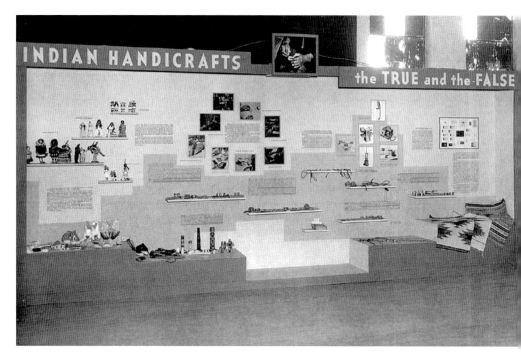

The true and the false. The 1958 exhibit "Indian Handicrafts, the True and the False," developed by the Indian Arts and Crafts Board, was part of an ongoing effort to educate the public about authenticity. Note the textiles in the lower right, two of which are labeled "true" and one of which (the rightmost one with fringe) is labeled "false."

(Image courtesy of the National Archives, photo no. 435-DB-29-1)

Textile inspired by a Saltillo serape. In the early 2000s, several of the more successful weavers in Teotitlán (including Jacobo Mendoza, who wove this textile) began to experiment with design elements common to nineteenth-century serapes from Saltillo in northern Mexico.

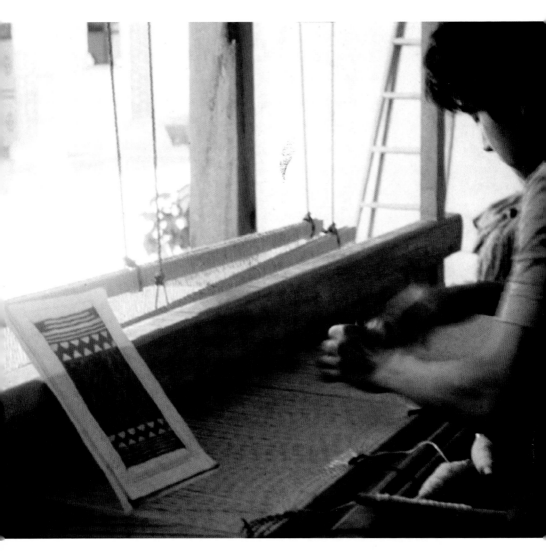

Another Zapotec weaver at work. On the shaded verandah of his parents' home in Teotitlán, a Zapotec weaver working for a professional buyer from the U.S. (in this case, a retail business owner from California) weaves a Navajo pattern. Note the color photocopy from a Navajo textile exhibit catalog on the left.

PART TWO

CRAFTING TEXTILES

AND WEAVERS

The history of the process of *the internalization of social speech* is also the history of the socialization of children's practical intellect.

—*Lev Vygotsky*

FOUR

The Zapotec Textile Production Complex

Cultural anthropologists have long focused on textile production in the indigenous communities of Oaxaca's Central Valley. Elsie Clews Parsons, for instance, began the fieldwork for her book *Mitla, Town of the Souls* in 1929, and the book makes occasional references to textile production in Teotitlán. Three decades later, Robert Taylor conducted fieldwork there for his 1960 dissertation entitled "Teotitlán del Valle: A Typical Mesoamerican Community." Taylor's work is largely descriptive, enumerating a number of "Mesoamerican cultural" criteria that he considers to indicate "indianness." His idea was to literally count "features" to determine the degree to which the local indigenous culture had been compromised by outside influences. He concludes, on the basis of the number of such "features" present, that Teotitlán is a "typical Mesoamerican community."

In the mid-1960s, Emily Vargas-Baron lived in the community of Díaz Ordaz and studied Zapotec textile production for her 1968 dissertation, "Development of Rural Artisanry: Weaving Industries of the Oaxaca Valley, Mexico." While there, Vargas-Baron carried out fieldwork in the nearby communities of Teotitlán and Santa Ana, which were also involved in textile production. She argues that in each of these places, Zapotec textile production cannot be understood in isolation; rather, Teotitlán, Santa Ana, and Díaz Ordaz together form a "weaving production complex." As far back as 1968, then, Vargas-Baron's concept of a weaving production complex set the stage for understanding how

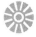

textile production in these communities is tied to national and international economic formations.

In the decades since Taylor's and Vargas-Baron's research, a steady stream of researchers have been conducting studies touching, in one way or another, on the topic of textile production in the communities of Vargas-Baron's weaving production complex. While Vargas-Baron's groundbreaking work is infrequently cited, it seems to be widely accepted by anthropologists whose work focuses upon some aspect of Zapotec textile production.[1]

This chapter traces the historical development of how researchers have characterized Zapotec textile production in Taylor's "typical" community, as well as in the communities first identified by Vargas-Baron (later, people also began weaving in San Miguel), and adopts and further develops that characterization to account for changes in Zapotec textile production since the 1980s. As one might surmise, given the people and places involved in the production of Hearst #235 (as described in chapter 3), Vargas-Baron's weaving production complex has transformed into a transnational network of businesses producing Zapotec textiles. Taking a "commodity chain" approach helps us make sense of the economic relations within this network.

Two ethnographic vignettes will demonstrate the degree to which the production of some Zapotec textiles and the lives of some Zapotec weavers have become transnational. The work and business arrangements of Antonio Mendoza, who lives in Santa Ana and coordinates the production of Zapotec textiles with his brother in Teotitlán through digital photos, e-mail, and faxes, illustrate the degree to which the Zapotec themselves, and not just businesspeople like Michael Wineland, live and work transnationally. And tracking the creation of textile F.A.3828.2004-5, now held (like Hearst #235) in the NHMLAC's ethnology collection, will demonstrate that the circumstances surrounding the production of Hearst #235 reflect broad shifts in the relations of Zapotec textile production since the 1980s. All together, these ethnographic vignettes, the review of current and past research on Zapotec textile production, and the introduction of a commodity chain approach will set the stage for the remaining chapters of part 2, which focus on how one becomes a Zapotec weaver by working at weaving within what is now a transnational weaving production complex.

Weaving in a Typical Mesoamerican Community

Taylor's dissertation offers some important insights into Zapotec textile production in the mid-1950s. He describes in detail the loom, its parts, and its

function, as well as the processes whereby the wool is cleaned, carded, spun into yarn, dyed, and finally woven into blankets. While this discussion of how a textile is made—with what, and by what techniques—is largely divorced from any substantive description of how the people who make it are organized into productive units, some interesting clues about how weaving activities were organized in the mid-twentieth century are inserted into his description at various points.

According to Taylor, agriculture is primarily a "subsistence" activity, while weaving is the means by which "people acquire most of their cash." He describes the weaving process as following a "natural" progression "from sheep to serape" and identifies "the family" as the means by which labor is allocated to various tasks. He observes that "the entire family is involved in one way or another in the production of serapes, and virtually every family has at least one weaver . . . Ordinarily, the men do all of the weaving, and the women and older children handle most of the spinning, dyeing, and other preparations." Yet, even though he feels compelled to describe the sheep and how wool is obtained from them, he also says that most of the wool used in weaving is purchased in Oaxaca City at the Saturday *tianguis* (market) from Mixtec Indians from the mountainous Sierra region.[2]

According to Taylor, natural dyestuffs were almost unused in the 1950s. "Aniline dyes, purchased in the stores in Teotitlán or Oaxaca [City], are used almost exclusively. Vegetable dyes are rarely used now, because they have been found to be both inferior and difficult to prepare."[3]

Taylor constructs a "traditional" scenario in which the family—husband, wife, and children—are all involved in textile production "from sheep to serape." This scenario domesticates textile production and, at the same time, marginalizes other economic and social relations (e.g., connections to wool markets and stores that sell chemical dyes), relegating them to casual observations and passing comments. In constructing such a scenario, Taylor both assumes and attempts to impose coherency on the social context of Zapotec textile production, focusing on every process "from start to finish" while paying little attention to who is actually carrying out those tasks and their social (not to mention economic) context. As Taylor's description proceeds, this "natural" family-focused approach fails him in telling ways.

Such a failure is first noticeable in his discussion of how the warp thread is purchased at market in the nearby district capital of Ocotlán, prepared, and attached to the loom in preparation for weaving. Taylor writes that the work of weaving really begins with the preparation of the warp, and "when a

family hires a weaver, this is his first task." He offers relatively few state-
ments such as this, where we see glimpses of the ways that "the family" is not
the only social entity through which labor is brought to the activities associ-
ated with weaving. Only at the end of his discussion does Taylor do more
than hint that there might be more to Zapotec textile production than family
members working together at various tasks.

> Weaving is a source of some feeling of pride, but it is long hard work . . .
> Those without land and who weave for wages are always poor, for they receive
> less than three pesos a day. Weaving is most profitable for those who have
> money to invest in the wool, yarn, dye, and acid to make their own serapes and
> to pay wages to employ others to weave for them. A number have more than
> one loom and weave on one while hiring someone else for the other looms.

As he concludes his account, he says that most weavers sell their textiles not
directly to consumers but to "retailers" in Teotitlán. These men have houses
along the main road into town and keep large stocks of textiles made by oth-
ers, which they resell to tourists brought out from Oaxaca City by cab driv-
ers who are paid on commission (just as our tour guide was in chapter 2).[4]

Despite Taylor's early statements and framework, then, which posit that
families work together as social entities (young children herding sheep and
helping to prepare wool for their mothers to spin and for their fathers to
weave into textiles) and sell their crafts directly to consumers in friendly
competition with other families, we see glimmers of a different reality.
These revealing passages appear in Taylor's discussion of textile production
late and unsystematically (quite unlike the rest of his discussion). In a clear
break with the rest of his narrative, nearly all of his comments about tour-
ists, retailers, commissions, and the poverty of the actual weavers enter the
discussion in the final three pages. It is as if he were unable to let these as-
pects of his research experience go completely unsaid but, at the same time,
could not integrate them with the rest of what he saw, experienced, and
tried to describe.

One might well ask how these aspects of Zapotec textile production, an
important part of the experience of many who live and work in Teotitlán,
can be made to fit into a description and analysis of what Taylor ultimately
concludes is a "typical Mesoamerican community." The short response is
that they cannot. They are factors or "features" (to borrow Taylor's vocabu-
lary) of textile production that are atypical and exist outside the community

(at least as Taylor and others conceive it). In many ways, my goal in this ethnography is to answer the question posed above. I want to make those aspects of the work of Zapotec weavers that Taylor struggled to fit into his text a central part of the discussion and analysis—even though understanding them necessitates moving the account well outside rural Oaxacan communities like Teotitlán, Díaz Ordaz, Santa Ana, and San Miguel.

Ethnographic Vignette #1: Antonio Mendoza, a Typical Zapotec Weaver?

When I met Antonio Mendoza, he was in his late twenties and interested in starting a (Zapotec-speaking) family. Taylor would no doubt have found him to be typical of Zapotec weavers in many ways. He speaks Zapotec, is Catholic, and consumes tortillas as a central part of his diet—all "features" on Taylor's list. The loom he has used since childhood and the yarn he employs, purchased from the mill in Teotitlán, are "typical" technologies and materials. But many aspects of his work as a Zapotec weaver in Santa Ana do not so easily fit the list. His use of the latest technologies (the Internet and digital photography) and the new markets he is working to establish for his textiles—indeed, much of his work as a weaver—are difficult to describe as typical and even more difficult to understand as part of life in a typical Mesoamerican community.

Antonio weaves as we talk. We are in his house, a house he shares with his two sisters' families in Santa Ana. The room is largely empty, with the exception of several piles of textiles (Antonio's inventory) and some weaving supplies, as well as the loom, a chair, and a portable stereo. Typically, the homes of families that weave devote a room, or sometimes simply a covered part of their home's patio, to the activity. In homes where there are many weavers working and many looms, it can be the largest room in the house. This is not the case in Antonio's house, where there is just one loom, floor skiff, and spinning wheel. It is a small operation, well suited to Antonio's small but developing business.

Antonio is relatively young, but is very serious about his weaving and the business he has been working to develop for the past five years. Like many, he has been weaving since childhood, but now that he is a young adult, he wants something of his own, separate from his parents. In these respects, Antonio is typical of other young men who earn a living by making and selling Zapotec textiles.

As we talk about Antonio's attempts to develop a clientele for his business, he explains that he feels as though he is on a mission. He has come into contact with people who know about Zapotec reproductions of Navajo textiles and he wants to defend what he sees as his culture and his textile tradition from any appearance of impropriety. Using vocabulary similar to that which we encountered during the tour to Teotitlán (chapter 2) and in *Seenau Galvain,* Antonio says that he is working to develop "true" Zapotec weaving designs and naturally dyed yarn while others are more concerned with simply selling textiles. While he knows that many Zapotec weavers are no longer making reproductions of Navajo designs, he characterizes the practice as a kind of "lack of respect for the Navajo [and], on the other hand, it is a lack of respect for the Zapotec." He wants to work differently, not relying so heavily on people like Michael Wineland and Brice McCoren but selling directly to a smaller, more distinguished clientele. He sees himself as an educator, both of Zapotec children who he thinks are losing touch with their Zapotec roots and of a clientele whom he wants to introduce to true Zapotec culture.

We talk about how Antonio is setting up his business. A single loom is not sufficient to produce the inventory that lies in stacks against the wall of the room we occupy. He describes how he works with his brother to keep enough stock on hand to show his clients the breadth of designs and colors available. In the beginning, he notes, he relied on relatives traveling between his family's home in Teotitlán and his home in Santa Ana to pass notes to his brother describing the textiles he needed. Now they rely on the Internet and digital photos to pass information back and forth concerning designs, numbers of textiles, colors, and supplies such as yarn.

Like many other weavers in Santa Ana, and as described in an extensive literature on the connections between Teotitlán, Santa Ana, Díaz Ordaz, and San Miguel, Antonio relies heavily upon his family's operation in Teotitlán. When Antonio needs yarn, for example, his brother supplies it, and when he needs more textiles, his brother sends them to him. Antonio stresses that technological developments make it easier for them to work in this way. In the past few years, the Internet has become widely available to people in Teotitlán, so that today, when Antonio sells a textile, he can e-mail his brother requesting a replacement and include a photo of the textile in his message so that there is no confusion about the design and colors. Antonio thinks of these developments as part of a process of professionalization, noting that they give him and his brother an advantage over others who are relying upon less secure forms of communication (drawings, for example, instead of digital images):

Now we are learning more, we are becoming more professional in our communication—there is e-mail, the digital camera, the computer, at times the fax . . . now it is normal, it is . . . very important for the person . . . [he switches to English] we have to be ready for business to, to use the technology that you have to make the communication a lot easier because you have to be on top of everything.

Those purchasing Zapotec textiles in galleries and gift shops might be surprised to learn about Antonio's use of the latest communications technologies in his textile business. In fact, he and his brother are not the only ones using such technologies. The relationship between these two households in Santa Ana and Teotitlán is also not an unusual one—many textile-producing households have such connections. There are, however, several differences between the home that Antonio shares with his sisters' families and the homes of other Zapotec weavers. For example, the room that he works in is in a one-story ranch-style home built, along with the rest of the homes in the development, in the 1980s. Antonio's "studio" is the home's original patio, which has been carpeted and enclosed, and the room's window looks out into a fenced back yard that abuts his neighbor's home. Taylor would have considered these "features" very atypical. Indeed, Antonio's home and business in Santa Ana are very different from the homes and businesses of other Zapotec weavers. Those differences stem from one simple fact: Antonio lives and operates his fledgling textile business in Santa Ana, California, not Santa Ana, Oaxaca.

As a consequence, when Antonio spoke with me about the clients with whom he is attempting to work and about the venues where he sells his textiles, he was talking about Southern California businesses, craft events, and fairs (like the Orange County Fair) where he sets up his booth and, on occasion, his loom to give demonstrations and sell his weavings. Likewise, before they began using the Internet, the notes he and his brother sent back and forth about the color yarn he needed or about replenishing his textile inventory were carried by relatives and close friends who flew between Oaxaca and Southern California and hand-delivered them in a matter of hours.

Fortunately, there are many Oaxacans here, there is always someone, some person who is going to Oaxaca . . . when the rumors that a countryman was going to Oaxaca arrived, I would quickly take specific notes about everything that I was going to need [and] . . . in the passage of twenty-four hours, the information arrived in the hands of my family.

Antonio and his business are, if not "typical," at least understandable in light of how the organization of Zapotec weaving workshops and the markets for Zapotec textiles have shifted over the past eighty years. Of course, that organization (like Antonio's California home) is not visible if we focus solely on the communities in Oaxaca where most Zapotec textiles are made. A transnational, multi-sited approach is required, but the antecedents of Antonio's approach to developing his business can be found in the ways that Zapotec weavers have developed their businesses in the past.[5]

The Tlacolula Valley Weaving Production Complex

After Taylor, the next anthropologist to have a significant research project focused on Zapotec textile production was Emily Vargas-Baron. Taking quite a different approach from Taylor, she traced the development of the weaving industries of Díaz Ordaz, Santa Ana (in Oaxaca), and Teotitlán, each of which, according to her, had specialized in particular styles and types of textiles since before the turn of the century (she completed her fieldwork in 1967). She explains that the three industries developed in relation, with no village constituting a single isolated entity, and hence that the three villages should be thought of as a "weaving production complex" (WPC).

Whereas Taylor's "community study" had trouble accommodating the extra-familial and intercommunity aspects of Zapotec textile production, Vargas-Baron's research plan was well suited to capturing them. She documents, for example, that well before 1950 the use of intermediaries had increased, with sales throughout southern Mexico, including in the surrounding mountainous Sierra region, the Pacific coastal lowlands, and the state of Chiapas. Toward the middle part of the century, Teotitecos resold the work of others in most of Mexico, and trucks and buses began to be used as a means of transport. After 1950, a putting-out system was established, with weavers doing piecework at home or in workshops, and merchants from Teotitlán came to dominate access to the new markets that were developing. Merchants also began to commission work and buy in larger volumes during this period, and textiles from Teotitlán began to be shipped by air all over the world.

Before 1950, each of the villages in the WPC produced a different kind of blanket, each of which had its own distinct market. Díaz Ordaz specialized in *peluza* blankets, utility textiles made of a blend of wool and animal hair (usually burro), which were marketed in the Oaxaca Valley and nearby

Sierra regions by the 1930s. Santa Ana and Teotitlán specialized in woolen textiles, which developed a similar market before 1950. Teotiteco weavers incorporated more complicated designs than did Santa Ana weavers, who wove mostly plain or simple striped blankets. In the 1930s, sales of *peluza* blankets of Díaz Ordaz and of the plain and striped blankets of Santa Ana declined, as inexpensive factory-made blankets from central Mexico became available in the local markets.[6]

In Díaz Ordaz, weaving changed from the occupation with the "greatest returns" to the one with the "least returns."[7] At the same time, new and different markets developed for the kinds of textiles produced in Teotitlán. Concurrently, the number of pieceworkers and piecework shops increased as more weavers became increasingly reliant upon fewer Teotiteco merchants with established clients. As a consequence, more textiles passed through more hands, but under the control of fewer individuals, on the way to markets.

Textiles continued to be produced in independent family households and sold directly to consumers; but after leaving the household they were also being sold to merchants in Teotitlán, who might then sell them to store and gallery owners in Oaxaca City or elsewhere. Merchants might also hire itinerant peddlers to sell the textiles on the streets of Oaxaca City for a commission, or sell them on to another local merchant, to a retailer in a Mexican resort, or to someone from the U.S. At the time of Vargas-Baron's fieldwork, however, most textiles were produced in either a merchant-owned workshop in Teotitlán or the home of a pieceworker. In those cases, she documents a number of routes they might take from the weaver, to merchants of various sorts, to store owners, and finally to the consumer; significantly, all of them ran through Teotitlán. In short, as the market for *peluza* and plain or simple striped wool textiles dried up, the markets for woolen textiles with intricate designs, the tourist and export markets, expanded. As a consequence, weavers in Santa Ana and Díaz Ordaz began making such blankets for merchants in Teotitlán.

Vargas-Baron ties these shifts in the production and marketing of Zapotec textiles to a variety of outside influences, starting with the introduction of factory blankets in the 1920s. She also notes that the completion of the Pan-American Highway in the late 1940s improved transportation for both Teotiteco merchants and tourists visiting Oaxaca, enabling Teotitecos to more easily exploit markets in Mexico City and Acapulco and tourists to more easily visit Teotitlán. The Mexican government organized fairs, competitions, and other programs for improving crafts. Finally, Oaxaca City

merchants owning tourist shops played a major role, as they "sponsored the training of selected Teotiteco artisans in dye-fast techniques taught by dye companies in Mexico City."[8]

The most interesting aspect of Vargas-Baron's study, and the basis for her ideas about the WPC, is the changes in what she calls "connectivity"—the degree to which all of the locations involved in the production and marketing of textiles were linked through sales to one another. While the villages that were a part of the WPC became steadily more interconnected through sales and through piecework done both at home and in workshops, the WPC as a whole became less connected to the major sales outlets for Zapotec textiles. She argues that these changes in production and sales were the result of Teotitlán's position as a funnel for textiles going to market and as a conduit for contract sales, in which weavers in Díaz Ordaz and Santa Ana (as well as Teotitlán) either independently sold their weavings to merchants from Teotitlán or did piecework at home for them. On the whole, then, the WPC became less connected to markets as merchants in Teotitlán monopolized access to the strongest newly emerging ones.

Vargas-Baron's research provides important insights into the organization of Zapotec textile production in the mid-1960s as well as its historical development. Her work, grounded in the economic development theory of the time (Keynesian "take-off" theory), predicted that Zapotec textile production would move into factories. Yet her work is innovative for its focus upon the multiple communities that make up the Tlacolula Valley WPC and, in this respect, it anticipated more recent concerns about connecting rural peasant and indigenous communities to wider cultural, historical, and economic forces and trends.

Since Vargas-Baron's work in Oaxaca, a number of authors, including Scott Cook and Leigh Binford, Jeffrey Cohen, and Lynn Stephen, have worked from her ideas and described how merchants in Teotitlán built an ever-widening circle of influence on (and control over) newly developing markets and weavers. More particularly, they describe how this expanding control and circle of influence works within the Zapotec WPC as well as how the Zapotec use kin, fictive kin, ritual obligations, and a gendered division of labor to control the productive activities associated with textile production.[9]

Whereas Vargas-Baron used Keynesian take-off theory to ground her analysis, Cook and Binford and Stephen turned to Marx's ideas about the relations of production in capitalism for insights into the role local merchants have played in Zapotec textile production. Both Stephen and Cook and Bin-

ford work from a framework developed by Kate Young in her 1978 study of the effects of the development of commercial coffee production in Oaxaca. Young argued that as commercial coffee production increased between 1870 and 1970 in the mountainous Sierra region of Oaxaca, local merchants gained increasing control over the local economy. She documents how they promoted an increasingly monetarized economy, which she ties to a shift from mercantile to commercial capital.[10]

In reviewing Young's argument as a part of their study of small-scale production ("simple" or "petty commodity production") throughout Oaxaca, Cook and Binford explain that her thinking was that because commercial capital promotes the interests of industrial capital "where industrial capital does not intervene directly," the absence of industrial capital should not be taken to indicate that capitalist relations of production did not predominate in the rural Oaxacan coffee economy. In her study, Young went on to demonstrate that the incursion of commercial capital had severe consequences for women (the main focus of her study), who, as a result, were reduced to seasonal and unpaid household labor. Indeed, much of Young's work in the Sierra documents the ways in which a shift from mercantile to commercial capital affects household economy, including factors such as migration out of the community, the viability of subsistence farming, household craft production, and the changing nature of women's work—issues related to household labor allocation more generally.[11]

Stephen applies the distinction between mercantile and commercial capital to the historical development of textile production in Teotitlán and argues that a shift similar to the one described by Young has occurred in the second half of the twentieth century in Teotitlán and the other communities that make up the WPC. She writes that "international commercial capital" has penetrated Teotitlán and that, as a result, formerly egalitarian social relations have become more exploitative; class divisions developed as "merchants purchased labor directly" from weavers.[12]

Following Vargas-Baron, Stephen describes how cheaper factory-made blankets were introduced, forcing weavers from Santa Ana and Díaz Ordaz to work for merchants from Teotitlán. She also argues that at the same time that the Pan-American Highway and tourism came to Oaxaca, the Mexican government began promoting indigenous crafts. Finally, complementing Vargas-Baron's argument, Stephen adds that through the second "bracero" program, men from Teotitlán were able to earn enough as agricultural laborers in the U.S. to purchase looms and raw materials and thereby set themselves up as merchants in the textile business.

Of equal importance, according to Stephen, was the understanding of U.S. consumer preferences gained by workers who participated in the bracero program. As a result, she concludes, they were better able to meet the consumptive desires of the increasing numbers of tourists visiting Oaxaca, as well as of the consumers shopping at gift shops and other retail outlets in the U.S. Stephen thus sees Teotiteco merchants (who participated in the bracero program) not only as embodying the interests of industrial capital (they are the representatives of commercial capital) but also as a conduit or funnel through which the tastes of consumers in the U.S. entered the Zapotec textile WPC, which then catered to them.[13]

While it is undoubtedly the case that in many instances men returned from work in the U.S. with enough money saved to buy wool and looms, the notion that they may have returned with a wider sense of the interior decorating tastes of people in the U.S. is another matter. This interpretation of the multiple roles of local merchants becomes especially problematic if one considers that during the bracero program, farm workers from Mexico were to a large degree sheltered from wider U.S. society. Not only were they frequently transported to and from Mexico, but the farms where they worked also provided lodging. Their access to and ability to observe middle-class tastes and living patterns would, then, have been limited. Additionally, interior decorating tastes in the U.S. are quick to change, which makes the idea that largely secluded Mexican farm workers might be able to exploit whatever they had learned decades later (in the 1980s) less than compelling.

In her research, Stephen finds that these historical factors have fostered the development of a highly complex system of piecework subcontracting. To tease apart the intricacies of that subcontracting system, she turns to the earlier work of Cook and to a focus on the place where commercial capital meets the productive activities of Zapotec weavers: household production units. Cook's elaborate typology differentiating between types of production units on the basis of the control of productive activities exerted by commercial capital provides the framework for her analysis of changes that have occurred in Zapotec textile production in the 1970s and '80s.

Stephen writes that the 1980s were a boom period in Teotitlán and that the labor of unpaid household members was critical to expanding production during this period, as had been the case when the tourist and export markets had begun to expand in the 1950s. Citing the research of Jeffrey Cohen and Helen Clements, who worked in Santa Ana and San Miguel, respectively, Stephen argues that this pattern of expansion and use of the labor of women and children has been duplicated in the other communities that

make up the WPC. In Teotitlán this boom period corresponded with some significant changes in both who purchased the textiles and the location of their market: "While a majority of sales in the 1970s were to tourists in Mexico and Mexican nationals, as the spiraling devaluation of the peso began in 1982, the market for Zapotec textiles started to shift to an export market centered in the United States."[14]

Stephen thus locates factors contributing to this market shift in the economic crisis that Mexico suffered in the mid-1980s and a resulting "steady stream of foreign merchants." The rise in the purchasing power of U.S. dollars, she concludes, brought more entrepreneurs from the U.S. into the importing business, even while competition forced them to cut costs and come directly to the villages. These seemingly contradictory circumstances cut out importers in Mexico City and Oaxaca City and made some Teotiteco merchants quite wealthy by village standards.[15]

Cook and Binford, whose work is focused more broadly, also find that the wider world economy (and the representatives of commercial capital) has penetrated simple, small-scale commodity production throughout the region. They argue that while the Oaxaca Valley has witnessed an even more drastic shift from mercantile to commercial capital than the Sierra over the same general period, the interests of commercial capital have not brought an end to long-standing ways of organizing craft production at the household level. According to them, in many cases (including that of Zapotec textile production) commercial capital and mercantile capital now coexist through a "mostly hybrid, indigenous type of merchant capital." This process of commercialization has promoted "indigenous small-scale industrialization." In "adjuncts of the Oaxaca economy's tourist sector" a "significant role" may develop for "a new type of labor intensive feeder industry—either of the assembly shop (*maquiladora*) variety or of rejuvenated or newly established manufactories or factories producing or assembling new lines of commodities for absentee mass merchandising and/or production enterprises."[16]

Cook and Binford's discussion of this phenomenon is quite short and they are not altogether clear about the conditions under which these "feeder industries" have developed. At the same time, however, they are careful to locate them as emerging from "within simple commodity forms in the countryside," writing that their development will continue "with a relative *absence* of modern industrial capitalist enterprise."[17] This is perplexing, given their emphasis that commodities would be assembled for "absentee mass merchandising and/or production enterprises." While the meaning of this phrase is murky, it is difficult to imagine how "labor intensive feeder" production

units might be organized around "absentee mass production enterprises" without the wider capitalist world system ("industrial capitalist enterprises") playing a prominent role.

What a very complicated situation. Apparently the circumstances surrounding "simple," "small-scale" commodity production are far from simple: hybrid indigenous merchant capital (a kind of masked or disguised commercial capital) that does the bidding of commercial capital; small-scale production units that are actually feeder industries for one of Oaxaca's most important economic sectors (tourism); U.S. businesspeople with greater purchasing power traveling all the way to Oaxaca to cut out middlemen and save money; and braceros returning to rural Oaxaca with a nuanced understanding of shifting consumer preferences in the U.S.—none of which constitutes full-fledged industrialization, but rather some fuzzy or "hybrid" middle position from which weavers can be both indigenous peasant crafters and a part of the capitalist world system (not really the proletariat but acting very much like it).

Perhaps these circumstances (and the distinctions being drawn by these researchers) can be made more comprehensible by turning to a concrete example. What do the relations of production look like in one of Cook and Binford's adjunct feeder industries? How do the alumni of Stephen's bracero program really learn about U.S. consumer preferences? How do U.S. wholesalers and retailers work in rural Oaxaca without Mexican middlemen? And how can Oaxacan peasant crafters (and the local merchants they work for) be a part of the modern industrial world and at the same time remain separate? Perhaps turning to the example of how the textile F.A.3828.2004-5 was made will help to clear things up.

Ethnographic Vignette #2: F.A.3828.2004-5, a Typical Zapotec Textile?

In 1998, in Chimayó, New Mexico, I purchased a textile that is now held in the NHMLAC's collection, accession code F.A.3828.2004-5. Like Teotitlán, Chimayó (a small town located about twenty miles northeast of Santa Fe) is a center of textile production, and it is well known for the Río Grande–style woolen textiles produced there. Like Zapotec textiles, Río Grande–style woolen textiles are sold as interior design accouterments in the Southwestern or Santa Fe style. Because Chimayó is one of several communities where these textiles are produced, all of the roads leading into it have galleries or gift shops where the work of local weavers is sold. As in

Oaxaca, those owning shops along the main thoroughfares are merchants, reselling to tourists piecework textiles created by a network of weavers. I bought F.A.3828.2004-5 in one such business. It was made in the Rio Grande style and features a stylized central diamond motif that is characteristic of textiles made in the area, but the tag on it read,

> Hand woven in Mexico for Lanería de Ocotlán, Benito Juarez #119, Ocotlán de Morelos, Oaxaca, Mexico. This rug, which is approx. 30" by 60" in size, was made by Zapotec Indians of Teotitlán del Valle, Oaxaca, Mexico using 50% wool 50% mohair weft. Model 2101, S-Blanket. Dry cleaning recommended.

The tag on the textile and my conversation with Tim Cordova, the owner of the gift shop/gallery where I bought it, made clear to me that the story of the creation of F.A.3828.2004-5 would move well beyond the communities of Vargas-Baron's WPC in Oaxaca. As I talked with Tim about how a Oaxacan textile had ended up in a Rio Grande gallery in Chimayó, New Mexico, it became clear that he had not simply purchased the textile from a Teotiteco or Santanero merchant working with a network of pieceworkers. Rather, an international set of characters worked to make the textile in Tim's shop in a host of transnational locations.

In fact, Tim had never been to any of the communities making up the Tlacolula Valley WPC, or even to Oaxaca, and seemed to have no real sense that the Zapotec-made Chimayó textiles that he was selling, like textiles made in Chimayó, were woven in a community with a centuries-old history of weaving. Tim, it appeared, simply assumed that the business with which he was working had a production facility in Mexico and had never given much thought to the people (the Zapotec Indians mentioned on the tags) who were actually making his merchandise. He told me he had contracted with a pair of Englishmen named Graham and James to have the textiles made. According to Tim, Graham and James had a mohair mill (mohair is a blend of angora wool and cotton) in Texas, and were also partial owners of a wool mill in Ocotlán de Morelos, where they had begun to produce their blended yarns.

Tim described how he had created a simplified version of a Chimayó diamond motif for a new line of textiles which he had provided to James. Within a couple months' time, James brought Tim a couple dozen textiles of varying color combinations and sizes with the design motif that he had supplied. Because James wanted to cultivate Tim as a regular client, Tim was

able to place his order with no down payment, and was paying for the textiles as he sold them.

Later that year, I went to the street address listed on F.A.3828.2004-5's tag, hoping to meet the Englishmen who owned Lanería de Ocotlán. There, I met Graham, James's business partner, and after he showed me around the mill we sat down together over the midday meal and a beer. Graham explained that he and James had lived for several years in central Mexico, working for the U.K.-based nonprofit Oxfam, coordinating a variety of grassroots development projects. They had retired in the 1980s but had lost much of their retirement savings in stock market drops and had needed to go back to work. Graham, a mechanical engineer by training, is from northern England and was raised in a wool-milling town. In Oaxaca, he found old, dilapidated wool milling equipment that he purchased for a modest sum and fixed. Since that time, he and James had worked to build a business as producers of fine angora wool and mohair yarn, but also supplied finished textiles to other businesses. (In 2005 I learned that James had worked as a professional rug buyer in Teotitlán for several years.)[18]

From Graham's perspective, the story of how the textile was made began in New Zealand, where the angora wool came from. It was shipped from New Zealand to a port in Texas, where Graham had placed his order, and then from Texas to Oaxaca. At Graham and James's mill in Ocotlán the wool was spun into yarn, and then the yarn was trucked to Teotitlán. Once in Teotitlán, it was dyed by a local merchant family with whom they had contracted, and then distributed, along with copies of Tim's design, to a network of pieceworkers in Teotitlán (according to Graham, none of the textiles for Tim's order were woven in Santa Ana, San Miguel, or Díaz Ordaz). As the textiles were woven, they were collected by the merchant family in Teotitlán, who, Graham thought, were paying the weavers approximately $25 per textile from his down payment (a "generous" one-half of the total cost of having the order filled). When the order was complete, the textiles were trucked back to Ocotlán, the merchant family was paid the second half of the bill, and the textiles were packaged and shipped airfreight to Albuquerque, New Mexico, and then overland to Chimayó. In Tim's Chimayó gift shop, the Zapotec-made Rio Grande textiles are displayed alongside textiles made by Hispano weavers from Chimayó and surrounding communities. They are offered as a less expensive alternative to those Rio Grande textiles made in the U.S. I bought F.A.3828.2004-5 for $190.

What at first blush might seem to be an unusual set of circumstances and connections between New Zealand, Texas, Oaxaca, and New Mexico, pro-

ducing a very unusual piece of "ethnic art" through almost surreal and convoluted channels, is actually the historical outcome of trends and patterns that were initiated in Teotitlán nearly a century ago and first captured in Vargas-Baron's research. Of course, as this short example illustrates, the weaving production complex in which Zapotec textiles are made now extends well beyond the Tlacolula Valley. Neither the production of Zapotec textiles nor the development of a market for less expensive ethnic textiles in the American Southwest can be understood in isolation—they are instances of translocal, indeed transnational, creation, marketing, and sale. Uncovering the story of how the Zapotec textile production complex went global requires an analytic focus distinct from that forged by previous researchers. It requires a focus not on piecework production units in a regional marketing system in which local merchants do the bidding of commercial capital, but on a transnational network of connections linking semi-autonomous businesses together into a commodity chain.[19]

From Weaving Production Complex to Global Commodity Chain

Well into the 1970s, the marketing and consumption of Zapotec textiles, with few exceptions, was intimately tied to tourism in Mexico. Zapotec textiles were sold in Teotitlán, at tourism sites in Oaxaca, and throughout Mexico wherever people vacationed. By and large, merchants from Teotitlán either bought up or commissioned large quantities, which they either distributed to retailers throughout Mexico or sold to wholesale and retail business owners (including businesspeople from the U.S.), who then distributed them.

This general pattern changed in the early 1980s when large quantities of textiles began to be exported to the U.S. to supply a newly developing market there. Santa Fe, New Mexico, had become the single most visited vacation spot in the continental U.S. and the emblems of the Santa Fe or Southwestern style (adobe or "mission" architecture, Tex-Mex cuisine, and, most importantly to our purposes, Native American arts and crafts) gained widespread popularity.

Throughout the 1980s, as this newly emerged market for Zapotec textiles gained momentum, the number of professional textile buyers from the U.S. dramatically increased. These buyers began to regularly buy large quantities of textiles in Teotitlán and to interact differently with Teotiteco merchants. Textile buyers from the U.S. who had worked in Teotitlán since the 1970s describe a dramatic shift in how business was done in Teotitlán

at this time—an intensification of textile production, a sort of "mass production," accompanied their increased presence. As Ross Scottsdale put it,

> Before 1980 it's just a real casual thing and I didn't really do any designing. I may have brought down a few Navajo books, but not much. And I left for a year . . . and when I returned . . . there was a notable shift in the style of production, that they were doing more volume, doing repeat orders. There wasn't a "man in his house" sort of feeling—[deciding] what type of color he wanted to work with and design that [over] the next few weeks on the loom but having—having someone in his family let him know that if he wove ten of those, he could sell them all to that man [a professional buyer]. So there was a lot more mass production at that time.

Production of textiles in the 1980s and early 1990s (Ross and I spoke in 1993) was quite different from that described in the earlier ethnographic literature, according to which Teotiteco middlemen put together orders and transported textiles to market centers throughout Mexico, and professional textile buyers from the U.S. went to Teotitlán and bought textiles from the existing stock of Teotiteco merchants. While Ross does say that he (and presumably other business people from the U.S.) had previously brought museum catalogs and coffee-table books containing photos of Navajo and other Southwestern U.S. textiles to Teotitlán (and by implication had done so even more often after the shift), he soft-pedals how his own interaction in Teotitlán changed after the noted shift. His rather vague indication that "someone" would "let him [the weaver] know" that "that man" was a professional textile buyer putting together an order obfuscates as much as it reveals.

He might more straightforwardly have asserted that weavers were, by the mid-1980s, producing multiple copies of a single textile design and that, in many instances, merchants from Teotitlán and U.S.-based businesspeople were doing much more than simply "letting someone know" about people interested in purchasing particular designs. Businesspeople from outside Mexico had also begun to work directly with, and directly pay, merchants and weavers. At first this paid work was principally, although not entirely, limited to creating new designs and overseeing the dyeing of wool in colors they knew would sell well in the U.S. market. But eventually nearly every aspect of textile production, from design to preparation and dyeing of the wool and yarn, would come under their oversight and control—everything except the actual work at the loom. These were the circumstances under

which both F.A.3828.2004-5 and Hearst #235 were created. In fact, as the case of Antonio's Orange County, California, business shows, many of these aspects of Zapotec textile production no longer take place within the communities making up the Tlacolula WPC, even among some Zapotec families in those communities.[20]

By the late 1980s, Teotitlán had begun to take on many of the characteristics of an off-shore production zone.[21] The making of textiles like Hearst #235 and F.A.3828.2004-5 illustrates the "shift in the style of production" that Ross describes and answers the questions posed earlier: alumni of the bracero program in Teotitlán are taught about (and directed to produce) textiles that will suit the taste of U.S. consumers by businesspeople from the U.S. (and other countries). They return from their work experience in the U.S. not with a knowledge of middle-class interior decorating tastes, but with exposure to and an understanding of how to work for or with a U.S. business owner. U.S.-based wholesale and retail business owners, as a consequence, do not need Mexican middlemen to act as go-betweens—and when one looks beyond the communities of the Tlacolula WPC to Chimayó, Los Angeles, and Santa Fe (among other places), Cook and Binford's adjunct feeder industries look very much like global commodity chains.

During the 1980s, the work of professional textile buyers from the U.S. came to be characterized less by the buying up and reselling of finished textiles and more by the subcontracting of small batches of textiles in an off-shore production zone—a pattern fitting squarely into what has been called "flexible" relations of production. David Harvey, for example, describes how regimes of "flexible accumulation" have developed since the 1970s, mostly as a consequence of contradictions inherent to capitalism and technological advances in transport and communication. In the organization of manufacturing, this flexibility takes the form of subcontracting, outsourcing, and the general dispersal of productive activities; in the disciplining of labor, it takes the form of temporary and part-time employment of marginal and more easily exploitable populations; and in product lines it takes the form of small-batch production for an ever-growing number of micro-niches. Of paramount relevance is Harvey's contention that flexible relations of production sometimes incorporate already existing systems for organizing manufacturing and controlling labor. He writes that flexible production "in some instances permits older systems of domestic, artisanal, familial (patriarchal), and paternalistic ('god-father', 'guv'nor', and even mafia-like) labour systems to revive and flourish as centrepieces rather than as appendages to the

production system." As Vargas-Baron's work demonstrates, such domestic, familial, and paternalistic forms were already in place in the Tlacolula WPC prior to the 1980s.[22]

The relations of production under which Hearst #235 and F.A.3828.2004-5 were made illustrate that many Zapotec weavers are now part (indeed, the "centerpiece") of a subcontracting network that produces inexpensive "ethnic" or "Indian" textiles for a largely U.S. market.[23] Such textiles are the product of a flexible regime of production that developed across multiple sites in the late 1980s and that was centered in Santa Fe and the American Southwest more broadly. Throughout the Tlacolula WPC, as this productive regime took shape, older patterns continued: tourists visited Teotitlán (and Santa Ana, Oaxaca) to purchase textiles, Teotiteco merchants shipped and sold Zapotec textiles across Mexico, and U.S.-based businesspeople bought textiles from the stock of Teotiteco merchants. At the same time, however, a limited number of U.S. businesspeople, in many cases those more closely involved in the Santa Fe ethnic art market, began to become more centrally involved in the production of Zapotec textiles, such that by the late 1980s and early '90s they were coordinating and overseeing the subcontracting of Zapotec textile production across multiple and highly dispersed sites in Mexico and the U.S. Zapotec textile household production units had become immersed in a highly dispersed and flexible regime of production.

Approaching these developments from a transnational commodity chain perspective leads one away from Cook and Binford's assertion that Zapotec weavers working in home-grown, labor-intensive feeder industries are still simple commodity (peasant) producers, to the very different conclusion that the conditions under which Zapotec pieceworkers toil are those endured by a growing segment of the proletariat under late capitalism.

Gary Gereffi is among a group of economists who use the metaphor of a chain to characterize the linkages between production units in which this growing segment of the proletariat works. They use the term "commodity chain" to describe a "network of labor and production processes whose end result is a finished commodity." Central to the commodity chain approach is a focus on governance as well as the "backward" and "forward" linkages, across international borders, between independent and semi-independent businesses. Backward linkages are those linking productive practices back to raw materials and the parts assembled into commodities, while forward linkages are those linking productive practices to finished commodities and consumers. In the production of commodities, first raw materials, then parts, and ultimately the finished products move along a chain of indepen-

dent and semi-independent businesses toward consumption. "Governance" describes the relative decision-making capacities (and relative independence) of businesses at different points along the chain of productive activities. Those relations may be relatively balanced or occur through buying and selling under "market" conditions, or they may be relatively hierarchical or occur through "directed" or "driven" relationships in which one business may "specify what is to be produced and by whom."[24]

Among these scholars, Gereffi is notable for his distinction between producer-driven and buyer-driven commodity chains. Producer-driven commodity chains are relations of production controlled or directed by businesses (often large transnational corporations) that produce commodities and subcontract the production of components out to other businesses, while buyer-driven commodity chains are productive relations in which merchandisers, retailers, and trading companies not owning or operating any production facilities "design and/or market, but do not make, the branded products they sell." Buyer-driven commodity chains coordinate the productive activities of a network of producers whose product they then market either directly to consumers or to retailers.[25]

The commodity chain approach helps us to focus neither on Oaxaca's regional marketing system (à la Cook and Binford) nor on the communities making up the Tlacolula Valley WPC and their connections to the "capitalist world system" (à la Vargas-Baron, Stephen, Hernández-Diaz, and Cohen), but on what has clearly become a transnational WPC. Distinctions between buyer-driven chains, like that organized by Michael Wineland in the production of his Hearst Americana series, and producer-driven chains, like that coordinated by the owners of the Lanería de Ocotlán, would be invisible to a researcher narrowly focused on the communities of Teotitlán, Díaz Ordaz, and Santa Ana (Oaxaca). A commodity chain approach, however, frames the productive activities of those working in Santa Ana (California), Los Angeles, and Santa Fe not as adjuncts to a local or regional Oaxacan-focused ethnography (with the "world system" as an economic backdrop to local developments), but as equally important spaces through which an ethnography exploring how Zapotec textiles and weavers are crafted must move.

The images of the weavings and weavers that are stressed by tour guides, in the travel literature, and on the Internet, while important to understanding what drives consumer desire for the textiles, simply do not capture the nature of the lives of Zapotec weavers as they work in the very complex network of subcontracting, regional (and global) supply chains, and shifting

micro-niches for Zapotec textiles. These are the circumstances under which Zapotec children and teenagers go to work and learn to weave; the fantasies of children working with their parents in familial bliss are simply that. By training our attention on the specific "trajectories" of Zapotec weavers over the course of their lives from childhood to adulthood in this complex network, we will come to see how learning to be a Zapotec weaver is strongly shaped by the relations of production in late capitalism.

FIVE

"We Learn to Weave by Weaving"

"We learn to weave by weaving," matter-of-factly states Na'un, a young Zapotec weaver. In Teotitlán, there is no mystery about how one becomes a weaver, and the topic receives little discussion or attention among weavers. Most of those with whom I broached the topic of how one learns to weave (or teaches someone else) had a hard time understanding what there was to discuss. For the most part, one simply weaves and does other tasks associated with textile production in rooms and patios where others are also working at these tasks. That is not to say, however, that everyone learns how to weave, or that those who do all learn equally well. This chapter explores what that means for the weaving practices of those who learn Zapotec weaving, or are made into Zapotec weavers in the spaces MADE IN MEXICO.

I agree with Lave and Wenger that "social practice is the primary, generative phenomenon, and learning is one of its characteristics."[1] Put somewhat differently, learning may be understood as something that goes on all the time—it simply is. For Zapotec weavers, learning to weave is simply one of the aspects of making Zapotec textiles (or, to borrow Lave and Wenger's phraseology, of participating in the primary social practices of which making Zapotec textiles is a part). Not learning to weave (and learning not to weave) must be understood from this perspective as well. Lave and Wenger group these issues under the rubric of "legitimate peripheral participation," giving primacy to the limits set on participation as well as to the forms of participation available to novices. This

chapter explores these ideas in the context of the social and economic world in which Zapotec textiles are produced.

Children are made a part of textile production from a very early age, even if only tangentially, since they live in the household spaces that make up the production unit (i.e., the spaces where the looms and other equipment are kept, and where those making textiles work). By the time they become teenagers, they have often begun to participate more centrally, though in a limited number of ways. The most salient factor in predicting which Zapotec youth become "expert" weavers is the degree to which they want to become, and do become, a working part of a textile production unit (usually they are incorporated by parents who need more productive hands working to maintain the family). Their participation in various production units may enable them to move into spaces where the "best" Zapotec weavers work. The career trajectories they construct for themselves, then, may enable them to associate and work with those recognized as master weavers and to become recognized as master weavers themselves.

Throughout this chapter I focus on how personal weaving histories, so intimately connected to the political economy of Zapotec textile production, shape the development of weaving practices. Oral histories show how changes in the wider cultural space and economy within which textile production takes place shape the experience of learning to weave by working at weaving. First, however, a more thorough treatment of Lave and Wenger's pivotal notion of legitimate peripheral participation is necessary.

Legitimate Peripheral Participation

Na'un's comment points to a perspective on "learning" that falls well outside what might be termed a standard pedagogical treatment of the subject. Lave has argued that academic treatments of the processes that enable cognitive development and learning have been, by and large, predicated on a single account of the nature of reality, of which nineteenth-century British empiricism is the most coherent and well-known example. This account, which permeates much of Western popular ideology, asserts that learning entails the acquisition of bits of knowledge, of facts. For researchers studying learning in social context, "the social character of learning mostly consists in a small 'aura' of socialness that provides input for the process of internalization viewed as individualistic acquisition of the cultural given." Lave and Wenger argue that such accounts of learning in social context amount to "no account" at all.[2]

In contrast, the notion of legitimate peripheral participation developed by Lave and Wenger begins from the position that learning is simply participation in social practice. They emphasize the social embeddedness of learning (that learning is a "situated activity" at all times and in all places) and argue that its "central defining characteristic" is the "process" of participation through well-defined ("legitimate") social roles in social practice. This argument carries with it a number of consequences. First, from this perspective, peripherality may be legitimate. Hence, dichotomies such as inside/outside, center/periphery, and complete/partial are not necessarily markers of nonparticipation, but rather of degree of participation and, relatedly, the role of the participant in social practice. Second, it brings the changing position of individuals in the "social world" (e.g., changes in membership or identity over time) to the forefront of the analysis. The question changes from "has so-and-so learned something?" to "how does so-and-so participate in such-and-such an activity?" Third, the ambiguous nature of peripherality shifts the emphasis to issues of access and legitimacy, and as a result, to the "social organization of and control over resources" and to "social structures involving relations of power." This final shift in emphasis, a shift that both ties the two previous consequences together and instantiates them in a specific conception of the social, brings to the forefront of analysis the interrelated and co-constitutive relations between location and practice (which I emphasized in the introduction).[3]

Lave and Wenger argue that the idea of peripherality and its ambiguous nature must be "connected to issues of legitimacy, of the social organization of and control over resources, if it is to gain its full analytical potential."[4] Conceiving of the social structure of the weaving community (the community of practice) in terms of political (power) struggle provides a conceptual (and methodological) frame that does just that. Further, the idea (inspired by Bourdieu) that such contestations occur through, or in terms of, a field of power relations provides a corresponding frame for theorizing the participatory patterns of Zapotec weavers in the wider social field of Zapotec textile production—the space where things are MADE IN MEXICO.

In *The Rules of Art*, his work on the French literary world, Bourdieu argues that the biographies or career histories of writers follow "trajectories" that can be mapped across the field of cultural production of which the production of French literature is a part. Bourdieu finds that French writers tend to ascend to prominence and then fall from it, or move either from success in more rarified genres (e.g., poetry) to the production of literature for a more mass audience (e.g., novels) or from a mass audience to a more limited one.

Similarly, Zapotec weavers follow relatively standard career histories, beginning as children working to prepare bobbins and untangling skeins of yarn, and becoming young adults dyeing large quantities of wool to the specifications of a gallery owner from Santa Fe, New Mexico. This description is only the most obvious application of the combination of Lave and Wenger's concept of peripheral participation and Bourdieu's thinking on career trajectories through the field of cultural production. The trajectories of Zapotec weavers are not confined within household production units, but may also involve the wider community of practice in which the craft of Zapotec weaving (and the identity of Zapotec weavers) is made meaningful. Zapotec weavers may be recognized as successes by the Mexican government, which consecrates their work by promoting it in a program to advance the folk arts, or by writers and patrons, who promote the work of weavers for personal and idiosyncratic reasons.[5] We begin our discussion here, however, with some general points about the career trajectories of Zapotec weavers.

Making Zapotec Textiles, Crafting Weaving Trajectories

The discussion that follows is first and foremost a description of the multiple ways in which Zapotec weavers participate in textile production. As a consequence, it is also a description of the various practices associated with the making of Zapotec textiles. It differs markedly, however, from a generalized account of the steps involved in making them, such as Taylor's "sheep-to-serape" narrative. Instead, it understands these practices to both result from and be central to the very existence of the "procedure" or, better, practice itself. It is specific to the people it discusses: this account of Zapotec weaving is told through particular lives lived working at Zapotec weaving.

Accounts of the weaving process that assume a "natural" progression "from start to finish," from the sheep to the finished textile, divorce how a textile is made from the division and organization of labor in which textile production is enmeshed.[6] While such accounts seem straightforward, they reveal little about the practices associated with Zapotec textile production *as lived and learned by Zapotec weavers*. Their "naturalness" is the product of a number of descriptive devices employed to aid understanding of the general process but which instead serve to disembed the making of Zapotec textiles from its historical and social context. These narratives create an artificial cohesion that blocks out a great deal of what we must focus on if we are to follow the lead set by Lave and Wenger and bring issues of legitimacy, access to resources, and personal history to the forefront. This account presents the various prac-

tices associated with Zapotec textile production as people typically engage in and master them in the course of growing up and growing old producing Zapotec textiles. In short, my focus is on how, when, and where Zapotec weavers are given the opportunity to learn different aspects of textile production, and only incidentally on how Zapotec textiles are made.

Most of those with whom I spoke about gaining a knowledge of the processes associated with wool preparation, dyeing, and weaving described how, as young children, they had helped their parents and grandparents. My observations and participation in workshops and homes also support this general contention: you begin the process of learning to weave by lending a hand to those more centrally involved in textile production in your own home. Most children begin to learn how to produce textiles by undertaking minor tasks that support the work of weavers and thereby contribute to the economic livelihood of the household.

An older Ordazeño, for example, described with great fondness the childhood trips he made with his father to Oaxaca City to purchase burro and horse clippings from stables in preparation for weaving *peluza* blankets. Several older Teotitecos described how they had gone with their parents to the river to help wash wool. Many recounted spending long hours winding bobbins, carding wool, making the fringe of textiles that had been cut off the loom, and cleaning the surfaces of finished serapes. In short, they described a period of time (which varied from family to family and child to child) during which their involvement in textile production was limited to small tasks not directly associated with the three central processes of textile production: spinning wool into yarn, dyeing it, and then weaving it into a textile.

David Montoya, who was in his thirties and had children of his own at the time of our interview, said that he began to help his parents "at the age of ten. We began working, but . . . at . . . washing wool. We went to the river to wash the wool in baskets and . . . and in that way, well, we started or began to work." The raw wool was not sheared from the family's own sheep but purchased in regional markets. Because cleaning wool in the river is an arduous job, however—workers must rasp the raw wool against the inside of an extremely large, loosely plaited cane basket while standing knee-deep in running water—some commented that most young children help out with the less physically demanding aspects of cleaning the wool, such as laying the freshly washed wool out to dry on nearby rocks and then gathering it and carrying it back home.

Others described how they had begun the process of cleaning the raw wool by helping to "open it up" (*abriendolo*) at home on the patio before going

to the river with their parents or older siblings to wash it. Lucero Cardenas described the entire process and her interaction with her parents in this way:

> You clean it, by crumbling it up, opening it up, right? Loosening it up with your hands, loosening it up like this [she gestures to demonstrate] so that the wool is opened up and the manure from the sheep is removed, right? . . . the spines, the leaves, everything that's in it. First you have to do a big pile like that [pointing to a knee-high pile of corncobs] of, of . . . because the wool is coarse, you make a big pile like that; now everything is ready and one has to go to the river to wash it.

Lucero went with her father to market in Tlacolula on Sundays to purchase the raw wool brought down to the valley from the nearby mountains.

Many of the older people I spoke with began, like David, by washing wool in the river. This is a less common experience for children now, however, because many homes have running water for most of the year. Similarly, children used to spend long hours carding the washed wool and, when older, spinning it into yarn at the spinning wheel. They rarely do so now, because hand-spun yarn is available from other villages (like Chichicapa) and, more importantly, because the factory in Teotitlán has been producing yarn since 1984. Many young children (especially those of merchants who supply dyed wool yarn to weavers under contract) now spend long hours first making, and then washing, skeins (*madejas*) of yarn. (The process of making *madejas* involves rewinding the yarn from a cone of factory yarn or a one-kilogram ball of hand-spun yarn by coiling it around the circumference of the large wheel of a spinning wheel and then loosely tying the ends of the yarn together. The *madejas* are washed at home in tubs of soapy water or, less frequently, in the river. They are then ready to be dyed by those more experienced and more directly involved in the main aspects of textile production than the children.) Children also spend many hours at the spinning wheel winding bobbins of yarn (*canillas*) from both dyed and undyed, or "natural," *madejas* for those who are weaving. Depending on the pattern to be woven, a single experienced child may be able to wind enough bobbins for an entire day of weaving in a relatively short period of time (e.g., in the hour or two before going to school).

For most, then, their first participation in making textiles means many hours of processing and preparing the wool for those who dye and weave it. In the early 1990s, however, most children spent more time in school than participating (even marginally) in textile production. In fact, while Stephen

notes that the availability of factory-spun yarn freed Zapotec women and children from the work of processing wool so they could spend more time at the loom,[7] it has also meant that very young children may not be pulled away from schoolwork to participate in textile production. When not in school, however, they may still spend considerable time at these sorts of tasks. Many children also play at weaving on makeshift looms created from the rungs of upturned chairs. One can walk into any number of houses and find crude napkin-size textiles strung between the legs of chairs.

As children grow older and more experienced, they may begin to participate in peripheral aspects of the three central processes (spinning, dyeing, and weaving). Later, and often on their own initiative, they move into more centralized roles—many express a desire to work at the loom.

Ricardo Cardenas, for example, described how he both wove and went to school full-time, not because he had to work to help support his family, but because he was interested in weaving. He might have spent less time weaving and more time in school had he so desired. However, not all families can afford to have their children spend many hours in school, contributing little to the economic livelihood of the household. Girls often spend less time in school than boys. Thus, the ways that economic necessity and the composition of the household's labor force affect school attendance also influence how children participate in the processes associated with textile production and, consequently, what they learn about textile production.

In households where economic necessity requires it, or where they express an interest, children as young as ten or eleven may make important contributions by weaving smaller (e.g., 50 × 80 cm) textiles in simple geometric patterns. Typically, however, the first textile that a child weaves, or helps to weave, is a *mil rayas* (thousand bands) design, which uses scraps of otherwise unusable yarn. Several family members may participate in the production of one such textile. As a consequence, then, children often begin to learn weaving before learning how to warp the loom, which illustrates why a "from sheep to serape" description of weaving does not accurately reflect how weavers learn to weave.

Frequently, an older sibling or parent will have warped the loom and begun weaving the textile before a younger child makes a first attempt to weave; but just as frequently, the younger children will help to count the warp threads. In either case, they may help to rethread the warp through the loom's heddles when the threads break during weaving. When that happens, they can thus be characterized as participating legitimately, although peripherally, in the process of warping the loom. The *mil rayas* textile itself can be

characterized as a legitimately peripheral product, as it is manufactured using materials that would be otherwise discarded and is almost never sold, but used within the household compound.

It is important to bear in mind, however, that children learn to weave by helping out in households that are also, at the same time, textile production units in a commercial enterprise. The composition of those units and their changing position in the relations of production influence which weaving skills children learn and where, how, and when they learn them. A full description of the ways that the Zapotec participate in textile production must include the ways that dispersed and "subcontracted" forms of textile production shape the participatory patterns of Zapotec weavers.

Households, Production Units, and Weaving Trajectories

A solid grasp of the different ways in which textile production is organized is necessary for a detailed understanding of participatory patterns in weaving and the economic forces that impinge upon learning to weave. Stephen and Cook and Binford (following the work of Deere and de Janvry in Peru)[8] distinguish between four different kinds of production units—pieceworker, subcontracted, merchant, and independent. The different kinds are defined by their different degrees of access to and control over labor power, the means of production (durable items, such as looms and pots or vats), and the means of work (consumables, such as yarn and firewood), all of which are affected by the incursion of commercial capital. Independent household production units use their own labor power, own the means of production, and finance the means of work, while piecework shops and those who hire at-home pieceworkers hire labor power, and pieceworkers themselves do not finance the means of work. But focusing on local distinctions between merchant and weaver status, while excluding important connections to businesspeople from the United States, distorts analysis of the connections between the production units in the U.S. and in Mexico. It may also lead researchers to distinguish between pieceworker and merchant production units where no such distinction exists.

For example, many production units that have been described as merchant may not finance the means of work, at least not directly, and not doing so is the distinguishing characteristic of pieceworker households. Consequently, many of those whom researchers describe as having achieved merchant status since the 1980s may in fact fall into an entirely different category—what one might call the "subcontracted merchant production

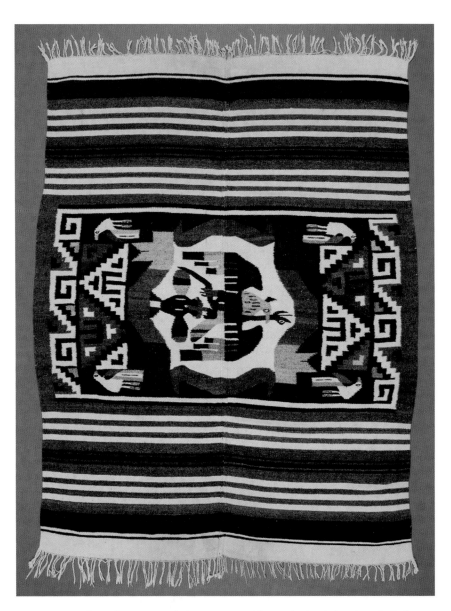

Eagle-with-serpent textile. Woven in Díaz Ordaz by Celso Cristobal, this textile features a common figurative design element in the center—an eagle perched on a cactus and clutching a snake, like the one on Mexico's national flag.

(NHMLAC item F.P.2003-34; image courtesy of the NHMLAC Foundation)

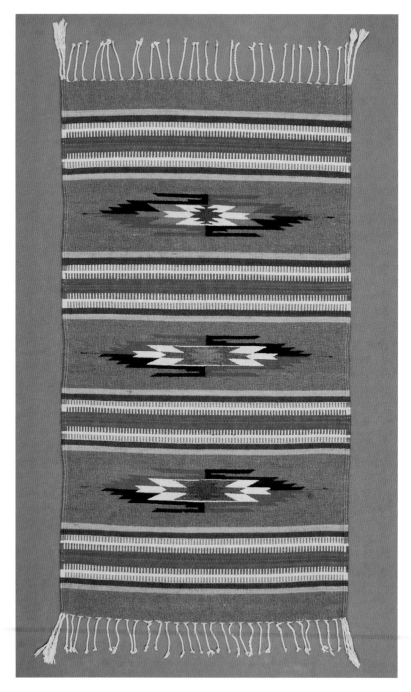

Zapotec Chimayó textile. The chain of businesses involved in the production of this Chimayó-style textile stretches from New Zealand to Texas, Oaxaca, and New Mexico.

(NHMLAC item F.A.3828.2004-5; image courtesy of the NHMLAC Foundation)

Dios ("god") textile. This textile features a coarsely woven figure
representing a pre-Hispanic deity or *dios*.

(NHMLAC item F.A.3828.2004-9; image courtesy of the NHMLAC Foundation)

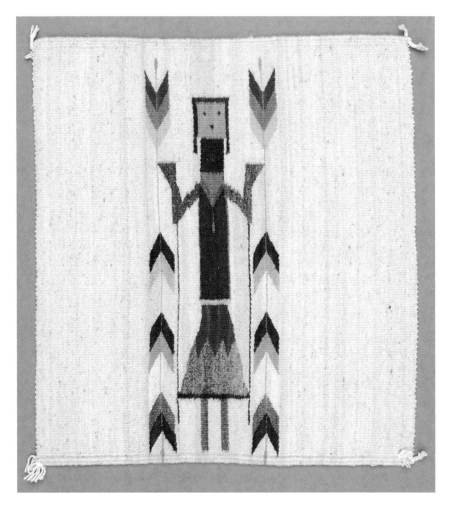

A would-be pillow cover. This was José's first Yei figure pillow cover.
Note the irregular weaving and resulting uneven lines on the figure's upper
arms and dress.

(Textile from the collection of the author; image courtesy of the NHMLAC Foundation)

Would-be pillow cover, detail 1. The textile is oriented horizontally, as José wove it. The upper arm of the Yei figure gave him difficulty.

(Textile from the collection of the author; image courtesy of the NHMLAC Foundation)

Would-be pillow cover, detail 2. The textile is oriented horizon-
tally, as José wove it. The center section of the lower edge of the Yei
figure's dress was woven by José's father.

(Textile from the collection of the author; image courtesy of the NHMLAC Foundation)

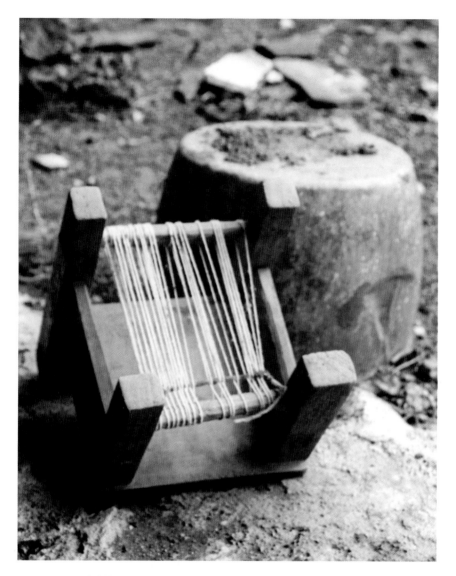

A child's loom. In Teotitlán del Valle, the rungs of chairs are often strung with thread and turned upside down, like this child-size chair, so that Zapotec children can "play" at weaving with discarded lengths of thread.

Selling raw wool. One can still buy raw wool and sheep hides by the kilo in the Ocotlán outdoor market on Friday. Similar vendors frequent the Tlacolula market on Sunday, where many weavers and merchants from Teotitlán, Santa Ana, San Miguel, and Díaz Ordaz, who spin their own yarn, buy their wool.

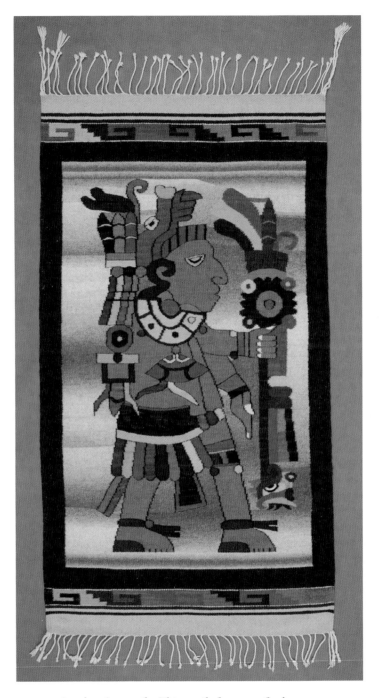

Another *dios* textile. This textile features a finely woven pre-
Hispanic *dios* figure that is an accurate reproduction of a figure
featured on leaf 19 of the Codex Nuttall.

(NHMLAC item F.A.3828.2004-10; image courtesy of the NHMLAC Foundation)

A "Casa Cruz" textile. One of Fidel and María Luisa's textiles featuring the seven different colors, from pink to dark purple, that Fidel obtains from the cochineal insect.

(NHMLAC item F.P.4.2003-32; image courtesy of the NHMLAC Foundation)

Fidel and María Luisa Cruz. The couple work together to prepare a
skein of wool yarn for the dye vat.

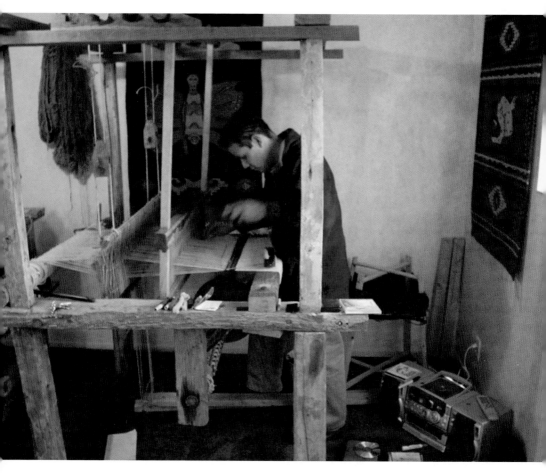

A Santa Ana weaver. Antonio Mendoza at work in his Santa Ana, California, household workshop, where his weaving is dependent upon the skeins of wool yarn (visible in the upper left) that his brother ships from the family home in Teotitlán del Valle, Oaxaca.

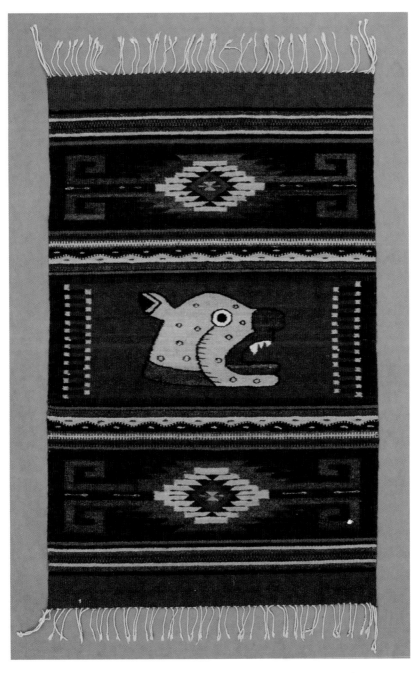

Antonio's award-winning textile. In 2002, Antonio Mendoza won first prize at the Orange County (California) Fair for this textile depicting the head of a jaguar. The image is carved into the foundation stone of a house located in Teotitlán del Valle, Oaxaca.

(NHMLAC item F.P.4.2002-16; image courtesy of the NHMLAC Foundation)

Properly placing a weft. Flying like the hooves of the galloping horse captured in Eadweard Muybridge's well-known photographs, the hands and feet of experienced Zapotec weavers quickly repeat the series of actions depicted here with every weft thread in a textile.

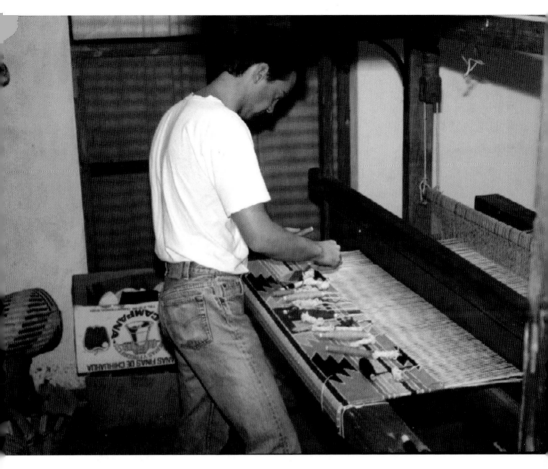

Learning to weave by weaving. For the Zapotec (as well as for me), learning to weave will require many hours alone at the loom, repeating the sequence of practices for properly placing weft threads until it becomes almost automatic, and, most importantly, learning to see the design in terms of those threads.

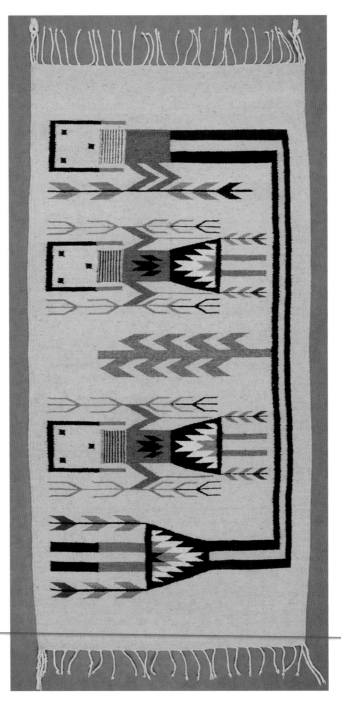

Zapotec Yei textile. Purchased in Santa Ana del Valle in 1987, this textile bears one of the most frequently reproduced Navajo motifs: Yei figures.

(NHMLAC item F.A.3828.2004-7; image courtesy of the NHMLAC Foundation)

unit"—production units doing piecework for businesspeople from the U.S. and also subcontracting piecework out to other households in Oaxaca. In Stephen's and Cook and Binford's terms, these production units are like piecework units in that they do not finance the means of work, but like merchant household units in that they either hire someone to work in-house or contract with pieceworkers who work in their own homes. Such production units are hybrid (they are simultaneously merchants and pieceworkers) and have transnational linkages (they are "working for" merchant production units in the United States just as some pieceworkers in Santa Ana, Oaxaca, for example, are working for merchant production units in Teotitlán).

Any research design with a purely "Oaxacan" (i.e., a "local community" or "regional") focus will be unable to recognize that such production units exist.[9] Adding the provisional category of subcontracted merchant allows us to extend the body of accumulated research and build a framework that easily accommodates the participatory patterns of Zapotec weavers in production units having appendages in Santa Fe, New Mexico, and elsewhere in the United States. When we do so, the United States businesses become one of a variety of textile production units in which Zapotec weavers have been enmeshed since the mid-1980s. Further, because the Zapotec learn to weave as they work in such production units, these are issues central to understanding not only the economics of Zapotec textile production, but also how, where, and when the Zapotec learn to weave by working as weavers.

As Stephen describes, weavers may work in several such units at once, or shift relatively quickly from one to another.[10] For example, a young man from Díaz Ordaz, recently married and with several young children, may not have the resources to finance the means of work (usually yarn) or even the means of production (usually a loom) and as a result may find it necessary to do piecework in his home. However, if he is frugal, he may manage to build up a sizable stock of yarn by making the contracted textiles just slightly smaller than the agreed-upon size. With this yarn he can weave several textiles, which can be sold for a better price then contracted piecework. The textiles might be offered door to door to known merchants in Santa Ana or Teotitlán, or even taken to Oaxaca City, where they might be sold on the street or in the Zocalo to a tourist for a significant profit.

Households like this young man's, which are simultaneously pieceworker households and independent weaver household workshops, are actually quite common. When his textiles go to the merchant who provided the yarn as a part of a piecework contract, then his is a pieceworker household, but when someone else purchases them, whether a merchant in another village or a

tourist from the United States, it is an independent weaver household. Now suppose that this young man, while strolling through the Zocalo in Oaxaca City with his textiles draped over his shoulder, passes the table of a gallery owner from the American Southwest whose eye is caught by the design of one textile in particular. The gallery owner, on a buying trip in preparation for Indian Market (the most important sales period of the year for business owners in Santa Fe), offers to buy two dozen textiles of the same design in varying colors if they can be ready in ten days (when he will leave). Should our Ordazeño weaver be able to convince him to place a deposit on his order (covering the cost of purchasing the wool, dyes, and other materials, which would otherwise be prohibitively expensive) and make arrangements with his cousins, friends, and neighbors in Díaz Ordaz, and perhaps the family of an in-law in San Miguel, to make some of those twenty-four textiles in their houses at an agreed-upon price, using dyed wool he will provide, then his household will become a contracted merchant workshop with pieceworkers, part of a transnational arrangement in which he is both subcontracted (by the gallery owner who provided the capital) and subcontractor (of the weavers making the textiles for him).

Very young children most often participate in textile production by helping their parents. However, they also participate in these multiple and often widely dispersed production units. For example, imagine how the participatory patterns and weaving practices of the children of our imaginary Ordazeño weaver might be affected were he to establish a long-term contractual relation with our imaginary shop owner. They would probably do very little weaving at all, instead spending most of their time making skeins of yarn, washing them, and dyeing them for distribution to the pieceworkers with whom their father had contracted to fill the orders placed by the Santa Fe shop owner.

María Sosa (who was in her mid-thirties at the time of our interview) told me that, because her parents were merchants and only resold the work of others, she learned to weave from someone whom her parents had hired to work in their house. María has six siblings, two brothers and four sisters. While in many families a younger sibling might learn weaving by watching and helping an older brother or sister, her older sisters all chose other career paths, expressing little or no desire to learn to weave. In fact, María indicated that the weaver was hired, at least partially, to teach her to weave.

> Well, from the time I was very little I liked . . . weaving . . . textiles, but my father didn't weave here [at the house]. We had a worker who wove, or a man

who came to weave, and my father, well . . . paid him. And my other sisters, they . . . they dyed the yarn, and they wound the bobbins, and the skeins, all those things. I was fascinated by this, I wanted to learn to weave but nobody . . . the men, they didn't want to teach me because they said that women shouldn't, they ought not to weave, because at that time women didn't weave. Women didn't weave . . . except one woman—her name was Elena . . . she was imposing, strong . . . she was big. Well, I wanted to learn to weave but they said no, no . . . so one day I told my mother that I wanted to learn to weave and she laughed. She told me, "No." She said, "You what? You're going to learn in this house? Nobody [here] knows how." She said, "Not your father, not anyone," she told me, "not even your sisters, and now you are going to learn!" and so I said to her, "Yes, I want to learn," and . . . so they saw that I had it in my head, so my mother said, "I'm going to go talk to a woman," and she went and she spoke to Elena, and then Elena looked at me and said, "This little thing?" And I said, "Yes," I said, "I want to learn." "OK, that's just fine," she told me. So, then . . . my mother bought yarn and everything, you see? So then we had everything and so we said to the worker, "Don't come anymore." And then Elena came, you see?

The importance of power (patriarchy, in this case) and legitimacy to peripheral participation, which Lave and Wenger emphasize, is clearly visible in María's story. She highlights the struggles over resources, social organization, and relations of power that are a part of real-world communities of practice and that ought to be central to any description of learning. For instance, her recollection that the man or men working at her house were unwilling to teach her to weave points to a gendered (and perhaps class-based) division of labor and indicates the saliency of these issues to the notion of legitimacy.

The popular and tourist literature and weavers themselves often say that men do the weaving. As Stephen, Cook and Binford, and other researchers have pointed out, this is not the case. However, María's characterization of Elena as "big" and important (she went on to say that Elena was the first woman to weave and that she taught the craft to many girls), her description of her mother's role in arranging for her to learn to weave (her father—who, we should recall, paid the male weaver—is conspicuously absent from her account), and the dismissal of the male weaver who had been coming to the house all hint at the difficulties that some young girls who want to learn to weave may face.[11]

María and her mother went to great lengths to secure for her a legitimate role participating in the activities associated with the actual weaving aspects

of textile production. While gender no doubt played a role in the difficulties they faced, so did the relations of textile production in her household. Her father was a very successful merchant with clients throughout Mexico, a stall in a Oaxaca City market, and a regular place at the Tlacolula cyclical market on Sundays. He never established contractual relations with business owners from the United States and seldom worked with outside pieceworkers. He was, however, well known as a buyer of textiles, and weavers from Teotitlán and Santa Ana frequently stopped by the household compound to sell him weavings. As María indicated, he also hired at least one weaver to work in their home. For the most part, however, he bought and sold textiles made by others, and his family's involvement in textile production was fairly limited. He had paid weavers (who, María later indicated, worked as general hired hands [mozos] for the family). María's older sisters all took part in textile production (e.g., by dyeing wool), as did María and her mother, but the actual work of weaving at the loom was another matter. In spite of the multiple ways that the organization of textile production in her home conspired against her working at the loom, she and her mother managed to create a space for her to do so. Since she learned (and has now taught her brother) to weave, María related with some pride that her family has not needed to hire weavers.[12]

The account of another woman in her mid-thirties illustrates many of the same points and highlights still others. Lucero, whose parents wove themselves and also ran a very successful workshop employing several weavers, described how she worked to create a space for herself in their workshop.

> Well . . . I began to work in crafts; when I was very young I began with my parents. The first things that I learned were for the kitchen. I was in the kitchen for about six years; I learned how to prepare everything. Everything to make tortillas, everything for all of the domestic chores. But at that point I became very enthusiastic about crafts and so I spoke to my father, at the age of six I spoke to my father (and I was in school studying, right?). But I was already taken with [thoughts of] beginning to weave.

Here we see other aspects of the gendered division of labor in Teotitlán. Lucero spent a great deal of her time helping in the kitchen and learning to make many of the staples of her family's diet. Nor did all of Lucero's five sisters (there were ten siblings in all) learn to weave as she did. In fact, the next youngest sister never developed any skill at weaving, having spent the majority of her time helping her mother to feed the rest of the family and those employed in the workshop.

The participatory patterns in textile production that developed early in the lives of all three of these women (María, Lucero, and Lucero's younger sister) have played a major role in their learning to weave and learning not to weave. The gendered division of labor in the household and household demographics (e.g., birth order and the numbers of male and female siblings) strongly influenced the degree to which they were able to participate in activities that allowed them to observe and practice the skills involved in learning to weave.

Lucero and María began the process of learning to weave on their own initiative. One of Lucero's brothers did so as well:

> I lived with my father, I began to work with him when I was eight . . . or nine years old. I don't know, I don't remember exactly, but I think it was when I was about eight years old. Right now I am twenty-six. I . . . I learned directly from him, like everyone and like in all the families in Teotitlán. It is inherited work, it is a tradition . . . So I was taken by the idea [of weaving] from an early age, from having seen my father weave. I would sit under my father's loom, watching like this [referring to a baby at our feet looking up at us], watching him weave. I said that I wanted to . . . that I wanted to weave . . . and I began. When I wove my first textile I wasn't tall enough for the loom so we . . . my father made two very high wooden platforms and we set up for what we call here "the first" [i.e., the first textile]. Just like that, at that point . . . I could reach the loom and was able to weave.

In short, if their participation in textile production is to become more centralized, children must take the initiative, ensuring that they are in the right place, interacting with the right people, to be able to learn the necessary skills. Many Zapotec weavers, both men and women, take great pride in having told their parents that they wanted to weave, that they wanted to contribute (in the "traditional" way, as this young man put it) to the economic livelihood of their families. For many, weaving is an important part of their identity.

Parents, in turn, seem to take great pride in children who show an interest in weaving at an early age. By accommodating and encouraging the interests of their children, parents create positions from which their children can gain exposure to the skills and knowledge associated with textile production. They make legitimate the roles that their children desire to take on— even if only on the "play looms" of upturned chairs. One Teotiteco described "play weaving" and its role in his childhood experiences this way:

Well, it's like playing and making little things in your free time, or something like that . . . It's just to . . . to practice and for some kind of play. The child initiates this . . . you have to understand that the father helps him, right? He tells him more or less how to do it, but it's on the child's initiative. Because he wants to do what his father's doing, what he's weaving. Even I felt this, right? And this . . . just now I'm remembering, and I believe that all the kids during my childhood did this.

Weaving is all around children, and adults encourage and support their interest in it. Many of them grow up in households where weaving is the focal point of most of the daily household activities. Weaving tools, materials, and equipment are permanent features of their environment. Weaving permeates their lives, and even their play revolves around it from time to time.[13]

The pattern through which children are included in textile production has specific consequences for what children know about it and how they come to have that knowledge. Some may never be more involved in textile production than the play and contributory activities described here make them. The relations of production characterizing Zapotec textile production are immensely important to understanding their trajectories, as well as the participatory patterns of those who become Zapotec weavers. For example, children growing up in a pieceworker household may be exposed to very different activities than those growing up in a merchant household that employs at-home pieceworkers. While children growing up in a merchant household with few weavers at work in the family compound may spend considerable time helping their parents to dye wool (especially if their parents have a large number of weavers working for them) and very little time winding bobbins, children growing up in a pieceworker household may almost never be involved in yarn-dyeing activities, because the yarn their parents use is supplied to them already dyed. The children of a merchant with a large number of pieceworkers but very few or no in-house weavers may have little exposure to the activities associated with actually working at the loom—María's story is a perfect illustration of this point.

As we have seen, children do not learn weaving from start to finish, "from sheep to serape," but in fits and starts, simultaneously exposed to multiple points in the production process. They learn weaving in the household workshops scattered throughout Teotitlán, Santa Ana (Oaxaca), San Miguel, Díaz Ordaz, and beyond. They do so by participating in productive activities (including the core processes of yarn making, yarn dyeing, and weaving)

that, as a consequence of the relations of production that characterize Zapotec textile production, are highly dispersed and riddled with divisions. This pattern, as well as its resultant effects on weaving skills and knowledge, does not, however, end in childhood.

As children get older, parents sometimes make arrangements for them to work in the homes of relatives or godparents. In fact, many young teenagers find work as weavers outside their own households. The reasons for this are multiple and range from the straightforwardly economic to the very personal. Today, young men and women may move from one household workshop to another. In an Ordazeño weaver's words,

> The young people, those about twenty years old or those that have parents who do not know how to weave . . . they learn how to weave when they are quite old, like twelve or fourteen . . . in order to . . . in order to work. It's more, it's more like a necessity, not in order to learn to weave. Most often it is out of economic necessity. It is out of necessity that they go to another house to learn, right? At that point you're talking about . . . about whether or not someone can make skeins or whatever, whatever job . . . or go to the U.S. and make a lot of money, right? It's an economic question.

Many of the families of the young men and women fitting this description simply do not have the economic resources to finance textile production and then to wait for a textile to sell, much less to hire someone to teach them. Some weavers (especially those weaving to provide extra income to their families or to raise enough money to finance a trip north to the U.S. to work) may weave, either at home or in their employer's workshop, because they know that they will be paid immediately upon finishing the textile. Because piecework is paid on completion of each piece, it also appeals to those without contacts with professional textile buyers from the United States, who might otherwise have to rely on sporadic sales of textiles to tourists (weavers in San Miguel and Díaz Ordaz are more likely to be in this position).

Some young weavers begin to work in another household out of a desire to be more independent and to distance themselves from their parents. Others enter such arrangements on the understanding that they will have access to skills and knowledge that would otherwise remain unavailable to them, and their parents often help arrange these moves. Ricardo Cardenas, who was in his late twenties when we spoke, began to work in the workshop of his father's brother when he was in his early teens. He emphasized that he

did so in order to improve the quality of his weaving and to learn how to weave different designs.

> I asked him . . . for the opportunity to be able to learn [to weave] the figuratives [figurative designs]. And . . . he wanted to . . . he was a good person . . . in the sense of being able to teach you something. And he wanted to teach me because I wanted to work for him, you know? . . . I liked to try to do something different from what I could already do—from the geometrics [geometric designs] like the *grecas* [Greek key motifs]. But I wanted to develop . . . to improve my work and do other, more interesting things, you know? So I asked him for this opportunity and he said yes, that he would be able to teach me how to manage [*manejar*] the threads and . . . the colors and everything. So he accepted with great pleasure.

Both Ricardo and his parents recognized that the weaving "education" he could get at home was limited in important ways. The relations of production in Ricardo's parents' household could be characterized as shifting between the models of independent weaver, merchant employing at-home pieceworkers, and pieceworker. His father and older siblings sold their textiles and the textiles of contracted pieceworkers in Teotitlán's textile market but also worked as subcontracted pieceworkers for Ricardo's uncle. Because of these arrangements, Ricardo was able to participate in and gain mastery over the processes associated with wool preparation and dyeing as well as weaving. As he indicated, however, he wanted to challenge himself and expand his design repertoire and weaving techniques in ways that his father was unable to support. His uncle was a major political and economic figure in Teotitlán. A number of weavers of varying skills spent long hours at the looms in his family workshop, and he was well known in both Mexico and the United States for the large, complex *codex* (indigenous pictographic manuscript) design textiles produced in his workshop. Ricardo's desire to work in his workshop and learn from him is perfectly understandable.

Very little formal teaching is involved in maturing as a weaver, and this is widely recognized throughout the Oaxacan villages where Zapotec weavers live and work. "Teaching" for Zapotec weavers might be characterized as doing something in the presence of someone else, and, as a consequence, learning to weave is the responsibility of the person doing the learning. If one wishes to learn something, the most that one can hope for is to be in the presence of those undertaking similar activities. In short, the work of pro-

ducing textiles is a part of daily lived experience: what one learns about producing woolen textiles and how proficient one becomes at doing so depend on one's own initiative, skill, and intelligence.

A major shift in participatory patterns may occur when individuals marry and start a family. Tomas Montoya and his wife Josefina, who live with Tomas's parents, had been married for only a few years in 1991, when I interviewed them for the first time. As a child, Tomas had worked alongside his three older brothers and his father in textile production in the early 1970s. Now Tomas's father was a pig butcher, and Tomas spent most of his time either helping slaughter and process the pigs or working at his own textile business. At the time, they had one young daughter (Lupe), and Josefina was expecting a second child. Tomas was also beginning to hold minor, although time-consuming, religious and civil offices, as is expected of young men. Josefina was quite busy with her child, her pregnancy, and the work around the house that Tomas could not do when he was busy at the church (*templo*) or the town hall (*municipio*). In short, Tomas and Josefina were just beginning their family and had begun to take on the responsibilities of adulthood, including providing for their children.

By the end of 1992, Tomas's textile business was in trouble, and when I spoke with him again he expressed his concern over the situation as well as the added responsibility of providing for his growing family. At that time, he was working closely with merchants from the United States, and unfortunately, because the boom of the early and mid-1980s had ended, business was not good. Tomas's business was centered on Santa Fe–style pastel weavings and, for a time, saddle blankets. He confided that he felt squeezed between merchants from the United States, who were increasingly trying to hire weavers "on credit" (because the U.S. economy was sluggish and inventory did not move quickly) and the Mexican government, which had established official channels for—and taxes on—the export of textiles to the United States during the Santa Fe–led boom of the 1980s.

> It's more difficult and now you just can't sell to sell [i.e., on a small scale, to make a little money]. Before you didn't . . . you didn't have to give these . . . these notices to SECOFI [the Secretariat of Commerce and Finance], [now] nothing is open, everything [changed] in . . .'88 or '89 . . . That's where we are now. I don't know how . . . how it can continue to function like this. I don't know exactly where it's going or if it's finished. I don't know if free trade [i.e., NAFTA] can help, I just don't know.

By the early 1990s, Tomas and Josefina had three looms and a couple of weavers who worked sporadically. Most of the textiles they sold, however, were produced by pieceworkers in Teotitlán and Santa Ana. Tomas, Josefina, and one of Tomas's sisters constituted the core of the household workforce. Tomas's sister was between jobs in Mexico City at the time, and after an extended stay in Teotitlán, she eventually returned there to work as a domestic.

Josefina's family background was quite different from Tomas's, and somewhat unusual. Her father had a market stall in Oaxaca City where he sold textiles, so Josefina, an only child, and her mother were frequently left at home alone. A merchant, her father bought many of the textiles that he resold at his stall. His small family could not provide enough labor to expand the business and, as a consequence, Josefina's exposure to and involvement in the activities associated with textile production was very limited. Josefina put it this way: "When I began to weave I was eight years old . . . now, um, I made [wound] bobbins and I wove once in a while . . . but now that I've come here, now, little by little, I've been learning."

As a child, she had helped out around the house, as any daughter would, by making bobbins and doing some weaving. Also, as a daughter, she had little responsibility for deciding what ought or needed to be done at a given time. When Josefina married Tomas and moved into his family's compound in 1990, things drastically changed for her. She took on very different roles in her new household (mother, wife, and daughter-in-law), and along with those new roles came new responsibilities, especially where textile production is concerned.

> When I came here, well, I had to learn everything. How to wash the wool, yes, that I did in my house and at first when I came here, that's when . . . when I had to wash the yarn, make the bobbins . . . little by little they taught me how to dye the yarn and . . . now I dye the yarn.

By the beginning of 1993, when I interviewed Josefina again, she had given birth to a second daughter. In addition to caring for her two small children, Josefina was also learning to think about what needed to be done to maintain her family's textile business. In other words, in a household employing a large number of at-home pieceworkers, she had to learn to manage a workshop. She had to take responsibility for making sure that others had work to do.

What I learned here was to see. To see what they need to do to make the textiles or what size to make. Because in my house, yes, textiles were made . . . but they just told me what size I was going to make . . . one twenty [centimeters wide] or a meter, but I didn't know about anything else, forty, fifty, or sixty [centimeters] by a meter. I didn't know any of this until I came here, that's when I learned.

In short, Josefina, who had never been much involved in wool and yarn preparation in her parents' home, gradually took on more and more responsibility in her new family's textile business. She began in peripheral roles in textile production in her new household: making skeins, winding bobbins, and washing yarn (something with which she had some familiarity). From there she moved into more centralized forms of participation: calculating how much wool would be needed for an order, for example, then dyeing it and supplying it to the pieceworkers in their employ. Just as the organization of her parents' textile business affected what Josefina learned about making Zapotec textiles, so too, her new family's textile business had profound effects on what she learned. Josefina's practical weaving knowledge was a testimony to the changing contexts in which she worked—a product of her personal historical pattern of participation in textile production. Within three years, however, Tomas and Josefina had given up their weaving business and committed themselves to working as butchers full-time.

The fluid, flexible arrangements that characterized both Tomas and Josefina's personal histories in textile production and its organization in their home are the rule rather than the exception for most Zapotec weavers. Because Zapotec weavers learn to weave as a part of working in family businesses, either their own or those of others, changes in the success of those businesses, the economic climate in which Zapotec textiles are produced, and the position of those businesses in relation to others in both Oaxaca and the United States have profound effects on learning to weave. Many people in the Oaxacan villages where Zapotec textiles are made never become proficient weavers, for a variety of reasons: some are economic, some have to do with household demographics, and some have to do with personal inclinations. Learning to weave under these conditions is, quite literally, often a by-product of making a living. Consequently, issues of personal history, access to resources, and the social control of those resources occupy a central position in discussions of the changing patterns of participation of those who learn to weave by working as weavers.

By 1997 Tomas and Josefina had completely abandoned their textile business—or, more exactly, it had abandoned them. The concerns that Tomas had expressed in 1992 over what the future would bring and the pressure he felt on his ability to maintain the business were well-founded. As the Santa Fe market for Zapotec textiles shifted to Navajo look-alike weavings in the early and mid-1990s, Tomas and Josefina came to rely more and more on a small number of clients (especially one business in the United States) and on the production of thick saddle blankets, for which Tomas had learned to wind bobbins of very thick three-ply yarn. Unfortunately for Tomas and Josefina, at the same time in Ocotlán Graham and James, whose business I described in chapter 4, were beginning to produce tightly woven textiles on mechanized looms that needed only to be monitored by an operator. The lanolin-heavy yarns they were producing from their imported New Zealand wools lent themselves especially well to thick but simply designed saddle blankets. Tomas and Josefina lost their most important client to Lanería de Ocotlán, which spelled the end of their business and the end of semi-regular employment for the pieceworkers with whom they worked. Tomas and Josefina's children will more likely learn the skills of butchering pigs and making *chicharrón* (deep-fried pig skin) and *chorizo* (pork sausage) than of crafting Zapotec textiles.

Legitimate Peripheral Participation in Zapotec Weaving

When people in the villages of Teotitlán, Santa Ana (Oaxaca), San Miguel, and Díaz Ordaz learn to weave (and learn to be Zapotec weavers), they do so in fluid social contexts. Their circumstances are, if not in a continual state of flux, certainly never stable for long.[14] On the other hand, the ways that people move through and among these unstable contexts are significantly ordered and regular, whether because of particular aspects of family structure or simply because of financial considerations. This pattern of change, and the consequent order in the fluidity of the contexts in which the Zapotec work at weaving, are important features of learning to weave by working as a weaver in the spirit MADE IN MEXICO. Zapotec textile production is so highly dispersed, and the relations of production so highly volatile, that any one weaver's knowledge of the craft of weaving is the product of participation in multiple contexts of learning to weave. This pattern of participation is the order in the social context through which the Zapotec know of weaving. It is the world as lived, and it, rather than a "from start to finish" model, must be made the defining feature and organizing principle of our under-

standing of the ways through which Teotitecos, Santeros, Migueleños, and Ordazeños learn to weave.

In other words, the order or stability of the context of learning to weave—or working as a weaver, as Na'un put it—is not strictly speaking a factor of household composition or production unit organization, but may be discerned in the patterns of participation that emerge as one focuses on the working lives of Zapotec weavers. We should not ignore how household workshops are organized and how they are connected to a wider universe of people engaged in crafting Zapotec textiles, but such connections and social milieus are but one axis of the context of becoming a Zapotec weaver. The second structural axis is the biographies of weavers. Together, they create what Bourdieu calls the "space of possibilities" that shape practice.

Weaving is both an economic activity and frequently a part of daily experience in the home. Consequently, the demographic composition of a household must be considered central to any description and analysis of learning to weave. When one learns to weave in Teotitlán, Santa Ana, San Miguel, or Díaz Ordaz, one does so while enmeshed in relations of production and a division of labor that have profound effects on what one knows—and what one can learn. The nature of household reproduction and organization, and the related issues of labor force composition and resource allocation within the household, are therefore important to a study of learning to weave. Of equal importance, however, are the participatory practices of Zapotec weavers—a life's work at weaving is the medium through which such factors are brought to bear on the context of learning to weave.

Beyond the level of the household, learning to weave as the Zapotec do is also a part of generative social practice, engaging with the highly diverse and fluid arrangements that have come to characterize the relations of production of Zapotec textiles over the past forty years. The different types of production units encompassing more than one household (pieceworker production units, merchant production units with hired laborers, and so on), whether different households in a single village or households in multiple villages (and even across international borders), are also important to understanding the generative social practice of which learning to be a Zapotec weaver is a part. Changes in the organization of these production units over time and in the participatory patterns of Zapotec weavers over the course of their careers embed the practices and resultant practical weaving knowledge of the Zapotec in a dual history: in the personal histories of individual weavers and, simultaneously, in the history of changes in the relations of Zapotec textile production that have been so well described by previous researchers.

In Teotitlán and the other villages where Zapotec weavers live and work, one of the most important implications of the ways that peripherality and legitimacy structure learning to weave is that not everyone learns to weave—at least not to the same degree. The Zapotec learn to weave mostly by working as weavers for their parents or for another family as they contribute to their own household's economy. They may work for another family for economic reasons or to learn specific skills and processes. Conversely, people from these villages may not become proficient weavers, either because the household in which they grew up was not involved in textile production, or because their own contributions to the household economy involved other activities (e.g., activities associated with child rearing, food preparation, agricultural work, or migration to the United States).[15]

Many begin to weave at a very early age, and are weaving full-time (in their home or the workshop of someone else) by the time they are fifteen. They may move into entrepreneurial roles in their mid-twenties and oversee the dyeing of large quantities of wool. By the time they are thirty-five years old, they may be working with professional textile buyers from the United States to design an entire line of textiles to be marketed in galleries and gift shops throughout the American Southwest. Others, because of household circumstances or a general disinterest in weaving, may never move far beyond the peripheral tasks, such as winding bobbins and making the fringes of textiles, that they began doing when very young. Here again, the Zapotec learn *not to* weave through their participation in social practice.

What is entailed in Zapotec social practice? Part 1 of this book explored a number of spaces (geographic and cyber) in Mexico and the United States where Zapotec textiles are crafted, demonstrating that issues of authenticity are the medium through which the contours and borders of these spaces are debated and distinguished. Collectively, such spaces are crafted through the varied practices of a community of people who are simultaneously debating and distinguishing the limits of those spaces in their practice. The Zapotec learn to weave by working with and against those people to craft authentically Zapotec textiles.

Following the recommendations of Lave and Wenger, this chapter has explored weavers' participatory biographical patterns as they grew up working at weaving. As we explored the intricacies of these participatory patterns, we also developed a sense of how issues of legitimacy and relations of power were implicated in access to and control over resources as well as in the life trajectories and histories of Zapotec weavers. This focus on how learning to

weave is an "integral part of generative social practice in the lived-in world"[16] has a number of consequences for our understanding of both the immediate and broader social milieus within which learning to weave as the Zapotec do takes place, and on practical weaving knowledge itself. By drawing directly on Zapotec weavers' own accounts of their lives, this ethnography documents that, for most, learning to weave is a part of generative social practice both within the household and across one or more production units, and (as the opening discussion of the next chapter will show) is also connected to a wider network of people working to craft Zapotec textiles, both materially and symbolically.

As the focus of this study continues to narrow, we will gain a clearer picture of how the skills and knowledge of Zapotec weavers develop as they participate in specific practices associated with the production of this material and symbolic product. As Zapotec weavers move from one weaving context to another throughout their lives, they embed themselves (and others help to embed them) as weavers in social practice, crafting particular career trajectories with corresponding practical weaving experiences, which are given form and shape through the social context of their appropriation—that is, through participation in weaving practices. Here again, it is not immersion in the context of social practice that "determines" weaving skills and knowledge, but participation in social practice that opens a space of possibilities for becoming a Zapotec weaver. Through the medium of experience, weavers craft career trajectories that shape weaving skills and knowledge—that is, in practice through shifting patterns of participation. Becoming a Zapotec weaver entails embodying weaving practices in a division of labor and within a workshop environment with connections to other workshops as well as the social spaces where "authenticity" is crafted. That is what Lave and Wenger meant when they wrote that learning is, quite literally, a process of appropriating the structural characteristics of a community of practice.

To Learn Weaving, MADE IN MEXICO

Learning to be a Zapotec weaver is an "accumulation strategy." Donna Haraway used this phrase when commenting on the social construction of the body:

> There is some kind of deep corporealization that has gone on through the on-the-ground social practices of the constructions of the body for us in institution after institution . . . which have deep material consequences and are deeply materialized instances for bodies enclosed in particular ways.[1]

Haraway's notion that the body is an open-ended project of corporealizing social practice is, broadly speaking, in keeping with the position on bodily techniques and practical weaving knowledge that I developed in the introduction, following Vygotsky and Mauss. To say that becoming a Zapotec weaver is an accumulation strategy is to emphasize that each weaver's practical weaving experience is central and that each comes to embody the social conditions (filtered through a career trajectory) in which he or she works. The Zapotec embed themselves as weavers (and others help to embed them) in social practice, and the resulting bodily techniques and practical weaving knowledge are the cumulative result of that strategic career trajectory.

Rather than viewing the social construction of Zapotec weavers as deterministic or imposed from above, this account stresses that the Zapotec actively construct themselves as weavers. The vocabulary used to describe this self-construction—

"strategy," "appropriate"—highlights Zapotec agency as it points to the ways the Zapotec themselves strategically frame their participation in textile production and position themselves in ways that enable them to appropriate the weaving practices they deem it important to master. It is in this sense that their bodily weaving practices and knowledge are the cumulative expression of strategic career trajectories.

It should be noted, however, that they strategize within a social universe that is, to a large extent, controlled and managed by others. The associations between indigenous crafters (and the product of their labor) and what is thought to be authentically indigenous, which are carried around like so much baggage by those who purchase Zapotec textiles (and shaped by those who inform our understanding of the worth of the textiles), are an important part of that universe. To borrow from Bourdieu, there is a "space of possibilities" for Zapotec weavers,[2] but that broader social space is a large project negotiated through the power plays of a multitude of competing interests, of which the Zapotec are an important part, but nonetheless just a part—particularly since almost all Zapotec weavers are working for someone else when they weave.

David Harvey later took up Haraway's concept of an accumulation strategy in his exploration of the place of the body in capitalism, noting that because "we all live within the world of capital circulation and accumulation this [fact] has to be a part of any argument about the nature of the contemporary body."[3] Harvey's insight that capitalist relations of production are an important part of the social construction of the body allows us to couple this account and analysis of Zapotec bodily weaving techniques and knowledges with the analysis of the relations of production in late capitalism that informed chapter 4's treatment of post-1980s changes in the Zapotec textile production complex.

Harvey begins with Marx's suggestion (in volume 1 of *Capital*) that workers are transformed into appendages of capital, noting that recent interest in the social construction of the body has all but ignored Marx's important contributions to theorizing about the body as a social project. Felicity Collard, like Harvey, notes that Marx paid a good deal of attention to the body and that his work anticipates "post-modern" theorizing on the subject. Too often, she finds, the important work of Haraway, Michel Foucault, Judith Butler, and others is watered down into a "generalized narrative" that assumes "fragmentation" and "hybridity," and this work is "run together to produce slack composite versions of 'postmodern identity.' "[4] The great danger, she insists, is that this generalized narrative about the post-modern body

has lost track of its debt to *Capital,* even while building on it. Closer examination of what Marx actually wrote about the laboring body, for example, makes problematic the simple divide between modern, naturalized bodies and post-modern, fractured bodies assumed by many who work from the generalized post-modern theoretical narrative that Collard describes. Marx, she notes, found that manufacturing (machine) work "converts the worker into a crippled monstrosity . . . the individual himself is divided up, and transformed into the automatic motor of a detail operation."[5] Through such passages, according to Collard, Marx put forth a basic argument about how power transforms and reorganizes (even disciplines) the laborer's body to suit its own ends.

Harvey stresses that Marx's work is complementary to that of contemporary theorists, such as Foucault's analysis of how the historical development of institutional power has disciplined the body (what Foucault calls "biopower").[6] To understand how capitalism disciplines the bodily practices of laborers, he works from Marx's notion of "variable capital": a principal process for extraction of surplus value through the "circulation" of "labor power" from laborer to capitalist to commodity and wage, and back again to laborer. In that process, the "exigencies of capitalist production push the limits of the working body . . . in a particular set of contradictory directions" that are, in turn, shaped by the value of labor as measured "through the exchange of commodities over space and time."[7]

In essence, the contradictory pulls of capitalism require a laboring body that is conflicted, one that is simultaneously docile and passionately creative, intuitively responsive to various possibilities but blinded to other sources by tunnel vision. Harvey puts it this way: "capital requires educated and flexible laborers, but . . . it refuses the idea that laborers should think for themselves."[8] The directions of such pushes and pulls are a response to the degree to which the commodities produced by the laborer are themselves valued in the market and the degree to which the work of the laborer increases the exchange value of the product of that work. The laboring body, disciplined in terms of the circulation of variable capital, is a repository of that process. It quite literally accumulates or "puts flesh on" the history of the contradictory pulls to which capital subjects it. Further, the bodily practices of laborers, that is, their bodily techniques and practical weaving knowledge, carry the imprint of that contradictory history.

In his review of Mauss's perspective on the body and its relation to poststructural theory (notably, Foucault's notion of "techniques of the self"), Ian Hunter argues that bodily techniques are more appropriately understood as

"specific assemblages of actions, stored and transmitted in particular social organizations and relationships" that are the "cultural and historical artefact of particular 'gymnic' arts and technologies."[9] Having developed an account of the social (and economic) organizations and relationships through which Zapotec weaving practices are stored and transmitted in the previous two chapters, this discussion will now focus on one assemblage of Zapotec weaving practices and work toward an understanding of how social (and economic) organizations and relationships leave their imprint on Zapotec weaving knowledge and practice. A key component of that story will be Harvey's exposition of the role of variable capital—the contradictory pulls it places on the bodily practices of Zapotec weavers, on their hands and feet, while they work at the loom. The exchange value of Zapotec textiles—broadly speaking, their worth in the market added to the value of the labor involved in their production—produces a particular set of contradictions, pulling at the same time toward one-of-a-kind "works of art" and commercial, nearly "mass-produced," craft items. These contradictory impulses, whose relative weight follows from the value of Zapotec labor as negotiated in the wider weaving community where Zapotec textiles are made, are in turn materialized in the bodily weaving techniques of Zapotec weavers; they push and pull at the weavers' practices even as the weavers use their looms to push and pull woolen yarn into textiles.

Weaving Trajectories in the Field of Zapotec Textile Production

By all accounts, 1997 was a very good year for Fidel and María Luisa Cruz. Fidel was recognized on three separate occasions for his use and development of "natural" dyes—once by the state government of Oaxaca and twice by the Mexican federal government. But the couple considered his greatest achievement of the year to be winning the grand prize at the Exposición y Concurso Nacional de Artesanías, "Las Manos de México: Forma, Color, y Textura . . . Lenguaje de los Artesanos" (National Crafts Exposition and Competition, "Mexican Hands: Form, Color, and Texture . . . Language of Artisans"). In the following year, the Oaxacan government presented him with awards for having won that prize—on no fewer than three separate occasions.

Just as Tomas and Josefina were giving up on saddle blanket textiles, then, Fidel and María Luisa were seeing their greatest success. Comparing Tomas and Josefina's declining business with Fidel's awards and recognition helps demonstrate how weaving (and dyeing) practices and the career trajectories

of Zapotec weavers arc shaped by institutions and social formations beyond the production units and household structures considered thus far. This is not to say that household formation and organization of textile production should not be taken into consideration. Rather, Fidel and María Luisa's "success story" will highlight the connections among household production units, the weavers who work in them, and a wider social universe of which both groups are a part. Lave and Wenger's framing of changing patterns of social practice in terms of legitimate peripheral participation will here be applied to cultural spaces well beyond Oaxacan villages, emphasizing that Na'un's insight that the Zapotec learn to weave by weaving must be applied to the wider Zapotec weaving community of which their work is a part.

In their book *Mexican Folk Art from Oaxacan Artist Families,* Arden Aibel Rothstein and Anya Leah Rothstein declare that Fidel is a "virtuoso of color." The Rothsteins are not alone in their emphasis on the "glorious and exotic array of natural dye colors" that Fidel has developed. In a book devoted in its entirety to Fidel's work, John Forcey explains that Fidel and María Luisa evidence a "pride and a vocabulary that indicated a more complete knowledge [than other Zapotec weavers had] . . . not only of [the value of] using natural dyestuffs but also of how to [actually] use them." Both books introduce many of the themes that will frame the ways Zapotec weavers participate in a dispersed set of social practices that help to craft a desire for Zapotec textiles: an emphasis on natural dyes and corresponding connections to pre-Hispanic "tradition," as well as the textiles' legitimation and authentication by both institutions and interested persons.[10]

The story of Fidel and María Luisa began when they were married in the early 1990s.[11] Like most recently married couples in Teotitlán, the newlyweds moved in with the groom's family. Fidel's family employed as many as six weavers in their shop, as well as several more who worked in their own homes in Teotitlán and Santa Ana. The family also worked with several professional buyers from the United States, producing a wide variety of textiles for the Southwestern art market, including reproductions of Navajo designs. As Fidel and María Luisa tell it, however, they soon wanted to do something very different, both because of a lack of support from Fidel's family and out of the desire to create something unique and independent. This is an urge that Fidel has had since he was a young boy, as María Luisa explained to me:

> He's always had, well, this desire . . . he traveled for the first time, without knowing anything about it, to Mexico City at the age of *ten,* alone, to go to an

exposition where his parents had been invited to sell textiles. "Well," he said, "I'm going, and I can do it."

The story that Fidel and María Luisa tell is one of financial hardship. They had been living with Fidel's parents for less than two years when they decided to strike out on their own, building their own house and starting a business with half a dozen textiles that Fidel had woven and a couple of looms. In those difficult days they did not even have the financial resources to buy the chemical dye packets and acid that most weavers use, so they turned to something they could get for free: pomegranates collected from the garden of María Luisa's mother and a locally grown shrub (*Jacobinia spicigera*) known as *sacatinta* (which means "gives color" in Spanish). The textiles they wove using these natural colorants sold readily, and with some of the proceeds from those sales they purchased cochineal. Fidel began to experiment with various methods and mordants (color fixatives), and with time began to see some success.

> Well, I more or less did it because I didn't have the resources. And what I didn't have in that time were the colors from indigo and cochineal . . . because I didn't have money to buy them. And after selling my pieces, then I had some resources.

By the time of our interview in August 2002, Fidel and María Luisa had two young sons. In the decade since they were married, as they describe it, they had striven, through hard work and initiative and without help from others, to make their textile business unique in a village full of such businesses. Now they had a large house on the highly touristed main road into town, their business included at least four at-home piece-wage weavers, several looms, dye vats, spinning wheels, and other materials, and they sold textiles to an international clientele.

They had been able to craft a unique identity for their business, grounded in their development of a distinct palette of colors derived from natural sources, including walnuts, moss, and cochineal. Forcey reports that they "speak of *their* dyes, *their* colors,* and in fact, their colors are different from any of the few other artisans who work with natural colors." He quotes them as saying, "we can do something special, something different, that no one else does."[12] Dyeing demonstrations at their home, for example, emphasize that they have developed not just a single cochineal red but seven different shades, ranging from a rosy pink to a deep, dark purple. Over the course of a couple

of hours, Fidel adds heaps of cochineal freshly ground by María Luisa and a variety of mordants to the boiling vat, pulling the wool yarn out periodically to demonstrate how the color gets darker and richer. The monotony of the two-hour-plus dyeing demonstration is broken up with carding and spinning demonstrations performed by María Luisa, a weaving demonstration, and time for the visitors to purchase textiles.

Clearly, their plan to do something unique and special has some antecedents. Like Carlos's family (described in chapter 2), Fidel and María Luisa position themselves as different from other Zapotec weaving businesses because of their use of natural dyes. Both Fidel and Carlos emphasize their individual spirit and drive to do something that requires an immense personal investment with no great financial incentive (considering that weavers not using natural dyes are generally successful). To borrow Peden and Paterson's description of Carlos, they are "pure artists"[13] who have resisted the more immediate financial gains of working with the cheaper chemical dyes as well as their fellow weavers' lack of interest in developing such expertise, simply because of their own desire to explore these techniques. Contradicting their assertions that they lacked the financial resources to buy chemical dye packets when they started out, María Luisa states that Fidel was simply unable to bring himself to use them:

> Actually, [he] couldn't, he couldn't do it . . . he had like fifteen kilos of wool, skeins of wool, white and gray, that he was going to dye, supposedly in artificial colors, and he was there ready to dye it, but he never dyed it. So he says, "but this is the thing I am most, most embarrassed about," he says, "this isn't the right way," he says, "let's not even try it [like this]."

According to this narrative, Fidel and María Luisa struck out on the "right" path despite personal hardship and a lack of resources, a path that required sacrifice and perseverance but about which Fidel would not be embarrassed—using natural dyes for their textiles.

Fidel and Carlos are not the only weavers to have distinguished themselves from others by developing and using natural dyes. For example, Forcey says that María Luisa's "father had tried years before to encourage the use of the old natural dyes made from plants that grew in the town or in the communal land of the village, but when he had died, the motivation and vision to use the traditional methods had seemed to die also . . . with only Maria Luisa's memory to guide them, they had found . . . the secrets of producing the colors." Moreover, all five families featured in the Rothsteins' text

express pride in the use of natural dyes. Photos of four of the five families include images of women grinding cochineal by hand (while the men are photographed at the loom). Clearly, Zapotec families (including Fidel and María Luisa, and Carlos and his family) are deploying a limited, prescribed, and highly codified frame to distinguish their work from that of others.[14]

The organizers of the 1997 Exposición y Concurso Nacional de Artesanías summoned Fidel to Mexico City (with little warning and at a relatively inopportune time) to receive his grand prize for the use of natural dyes. They called him at home in the morning to make arrangements to bring him to Mexico City that afternoon, gave him the award, and sent him back to Teotitlán the same day. Although Fidel and María Luisa were bemused by this treatment, they recognize that institutions like this exposition, promoting crafts in Mexico, have been important to their success. The exposition had a number of sponsors, including the Secretaría de Economía (Secretariat of Economy), the Secretaría de Desarrollo Social (SEDESOL, Secretariat of Social Development), the Instituto Nacional de Antropología e Historia (INAH, the National Institute of Anthropology and History), and the Fondo Nacional para el Fomento de las Artesanías (National Fund for the Promotion of Crafts, FONART). FONART falls under the auspices of SEDESOL, and its mandate is to promote the interests of artisans through diverse programming ranging from rural credit initiatives, to expositions and competitions, to the well-known sales outlets for crafts it runs throughout Mexico.

Victoria Novelo's study of the development of the Mexican state's multifaceted apparatus for protecting and promoting crafts provides a frame and historical backdrop. She writes that the first institutions to develop (like the Instituto Nacional Indigenista, founded in the wake of the first Interamerican Indigenous Congress in 1940) focused their activities on the "protection, preservation and diffusion of the authentic traditional production" of craft objects. During the 1960s, "together with the nationalistic ethnographic conception of the crafts, an economistic conception, of 'salvation,' appeared, as much for the producers themselves as for economic development in general."[15] FONART programs also concentrate on economics and cultural nationalism, and these themes are represented in the multiple institutions that supported the exposition at which Fidel received his award.

Honors, awards, and recognition of the sort conferred upon Fidel sanctify the work of Zapotec weavers and generate interest in their craft. Fidel and María Luisa have seen more and more visitors to Teotitlán seek them out specifically. The number of tours and weaving and dyeing demonstrations

they are requested to provide has increased, and the prices of the textiles they sell have risen as a result of their renown. Their participation in expositions and competitions organized by the Mexican state apparatuses that promote crafts has been instrumental in Fidel and María Luisa's deployment of the codified frame described earlier, supporting their argument that their textiles are "special" and "unique" because they are more "authentically" indigenous than those of others. Such participation, then, has been a significant factor in their ability to manipulate the symbolic logic of the field to support and position their work in relation to the work of other Zapotec weavers.

This pattern of sanctification by the Mexican state is, and has been, deployed by a number of Zapotec weavers. Use of natural dyes (especially cochineal) is one of the principal markers employed by Zapotec weavers to distinguish their work and is emphasized in publications by Forcey and the Rothsteins. In their introduction to the section of their book on Teotitlán, the Rothsteins deploy this frame:

> The finest work is carried out by a few families (estimated variously from five to ten) that create dyes from natural substances and use pure hand-spun wool . . . This is in contrast to the vast majority of families using chemical dyes and acrylic fibers.[16]

Such deployments simultaneously construct the field (its internal structure as well as its limits) and make claims to participation or inclusion in the weaving community crafting Zapotec textiles and weavers. As Zapotec weavers (and others) deploy this frame, then, they are working with those institutions and persons who make up this weaving community while simultaneously making assertions about their position in that community by deploying the logic of the field to their advantage. Such assertions are made through the symbolic weight of particular privileged weaving practices and materials. Using "natural" materials and making things "by hand" carries greater symbolic weight, as do the textiles that result from these practices.

Bourdieu's insight that career trajectories may be understood in terms of movement through the symbolic space of the field of cultural production offers a way to understand the deployment of the symbolic frame of the natural dye and its impact on Fidel and María Luisa's career. Bourdieu argues that career trajectories may be understood symbolically in terms of a *"series of positions* successively occupied by the same agent or the same group of agents in successive spaces" in the field.[17] Understanding Fidel and María Luisa's trajectory as

movement from one position in the field to another—from commercial production (for example, reproducing Navajo textiles with Fidel's father) to the production of more rarified textiles (one-of-a-kind original designs employing natural dyes)—also frames understanding of the community of people with whom they work to craft Zapotec textiles more broadly.

When Fidel and María Luisa moved out of Fidel's parents' home, they also initiated a move through the symbolic space of the field of Zapotec textile production. Their move into their own home marked a distancing from his parents, both literally and symbolically. This was a move not only away from the working connections his father created with other weavers in Teotitlán and Santa Ana (as well as wholesalers and gallery owners from the American Southwest), but also away from the symbolic associations carried by his father's more "commercial" textiles. It marked a shift in their participation in the weaving community that crafts Zapotec textiles and weavers, a shift away from participation in textile production through the social space of his parents' textile business (including its connections to the wider community of wholesalers, gallery owners, etc.) and toward that of María Luisa's family. When Fidel and María Luisa married, the connections of María Luisa's family opened to him, along with new opportunities for participation with those crafting Zapotec textiles and weavers.

Comparing Fidel and María Luisa's successes with Tomas and Josefina's decision to leave the textile business, in terms of Lave and Wenger's notion of legitimate peripheral participation, highlights how the social context in which the Zapotec "learn to weave by working as weavers" is part of a community of people crafting Zapotec textiles (and weavers) that extends well beyond the geopolitical limits of Teotitlán and other nearby Zapotec communities. Whereas Fidel and María Luisa were able to put family resources to work for them as they sought to craft a unique identity for their business, Tomas and Josefina either were not able to do so (the resources may simply not have existed) or did not care to. What Fidel and Josefina were able to "learn to see" as they moved into a new social circumstance after their marriages is telling in this regard. Josefina's participation in the textile business of her new husband and his family included learning to see the quantities and colors of wool yarn that would be necessary to fill the orders of wholesale and retail business owners, and to coordinate the work of weavers in their homes. She learned to see and master her role in a transnational community of people crafting saddle blankets for a very narrow market niche of a business based in the Southwestern United States. Meanwhile, Fidel learned to see, and has come to master, his new role as one of a few Zapotec weavers

using natural dyes (including cochineal) as part of a community of practice that includes a diverse, transnational group of institutions and individuals. The successes and failures in Josefina's and Fidel's career trajectories point to the ways that their learning to weave by working as weavers is shaped by institutions and social formations extending well beyond the household production units in which they work. They point to how Fidel and Josefina both participate in and shape a weaving community as they themselves and their weaving practices are crafted.

Seeing the Design, Planning to Weave

Zapotec textile production is, at one and the same time, both an economic enterprise and a creative endeavor. Zapotec weavers simultaneously create symbols of an indigenous identity and, especially in the American Southwest market, successfully sell weavings, not because consumers are particularly interested in the Zapotec, but because they have traditionally used weaving devices that are more efficient than those of other Native American groups—most especially the Navajo—and because they sell their labor more cheaply. The loom used by the Navajo, like the back-strap loom used by so many indigenous groups in the Western hemisphere, is simply more time-consuming to use. Individual *hilos* (strands of yarn or "threads") are manipulated by hands alone to produce a Navajo textile, whereas individual threads are manipulated by the hands and feet among the Zapotec. The secret of the Zapotec weavers' success, then, lies in their feet—or more accurately, their use of their hands and feet simultaneously in the weaving process.

The basic fact that it is weaving that feeds the families of Zapotec weavers structures even the micro-practices of weaving, including what Zapotec weavers do with their hands and feet at the loom. It is the origin of the basic tension that pulls Zapotec weaving practices in the contradictory directions noted by Harvey—toward creating one-of-a-kind, hand-crafted textiles and toward producing textiles quickly and economically enough to fit a specific niche in a market whose geographic and ideological centers lie in the post-revolutionary space of Mexican cultural patrimony and the enchanted space of the Southwestern U.S.

In *Navajo Shepherd and Weaver,* Gladys Reichard's 1936 account of the lives and work of Navajo weavers, she writes that the weaver

> must see it [the textile's composition] as a huge succession of stripes only one weft strand wide. It matters not how ideal her general conception may be, if she

cannot see it in terms of the narrowest stripe, meaning a row, of properly placed wefts, it will fail of execution.[18]

Zapotec textiles are essentially built up of successive rows of colored threads as well, but my experiences with Zapotec weavers have helped me to understand that, because of their expertise as weavers, they do not "see" or think of a textile's composition in the way Reichard describes. Rather, they see the design, or at least geometric patterns, in terms of rectangular and triangular blocks of colors that are, in turn, built up out of narrow stripes of color.

A geometric design will "fail of execution" if the weaver does not place the rows of colored weft properly, but experienced Zapotec weavers do so almost automatically, so that they may concentrate instead upon creating regular, well-formed blocks of color. In fact, were the Zapotec weaver to concentrate solely upon the placement of rows of color (i.e., on creating the design by building up row after row of single colored threads), the textile would most likely fail of execution—not because of irregularities in the pattern, but because the textile would take so long to make that its completion and eventual sale would fail to support the weaver's family.

It is only through making the placement of rows of color a semi-automatic routine, sped up by a loom on which both the hands and feet are used, that Zapotec weavers can weave fast enough to make enough money to feed their families. If the Zapotec weaver is to weave quickly and at the same time monitor the textile's progress, making decisions about the soundness of the design's composition and the textile's structure, then he must be able to quickly and efficiently place those horizontal bands of color while concentrating on other things.

At the same time, the actual work of weaving at the loom is only a small part of the production of a Zapotec textile. Many processes must be undertaken before one ever gets to the loom, and more must be undertaken at the loom before one can begin to weave. We begin with how the loom is prepared for weaving because it is at this point that weavers first think of their designs in terms of blocks and triangles of color. If they do not understand them in this way before they actually begin weaving, their designs will also fail of execution.

The loom used by the Zapotec is similar to looms used throughout Mexico, which are known variously as treadle looms, upright looms, Spanish floor looms, and Mexican tapestry looms.[19] For the purposes of exposition it can be divided into two basic parts: the frame and the moving parts. The moving parts include the warp beam and ratchet that hold the warp thread

in tension; the heddles and harnesses that weavers use to manipulate the warp thread during the weaving process; the beater and comb that they use to push the weft thread into place; the breast beam, cloth beam, and ratchet that take up and hold in tension the newly woven textile; and the all-important pedals or treadles connected by twine or rope to the harnesses and heddles, enabling weavers to use their feet to manipulate the warp thread.

Zapotec looms are large, so that the weaver stands almost inside the loom frame in front of the breast beam, either on the pedals or on the floor with one foot on the pedals. The warp is attached to the loom, where it is held in tension, and the weaver places weft thread between the warp threads, interlacing them to form the interlocking structure of the textile. Preparing the loom for weaving principally involves organizing the warp (calculating its length, the number of threads, etc.) and then attaching it to the loom. This is a time-consuming processes and must be undertaken with great care so as to avoid costly, time-consuming mistakes requiring it to be detached, untangled, and then retied to the loom.

Before the weaver can begin preparing the loom, the width of the textile to be woven must be decided. Generally speaking, no textile can be wider than the loom on which it is woven;[20] and the most common loom width among the Zapotec is one meter. Designs with a single central motif require more planning than do designs with horizontally and vertically repeating elements that run across the width and length of the textile and which may begin or end at any point along its length or width.

When the textile features a central motif, the necessary number of warp threads must be accurately calculated. Frequently, however, the weaver (or the merchant supplying the yarn) simply decides on the rough size of the textile. Then, once the warp is attached to the loom and the bottom border or stripe has been woven, the weaver lays out the design by marking the warp threads (e.g., with a pen) to correspond to the design elements making up the design field, accommodating the number of warp threads taken up by the design itself, or adjusts the width of the border (in effect adjusting the design to fit the warp thread on the loom, rather than deciding on the warp to fit the design).

The size of the textile, whether dictated by the design or the weaver, determines both the length of the warp and the number of threads composing it. The warp is prepared for the loom by winding thread around a series of pegs—what is called a warping frame. The Zapotec make their warping frame using three wooden pegs or stakes, most commonly driven into the ground but sometimes attached to a bench or ladder. The distance between

the first and third pegs corresponds roughly to the length of the textile (or several textiles), including the fringe. A single thread is tied to the third peg and then walked down to be wound around the second and then the first, forming a criss-cross between them, before it is looped back to the third; the overall effect is a large figure eight. This pattern is repeated fifty, a hundred, or two hundred times, depending on the width of the textile.

A string or piece of twine is often inserted through the criss-cross formed between the first and second pegs as a method of counting the warp threads and then, once the warp is ready for the loom, the string is knotted to hold the warp threads in place while the warp is transferred to and then tied onto the loom. A second string is used to tie together the loop around the third peg, and then the warp is taken up off of the pegs by inserting one hand through the loop where the third peg was and pulling the rest of the warp through the loop to form another loop, through which the warp is pulled again, and again, and again. This is done to keep the warp thread from tangling, because once at the loom, it must be attached to the warp beam in exactly the same order it had when strung around the pegs of the warping frame.

Attaching the warp to the loom is a time-consuming job—the continuous warp thread is broken into separate threads which are, in turn, tied by hand individually to "dummy" or "leader" warp threads which are permanently attached to the warp beam. The end of the warp corresponding to the third peg is looped around the cloth beam and the weaver begins tying the other end (the end corresponding to the first peg) to the dummy threads. Basically, while the weaver sits on the cloth beam in front of the comb and beater, each loop in the continuous warp thread is broken in two by pulling it apart by hand and then tying each end in turn to the dangling dummy or leader warp threads, one after the other, fifty, a hundred, or two hundred times, across the width of the loom. When the entire warp has been tied to the loom, it is then very carefully pulled through the comb and harnesses as it is wound around the warp beam until taut. Once the warp threads have been spread out evenly across the warp and cloth beams, a thick side selvage (edge), made up of several lengths of warp thread twisted together, is added to both sides and the tension of the warps readjusted on the loom. Now the first weft threads may be woven into the warp.

Manejando Bien el Telar and Properly Placing the **Wefts**

Zapotec floor looms, like most Mexican looms, typically have only two sets of harnesses strung on two heddles.[21] One set is attached to each pedal, with

warp threads passing alternately through one and the other so that standing or pressing down on the pedal depresses every second warp thread while simultaneously lifting the others. This opens a space, called the shed, between the even- and odd-numbered warp threads. Weaving on such a loom essentially consists of passing weft thread through that open space; one first depresses one set of warp threads and passes the weft thread by hand between them in one direction (say from right to left), and then depresses the other set of warp threads with the other pedal while passing the weft thread back in the other direction. The weaver works in the space between the breast beam and the beater, and from time to time pulls the beater onto the working edge of the textile, thereby packing the weft threads tightly together. Because the weft thread has a greater diameter than the warp thread, packing the weft threads tightly together with the beater buries the warp threads under the weft thread so that the weft threads and the design created with them form the surface of the textile. Such textiles are called "weft-faced" and are characteristic of Mexican tapestry weaving.

As the weaver progresses in weaving a particular textile, warp is unwound from the warp beam and the finished part of the textile is wound around the cloth beam; the beams are held in tension against one another by ratchet mechanisms that anchor them to the loom frame. Because the working space between the breast beam and the beater is only about half a meter wide, this simultaneous unwinding of thread from the warp beam and winding of the finished textile around the cloth beam occurs regularly, as the woven area progresses. Every time that it is done, the tension of the warp threads must also be readjusted. The tension affects the size of the shed; if the warp is too loose, the shed will be smaller and, as a result, the multiple acts of inserting weft thread (and one's hands) will cause the warp thread to wear unevenly and possibly break. Too little tension also makes it difficult to maintain a straight side selvage, making the textile both more time-consuming to make and harder to sell. A Zapotec weaver who experiences these problems is said to not have been *manejando bien el telar* (operating the loom well).

Manejando bien el telar involves monitoring both the tension and the wear of the warp threads while, at the same time, mitigating their impact on the weaving. In other words, problems with tension and uneven thread wear (in effect, pushing and pulling at the warp thread) are always present and always affecting the weaving and the speed at which the weaver can work. At the same time, the weaver must also balance the contradictory pushes and pulls of variable capital and the basic tension of the structure of the field of

Zapotec textile production. *Manejando bien el telar* entails balancing these pushes and pulls, all the while pushing and pulling the weft thread around and through the warp on the loom.

Placing a single weft thread involves several steps that the accomplished weaver undertakes in a seemingly automatic, continuous stream of motion. Of course there are multiple variations on this basic process, depending, for example, upon the length of weft, the thickness of the weft thread, and whether the weft will be a part of the side selvage. Overall, however, the process changes surprisingly little and, from start to finish, lasts not much longer (and sometimes much less) than five seconds.

The process begins with the depression of one of the loom's pedals. One depresses the pedal that corresponds to the direction from which one will pass the weft. That is, if one is going to pass the weft from right to left with one's hands, then one depresses the right pedal with one's foot. Next, the points at which the weft thread will be inserted into and extracted from the shed to be decided upon. Typically, the spot where the weft will be extracted is located first, by placing the fingers of the hand that will receive the weft slightly into the warp. This can be done by touch, almost without looking, by running one's fingers down the correct warp thread (where the color is to change), away from the weaving, until the space between the two sets of warp threads is wide enough for the bobbin of weft to be passed between them. How far down the warp this will be depends on a number of factors, including the quality of the loom (looms of good quality—those that *saca buena tapete,* "make a good carpet," as the Zapotec say—create the shed with very little pressure on the pedal) and the skill of the weaver. More skilled weavers can pass the bobbin through a very small shed. Beginners struggle, using most of their body weight to create a shed large enough to let them do this. However, the more one weaves and the more proficient one becomes, the more adept one also becomes at inserting weft with one's hands and the less one struggles against the loom and the pedals to open the shed.[22]

At this point in the process, and assuming the weft is going to be passed from right to left, one's left hand ought to be in the shed, waiting to have the bobbin passed to it. The bobbin is inserted into the shed with the right hand, also by touch—the weaver traces the appropriate warp thread away from the weaving with the tip of the bobbin to the most open part of the shed. A skilled and practiced weaver positions both hands almost simultaneously. The third step is to pass the bobbin from one hand to the other. When the left hand receives the bobbin, it pulls the weft into the correct position as it pulls the bobbin out of the shed.

Next, the weft thread just passed through the shed must be positioned properly before it can be pushed into place with the beater and comb. Again, skilled weavers move both hands almost simultaneously. While one's left hand is pulling the weft into approximately the correct position as it removes the bobbin from the shed, one's right hand pushes the weft into place around the first warp thread, pressing it toward the edge of the weaving with the tip of the index finger. In a nearly continuous motion, the midpoint of the new weft thread is then taken between the thumb and index finger of the right hand and pushed away from the weaving, creating a small arch, and one releases the right pedal to press down on the left pedal, closing the shed (and simultaneously creating a new shed in which the warp threads that had just been depressed are raised, and vice versa) and holding the new weft strand taut in its arch. In a continuation of this stream of movement, one's right hand continues moving away from the weaving and to the beater, which it pulls down, packing the arched weft thread flat onto the working edge of the textile. One then repeats the process in the other direction to place the next weft thread, except that the relevant pedal is already pressed.

The arch in the weft thread is necessary because the weft thread runs around and between the warp threads, and it must therefore be longer then the actual distance between the first and last warp threads. Otherwise it will pull the warp threads closer together as it is packed into place with the beater, which will cause them to rub on the comb and beater, wear, and possibly break, and will make the textile uneven and less desirable. The arch of weft thread, then, is the extra length that is needed to keep it from pulling the warp out of position.

As mentioned above, this basic sequence whereby one "properly places a single weft," as Reichard put it, has several minor variations. I have described the most painstaking way of placing a weft thread, but some corners are sometimes cut. For example, if the length of weft to be inserted is very short (say, just a few centimeters in length), then less care may be taken to make sure that it has exactly the right amount of arch before the beater packs it into place. On the other hand, when weaving stripes that run across the entire width of the textile or solid sections of color, weavers will take great care to get the arch just right, because too much tension in a long weft thread will distort more of the warp. Another minor change in practices when weaving wide swaths of color is the use of a shuttle. The weaver passes the shuttle from one hand to the other, sliding it through the shed from selvage to selvage, instead of passing the bobbin directly from one hand to the other. Little else, however, changes in the process.

Taken all together, then, the sequence of properly placing a single weft thread (starting from the right) consists of these basic steps (see the photo captioned "Properly placing a weft"):

1) depress the right foot pedal;
2) locate both the insertion point (with the tip of the bobbin in the right hand) and the extraction point (with the left hand);
3) insert the bobbin into the warp shed and pass it from the right to the left hand;
4) pull the bobbin out of the shed and adjust the position and arch of the weft thread with the right hand;
5) depress the left foot pedal;
6) using the right hand, pack the weft thread into place with the beater and comb;
7–12) repeat steps 2–6 in the opposite direction.

Weavers usually perform this sequence of twelve actions twice before moving on across the width of the textile to the next section of color (for which they use a different bobbin of weft thread). It is this twice-performed twelve-step process that frames the orientation that Zapotec weavers bring to their weaving practice—it constitutes the core of the weaving technique that they work toward embodying as they learn Zapotec weaving. The weaving of most geometric designs is organized in terms of repetitions of this twelve-step sequence. Zapotec weavers move from color change to color change (bobbin of thread to bobbin of thread), back and forth on the working edge of the textile, repeating the basic sequence of actions over and over again. The material result of twice performing this sequence, four lines of newly inserted weft thread, is also the measure of the progress of the weaver toward finishing the textile and, most importantly, constitutes the vertical measure of the blocks through which the design is conceived.

The yarn the weavers use is uneven and varies in diameter. As a consequence, the working edge of the textile may be more or less uneven, depending upon whether the strand of weft thread has become thicker or thinner. Sometimes the places in a design where weft strands of two different colors circle around the same warp thread (the vertical line where two blocks of color meet, for example) also progress or build up more rapidly. The working edge of the weaving, then, is almost never a straight and even line, but rather an undulating space, rising where colors meet, and dipping within each section of color. To adjust the working edge, weavers must fill in

these dips, especially when a horizontal line of a new color (i.e., a new design element) is to be introduced. They do so by repeating the basic twelve-step sequence between the warp threads in the dip until the working edge of that section of color rises up to the same level as the rest of the weaving. In fact, *manejando bien el telar* essentially consists of continually adjusting the progression of the weaving through these types of techniques so that, even though the weft thread is constantly changing in thickness and tension and the warp is pulling in and sometimes even breaking, the weaving progresses evenly and as a consequence the design elements, and the textile, are well formed.

Properly placing a weft thread while *manejando bien el telar,* which has required several paragraphs to describe, can be done in the blink of an eye and may seem like pure magic. Especially when working with very short spans of color, the hands of the weaver work so quickly, passing the yarn back and forth, that one fully expects the bobbin of yarn to disappear, as if one were watching some sort of magician. Travel writers sometimes describe the nimble fingers of Zapotec weavers flying swiftly over the warp threads, and the magical result is beautiful textiles. My "frame-by-frame" dissection of how Zapotec weavers properly place weft thread (inspired by Eadweard Muybridge) is intended to neither replace nor undermine such fanciful, and perhaps mystifying, descriptions of the magical work of Zapotec weavers. My intent, in dissecting the micro-practices involved in placing weft thread, is to examine the space of bodily practice already opened up to the contradictory pushes and pulls of the field of Zapotec textile production (and, consequently, variable capital). I want to expose the work of these forces and structures on the bodily techniques and practical weaving knowledge of Zapotec weavers. Muybridge took his famous photographs of a horse in motion to settle a debate (and, supposedly, a personal wager) as to whether or not horses "fly" (bring all four hooves off the ground simultaneously) during a trot or gallop. I will not offer any proofs of the magic-ness of the flying fingers of Zapotec weavers, but simply hope to show something of the managedness of their flying fingers and feet in relation to the structure of the field of Zapotec textile production and the corresponding circulation of variable capital.

The "Sequence of Weaving": Zapotec Weaving Mētis

Of course, describing how to properly place a weft and understanding the general principles or practices that make up or constitute properly placing a

weft are not the same as actually being able to weave, let alone attaining mastery of the skills and knowledge required of the competent Zapotec weaver. No one would be able to weave as the Zapotec do on the basis of my description, and having read and understood this description is not the same thing as knowing how to weave. As James Scott noted in his discussion of mētis, knowing the rules of thumb, or having a sort of shorthand understanding of a particular activity (whether gained by reading a description or through extended fieldwork among Zapotec weavers) is not at all the same thing as accomplished performance. On the other hand, knowing how and when to apply those rules of thumb and guiding principles, Scott asserted, constitutes the "essence of mētis."[23]

Scott turned to the Greek word *mētis* as a means of capturing what he variously described as local, informal, vernacular, and common-sense knowledge—knowledge that he juxtaposes to the scientific, modern, universal, and formal knowledge that the state regularly, and often with disastrous results, brings to its very large projects, such as city planning, forest management, and collective farming. Scott argues that many such projects fail precisely because of their neglect of the homegrown sorts of knowledges he calls mētis. The way that Scott uses the word mētis also nicely captures the sense of acquired practical mastery that I have been trying to convey in describing Zapotec practical weaving knowledge.

What might be called Zapotec weaving mētis is difficult to acquire except through repeated engagement with weaving practices, and is even more difficult to teach "apart from engaging in the activity itself."[24] What develops from long hours of weaving is a "feel for" and attitude toward the loom and yarn that is difficult to describe, but that enable the Zapotec to keep up the basic mechanics of their weaving while concentrating on other things (like design composition). In much the same way that experienced drivers continuously adjust an automobile's course and speed in response to changes in the road and the surrounding traffic without having to think too much about the actual mechanics of what their hands and feet are doing, *manejando bien el telar* entails constantly adjusting the working edge of the textile without thinking too much about it. As experienced weavers work at properly placing wefts, they are also compensating for thinner or thicker yarn and changes in tension, so that the progression of the blocks of color that make up the design is regular and even. Weaving well is very much a matter of continually making small adjustments to pull the weaving back onto course—the course of regularity, uniformity, and soundness of construction—without thinking too much about what to do next with one's hand or foot. Sensing

irregularities through an embodied feel for how things ought to be progressing, and developing or accumulating a repertoire of responses to them, forms an important part of Zapotec weaving mētis.

For Scott, mētis is best suited to circumstances that are varied and mutable, and that require quick, almost automatic, responses. With hindsight, and as experience accumulates, subtle differences in problems and the resulting subtle shifts in the weaver's response may be reworked into the rules of thumb mentioned above, but such rules of thumb are, in fact, actually a way of describing an intuitive feel for what will resolve a given problem, and this feel is very difficult to pinpoint. Experienced Zapotec weavers do not need to decide which rule of thumb or response to employ (or even think of them as "rules of thumb"), they simply, and nearly automatically, make the right choices. In the meantime, they are free to concentrate on color choices, or subtle changes to a design motif, or a myriad of other important decisions.

Finally, as Scott emphasizes, mētis is "practical, opportune, and contextual" and only as accurate or precise as need be. What Scott terms "vernacular measures" are a prime example of these features.[25] While features like idiosyncrasy and variability give mētis its local relevancy—they are what make it eminently well suited to its intended purpose—they are also what make such knowledge of little use (and sometimes an actual impediment) to the state and its knowledge systems, which have been crafted with the intent of universal application (a centimeter is always and everywhere exactly the same distance).

Scott cites the example of "Squanto's maxim": his advice to European settlers in New England to plant New World cultivars "when the oak leaves were the size of a squirrel's ear."[26] The more "scientific" measures of soil temperature, length of day, and even date (based on a European calendar) might have more universal application, but they are also less well attuned to local circumstance and frequently require considerable adjustment. The Zapotec technique for laying out and weaving geometric designs in terms of blocks of color is a vernacular measure which is similarly unsuited to universal application—much to the chagrin of those marketing Zapotec textiles in the U.S.

Many business owners express exasperation at not being able to offer their clientele textiles of exact sizes, especially when a client has placed a "special order" for "so many" textiles of "such-and-such" a size. In addition to the difficulties that arise when trying to market a product in the U.S. made in a country that follows the metric system (as Mexico does), the fact that

Zapotec weavers do not lay out designs in either centimeters or inches is a frequent cause of friction. Because of the way that Zapotec weavers work, it makes little sense and would be very cumbersome for them to do so. On the other hand, laying out a design by blocks of color (which, in turn, affects the overall size of a textile) is perfectly in tune with their practice of making textiles.

The difficulty novices have when first learning to weave might be characterized in terms of the degree to which they are able to adapt or discipline their weaving practices to the structure of the twelve-step sequence and the corresponding blocking out of a design. Initially, many have problems coordinating the basic movements and carrying them out satisfactorily, and many also have problems keeping the working edge of the textile progressing more or less evenly, making it difficult for them to weave regular blocks of color.[27] Learning to weave as the Zapotec do is a process of gradually building speed, fluidity, and regularity in the movements of the twelve-step sequence until one approaches weaving any geometric design through that process, armed with the rules of thumb for making adjustments as needed. Zapotec weavers come to both see and then weave geometric design motifs through this sequence of practices—a disciplinary regime that the Zapotec move toward embodying as they become weavers. The turn of the weaver's hand as it moves the weft thread into position for the beater, the movement of the weaver's foot from one pedal to another: these practices, and the care and speed with which they are carried out, register this disciplinary regime.

For an experienced weaver, the process of moving back and forth across the width of the textile, repeating the twelve-step sequence to place the weft in blocks of color, is fluid and semi-automatic, and the weaver need not concentrate on what to do next. It is a system for organizing the weaving process that, with some variation, is common to all Mexican tapestry weaving. Hall comments on its importance:

> The sequence of weaving is an important part of the Mexican tapestry technique and is the secret of its speed. The sequence is a systematic manner of passing the butterflies [bobbins] of yarn through the warp, which helps the weaver work quickly and methodically. To weave with this sequence . . . a specific direction of weaving is used . . . this creates a zigzag movement from side to side across the tapestry . . . It also provides a systematic method that allows a regular rhythm of movement, which can leave your mind free for concentration on the design rather than the technique.[28]

The sequence of practices that form the core of Mexican tapestry weaving technique is built for speed and fluidity. In the case of the Zapotec, so too are the weavings themselves, and the designs featured on them.

What Gladys Reichard described as a painstaking, thread-by-thread conception and construction of the textile's design by the Navajo is very different from what I saw among Zapotec weavers, who conceive of and weave textiles as blocks of color. Zapotec weavers' ability to weave quickly and in a routinized manner is dependent upon their ability to do this, as well as upon what Hall calls "the sequence of weaving."

As the weaver works on a textile in this fashion, inserting strands of weft one after another, those strands build up into blocks or squares of colors (both a horizontal and vertical measure). For example, inserting ten lengths of weft thread (completing five of the twelve-step sequences) across five warp threads creates a 5×5 block of color. The means by which a design is laid out horizontally across the width of a textile (blocking it out in terms of groups of warp threads—five, in this example) is thus translated into a means for understanding a design's vertical layout—blocking out the design in terms of five twice-repeated twelve-step units.

In short, when laying out a design (at least, a geometric one) and when winding the warp, as well as when weaving the textile, it is these blocks of color (groups of thread) that must be considered, not the envisioned textile's length (or width) in centimeters—let alone inches. When Zapotec weavers think of and plan a textile's design, when they prepare the warp and weft to make the textile, and then when they actually weave it, their understanding of what they are and will be doing and the activities themselves are structured in terms of these blocks of color, which are, in turn, built up from twice-repeated twelve-step sequences. If the weavers do not think this way, the textile "will fail of execution."

Thinking of a textile's design in terms of blocks of color, and then actually weaving in a process of completing regular, well-formed blocks of color, speeds the process of weaving by simplifying the design. Weavers focus their attention not on a number of individual threads of varying lengths (as Reichard describes the Navajo doing), but on a much smaller number of blocks. Zapotec weavers strive for this simplification. Weavers understand that in weaving a Navajo design, for example, they must break the design down into more economical elements than the individual weft threads of the Navajo if they are to have any success. As one young Zapotec weaver remarked to me,

right now there are many books on Navajo [weaving in Teotitlán] but actually the Navajo work very differently from us. So yes, we can make the textiles that they make, but for us it's twice the effort . . . Because I have a friend who buys my textiles and he has brought me books of Navajo [weaving] and he said, "Can you make this?" Of course I can, right? But, my goodness . . . it would take months to finish it.

He is well aware of the time necessary to weave a true reproduction of a Navajo textile, but he is also aware that, given the economic niche filled by Zapotec textiles in the American Southwest's Native American textile market, he will not be compensated financially for the extra time and effort a true reproduction would require. Consequently, he expends "twice the effort" because he must first understand how the Navajo weaver constructed the design, and then figure out how to translate the spirit of the design into Zapotec blocks, simplifying it so that it can be woven much more quickly on a loom that is quite different from those used by the Navajo.

This Zapotec weaver's comments also point toward an intuitive understanding of the impact of the circulation of variable capital on Zapotec weaving practices—on the contradictory directions in which he is pushed and pulled at the loom as a consequence of the market demands of producing Zapotec textiles that will be sold in the American Southwest (the "exigencies of capitalist production," as Harvey put it).[29] His striving to streamline his technique and the product of his labor, all the while working to craft a one-of-a-kind item, is a manifestation of that contradiction. Furthermore, the value his labor brings to the market niche for which the textile is intended—more simplified and streamlined textiles are produced for more "commercialized" markets (to use the terminology of those involved), whereas one-of-a-kind textiles meet the demands of the "art" and "gallery" market niche—is the source of those contradictory pushes and pulls. He could make a thread-by-thread reproduction of the Navajo textile his "friend" has asked him if he could make, but his labor is not valued as highly as Navajo weaving labor, so it makes little financial sense for him to do so.

The secret of the speed of Zapotec weaving thus lies not only in the mechanical "sequence of weaving" with the hands and feet, as Hall described it, but also in how designs are conceived and constructed. This is one of the reasons that Zapotec weavers have been in such demand to reproduce Navajo textile designs—even though it is "twice the work" for them, they can produce Navajo-like textiles much more quickly and at a fraction of the cost. When the Zapotec learn to weave they are, in essence, learning to weave for

speed and fluidity within a technique and practical weaving knowledge (mētis) that preserves the look of individual artisanry and one-of-a-kind handcraftedness but at the same time streamlines and economizes both the product and the techniques of its manufacture.

When Zapotec weavers work at the loom, the most minute aspects of what they do (from each turn of the wrist to the occasional dropping of steps in the twelve-step sequence for the sake of speeding the weaving even further along) register that basic tension—the push and the pull—between handcraftedness and artisanry, on the one hand, and simplified, streamlined, or economical working habits, on the other. At the same time, the color block aspects of Zapotec weaving mētis also register that push and pull and, hence, the structural characteristics of the wider community of practice of which learning to weave by working as a Zapotec weaver is a part.

The previous chapter closed with the assertion that becoming a Zapotec weaver involves embodying the structural characteristics of a community of practice. The idea was not that the wider social context of which making Zapotec textiles is a part determines Zapotec weaving practice, but that the wider social context, filtered through a career trajectory that moves weavers through different spaces within it, shapes the embodied weaving practices and practical knowledge of Zapotec weavers: within a specific division of labor, within specific workshop environments with connections to other workshops, and within the social spaces where the "authenticity" of Zapotec textiles is crafted.

The minutely detailed discussion of Zapotec weaving practices and practical weaving knowledge presented in this chapter, a subset of the Zapotec weaving mētis, demonstrates how Zapotec weaving knowledge and practices at the loom, the ways that Zapotec weavers conceive of designs and use their hands and feet to make textiles, are shaped by this wider context. The basic tensions structuring the wider field of Zapotec textile production shape the ways Zapotec weavers work, and plan to work, at the loom. The distinctions marking authentic textiles begin to inform Zapotec weaving practices at the planning stage—when the design is being blocked out and the warp is being wound and counted out in terms of those blocks. They continue to inform the practices associated with Zapotec textile production while the weaver is at the loom, as the blocks of color themselves are rhythmically completed, row by row. Learning to weave as the Zapotec do entails gradually increasing one's ability to weave in this rhythm. It is in this sense that the weaving mētis and bodily weaving techniques of the Zapotec

are an accumulation strategy that registers the social idiosyncrasy of their place in, and the social structure of, the community of people crafting Zapotec textiles. And it is in this sense that becoming a Zapotec weaver, learning to weave in the spaces MADE IN MEXICO, involves embodying the structural characteristics of the wider weaving community creating Zapotec textiles.

In this concluding discussion, we explore more fully the relation between learning Zapotec weaving (the weaving mētis) and the sociocultural context of Zapotec textile production. We do so through a detailed examination of the production of a "Navajo" design and the problems one young Teotiteco weaver had in his first attempt to weave a Navajo Yei figure motif similar to the one woven by the elderly gentleman featured in *Seenau Galvain.*

In keeping with a broader pattern in which the "test" or "measure" of mētis is frequently its functionality and local adaptability, design motifs are broadly understood by Zapotec weavers to be either geometric (*geometrico*) or figurative.[1] This basic distinction is a reflection of differences in how such patterns are conceived and woven, and although the Navajo Yei figure motif has many geometric elements and is very simple and blocky, Zapotec weavers plan, lay out, and weave it as a figurative pattern. They do not see it in terms of single colored weft strands, however; nor do they see it in terms of regular rectangular and triangular blocks of color. Zapotec weavers understand figurative designs in terms of amorphous color shapes, and because such designs can be neither planned, laid out, nor woven in terms of blocks of color so many warp threads wide and so many weft threads high, the technique of weaving them differs in several ways from that of weaving geometric motifs. These differences are significant, and many Zapotec weavers never master them.

"Navajo" Weaving MADE IN MEXICO

The planning, designing, and weaving of figurative motifs is quite different from the blocking out by counting warps and weaving by blocks of color that typifies the making of geometric patterns. Figurative design elements, such as small birds scattered throughout a textile or large elements placed

189

prominently in a central panel, are not unusual in Zapotec textiles, but they are notable, and weavers recognize that special skills and knowledge are required in their production.

Generally, large figurative motifs are not simply drawn freehand but copied and enlarged from other sources, and families often have a stock of paper patterns stored in a safe place. When Zapotec weavers prepare to weave textiles with a large figurative element, they start by estimating the number of warp threads that will be necessary, having already drawn the design on a piece of thick paper with heavy pen or marker. In the case I describe here, the Yei figure design was drawn with pen and paper by Roberto, a well-known, gregarious man and a very successful merchant in Teotitlán, who copied it from a photo of a Navajo textile in a book supplied by the owner of a gallery in Taos, New Mexico. He gave the drawing to his son, José, who wove the textile in the family workshop in his father's home.

José learned to weave this particular design motif, just as he would any other design motif, as a part of working in his father's business. Had his father not been a successful merchant, subcontracted as part of a chain of businesses to supply a textile gallery in Taos, New Mexico, with less expensive reproductions of Yei figures on pillow covers, José might never have attempted to plan and weave them.

He began with the understanding that, while the width of a geometric design is estimated on the basis of the number of blocks of color in it, the width of a figurative motif is determined by measuring the drawing itself, calculating the corresponding number of warp threads, and counting them onto the loom's comb and beater. Once the warp was attached to the loom, the thick selvages added, and the tension of the warp properly adjusted, José simply traced the design across the warp threads with a marker. This can be done in a number of ways. José pinned the drawing under the warp threads in the working area of the loom (between the beater and the breast beam), holding the paper in place by running wooden sticks under it and slipping them through the selvage at both ends. He then marked the individual warp threads where they intersected with the lines of the drawing. The end result of this process is a kind of "connect the dots" drawing with which we are all familiar, except that the dots on the warp threads are unnumbered, their relation to one another having to be inferred from the pen and paper drawing itself. After removing the drawing from under the warp threads, José began to weave.

My observations of José, and Roberto as well, were fortuitous. I had not known that José would be weaving this particular design, nor would I ever

have known had I not happened to stop by his house to visit with his father. When I first arrived at their house, José had already begun to weave the textile. While waiting to speak to his father, I observed the design that he was working on (the drawing was lying next to the loom) and began to ask him about what he was doing and what he thought of the design, among other things. Just then his father walked in, and both Roberto and José explained that this was José's first attempt at weaving this particular design and the first time that he had outlined a drawing on the warp. I expressed my interest in talking to them about the process and observing José as he wove. They agreed that it would be interesting for me, and as José continued to weave, Roberto and I took our seats and began to talk about the other issues that had originally brought me to their house.

During a lull in the conversation Roberto got up to check on José's progress. José was a little over half-way through the design, but Roberto was clearly not very pleased with what he saw. José became embarrassed at his father's displeasure (embarrassment made even more acute, no doubt, by my presence) and, being a quiet, reserved boy, retreated, moving away from the loom as his father stepped onto the pedals and began to unravel the textile. Roberto rewove part of the section with which he was unhappy as José, at his father's insistence, watched over his shoulder. Roberto made few comments other than an occasional "watch this" or "you do it like this," and José said absolutely nothing. When he had rewoven approximately half of the section that he had unraveled, Roberto stepped away from the loom. José stepped back onto the pedals and began to examine what his father had done, and Roberto let out a nervous chuckle as he walked back across the patio toward me and explained, "That's how we teach here."

Over the next two days, I returned twice to talk to José and observe his progress. As is often done when weaving small textiles, the warp threads José had attached to the loom were long enough to let him weave several textiles before cutting them from the loom. In this case, he wove three that were nearly identical, except for variations in color. The interaction between José and his father that I observed on the first day was the only time (according to José and Roberto) he received any form of "teaching" from his father. With each subsequent textile, José had less and less difficulty with those areas of the design in which his father had found his work problematic. His difficulties reveal important things about the differences between weaving geometric and figurative designs.[2]

According to weavers familiar with the Yei figure design, it is a relatively simple one to weave. Most of its elements are composed of straight

horizontal, vertical, and diagonal lines rather than curved lines, and as a consequence it, like a geometric pattern, can be thought of in terms of blocks of color. The design is dominated by vertical elements (the elongated figure and the staffs on either side of it) but, as Roberto and José indicated to me, horizontal elements are less difficult and less time-consuming to weave, so it was woven with the figure lying horizontally (i.e., with the design rotated 90 degrees).

Having oriented the figure horizontally, then, José had finished one of the staffs and was beginning to weave the figure itself when I arrived at his house. When Roberto got up to check on his progress a little over an hour later, José had woven through the torso of the figure and was working on the top flared section of the skirt and the top upper arm of the figure. Roberto rewove this part of the skirt, and its top edge is clearly straighter than the bottom edge in the finished textile.

Because of the blocky and geometric nature of most of the Yei figure motif, José could weave this figure much as he had woven in the past—he could apply his weaving mētis and think of the design ("see it") in terms of blocks of color, as he had done since playing at weaving on the rungs of upturned chairs in his childhood. The figure itself is quite blocky, and even its diagonal elements could be envisioned in the same way as the triangular elements of the geometric designs with which José was quite familiar. For example, diagonal lines in many geometric patterns are woven by simply moving the entrance point of the weft thread one warp thread over after every pass (up one, over one), forming an approximately 45-degree angle. José wove the angle of the flared elements on the staffs in this manner, as can be seen in the photos of "a would-be pillow cover." In the Yei figure design, however, there are a number of places where the diagonals do not fall on a 45-degree angle—the upper arms and the skirt, for example.

José attempted to weave all the diagonal elements of the design motif in the manner in which he was accustomed (simply moving over a single warp with every pass of the weft), and this is what caused him trouble. A close examination of the bottom left corner of the skirt, which he wove first, reveals that he began in this way, but tried to follow the uneven and undulating line of the skirt by sometimes moving over several warp threads on a single weft pass. The result is a line that is far from straight, zigzagging across the ink marks on the warp that he was trying to follow. While José had enough experience to realize he needed to correct the angle of the line, he simply had not yet developed a rule of thumb for weaving a non-45-degree diagonal.

When weaving a textile with a figurative design, few weavers have trouble setting up the warp, making the drawing, and transferring it to the warp; but actually weaving it is another matter. Several of those I interviewed said that they had never mastered figurative weaving. Josefina Montoya (who figured prominently in chapter 5) was especially demonstrative in her explanation of the trouble she had:

> Well in truth . . . I wanted to do it [learn to weave figures] but . . . you see . . . Well, you paint, or actually to make an idol you draw . . . afterward you put it there in the warp and you paint it on with carbon or dye, or whatever, and it's the basis . . . so it's not done from, well, memory but on the basis of the lines and, well . . . I could never learn that because it is difficult to see the design as such . . . on . . . already on the yarn . . . I could never do it, I tried many times but I just never could do it.

As Josefina indicated, with figurative designs it is difficult to understand, from the marks on the warp, what to do with the yarn that one holds in one's hands: "it is difficult to see the design" on the "basis of the lines." Learning to weave figurative designs is a process of learning how to weave according to a different rhythm or sequence of practices, learning what the marks mean about how to manipulate the warp and weft in order to achieve the desired effect. In all fairness to Josefina, she spent little time weaving, instead selling textiles in her father's market stall and dyeing wool for the weavers working for him (and, later, for her and her husband Tomas). Had the nature of her father's (and her and Tomas's) business been different, she might have spent more of her time weaving and have come to understand how to "see the design as such." Zapotec weavers recognize that, if they are going to learn to weave figurative designs, especially the more complicated ones (such as those copied from pre-Hispanic codices), they must construct a career trajectory that will enable them to work with people producing or purchasing that kind of work.[3]

Josefina's comments and José's difficulties with the Navajo Yei figure take us to the heart of the differences between weaving a geometric pattern and weaving a figurative one. Whereas Zapotec weavers interpret geometric designs on the basis of blocks of color and translate that interpretation into certain very specific practices at the loom, they do not interpret the design elements of figurative motifs in terms of blocks of color. This change in the practical weaving knowledge employed by the weaver is a significant difference, with multiple implications for bodily weaving techniques as well.

In weaving geometric designs, the sequence of properly placing a weft thread is repeated many times, back and forth across the working edge of the textile. For every change in color, there is a corresponding change to a different bobbin of weft yarn, and the weaving process entails moving from bobbin to bobbin, back and forth across the working edge of the textile, building up row after row of the blocks of color that make up the design. Because figurative designs are not seen as rows of blocks of color, they cannot be woven this way, and as a result the "sequence of weaving," which Joanne Hall called the "secret" of the technique's speed and which "provides a systematic method" that enables the mind of the weaver to be "free for concentration on the design rather than the technique," is absent.[4]

The implications of this absence go much further than might be immediately apparent. For example, in weaving a geometric design, one of the basic aspects of properly placing a weft thread is using the beater and comb at regular intervals to pound the newly inserted weft into place. In weaving a figurative design, this is not so. Figurative weaving involves completing the amorphous sections of color that make up the design, and the working edge of the textile is consequently often very uneven. As a result, the beater and comb of the loom cannot be used, because the comb may not come into contact with the part of the working edge that is being woven. Instead, the newly inserted weft is pressed into place with a hand-held wide-toothed comb, like those used for combing hair. Instead of the rhythmic routine of inserting weft thread and pounding it into place with the loom's beater and comb, with its corresponding staccato thump, a different routine develops. In short, the weaver's interactions with the loom, the yarn, and the most basic activities associated with weaving are significantly altered.

A second difference arises in what Hall described as the overall working pattern created by the sequence of weaving. According to Hall, in this sequence "a specific direction of weaving is used," creating a "zigzag movement from side to side" across the working edge of the textile that helps to avoid the "confusion" of multiple weft threads "coming out of the shed in the same spot."[5] In the case of figurative designs, there is no "direction of weaving" and no "zigzag movement from side to side"—one simply weaves a bit here and a bit there as one completes first one and then another amorphous section of color, slowly building the design elements. It is the amorphous sections of color that structure the weaving process, and that structure holds little resemblance to the structure that Hall described as the "sequence of weaving."

As a consequence, novice weavers of figurative designs often experience the "confusion" that the sequence of weaving geometric designs helps them avoid. Many with whom I spoke about learning to weave figurative motifs emphasized how much time they had to spend thinking about the mechanics of weaving, searching for the right bobbin of yarn, and so on. Quite clearly, because the "sequence of weaving" cannot be employed when weaving figurative designs, much of what characterizes what Hall refers to as the "Mexican tapestry technique" cannot be employed either.

What replaces that technique? How do the weavers of figurative designs create a rhythmic stream of movements so that they can weave quickly and leave their minds free to contemplate the composition of the design? The answer is that in the case of very complicated figurative designs, they do not. Weaving a two-meter-wide figurative design from a pre-Hispanic codex, for example, may require hundreds of bobbins of yarn, so many that they have to be piled one on top of another on the breast beam, whereas the few needed for a geometric design would be evenly laid out across the width of the textile. Weaving figurative designs is a much slower and, quite often, very tedious enterprise to which not all Zapotec weavers are drawn while some, such as Ricardo Cardenas, are specifically attracted to the difficulties and challenges of, as he put it, *manejando tantos hilos,* "managing so many threads."

That is not to say that no rhythm or routine develops, but it is not the same routine that is a part of weaving geometric patterns. When weaving figurative designs, weavers develop a routine in the movement from one amorphous color section to another; the piles of bobbins, which may appear disorganized to an observer, are actually placed next to the amorphous color sections they will be used to weave. It is a routinization and order that does not create the kind of speed and fluidity that characterizes the sequence of weaving geometric designs. As a result, weaving a figurative design is slower, more tedious, and more labor-intensive.

Quite simply, the speed and rhythm of the Zapotec weaving technique, which makes Zapotec textiles so economical in comparison to Navajo textiles, do not exist in the weaving of complicated figurative designs. However, these designs only infrequently fit into the U.S. market niche for Zapotec textiles. Textiles depicting scenes from pre-Hispanic codices, for example, seldom find their way into the galleries of Santa Fe. Most often they are sold to wealthy Mexicans; their marketability and symbolic worth are, after all, predicated upon a complex of ideas about the relation of the textile and its maker to the "pre-Hispanic," ideas we discussed at length in part 1.

In part 2 we moved from analysis and description of these symbolic regimes into the weaving workshops of the Zapotec and ultimately to their looms and their weaving practices at them. That trajectory took us through the academic literature documenting nearly one hundred years of changes in the markets and organization of the production of Zapotec textiles. Working from Emily Vargas-Baron's notion of the weaving production complex, we developed an account of the transnational production of Zapotec textiles by adapting a global commodity chain perspective to the framework of the weaving production complex. Workshops from Santa Ana, California, to Santa Fe, New Mexico, to the Oaxacan communities of Díaz Ordaz, Santa Ana, San Miguel, and Teotitlán, we discovered, are connected in a complex transnational web of relations through which people work to craft Zapotec textiles—a transnational weaving community.

The tenor of this study shifted in chapters 5 and 6 as we began to examine how the Zapotec become weavers as they work in the transnational community of people making Zapotec textiles. Those chapters offered a detailed account of the working lives of Zapotec weavers, based on the personal history narratives of several weavers from Teotitlán, Santa Ana (Oaxaca), and Díaz Ordaz. Borrowing again from the work of Jean Lave and Etienne Wenger, as well as Pierre Bourdieu, we analyzed the participatory roles created for and by Zapotec children, adolescents, and young adults and how weavers craft career trajectories as the circumstances of their work as Zapotec weavers change over the course of their lives.

Those career trajectories have a profound effect on what weavers know of and about weaving, including the smallest details of how they use their hands and feet while working at the loom. We first worked toward a more general analysis of how geometric patterns are woven, and then toward an analysis of the difficulties one young Zapotec weaver had in his first attempt to weave a single figurative motif. As we did so, the ways that weavers work (within specific household workshops with their own distinct workforces that are, in turn, immersed in particular transnational chains of businesses producing textiles for unique regional market niches) took on greater significance as the medium through which their working lives intersect with the wider forces that structure the field of Zapotec textile production. In the end, a complex and detailed account of how Zapotec weavers come to embody the structural characteristics of the competitive sport of consecrating the producers of the products we call "Zapotec textiles" has emerged from the spaces MADE IN MEXICO.

Crafting Zapotec Weavers

Long before Zapotec weavers began to weave scenes from pre-Hispanic co-dices (in the late 1970s) and Navajo Yei figures (circa the mid-1980s) they were employing the technique of marking designs onto the warp. The *Flor de Oaxaca* ("Flower of Oaxaca"), a large circular motif with scalloped edges, which is often called "the most traditional" in Mexican popular literature and which we know from photographs that the Zapotec were weaving in the 1930s, is woven today using this technique, as are the eagle and serpent motifs of the Mexican flag, a stylized (and simplified) "Aztec sun stone," and a host of other designs. It is little more than a historical accident that in the 1990s these techniques were used to produce Yei figure motifs on textiles that looked like they were produced by the Navajo but which were made in Mexico.

The social and economic forces that set the stage for this historical accident, on the other hand, are complex. The effects of those forces on the working lives of Zapotec weavers are equally complex, and they are of utmost importance to the analysis of what, how, when, and where the Zapotec learn to weave. At the same time, however, they do not determine how the Zapotec weave. Put another way, the cultural product on which this study has focused and the practices through which it is produced are not "determined" by the symbolic space where the "authenticity" of textiles and weavers is negotiated; that symbolic space merely sets limits on what is possible. It opens a "space of possibility," to borrow Bourdieu's phrase one last time.

What I have termed the field of Zapotec textile production does not so much "determine" which textiles, weaving practices, and weavers are legitimate, but represents the cultural space in and through which the authority to give legitimacy to Zapotec textiles and weavers is conferred. People determine (and argue about) what is legitimate, and they write books, create exhibits, and purchase textiles that support their ideas about what (and who) is authentic. Cultural products, practices, and producers are not determined by the field, but are the product of a history of practice filtered through the prism of the field's symbolic logic. This is a logic that, in Mexico, legitimizes products and practices linked to the pre-Hispanic through distinct narrative operations. At the same time in the Southwestern U.S., the textiles produced for the Native American and ethnic art market based there, their producers, and the techniques of their manufacture are all legitimized in terms of a largely fantastical ("enchanted") conception of the Native American weaver.

These principles informed and shaped José's weaving practices as he created the Navajo Yei figure textiles. Whereas, according to Gladys Reichard, the Navajo must "see" the design as a huge succession of stripes of color in order to be able to weave it, the Zapotec (including José) break the design down into, and weave it in terms of, groups of stripes of color that are marked out on the warp. José needed to "see" the design not as a huge succession of stripes of color one weft thread wide, but as composed of amorphous sections of color. Furthermore, he had to learn to work at the loom in terms of the marks he had placed on the warp. While his initial attempt to do this was less than fully successful, with more time at the loom and by his third textile featuring the Yei figure motif, José had mastered this new technique, having developed a new set of bodily weaving techniques and practical weaving mētis to meet the demands of his father's client in Taos, New Mexico. One wonders if, as was asserted by the young Zapotec weaver quoted in chapter 6, it might not truly be "twice the work" for the Zapotec to learn to weave such designs.

Introduction

1. Pilcher, Jeffrey M. *Que Vivan los Tamales*, 77–99, 153.

2. Novelo, *Artesanías y capitalismo en México;* and Delpar, *The Enormous Vogue of Things Mexican.*

3. See Martí, *Our America.* Philip Foner's introduction to the collection is also valuable.

4. García Canclini, *Transforming Modernity,* 79.

5. Poole, "An Image of 'Our Indian,' " 80.

6. Ibid., 78. See also Jayne Howell's analysis of the popular (and global) uses of representations of one such female "type," the "Tehuana": "Constructions and Commodifications of Isthmus Zapotec Women."

7. Wilk, "Learning to be Local in Belize," 111. In addition to George Marcus's multiple essays on "tracking" or "following" as a useful methodology for global ethnographies, see Wilk, "Real Belizean Food," and Wood, "Flexible Production," for discussion and ethnographic examples of tracking stories or narratives as an ethnographic strategy.

8. Wilk, "Learning to be Local in Belize," 130, emphasis added.

9. Wilk, *Home Cooking in the Global Village,* 10. See Haugerud, Stone, and Little, *Commodities and Globalization,* for a comprehensive review of the growing literature on globalization.

10. Wilk, "Learning to be Local in Belize," 111. For Jonathan Friedman's work on the subject, see his "Being in the World," "The Past in the Future," and *Cultural Identity and Global Process.* The literature on cultural diversity, identity, and globalization is vast and growing, but for useful orientations to recent thought and debates on these topics see Appadurai, *Modernity at Large;* Friedman, *Cultural Identity and Global Process* and "From Roots to Routes"; Neizen, *A World beyond Difference;* Ong, *Flexible Citizenship;* Tomlinson, *Globalization and Culture;* and Tsing, *Friction.* Important theoretical essays are included in Appadurai, *Globalization;* Jameson and Miyosi, *The Cultures of Globalization;* King, *Culture, Globalization, and the World System;* Featherstone, *Global Culture;* and Mudimbe-Boyi, *Beyond Dichotomies.* Additionally, David Harvey's position, in "The Body as an Accumulation Strategy" and *Spaces of Hope,* on the body, capitalism, and globalization is widely regarded, and George Yúdice's recent work on culture and identity politics in the Latin American diaspora (*The Expediency of Culture*) offers an important regional take on the subject.

11. Wilk, *Home Cooking in the Global Village,* 196.

12. Ferguson, "The Country and the City on the Copperbelt"; Gupta and Ferguson, "Beyond 'Culture' "; and Hastrup and Olwig, introduction to *Siting Culture.*

13. Wilk, *Home Cooking in the Global Village,* 196.

14. García Canclini, *Transforming Modernity.* Michael Kearney has also suggested that moving beyond such modes of representing indigenous peasant farmers will entail situating "the production and consumption of representation of the peasantry within the relationships that join the anthropological self to the 'peasant' other it presumes to represent." Kearney, *Reconceptualizing the Peasantry,* 3. Put somewhat differently, an interpretive shift is required that will bring the work of ethnographers and the ethnographies they produce into the frame and make them part and parcel of the object of study. This ethnography explicitly makes that shift by locating our representations of indigenous and peasant Mexico within the ethnographic project in Mexico itself.

15. Wood, "Flexible Production."

16. Appadurai, *Modernity at Large,* 182, 184.

17. Ibid., 178–79, 185.

18. For example, see Michael Kearney's discussion of the development and limitations of various conceptualizations of rural "peasant" communities in Mexico (*Reconceptualizing the Peasantry,* 50–61), Eric Wolf's reassessment of the impact and misuse of his concept of the "closed corporate community" ("Closed Corporate Communities in Mesoamerica and Java" and "The Vicissitudes of the Closed Corporate Peasant Community"), Cynthia Hewitt de Alcántara's review of the various conceptual frameworks through which anthropological research in rural Mexico, and consequently other rural communities as well, has been approached (*Anthropological Perspectives on Rural Mexico*), and, finally, Erve E. Chambers and Philip D. Young's review of the community study genre through 1979 ("Mesoamerican Community Studies").

19. Lave and Wenger, *Situated Learning,* 98, 50.

20. Ortner, "Theory in Anthropology."

21. Lave and Wenger, *Situated Learning,* 29.

22. On the "sociocultural approach to mind," see van der Veer and Valsiner, *Understanding Vygotsky,* as well as Chaiklin and Lave, *Understanding Practice;* Daniels, *An Introduction to Vygotsky;* van der Veer and Valsiner, *The Vygotsky Reader;* and Wertsch, del Río, and Alvarez, *Sociocultural Studies of Mind.* The well-known educational theorist Jerome Bruner became interested in Vygotsky's work and wrote the introduction to *Thought and Language* (1962), the first of Vygotsky's books to be published in English (now translated as *Thinking and Speech*). Talal Asad also used Vygotsky's ideas in his article "Anthropological Conceptions of Religion." Fred Newman and Lois Holzman (*Lev Vygotsky*) argue that Vygotsky and his cohorts were, at the time of his death, actively engaged in working out the theoretical underpinnings and investigative methodology of a truly dialectical materialist psychology; Rom Harré and Grant Gillett (*The Discursive Mind*) see his ideas as marking a "discursive" turn in psychology.

23. Vygotsky, *Thinking and Speech,* 163. Vygotsky laid out the differences between his and Piaget's approaches to the relation between internal and external speech in several chapters of *Thought and Language* (1962) and summarized them in the first chapter of *Mind in Society* (1978). Vygotsky's characterization of Piaget's ideas on this issue are based upon his reading of Piaget's *Le langage et la pensée chez l'enfant* (1923), and he edited and contrib-

uted the preface to its first Russian translation (see Hanfmann and Vakar's editorial note in *Thought and Language,* p. 9, and Cole, John-Steiner, Scribner, and Souberman's editorial note 12 to chapter 1 of *Mind in Society*). See also Kozulin, "The Concept of Activity in Soviet Psychology," and Minick, "The Development of Vygotsky's Thought," for discussions of their differing accounts of egocentric speech (audible speech to oneself). Vygotsky's account of why egocentric speech in young children declines as the child begins to use social speech (audible speech to others) is profoundly different from Piaget's. In some of his best-known work, Vygotsky reinterpreted Piaget's findings in light of his reading of Piaget as well as a series of experiments fostering egocentric speech. He concluded that egocentric speech did not simply express the child's essential egocentrism, but that, by invoking the social realities of the child's past experience, it organized the child's practices.

24. Lave and Wenger, *Situated Learning,* 42. More recently, Etienne Wenger has further developed the idea of communities of practice, but in a different direction. He describes communities of practice as "shared histories of learning" and defines learning as both the "stage and the object" of practice (*Communities of Practice,* 86, 95). In other words, to be engaged in practice is to learn. The consequence, however, is that Wenger defines communities of practice essentially as shared histories of practice. This somewhat circular reasoning goes only slightly further than Lave and Wenger's original intuitive treatment of the issue.

In his "The Problem of the Environment," which remained unpublished in English until 1994, Vygotsky proposed a unit of analysis he called "emotional experience," through which the influence of the environment is refracted much as a prism refracts light (341–42). He went on to define emotional experience as "a unit where, on the one hand, in an indivisible state, the environment is represented and on the other hand, what is represented is how I, myself, am experiencing this" (342). Van der Veer and Valsiner point out that that the Russian text expresses the notion that a given reality may be "interpreted, perceived, experienced or lived through by different children in different ways" (354).

25. Bourdieu, *The Field of Cultural Production* and *The Rules of Art;* and Bourdieu and Wacquant, *An Invitation to Reflexive Sociology.*

26. Bourdieu, *The Rules of Art,* 223, 225.

27. Mauss, "The Techniques of the Body," 70, 72, 73, 74, 76.

28. Ibid., 85. On Foucault's notion of "anatomo-politics," see Foucault 1978. On sociological approaches to the study of the body, see B. Turner, "Recent Developments" and *The Body and Society;* and Farnell, "Moving Bodies, Acting Selves."

29. See B. Turner, "Recent Developments" and *The Body and Society;* T. Turner, "Bodies and Anti-bodies"; and Lyon and Barbalet, "Society's Body," for discussions of how Foucault's notion of anatomo-politics is overly deterministic.

30. Marcus, "Ethnography in/of the World System," 105–106. See also his "Contemporary Problems of Ethnography," "Imagining the Whole," and "General Comments."

31. See Walter Little's study of Maya craft vendors in Guatemala (*Mayas in the Marketplace*) and Michael Chibnik's research on Oaxacan wood carvers and decorators (*Crafting*

Tradition) for examples of multi-sited accounts of the lives of Mesoamerican crafters and merchants.

32. Wood, "Stories from the Field"; and Ortner, "Theory in Anthropology," 390, 398.

33. Roseberry, "Social Fields and Cultural Encounters," 515. See also Gluckman, *Analysis of a Social Situation in Modern Zululand* and *Order and Rebellion in Tribal Africa.*

34. Coronil, foreword to *Close Encounters of Empire,* xi.

35. Lave, "Science and/as Everyday Practice."

36. Harvey and Haraway, "Nature, Politics, and Possibilities."

1. ¡Viva Oaxaca, No Hay Otro!

1. "Lynn Youngstrum" is a pseudonym. This analysis is based on a transcription of Lynn's lecture, recorded with her permission on May 27, 1992.

2. Roseberry, "Hegemony and the Language of Contention," 361. On the encounter between weavers and entrepreneurs, see Wood, "Rapport Is Overrated" and "Stories from the Field."

3. Roseberry, "Hegemony and the Language of Contention," 364.

4. Pratt, *Imperial Eyes,* 7.

5. Thomas, *Colonialism's Culture,* 171, 173, 174, 185.

6. White, *Tropics of Discourse,* 2–4.

7. Before beginning her formal talk, Lynn remarked that she lectures frequently in the United States about Mexican folk art and that her talk had developed in that context. This may account, at least partially, for my being so forcefully jarred by the apparent inconsistencies between the Teotitlán she described and the one that I was, at the time, living in.

8. Morris, *Locations,* 22–23, 27. On von Humboldt and Bandelier, see Hammond and Goad, *A Scientist on the Trail.*

9. On the development of understandings of textile production in Teotitlán, see Wood, "Stories from the Field." For Paz, see his *The Labyrinth of Solitude,* 69.

10. Ober, *Travels in Mexico,* 543–44.

11. Corey, "Among the Zapotec of Mexico," 531–32, 549. *The National Geographic Magazine* has featured articles on Oaxaca's cultural and archaeological heritage on several occasions (in addition to Corey's, see, for example, Zimmerman, "Hewers of Stone," and Bevan, "Travels with a Donkey"). See Lutz and Collins, *Reading National Geographic,* for an analysis of the ways that discourse and images are used together in *The National Geographic Magazine* to create an idealized, even fetishized, non-Westerner and nature. They argue that images published in the magazine conform to an aesthetic that necessitates that the "culturally different person" be "cleaned up" so as to appear not too different and thereby ready for Western consumption (95–96).

12. Oglesby, *Modern and Primitive Arts,* 165–66.

13. Augur, *Zapotec,* 33, 34, 53.

14. Ibid., 60, 56.

15. Ibid., 65.

16. Greenblatt, *Marvelous Possessions,* 36.

17. Augur, *Zapotec,* 279.

18. Ibid., 62.

19. Wood, "Flexible Production" and "The 'Invasion' of Zapotec Textiles."

20. Mexican Secretariat of Tourism, "Colonial Excursions: Oaxaca."

21. Latitude International Folkart and Craft Exchange, "Zapotec Weavers."

22. Santa Fe Interiors, "Santa Fe Interiors Online."

23. Accents West, "The Zapotecs."

24. Folkways of Taos, "Folkways of Taos."

25. La Unica Cosa, "The Line of the Spirit Oaxaca Project."

26. Accents West, "The Zapotecs."

27. Arriero Zapotec Rugs, "History of Teotitlán del Valle"; and Celerina's Rugs, "Celerina's Rugs."

28. Pratt, *Imperial Eyes,* 102; and Roseberry, "Hegemony and the Language of Contention," 364.

29. Celerina's Rugs, "Celerina's Rugs."

30. Wood, *The Zapotec Textile Resource Pages.* See also Chibnik's discussion in *Crafting Tradition* of the important role played by "wholesalers" and other intermediaries both as a market and for their role in the production and marketing of Oaxacan *alebrijes* (carved, brightly painted wooden figures).

31. Wood, "Flexible Production."

2. Touring Zapotec Weavers, or the Bug in the Rug

1. Williams, *The Country and the City,* 50.

2. I have borrowed the phrase "the bug in the rug" from Gary Ross, who published several articles in popular magazines promoting travel in Oaxaca and the quality of Zapotec textiles made using "traditional" techniques and dyestuffs in the late 1980s. He uses it as little more than a catchy rhyme, not problematizing cochineal, its uses, or its associations.

3. Baskes, *Indians, Merchants, and Markets;* Chance, *Conquest of the Sierra* and *Race and Class in Colonial Oaxaca;* Hamnett, "Dye Production"; Spores, "Differential Response to Colonial Control"; and W. Taylor, *Landlord and Peasant* and "Town and Country."

4. Joseph, Rubenstein, and Zolov, "Assembling the Fragments," 11; and Vásquez Valle, *La cultura popular vista por las elites.*

5. Williams, *Marxism and Literature,* 132. In his most comprehensive treatment of the term, Williams explained that he deliberately chose "feeling" rather than more a formal term, such as "world-view" or "ideology," and he chose "structure" to connote a "set, with specific internal relations, at once interlocking and in tension" (132). His choice of terms, he points out, is an attempt to work between the present and the past, where the past is emergent in the present. The structure of feeling encompasses the "undeniable experience of the present" in process and as informed by history and social structure (128). It therefore represents an attempt to create a present neither overdetermined by a social

structure that took form in the past nor completely free of it: a moment with precedent and in process.

6. Rojek and Urry, "Transformations of Travel and Theory," 1. Given the difficulties of even defining "tourism" as an anthropological subject (a rather peculiar partnering of temporary migration and the products of what is now a global culture industry; see Clifford, "Traveling Cultures," and Bhabha, "Discussion"), I speak here of studies identified as ethnographies of tourism by their authors.

7. The tour described here is a composite of several actual tours to Teotitlán and environs, but is based primarily on a tour on September 17, 1993. It is presented in semi-documentary scenes which have been reconstructed from field notes and photos, and includes English translations of parts of the 1993 tour, a "weaving demonstration" video recorded on September 21, 1992, a tour on October 29, 2002, and observations made during eight months of participant observation fieldwork in three Zapotec households that incorporated gift shops. See also Wood, "To Learn Weaving below the Rock," for a translated transcription of the 1993 tour in its entirety.

8. All tour guides are paid in this way in Teotitlán. At the time of the 1992 tour, two families who gave a large number of weaving and dyeing demonstrations were in the midst of what their neighbors described as a feud for access to tour groups. They were attempting to outbid each other by giving the tour guides (who decide where to take their tours) larger commissions. The owner of the house that the 1993 tour visited had reportedly been offering tour guides as much as 40 percent of his total sales.

9. This is a standard way of organizing the demonstration and also a standard gendered division of labor in carding, spinning, and weaving demonstrations in Zapotec households (Wood, "To Learn Weaving below the Rock"). See, for example, a photograph published in *Anthropology News,* taken during a weaving demonstration in Teotitlán, depicting tourists (anthropologists in Oaxaca for a professional conference, in this case) seated in chairs around two women, the younger seated and carding wool and the older one standing and spinning it into yarn, while a male tour guide standing to the side of them delivers his lecture (American Anthropological Association, "Viva Oaxaca," 53).

10. In 1991 Margaret Sayers Peden and Carole Patterson published a book called *Out of the Volcano: Portraits of Contemporary Mexican Artists,* which contains photos and essays about the lives of Mexico's most prominent artists, musicians, poets, and writers, many of whom are world-renowned personalities like Octavio Paz. A small number of indigenous crafters are included, and Carlos is one of them. "[W]ith the advent of chemical dyes, Mexican weavers, artisans of all kinds, found an easier way to color their crafts. But some purists—we may well think of them as pure artists—have abandoned the harsher, flashier colors obtained from artificial agents and returned to the natural dyes of their ancestors" (187).

11. Millman, "Tiny Red Bugs," B1, C3.

12. Knight, "Racism, Revolution, and *Indigenismo,*" 82–83, 92–93.

13. Paz, *The Labyrinth of Solitude,* 69.

14. Rivera, "The Guild Spirit in Mexican Art," 174; and Caso, *La comunidad indígena,* 93, quoted in Knight, "Racism, Revolution, and *Indigenismo,*" 94.

15. Saragoza, "The Selling of Mexico," 95–101; and Castañeda, "The Aura of Ruins," 456. See also Castañeda, *In the Museum of Maya Culture,* for an extended discussion of the applicability of Walter Benjamin's well-known essay "The Work of Art in the Age of Mechanical Reproduction" to the analysis of the restoration or "reproduction" of the archaeological site of Chichén Itzá.

16. On the pre-revolutionary cultural industry, see Tenorio-Trillo, *Mexico at the World's Fairs.* Saragoza, "The Selling of Mexico," speaks of the "presentation of *mexicanidad*"; see also Zolov, "Discovering a Land 'Mysterious and Obvious.' " On the 1930s, see Novelo, *Artesanías y capitalismo en México.*

17. Zolov, "Discovering a Land 'Mysterious and Obvious,' " 241–49; Saragoza, "The Selling of Mexico," 98; and Zolov, "Discovering a Land 'Mysterious and Obvious,' " 246–49.

18. Novelo, *Artesanías y capitalismo en México,* 7. This and other translations from Spanish texts are mine, except where noted.

19. Ibid., 32–34.

20. Barta, "Of Alebrijes and Ocumichos," 57–58; see also Barta's "Más allá de la tradición."

21. Donkin, "Spanish Red," 45. On colonial cochineal production, see also Baskes, *Indians, Merchants, and Markets;* Hamnett, "Dye Production"; and W. Taylor, *Landlord and Peasant.*

22. Donkin, "Spanish Red," 24–25.

23. Von Humboldt, *Political Essay on the Kingdom of New Spain,* 77, quoted in Donkin, "Spanish Red," 28. On *nopaleras,* see Baskes, *Indians, Merchants, and Markets,* 68.

24. Donkin, "Spanish Red," 25.

25. According to these authors, because the Spanish crown placed severe limitations on who could supply credit to New Spain's Indian population, representatives of the crown (*alcaldes mayores,* who also collected Indian tribute) had a near monopoly on doing business with them. *Alcaldes mayores,* working in conjunction with Spanish merchants (who provided the necessary capital), supplied items and cash to the indigenous population on credit, to be repaid usually in foodstuffs or other items. This system, common throughout the Spanish Empire, was called the *repartimiento.* Many historians of colonial New Spain charge that the *repartimiento* was a predatory lending scheme that enabled Spanish colonists to force the Indian population to participate in the colonial economy: John Chance writes that "it more nearly resembled robbery than commerce" (*Conquest of the Sierra,* 97, quoted in Baskes, *Indians, Merchants, and Markets,* 111). *Repartimiento* loans to cochineal cultivators could be repaid only in cochineal, at a set price which was typically well below the market value of the cochineal.

26. Baskes, *Indians, Merchants, and Markets.*

27. Taussig, *Shamanism, Colonialism, and the Wild Man,* 82.

28. Skurski and Coronil, "County and City in a Postcolonial Landscape," 232, 235, 240. Similarly, William Roseberry argues that with the shift from an export economy based on coffee to one based on petroleum, the Venezuelan countryside came to occupy an ambiguous, "relatively a-historical" position in conceptions of Venezuelan

national patrimony. Accordingly, the Venezuelan petroleum industry embodies "both development and backwardness" (a kind of dependent economic development), so that the countryside (which is associated with the "agricultural past") is symbolically "devoid" of both "positive" and "negative" associations ("Images of the Peasant," 158). Like Skurski and Coronil, Roseberry finds that the vast plains (*llanos*) of the Venezuelan interior and its *mestizo* inhabitants (mixed Spanish and Native American *llaneros*) are inscribed in Venezuelan popular imagination as the "true Venezuela" and Venezuelans.

29. Ross, "The Bug in the Rug," 66; and Wood, "Stories from the Field" and "To Learn Weaving below the Rock."

30. The literature on the changing shape of Mexican national cultural patrimony and the role of intellectuals and artists in shaping the more liberal democratic versions that have developed since the Mexican Revolution is immense. On the development of Mexico's sense of its national cultural patrimony, see Castañeda, "The Aura of Ruins"; Delpar, *The Enormous Vogue of Things Mexican;* Kaplan, "Mexican Museums in the Creation of a National Image"; and Keen, *The Aztec Image in Western Thought.* For discussions of the role of indigenous crafts in the discursive construction of Mexican cultural identity, see Bakewell, " 'Bellas Artes' and 'Artes Populares' "; Barta, "Más allá de la tradición"; Delpar, *The Enormous Vogue of Things Mexican;* Errington, *The Death of Authentic Primitive Art;* García Canclini, *Transforming Modernity;* Novelo, *Artesanías y capitalismo en México;* and Schmidt, *The Roots of Lo Mexicano.* See also Barta, "Más allá de la tradición"; Cohen, "The Shan-Dany Museum"; Stephen, *Zapotec Women* (1991, 2005); and Wood, "Stories from the Field" and "To Learn Weaving below the Rock," for discussions of how Zapotec weavers and textiles are inserted (and to a limited degree insert themselves) into these constructions.

31. Delpar, *The Enormous Vogue of Things Mexican;* see also Castañeda, *In the Museum of Maya Culture;* Keen, *The Aztec Image in Western Thought;* and Littrell, "Symbolic Significance of Textile Crafts." Both Castañeda and Peter Hervik (*Mayan People within and beyond Boundaries* and "The Mysterious Maya of National Geographic") have documented how the image of the "mysterious Mayan" has been developed by a host of individuals, institutions (including U.S. universities and organizations funding anthropological research), and governmental agencies in Mexico, the United States, and Europe. This examination of how tour guides frame appreciation for Zapotec weavings reveals that Mexican sentiments toward Zapotec textiles and their producers, while a part of (and no doubt shaped by) such wider discursive flows, are also a part of attitudes and sentiments reflecting a distinctly Oaxacan social and economic relation between city and country, as I discussed in the introduction. It is a "structure of feeling," in Williams's sense, intimately tied to "city dwellers' " notions about natural wealth and indigenous "country inhabitants' " secret control over it which have developed historically in Oaxaca.

32. Camayd-Freixas, introduction to *Primitivism and Identity,* xviii.

33. Joseph, Rubenstein, and Zolov, "Assembling the Fragments."

34. Bourdieu, *The Field of Cultural Production,* 179, and *The Rules of Art,* 235.

3. Selling Zapotec Textiles in the "Land of Enchantment"

1. Lawrence, "Just Back from the Snake Dance—Tired Out," quoted in Theodore S. Jojola, "On Revision and Revisionism," quoting Marta Weigle, "From Desert to Disney World," quoting Lawrence's essay in Keith Sagar's edited volume *D. H. Lawrence and New Mexico*, p. 64. The essay was first published in the literary journal *Laughing Horse* in 1924.

2. Lawrence wrote two pieces based upon his viewing of the Hopi snake dance, "Just Back from the Snake Dance—Tired Out," and "The Hopi Snake Dance." His correspondence from the period reveals that he wrote "Just Back" first, and then "The Hopi Snake Dance" after Luhan reacted very badly to it. She wrote to a friend about "Just Back," "I grew inwardly colder and more aloof towards Lorenzo. I had not taken him to the Snake Dance to have him describe it in this fashion." Lawrence was clearly concerned by her reaction (Boulton and Vasey, *Letters of D. H. Lawrence*, 102–103). In the second piece, which she "approved," the snakes are described as "dangling by the neck from the mouths . . . and writhing and swaying slowly, with the small delicate snake-head held as if wondering and listening" (Lawrence, "Just Back from the Snake Dance—Tired Out," 855). See also Leah Dilworth, *Imagining Indians in the Southwest*, and her discussion (21–75) of the cultural history and politics of representation of the Hopi snake dance.

3. On the Santa Fe Railway and the Fred Harvey Company, see Howard and Pardue. *Inventing the Southwest;* Weigle, "From Desert to Disney World"; and Weigle and Babcock, *The Great Southwest.* On art patrons, see Mullin, *Culture in the Marketplace;* and Rodríguez, "Art, Tourism, and Race Relations in Taos," "Ethnic Reconstruction in Contemporary Taos," and "Tourism, Whiteness and the Vanishing Anglo." On Native American culture, see Chávez, *The Lost Land;* D'Arcus, "The 'Eager Gaze of the Tourist' "; Dilworth, *Imagining Indians in the Southwest* and "Tourists and Indians in Fred Harvey's Southwest"; and Jojola, "On Revision and Revisionism." On Santa Fe, see Wilson, *The Myth of Santa Fe.*

4. D'Arcus, "The 'Eager Gaze of the Tourist,' " 695, 712; and Riley, "Constituting the Southwest," 224. Compare James W. Byrkit's description of the Southwest as a geographically circumscribed region with a distinct and identifiable history, language, and culture ("Land, Sky, and People") to Riley's discussion of how the Southwest is a contested and discursively constructed social and cultural terrain. See also John R. Chávez's critique of "Anglo" representations and definitions of the Southwest as a geographical region for a counter-geographical description anchored in Latino/a politics and history—he quite rightly points out that the word "Southwest" itself assumes the "perspective of the Anglo-American cultural centers of the Atlantic Seaboard" (*The Lost Land,* 2). Finally, Barbara Babcock argues that this construction of the Southwest constitutes a "structure of domination more insidious than religious and military colonization" ("Pueblo Cultural Bodies," 51) and Sylvia Rodríguez links it to Orientalist discursive constructions (calling it a domestic, colonial, "Southwesternist" discourse of domination) ("Tourism, Whiteness and the Vanishing Anglo"; Rodríguez is here following Marta Weigle's "Southwest Lures").

5. "Ross Scottsdale" and "Brice McCoren" are pseudonyms. Information about these men and their businesses was obtained through interviews with them and fieldwork in

Oaxaca, the Santa Fe–Taos area of New Mexico, and Southern California between 1992 and 2003.

6. On sales of Zapotec textiles in the American Southwest, see Stephen, "Export Markets and Their Effects" and *Zapotec Women* (2005). On their presence as an "illegal invasion," see Wood, "Textiles oaxaqueños."

7. A large number of hippies made their way to Oaxaca in the late 1960s and early '70s on what was referred to as the "Gringo Trail." On the history and politics of this circumstance in Oaxaca, see Feinberg's description of United States "countercultural" interest in shamanic use of psilocybin mushrooms and resulting indigenous Mazatec identity politics within the context of international tourism (*The Devil's Book of Culture*).

8. Zapotec weavers refer to outlining a design element or giving it a border in a contrasting color (most often black) as giving the element a "shadow."

9. Lynn Youngstrum said that she went to Mexico for the first time in 1980 with a fairly small sum of money, $600; she traveled out to Teotitlán on a "third-class bus," spent a day buying textiles, and then took them home and sold them.

10. In fact, professional textiles buyers warned me that they would not discuss their clients at all, just in case I got the idea of starting up my own business.

11. Stephen, "Export Markets and Their Effects," 383–84; and M'Closkey, *Swept under the Rug,* 14.

12. M'Closkey, *Swept under the Rug,* 197.

13. Blomberg, *Navajo Textiles,* 234.

14. On the "living villages," see Blomberg, *Navajo Textiles,* 14–15; and Howard and Pardue, *Inventing the Southwest,* 57. On Hearst's correspondence with Schweizer and his purchases, see Blomberg, *Navajo Textiles,* 11.

15. Blomberg, *Navajo Textiles,* 234.

16. All information about Michael Wineland, his work with Bianca Dresner, and sales of Santa Fe Interiors textiles was obtained during an interview with him on April 9, 2002, in Santa Monica, California.

17. Stephen, "Export Markets and Their Effects," *Zapotec Women* (1991), "Weaving in the Fast Lane," and *Zapotec Women* (2005).

18. Wood, "Flexible Production." See also chapter 4 of this book.

19. Hearst #235 was produced in two versions: a largely gray and tan version using undyed yarn called "Hearst #235 Natural" and a bright red and orange version called "Hearst #235 *Rojo Fuerte.*" In 2004, Hearst #235 textiles ranged in price from $275.00 for a small weaving to $5,600.00 for a 9′ × 12′ area rug.

20. M'Closkey, *Swept under the Rug,* 197. I was not able to locate this passage when I visited the website.

21. Ibid., 14.

22. Ibid., 197.

23. Meyn, *More Than Curiosities,* 19.

24. Ibid., 5–6, emphasis added.

25. Indian Market is purported to have been established in 1922 and is currently overseen by the Southwestern Association for Indian Arts. Prizes are awarded for several

crafts, including weaving, and visitors wander from stall to stall purchasing craft items from artists and watching demonstrations. Strict rules govern participation—only craftsmen can participate, they must sell their own work, and they must use "traditional" materials and techniques. They must also be able to document at least 25 percent "Indian blood"—at least one of their grandparents must have been a member of a state- or federally recognized "tribe" (Cornelius, "Two Days, 1,200 Artists, 100,000 Buyers," 6–7). See also Mullin, *Culture in the Marketplace,* 135–46, and Meyn, *More Than Curiosities,* 125–27, for detailed discussion of the market's origins as an official event in 1971 and its relation to wider patterns in the exposition of indigenous culture. Mullin also reports that an early organizer modeled its precursor (weekly markets in the Santa Fe plaza in the 1930s) on her memory of open-air community markets in Mexico. On the seminar, see Mullin, *Culture in the Marketplace,* 162.

26. James, *Indian Blankets and Their Makers,* 160; and Dedera, *Navajo Rugs,* 100–101.

27. The Saltillo-style serape takes its name from the city of Saltillo, a center of textile manufacture during the colonial period and today the capital of the state of Coahuila in northern Mexico. On the history of Navajo textile production, see Howard and Pardue, *Inventing the Southwest;* Kaufman and Selser, *The Navajo Weaving Tradition;* Kent, "From Blanket to Rug" and *Navajo Weaving;* and Wheat, "Early Navajo Weaving"; on the influence of the Rio Grande style, see Jaramillo, "Rio Grande Weaving"; McIntyre, *Rio Grande Blankets;* and Wheat, "Rio Grande, Pueblo, and Navajo Weavers." For Chavez's discussion of the American Southwest, see his *The Lost Land.*

28. Churchill, "The Nullification of Native America," 23; and Dubin, *Native America Collected,* 40.

29. Throughout the remainder of this chapter, the word "Mexican" will appear in quotation marks to reflect the constructed nature of this ethnic and national category in the regional social hierarchy of the Southwestern United States. It will be used without regard to the multiple nuanced distinctions typically maintained in the Southwest between, for example, residents of Mexico, recent immigrants from Mexico, and those who trace their ancestry to the colonial settlers of New Spain (which became part of Mexico and then of the United States), although I recognize that these distinctions are important to those immersed in this hierarchy. See Chávez, *The Lost Land,* for a discussion of the history of ethnic cultural politics in the region from the mid-1800s through the 1970s.

30. Rodríguez, "Art, Tourism, and Race Relations in Taos," 80.

31. Bodine, *A Tri-ethnic Trap;* and Rodríguez, "Art, Tourism, and Race Relations in Taos," 87. On "Mexicans" and "Mexican" immigration as a symbol of poverty, see Mehan, "The Discourse of the Illegal Immigration Debate"; Pease Chock, "Ambiguity in Policy Discourse"; Santa Ana, "Like an animal I was treated"; and Vila, "Narrative Identities." On "Mexican" settler populations, see Chavez, *The Lost Land,* 85–106.

32. Wood, "The 'Invasion' of Zapotec Textiles" and "Textiles oaxaqueños."

33. See Dubin, *Native America Collected,* 39–43, and Wood, "Flexible Production," on the use of a "primitivist discourse" in the marketing of indigenous arts and crafts more broadly.

34. Riley, "Constituting the Southwest," 239.

The Zapotec Industry

1. García, "Interview," 369. On indigenous video, see also Himpele, "Gaining Ground"; and Smith, "Mediating Indigenous Identity" and "Mobilizing Indigenous Video."

2. Smith notes in "Mediating Indigenous Identity" that Fausto and Juan José met during a political organizing event (*encuentro*) for indigenous leaders. Further, she told me she suspects that the event was orchestrated by the Instituto Nacional Indigenista (INI); see Wortham, "Between State and Indigenous Autonomy," and Smith, "Mobilizing Indigenous Video," on the importance to indigenous video of the intersection of the state and indigenous identity politics.

3. See also Jeffrey Cohen's discussion of similar rationales for forming a co-op among weavers in the nearby town of Santa Ana ("Craft Production and the Challenge of the Global Market") and Stephen's extended discussion of Zapotec women's weaving co-ops (*Zapotec Women* [2005]).

4. On the founding of TMA, see Wortham, "Between State and Indigenous Autonomy," 363. On Juan José's and Guillermo's work since 1994, see ibid. and García, "Interview."

5. Through his Santa Fe Interiors business, Michael also produced a video about the Zapotec weavers of Teotitlán called *Oaxaca Weavers*. While space does not permit a full analysis of the representational differences between the videos made by Sarapes, Arte y Tradición and Santa Fe Interiors, it bears noting that, like Lynn Youngstrum's account of the life and work of Zapotec weavers in chapter 1, Michael's video does not dwell on Teotitlán's mechanized yarn mill, nor on the changes that the success of businesses like his have brought to Fausto's community.

6. Himpele, "Gaining Ground," 353.

7. Wortham, "Between State and Indigenous Autonomy," 364; and Himpele, "Gaining Ground," 353.

8. Adorno, *The Culture Industry,* 98, 100.

9. Bourdieu, *The Field of Cultural Production,* 42, and Randall Johnson's introduction to it, 20.

10. Comaroff and Comaroff, *Ethnography and the Historical Imagination,* 31, 18.

11. Lave and Wenger, *Situated Learning,* 55.

4. The Zapotec Textile Production Complex

1. Cohen, "Popular Participation and Civil Society," "Markets, Museums, and Modes of Production," "Craft Production and the Challenge of the Global Market," and "The Shan-Dany Museum"; Cook and Binford 1990; Cook and Diskin 1976; Hernández-Diaz et al., *Artesanías y artesanos en Oaxaca;* Littrell, "Symbolic Significance of Textile Crafts"; Stephen, "Weaving Changes," "Zapotec Weavers of Oaxaca," *Zapotec Women* (1991), "Export Markets and Their Effects," and "Weaving in the Fast Lane"; Popelka, "Profiles of Successful Textile Handicraft Entrepreneurs"; Tiffany, "Frame that Rug"; and Wood, "To

Learn Weaving below the Rock," "Flexible Production," "Stories from the Field," "The 'Invasion' of Zapotec Textiles," and "Textiles oaxaqueños."

2. Taylor, "Teotitlán del Valle," 105–106. *Tianguis* is the Nahuatl word for "market" and is used commonly in Oaxaca to refer to Saturday's market, one of a number of weekly markets in various locations in the Oaxaca Valley. This "cyclical market system" has been treated extensively by Beals, *The Peasant Marketing System;* Cook and Binford, *Obliging Need;* Cook and Diskin, "The Peasant Market Economy of the Valley of Oaxaca"; Diskin, "A Historical-Ecological Approach"; and Malinowski and de la Fuente, *Malinowski in Mexico.*

3. Taylor, "Teotitlán del Valle," 111.

4. Ibid., 114, 124, 129.

5. Wood, "Stories from the Field."

6. Vargas-Baron, "Development and Change in Rural Artisanry," 140–41.

7. Ibid., 125–26.

8. Ibid., 186, 189.

9. Cohen, "Markets, Museums, and Modes of Production" and "Popular Participation and Civil Society"; Cook and Binford, *Obliging Need;* and Stephen, "Weaving Changes," "Zapotec Weavers of Oaxaca," "Export Markets and Their Effects," and *Zapotec Women* (2005). In the latter, she expands upon this line of thinking to more thoroughly examine the ways that weaving families in Teotitlán have responded to globalization, especially through the formation of women's cooperatives.

10. Young, "Modes of Appropriation."

11. Cook and Binford, "Petty Commodity Production" and *Obliging Need;* and Young, "Modes of Appropriation," 149–51, 153.

12. Stephen, *Zapotec Women* (1991), 118–19.

13. Stephen, "Weaving in the Fast Lane," 38, 44. In her Ph.D. dissertation, "Profiles of Successful Textile Handicraft Entrepreneurs in Teotitlán del Valle, Oaxaca, Mexico," Cheryl Ann Popelka, the only non-anthropologist I consider here, commits herself to a similar agenda and, like Stephen, locates the nexus for change from "traditional" craft to "commercialized" product in merchants ("entrepreneurs") from Teotitlán serving tourist and export markets.

14. Stephen, "Weaving Changes," 124–27, 136. Jeffrey Cohen, "Markets, Museums, and Modes of Production," and Jorge Hernández-Diaz et al., *Artesanías y artesanos en Oaxaca,* offer detailed discussions of textile production in Santa Ana and its relation to merchants from Teotitlán in the late 1980s and 1990s. Helen Clements's conference paper "Buscando la Forma: Self-Reorganization in Craft Commercialization" outlines how San Miguel's more recent immersion in the WPC has affected the relations of production of textile-making there.

15. Stephen, "Weaving Changes," 164–65, and *Zapotec Women* (1991), 135–37.

16. Cook and Binford, *Obliging Need,* 197–98, 212–13.

17. Ibid., 213, emphasis added.

18. Graham and James's Laneria de Ocotlán has also begun to supply indigenous weavers in the Southwestern U.S. with angora yarn—they now stock the Teec Nos Pos

trading post in eastern Arizona, which supplies Navajo weavers with yarn. Wood, "Textiles oaxaqueños."

19. See also Chibnik, *Crafting Tradition,* for an application of this approach to the example of Oaxacan woodcarving and painting.

20. Wood, "Flexible Production."

21. Wood, "To Learn Weaving below the Rock."

22. Harvey, *The Condition of Postmodernity,* 147–57, 152; see also Lash and Urry, *The End of Organized Capitalism.*

23. Wood, "Flexible Production" and "Textiles oaxaqueños."

24. Hopkins and Wallerstein, "Commodity Chains," 17; Gereffi et al., "Introduction: Globalization, Value Chains, and Development"; and McCormick and Schmitz, *Manual for Value Chain Research on Homeworkers in the Garment Industry,* 43–45.

25. Gereffi, "The Organization of Buyer-Driven Global Commodity Chains," 96–100, 99. I do not use his work on "value chains" (Gereffi et al., "Introduction: Globalization, Value Chains, and Development") in my analysis. See Foster, "Commodity Futures," for a convincing critique of this more recent work.

5. "We Learn to Weave by Weaving"

1. Lave and Wenger, *Situated Learning,* 34.

2. Lave, "Science and/as Everyday Practice"; and Lave and Wenger, *Situated Learning,* 48–49.

3. Lave and Wenger, *Situated Learning,* 29, 34–43.

4. Ibid., 37.

5. For an example, see Peden and Patterson, *Out of the Volcano.*

6. Thorough discussions of loom building (Zumbühl, *Manuel de construcción de un telar de pedal*), "natural" dyes and dyeing techniques (Gally, Revah, and Blanco, *Teñido de lana con plantas*), and weaving (Lechuga, *Las técnicas textiles*) are available in Spanish. In her excellent *Mexican Tapestry Weaving,* Joanne Hall discusses not only the processes and techniques by which weft-faced (tapestry-weave) woolen textiles are produced in their entirety throughout Mexico but also illustrates, through diagrams, photos, and detailed drawings, many of the designs common to Zapotec textiles, providing step-by-step instructions in how to weave them.

7. Stephen, *Zapotec Women* (1991).

8. Deere and de Janvry, "A Conceptual Framework."

9. In fact, two production units are unaccounted for in the literature: subcontracted "merchants" with at-home pieceworkers and subcontracted "merchants" with in-house pieceworkers. In both cases, weavers in a household that appears to have risen to merchant status within the frame of the relations of production in the Tlacolula WPC may actually be spending the majority of their time doing piecework for a merchant in Santa Fe, and may also farm some of that work out to other pieceworker households.

10. Stephen, *Zapotec Women* (1991), 125–26.

11. Elena's life and her work weaving and teaching others to weave offer many important insights into the gendered relations of power that are a part of the organization of textile production in the social fabric of Teotitlán. Further investigation revealed that while Elena was not the only woman to have been weaving, she was indeed involved in teaching a large number of women and girls to weave. Two women I interviewed recounted how Elena (a strong, imposing, independent woman who took a husband from outside the village) had been hacked to death at night on the street with a machete. Although it is unclear why she was killed (some attribute the murder to a disgruntled lover, while others attribute it to her involvement in weaving and teaching other women the craft), her murder highlights the seriousness with which access to and legitimacy in participatory patterns in Zapotec textile production are taken in Teotitlán.

12. The *mozo* hired by her father may have understood that teaching his employer's children to weave did not promote his own job security.

13. Young girls also play at food preparation. They may be seen playing at making chocolate in miniature green-glazed jugs, learning to spin the wooden beater between the palms of their hands to create foam in the make-believe chocolate drink.

14. For example, in the year and a half that I lived in Teotitlán, not one workshop of the three in which I worked maintained a steady workforce. In fact, only one of the three seemed to be steadily involved in textile production at all—different people came and went, wove only sporadically, and would leave for hours, and sometimes no one would come at all for days at a time. There seemed to be little order to the contexts in which people learned to weave because there seemed to be little continuity in who was working on what and where.

15. See Cohen, *The Culture of Migration in Southern Mexico,* on how household composition affects migratory patterns.

16. Lave and Wenger, *Situated Learning,* 34.

6. To Learn Weaving, MADE IN MEXICO

1. Harvey and Haraway, "Nature, Politics, and Possibilities," 510.

2. Bourdieu, *The Rules of Art.*

3. Harvey, "The Body as an Accumulation Strategy," 405.

4. Collard, "The Body in Theory," 392; she is thinking specifically of Haraway, *Simians, Cyborgs, and Women;* Foucault, *The History of Sexuality,* vol. 1; and Butler, *Bodies That Matter.*

5. Collard, "The Body in Theory," 396, quoting Marx, *Capital,* 481–82.

6. Foucault, *The History of Sexuality,* vol. 1.

7. Harvey, *The Limits to Capital,* 405–409. He describes the circulation of variable capital more fully on pp. 113, 186, and 207–208.

8. Harvey, "The Body as an Accumulation Strategy," 406.

9. Hunter, "Mind Games and Body Techniques," 178–79.

10. Rothstein and Rothstein, *Mexican Folk Art from Oaxacan Artist Families,* 69; and Forcey, *The Colors of Casa Cruz,* 6.

11. The following account is based on both Forcey's and the Rothsteins' books as well as on interaction and conversations with Fidel and María Luisa and their families between 1991 and 2002. Unless otherwise indicated, all quotations are from an interview on August 20, 2002.

12. Forcey, *The Colors of Casa Cruz*, 47, 36.

13. Peden and Patterson, *Out of the Volcano*, 187.

14. Forcey, *The Colors of Casa Cruz*, 13–14; and Rothstein and Rothstein, *Mexican Folk Art from Oaxacan Artist Families*, 62–71. The Fomento Cultural Banamex program, intended to promote the folk art of Mexico, has called another well-known weaver-artist from Teotitlán, Arnulfo Mendoza, a "great master," and his use of natural dye substances (especially cochineal) is an important part of this frame and a marker of distinction: "he has developed a palette from the tones of his native land: the earth and the sky wear the reddish tones he draws from the cochineal." Fomento Cultural Banamex, *Great Masters of Mexican Folk Art*, 385.

15. Novelo, *Artesanías y capitalismo en México*, 15, 60.

16. Rothstein and Rothstein, *Mexican Folk Art from Oaxacan Artist Families*, 61.

17. Bourdieu, *The Rules of Art*, 258.

18. Reichard, *Navajo Shepherd and Weaver*, 86.

19. Hall, *Mexican Tapestry Weaving*, 23–30.

20. It is possible to weave two halves of a textile separately and then attach them together, creating a finished product wider than the loom. In the past, this was common practice. I heard on numerous occasions in Teotitlán that tourists and importers from the U.S. complained that the seam joining the two halves of the textile was unsightly and that weavers had tried to accommodate the *gringo* taste for uniformity and seamlessness by working with local loom builders to develop wider looms.

21. Hall, *Mexican Tapestry Weaving*, 30.

22. When I was beginning to learn to weave, and struggling against the loom, the strain that I placed on the warp thread with the weight of my body caused the warps to break in the harnesses. I was lectured by the young man overseeing my work; in one of only a few instances of "instruction," he told me not to stomp on the pedal, but to press it down firmly yet softly while I was working.

23. Scott, *Seeing Like a State*, 316.

24. Ibid., 313.

25. Ibid., 323.

26. Ibid., 311.

27. When I began to learn to weave, I had several mechanical problems. I often pressed one pedal when I should have pressed the opposite one; I had trouble setting the correct tension (making the arch the right size) on a newly placed weft thread; I had problems knowing when to fill in or otherwise adjust the twelve-step sequence to compensate for the varying thickness of the weft thread. These are all problems with which I saw others grapple as well.

28. Hall, *Mexican Tapestry Weaving*, 49–50.

29. Harvey, *The Limits to Capital*, 405.

Crafting Zapotec Weaving Practices

1. The figurative designs are called *dibujos,* "drawings," after the paper cartoons used in the planning process.

2. I purchased the first textile from Roberto, in order to have a visual record of my observations, while the second and third were shipped to the gallery in Taos, New Mexico, where they became the front panels of a pair of pillows. Because my observation of José's first few attempts at weaving a figurative design was fortuitous and consequently less than systematic, this discussion will be built, for the most part, around an analysis and discussion of the first Yei figure textile that he wove.

3. I experienced the difficulties of learning to weave figurative designs firsthand while working in the home of Antonio Mendoza Ruiz, Ricardo's cousin and the son of the man from whom Ricardo had learned to weave figurative designs. Had I not worked in Antonio's house, I might not have had the opportunity to learn this skill because, quite simply, I might not have been working among people doing that kind of work. I also might not have had the opportunity to watch others doing this kind of weaving, and I might not have been privy to the comments in passing, the suggestions during dinner-table discussions, and the impromptu demonstrations that constitute "teaching" in Teotitlán. For example, when I began my first figurative design I had a great deal of difficulty weaving gradually curving lines. The curved lines that I wove seemed always to turn out irregular, zigzagging back and forth across the marks on the warp. Antonio, who observed the difficulty that I was having, gave me a single piece of advice, casually, one day as he was passing the loom on his way out of the house—he told me that the most important thing is not to try to exactly trace the contours of the marks on the warp. He said that the marks should be considered little more than reminders of where in the design one is weaving. I found this piece of advice very helpful, and when I stopped tracing the dotted outlines of the design, the curved lines that I was trying to weave smoothed out and became less irregular.

4. Hall, *Mexican Tapestry Weaving,* 49–50.

5. Ibid.

Accents West. "The Zapotecs: The Other Native Americans." 2001. http://actwest
.home.texas.net/intro.html.

Adorno, Theodor W. *The Culture Industry: Selected Essays on Mass Culture.* New York:
Routledge, 1991.

American Anthropological Association. "Viva Oaxaca." *Anthropology News, Section News*
42, no. 6 (2001): 52–53.

Appadurai, Arjun. "Discussion: Fieldwork in the Era of Globalization." *Anthropology and
Humanism* 22, no. 1 (1997): 115–18.

———. "Disjuncture and Difference in the Global Cultural Economy." *Public Culture* 2,
no. 2 (1990): 1–24.

———, ed. *Globalization.* Durham, N.C.: Duke University Press, 2001.

———. *Modernity at Large: Cultural Dimensions of Globalization.* Minneapolis: University
of Minnesota Press, 1996.

Archuleta-Sagel, Teresa. "Textiles." In *Spanish New Mexico,* vol. 1, *The Arts of Spanish New
Mexico,* ed. D. Pierce and M. Weigle, 144–63. Santa Fe: Museum of New Mexico
Press, 1996.

Arriero Zapotec Rugs. "History of Teotitlán del Valle." 2000. http://www.arrierorugs
.com/history.htm.

Asad, Talal. "Anthropological Conceptions of Religion: Reflections on Geertz." *Man* 18,
no. 2 (1983): 237–59.

Augur, Helen. *Zapotec.* Garden City, N.Y.: Doubleday, 1954.

Babcock, Barbara. "Pueblo Cultural Bodies." *Journal of American Folklore* 32 (1994):
400–37.

Bakewell, Liza. "'Bellas Artes' and 'Artes Populares': The Implications of Difference in the
Mexico City Art World." In *Looking High and Low: Art and Cultural Identity,* ed. Brenda Jo
Bright and Liza Bakewell, 19–54. Tucson: University of Arizona Press, 1995.

Barta, Eli. "Más allá de la tradición: Sincretismo, género y arte popular en México."
Historia Mexicana 9, no. 1 (1998): 75–93.

———. "Of Alebrijes and Ocumichos: Some Myths about Folk Art and Mexican
Identity." In *Primitivism and Identity in Latin America: Essays on Art, Literature, and Culture,*
ed. Erik Camayd-Freixas and José Eduardo González, 53–73. Tucson: University of
Arizona Press, 2000.

Baskes, Jeremy. *Indians, Merchants, and Markets: A Reinterpretation of the Repartimiento and
Spanish-Indian Economic Relations in Colonial Oaxaca, 1750–1821.* Stanford: Stanford
University Press, 2000.

Beals, Ralph. *The Peasant Marketing System of Oaxaca, Mexico.* Berkeley: University of
California Press, 1975.

Benjamin, Walter. "The Work of Art in the Age of Mechanical Reproduction." In *Illuminations,* ed. Hannah Arendt, 217–51. New York: Schocken Books, 1968.

Bennett, Noël. *Genuine Navajo Rug—Are You Sure?* Window Rock, Ariz.: The Museum of Navajo Ceremonial Art and The Navajo Tribe, 1973.

Bevan, Bernard. "Travels with a Donkey in Mexico." *National Geographic Magazine* 66, no. 6 (1934): 757–88.

Bhabha, Homi. "Discussion: James Clifford." In *Cultural Studies,* ed. Lawrence Grossberg, Cary Nelson, and Paula A. Treichler, 112. New York: Routledge, 1992.

Blomberg, Nancy J. *Navajo Textiles: The William Randolph Hearst Collection.* Tucson: University of Arizona Press, 1988.

Bodine, John. *A Tri-ethnic Trap: The Spanish American in Taos.* Seattle: University of Washington Press, 1968.

Boulton, James T., and Lindeth Vasey, eds. *The Letters of D. H. Lawrence,* vol. 5, *March 1924–March 1927.* New York: Cambridge University Press, 1989.

Bourdieu, Pierre. *The Field of Cultural Production: Essays on Art and Literature.* New York: Columbia University Press, 1993.

———. *Pascalian Meditations.* Trans. Richard Nice. Stanford: Stanford University Press, 2000.

———. *The Rules of Art: Genesis and Structure of the Literary Field.* Stanford: Stanford University Press, 1996.

Bourdieu, Pierre, and Loïc J. D. Wacquant. *An Invitation to Reflexive Sociology.* Chicago: University of Chicago Press, 1992.

Bowen, Dorothy Boyd. "A Brief History of Spanish Textile Production in the Southwest." In *Rio Grande Textiles,* ed. Nora Fisher, 2–5. Santa Fe: Museum of New Mexico Press, 1994.

Brody, James J. "The Creative Consumer: Survival, Revival, and Invention in Southwest Indian Arts." In *Ethnic and Tourist Arts: Cultural Expressions from the Fourth World,* ed. Nelson H. H. Graburn, 70–84. Berkeley: University of California Press, 1976.

Butler, Judith. *Bodies That Matter: On the Discursive Limits of "Sex."* New York: Routledge, 1993.

Byrkit, James W. "Land, Sky, and People: The Southwest Defined." *Journal of the Southwest* 34, no. 3 (1992): 257–387.

Camayd-Freixas, Erik. Introduction to *Primitivism and Identity in Latin America: Essays on Art, Literature, and Culture,* ed. Erik Camayd-Freixas and José Eduardo González, vii–xix. Tucson: University of Arizona Press, 2000.

Carruthers, David V. "The Politics and Ecology of Indigenous Folk Art in Mexico." *Human Organization* 60, no. 4 (2001): 356–66.

Caso, Alfonso. *La comunidad indígena.* Mexico City, Mexico: Secretaría de Educación Pública, 1971.

Castañeda, Quetzil. "The Aura of Ruins." In *Fragments of a Golden Age: The Politics of Culture in Mexico since 1940,* ed. Gilbert M. Joseph, Anne Rubenstein, and Eric Zolov, 452–67. Durham, N.C.: Duke University Press, 2001.

———. *In the Museum of Maya Culture: Touring Chichén Itzá.* Minneapolis: University of Minnesota Press, 1996.

Celerina's Rugs. "Celerina's Rugs." 2001. http://www.celerina.com/home.html.

Chaiklin, Seth, and Jean Lave, eds. *Understanding Practice: Perspectives on Activity and Context.* New York: Cambridge University Press, 1993.

Chambers, Erve E., and Philip D. Young. "Mesoamerican Community Studies: The Past Decade." *Annual Review of Anthropology* 8 (1979): 45–69.

Chance, John. *Conquest of the Sierra: Spaniards and Indians in Colonial Oaxaca.* Norman: University of Oklahoma Press, 1989.

———, *Race and Class in Colonial Oaxaca.* Stanford. Stanford University Press, 1978.

Chávez, John R. *The Lost Land: The Chicano Image of the Southwest.* Albuquerque: University of New Mexico Press, 1984.

Chibnik, Michael. *Crafting Tradition: The Making and Marketing of Oaxaca Wood Carvings.* Austin: University of Texas Press, 2003.

Churchill, Ward. "The Nullification of Native America? An Analysis of the 1990 American Indian Arts and Crafts Act." In *Acts of Rebellion: The Ward Churchill Reader,* 23–41. New York: Routledge, 2003.

Clements, Helen P. "Buscando la Forma: Self-Reorganization in Craft Commercialization." Paper presented at the 16th International Congress of Americanists. Amsterdam, July 4–8, 1988.

Clifford, James. "Traveling Cultures." In *Cultural Studies,* ed. Lawrence Grossberg, Cary Nelson, and Paula A. Treichler, 96–112. New York: Routledge, 1992.

Coffey, Mary. "From Nation to Community: Museum and the Reconfiguration of Mexican Society under Neoliberalism." In *Foucault, Cultural Studies, and Governmentality,* ed. Jack Z. Bratich, Jeremy Packer, and Cameron McCarthy, 207–41. New York: State University of New York Press, 2003.

Cohen, Jeffrey. "The Artisan's Society of Santa Ana del Valle, Oaxaca, Mexico: Household Competition and Cooperative Management." In *At the Interface: The Household and Beyond,* ed. David B. Small and Nicola Tannenbaum, 15–29. Lanham, Md.: University Press of America, 1999.

———. *Cooperation and Community: Economy and Society in Oaxaca.* Austin: University of Texas Press, 1999.

———. "Craft Production and the Challenge of the Global Market: An Artisans' Cooperative in Oaxaca, Mexico." *Human Organization* 57, no. 1 (1998): 74–82.

———. *The Culture of Migration in Southern Mexico.* Austin: University of Texas Press, 2004.

———. "Markets, Museums, and Modes of Production: Economic Strategies in Two Zapotec Weaving Communities of Oaxaca, Mexico." *Society for Economic Anthropology Newsletter* 9, no. 2 (1990): 12–29.

———. "Popular Participation and Civil Society: The Shan-Dany Museum and the Construction of Community in Mexico." *Practicing Anthropology* 19, no. 3 (1997): 36–40.

———. "The Shan-Dany Museum: Community, Economics, and Cultural Traditions in a Rural Mexican Village." *Human Organization* 60, no. 3 (2001): 272–80.

Coleman, Cornelius. "Two Days, 1,200 Artists, 100,100 Buyers: The 71st Indian Market Gears Up." In *The Albuquerque Journal's Guide to the 71st Santa Fe Indian Market.* Santa Fe, N.M.: Albuquerque Publishing Co., 1992.

Collard, Felicity J. "The Body in Theory." *Environment and Planning D: Space and Society* 16 (1998): 387–400.

Comaroff, John L., and Jean Comaroff. *Ethnography and the Historical Imagination.* Boulder, Colo.: Westview, 1992.

Cook, Scott. "Craft Commodity Production, Market Diversity, and Differential Rewards in Mexican Capitalism Today." In *Crafts in the World Market: The Impact of Global Exchange on Middle American Artisans,* ed. June Nash, 59–83. Albany: State University of New York Press, 1993.

———. "Peasant Economy and the Dynamics of Rural Industrial Commodity Production in the Oaxaca Valley, Mexico." *Journal of Peasant Studies* 12, no. 1 (1984): 3–40.

Cook, Scott, and Leigh Binford. *Obliging Need: Rural Petty Industry in Mexican Capitalism.* Austin: University of Texas Press, 1990.

———. "Petty Commodity Production, Capital Accumulation, and Peasant Differentiation: Lenin vs. Chayanov in Rural Mexico." *Review of Radical Political Economics* 18, no. 4 (1986): 1–31.

Cook, Scott, and Martin Diskin. "The Peasant Market Economy of the Valley of Oaxaca in Analysis and History." In *Markets in Oaxaca: Essays on a Regional Peasant Economy of Mexico,* ed. Scott Cook and Martin Diskin, 5–25. Austin: University of Texas Press, 1976.

Corey, Herbert. "Among the Zapotec of Mexico." *National Geographic Magazine* 51, no. 5 (1927): 501–53.

Cornelius, C. "Two Days, 1,200 Artists, 100,000 Buyers: The 71st Indian Market Gears Up." *Albuquerque Journal Guide to the 71st Santa Fe Indian Market.* Albuquerque, N.M.: Albuquerque Publishing Co., August 19, 1992.

Coronil, Fernando. Foreword to *Close Encounters of Empire: Writing the Cultural History of U.S.-Latin American Relations,* ed. Gilbert M. Joseph, Catherine C. LeGrand, and Ricardo D. Salvatore, ix–xii. Durham, N.C.: Duke University Press, 1998.

Daniels, Harry, ed. *An Introduction to Vygotsky.* New York: Routledge, 1996.

D'Arcus, Bruce. "The 'Eager Gaze of the Tourist' Meets 'Our Grandfathers' Guns': Producing and Contesting the Land of Enchantment in Gallup, New Mexico." *Environment and Planning D: Society and Space* 18 (2000): 693–714.

de Certeau, Michel. *The Practice of Everyday Life.* Berkeley: University of California Press, 1986.

Dedera, Don. *Navajo Rugs: How to Find, Evaluate, Buy and Care for Them.* Flagstaff, Ariz.: Northland Publishing, 1975.

Deere, Carmen Diana, and Alain de Janvry. "A Conceptual Framework for the Empirical Analysis of Peasants." *American Journal of Agricultural Economics* 61 (1979): 601–11.

Delpar, Helen. *The Enormous Vogue of Things Mexican: Cultural Relations between the United States and Mexico, 1920–1935.* Tuscaloosa: University of Alabama Press, 1992.

Di Michele, Laura. "Autobiography and the 'Structure of Feeling' in *Border Country*." In *Views beyond the Border Country: Raymond Williams and Cultural Politics,* ed. Dennis L. Dworkin and Leslie G. Roman, 21–37. New York: Routledge, 1993.

Dilworth, Leah. *Imagining Indians in the Southwest: Persistent Visions of a Primitive Past.* Washington, D.C.: Smithsonian Institution Press, 1996.

———. "Tourists and Indians in Fred Harvey's Southwest." In *Seeing and Being Seen: Tourism in the American West,* ed. David M. Wrobel and Patrick T. Long, 142–64. Lawrence: Published for the Center of the American West University of Colorado at Boulder by the University Press of Kansas, 2001.

Diskin, Martin. "A Historical-Ecological Approach to the Study of the Oaxaca Plaza System." In *Markets in Oaxaca: Essays on a Regional Peasant Economy of Mexico,* ed. Scott Cook and Martin Diskin, 235–45. Austin: University of Texas Press, 1976.

Donkin, R. A. "Spanish Red: An Ethnogeographical Study of Cochineal and the Opuntia Cactus." *Transactions of the American Philosophical Society* 67, no. 5 (1977): 5–77.

Dubin, Margaret. *Native America Collected: The Culture of an Art World.* Albuquerque: University of New Mexico Press, 2001.

El Paso Rug and Import. "Southwest Handwoven Wool Zapotec Rugs." 2001. http://www.elpasorug.com/zapotec_rugs.htm.

Errington, Shelly. *The Death of Authentic Primitive Art and Other Tales of Progress.* Berkeley: University of California Press, 1998.

Farnell, Brenda. "Moving Bodies, Acting Selves." *Annual Review of Anthropology* 28 (1999): 341–73.

Featherstone, Mike, ed. *Global Culture: Nationalism, Globalization, and Modernity.* London: Sage, 1990.

Feinberg, Benjamin. *The Devil's Book of Culture: History, Mushrooms, and Caves in Southern Mexico.* Austin: University of Texas Press, 2003.

Ferguson, James. "The Country and the City on the Copperbelt." In *Culture, Power, Place: Explorations in Critical Anthropology,* ed. Akhil Gupta and James Ferguson, 137–54. Durham, N.C.: Duke University Press, 1997.

Fernández Retamar, Roberto. "Against the Black Legend." In *Caliban and Other Essays,* trans. E. Baker, 56–73. Minneapolis: University of Minnesota Press, 1989.

Folkways of Taos. "Folkways of Taos." 2001. http://www.zapotec.com/folkways.html.

Fomento Cultural Banamex. *Great Masters of Mexican Folk Art, from the Collection of Fomento Cultural Banamex.* Edited by Cándida Fernández de Calderón, Alberto Sarmiento, and Victoria Fuente de Álvarez. Mexico City, Mexico: Fomento Cultural Banamex, 1998.

Foner, Philip S. Introduction to *Our America: Writings on Latin America and the Struggle for Cuban Independence,* by José Martí, 11–68. New York: Monthly Review Press, 1977.

Forcey, John. *The Colors of Casa Cruz: An Intimate Look at the Art and Skill of Fidel Cruz, Award-Winning Textile Weaver.* Oaxaca, Mexico: Impresos Árbol de Vida, 1999.

Foster, Robert. "Commodity Futures: Labor, Love and Value." *Anthropology Today* 21, no. 4 (2005): 8–12.

Foucault, Michel. *The History of Sexuality,* vol. 1, *An Introduction.* New York: Random House, 1978.

———. "Technologies of the Self." In *Technologies of the Self: A Seminar with Michel Foucault,* ed. Luther H. Martin, Huck Gutman, and Patrick H. Hutton, 16–49. Amherst: University of Massachusetts Press, 1988.

Friedman, Jonathan. "Being in the World: Globalization and Localization." *Theory, Culture, and Society* 7 (1990): 311–28.

———. *Cultural Identity and Global Process.* London: Sage, 1994.

———. "From Roots to Routes: Tropes for Trippers." *Anthropological Theory* 2, no. 1 (2002): 21–36.

———. "The Past in the Future: History and the Politics of Identity." *American Anthropologist* 94, no. 4 (1992): 837–59.

Gally, Rosa, Patricia Revah, and Auberto Blanco. *Teñido de lana con plantas.* Mexico City, Mexico: Arbol Editorial, S.A. de C.V., 1982.

García, Juan Jose. "An Interview with Juan Jose García, President of *Ojo de Agua Comunicación.*" By Anna Brígido-Corachán. *American Anthropologist* 106, no. 2 (2004): 368–73.

García Canclini, Néstor. *Transforming Modernity: Popular Culture in Mexico.* Austin: University of Texas Press, 1993.

Gereffi, Gary. "Beyond the Producer-Driven/Buyer-Driven Dichotomy: The Evolution of Global Value Chains in the Internet Era." *Institute for Development Studies Bulletin* 32, no. 3 (2001): 30–40.

———. "Mexico's 'Old' and 'New' Maquiladora Industries: Contrasting Approaches to North American Integration." In *Neoliberalism Revisited: Economic Restructuring and Mexico's Political Future,* ed. Gerardo Otero, 85–105. New York: Westview, 1996.

———. "The Organization of Buyer-Driven Global Commodity Chains: How U.S. Retailers Shape Overseas Production Networks." In *Commodity Chains and Global Capitalism,* ed. Gary Gereffi and Miguel Korzeniewicz, 95–122. Westport: Greenwood, 1994.

Gereffi, Gary, John Humphrey, Raphael Kapinsky, and Timothy J. Sturgion. "Introduction: Globalization, Value Chains, and Development." *Institute for Development Studies Bulletin* 32, no. 3 (2001): 1–8.

Gluckman, Max. *Analysis of a Social Situation in Modern Zululand.* Manchester, U.K.: Manchester University Press, 1940.

———. *Order and Rebellion in Tribal Africa.* New York: Free Press, 1963.

Greenblatt, Stephen. *Marvelous Possessions: The Wonder of the New World.* Chicago: University of Chicago Press, 1991.

Greenfield, Patricia Marks. *Weaving Generations Together: Evolving Creativity in the Maya of Chiapas.* Santa Fe, N.M.: School of American Research Press, 2004.

Gupta, Akhil. "The Song of the Nonaligned World: Transnational Identities and the Reinscription of Space in Late Capitalism." In *Culture, Power, Place: Explorations in*

Critical Anthropology, ed. Akhil Gupta and James Ferguson, 179–99. Durham, N.C.: Duke University Press, 1997.

Gupta, Akhil, and James Ferguson. "Beyond 'Culture': Space, Identity, and the Politics of Difference." In *Culture, Power, Place: Explorations in Critical Anthropology,* ed. Akhil Gupta and James Ferguson, 35–51. Durham, N.C.: Duke University Press, 1997.

————. "Discipline and Practice: 'The Field' as Site, Method, and Location in Anthropology." In *Anthropological Locations: Boundaries and Grounds of a Field Science,* ed. Akhil Gupta and James Ferguson, 1–46. Berkeley: University of California Press, 1997.

Gutmann, Matthew C. "For Whom the Taco Bells Toll: Popular Responses to NAFTA South of the Border." *Critique of Anthropology* 18, no. 3 (1998): 297–315.

Hag, Ghassan. "A Not So Multi-sited Ethnography of a Not So Imagined Community." *Anthropological Theory* 5, no. 4 (2005): 463–75.

Hall, Joanne. *Mexican Tapestry Weaving.* Helena, Mont.: J. Arvidson Press, 1976.

Hammond, George P., and Edgar F. Goad, eds. *A Scientist on the Trail: Travel Letters of A. F. Bandelier, 1880–1881.* Berkeley: The Quivira Society, 1949.

Hamnett, Brian. "Dye Production, Food Supply, and the Laboring Population of Oaxaca, 1750–1820." *Hispanic American Historical Review* 51 (1971): 51–78.

Haraway, Donna. *Simians, Cyborgs, and Women: The Reinvention of Nature.* New York: Routledge, 1991.

Harré, Rom, and Grant Gillett. *The Discursive Mind.* Thousand Oaks, Calif.: Sage, 1994.

Harvey, David. "The Body as an Accumulation Strategy." *Environment and Planning D: Space and Society* 16 (1998): 401–21.

————. *The Condition of Postmodernity: An Inquiry into the Origins of Cultural Change.* Cambridge: Basil Blackwell, 1989.

————. *Justice, Nature, and the Geography of Difference.* Oxford: Blackwell, 1996.

————. *The Limits to Capital.* 2nd ed. New York: Verso, 1999.

————. *Spaces of Hope.* Berkeley: University of California Press, 2000.

Harvey, David, and Donna Haraway. "Nature, Politics, and Possibilities: A Debate and Discussion with David Harvey and Donna Haraway." *Environment and Planning D: Space and Society* 13 (1995): 507–27.

Hastrup, Kirsten, and Karen Fog Olwig. Introduction to *Siting Culture: The Shifting Anthropological Object,* ed. Karen Fog Olwig and Kirsten Hastrup, 1–14. New York: Routledge, 1997.

Haugerud, Angelique, M. Priscilla Stone, and Peter D. Little, eds. *Commodities and Globalization: Anthropological Perspectives.* Lanham, Md.: Rowman & Littlefield, 2000.

Hernández-Diaz, Jorge, et al. *Artesanías y artesanos en Oaxaca: Innovaciones de la tradicíon Oaxaca.* Oaxaca, Mexico: Conaculta-Fonca, 2001.

Hervik, Peter. *Mayan People within and beyond Boundaries: Social Categories and Lived Identity in Yucatán.* Amsterdam: Harwood Academic Publishers, 1999.

————. "The Mysterious Maya of National Geographic." *Journal of Latin American Anthropology* 4, no. 1 (2001): 166–97.

Hewitt de Alcántara, Cynthia. *Anthropological Perspectives on Rural Mexico.* London: Routledge and Kegan Paul, 1984.

Himpele, Jeff. "Gaining Ground: Indigenous Video in Bolivia, Mexico, and Beyond: Introduction." *American Anthropologist* 106, no. 2 (2004): 353.

Hopkins, Terrence K., and Immanuel Wallerstein. "Commodity Chains: Construct and Research." In *Commodity Chains and Global Capitalism,* ed. Gary Gereffi and Miguel Korzeniewicz, 17–20. Westport, Conn.: Greenwood, 1994.

Howard, Kathleen L., and Diana F. Pardue. *Inventing the Southwest: The Fred Harvey Company and Native American Art.* Flagstaff, Ariz.: Northland Publishing, 1996.

Howell, Jayne. "Constructions and Commodifications of Isthmus Zapotec Women." *Studies in Latin American Popular Culture* 25 (2006): 1–23.

Huizar Murillo, Javier, and Isidro Cerda. "Indigenous Mexican Migrants in the 2000 U. S. Census: 'Hispanic American Indians.'" In *Indigenous Mexican Migrants in the United States,* ed. Jonathan Fox and Gaspar Rivera-Salgado, 279–302. La Jolla: Center for U.S.-Mexican Studies, University of California, San Diego, 2004.

Hunter, Ian. "Mind Games and Body Techniques." *Southern Review* 26, no. 2 (1993): 172–85.

The Indian Arts and Crafts Board. "Indian Handicrafts: The True and the False." National Archives, 435-DB-40, 1964.

James, George Wharton. *Indian Blankets and Their Makers.* Chicago: A. C. McClurg; New York: Dover, 1974. (Orig. pub. 1914.)

Jameson, Frederick, and Masao Miyosi, eds. *The Cultures of Globalization.* Durham, N.C.: Duke University Press, 1999.

Jaramillo, Juanita. "Rio Grande Weaving: A Continuing Tradition." In *Hispanic Crafts of the Southwest: An Exhibition Catalogue,* ed. W. Wroth, 9–23. Colorado Springs, Colo.: Colorado Springs Fine Arts Center, 1977.

Johnson, Randall. Introduction to *The Field of Cultural Production: Essays on Art and Literature,* by Pierre Bourdieu, 1–25. New York: Columbia University Press, 1993.

Jojola, Theodore S. "On Revision and Revisionism: American Indian Representation in New Mexico." *American Indian Quarterly* 20, no. 1 (1996): 41–47.

Joseph, Gilbert M., Anne Rubenstein, and Eric Zolov. "Assembling the Fragments: Writing a Cultural History of Mexico since 1940." In *Fragments of a Golden Age: The Politics of Culture in Mexico since 1940,* ed. Gilbert M. Joseph, Anne Rubenstein, and Eric Zolov, 3–22. Durham, N.C.: Duke University Press, 2001.

Kaplan, Flora. "Mexican Museums in the Creation of a National Image in World Tourism." In *Crafts in the World Market: The Impact of Global Exchange on Middle American Artisans,* ed. June Nash, 103–25. Albany: State University of New York Press, 1993.

Kaufman, Alice, and Christopher Selser. *The Navajo Weaving Tradition: 1650 to the Present.* New York: E. P. Dutton, 1985.

Kearney, Michael. "The Effects of Transnational Culture, Economy, and Migration on Mixtec Identity in Oaxacalifornia." In *The Bubbling Cauldron: Race, Ethnicity, and the Urban Crisis,* ed. Michael Peter Smith and Joe R. Feagin, 226–43. Minneapolis: University of Minnesota Press, 1995.

————. "Integration of the Mixteca and the Western US-Mexican Border Region via Migratory Wage Labor." In *Regional Impacts of US-Mexican Relations, Monograph Series, No. 16*, ed. I. Rosenthal-Urey, 71–102. La Jolla: Center for US-Mexican Studies, University of California, San Diego, 1986.

————. *Reconceptualizing the Peasantry: Anthropology in Global Perspective.* Boulder, Colo.: Westview, 1996.

Keen, Benjamin. *The Aztec Image in Western Thought.* New Brunswick, N.J.: Rutgers University Press, 1971.

Kent, Kate Peck. "From Blanket to Rug: The Evolution of Navajo Weaving after 1880." *Plateau* 52, no. 4 (1981): 10–21.

————. *Navajo Weaving: Three Centuries of Change.* Santa Fe, N.M.: School of American Research Press, 1985.

King, Anthony D., ed. *Culture, Globalization, and the World System: Contemporary Conditions for the Representation of Identity.* Minneapolis: University of Minnesota Press, 1997.

Knight, Alan. "Racism, Revolution, and Indigenismo: Mexico, 1910–1940." In *The Idea of Race in Latin America, 1910–1940,* ed. Richard Graham, 73–113. Austin: University of Texas Press, 1990.

Kozulin, Alex. "The Concept of Activity in Soviet Psychology: Vygotsky, His Disciples and Critics." *American Psychologist* 41, no. 3 (1986): 264–74.

Lash, Scott, and John Urry. *The End of Organized Capitalism.* Madison: University of Wisconsin Press, 1987.

Latitude International Folk Art and Craft Exchange. "The Zapotec Weavers of Oaxaca, Mexico." 1996. http://www.folkart.com/~latitude/zapotec/zapotec.htm.

Lave, Jean. "The Practice of Learning." In *Understanding Practice: Perspectives on Activity and Context,* ed. Seth Chaiklin and Jean Lave, 3–32. New York: Cambridge University Press, 1993.

————. "Science and/as Everyday Practice." Lecture recorded on *The Anthropology of Science and Scientists* 1, tape 30-1B. Washington, D.C.: American Association for the Advancement of Science, 1991.

Lave, Jean, and Etienne Wenger. *Situated Learning: Legitimate Peripheral Participation.* New York: Cambridge University Press, 1991.

Lawrence, D. H. "The Hopi Snake Dance." *Theatre Arts Monthly* 8, no. 12 (1924): 836–60.

————. "Just Back from the Snake Dance—Tired Out." *Laughing Horse* 11 (September 1924): 26–29.

Lechuga, Ruth D. *Las técnicas textiles en el México indígena.* Mexico: Fondo Nacional para el Fomento de las Artesanías, 1982.

Lederman, Rena. "Globalization and the Future of Culture Areas: Melanesianist Anthropology in Transition." *Annual Review of Anthropology* 27 (1998): 427–49.

Little, Walter. *Mayas in the Marketplace: Tourism, Globalization, and Cultural Identity.* Austin: University of Texas Press, 2005.

Littrell, Mary Ann. "Symbolic Significance of Textile Crafts for Tourists." *Annals of Tourism Research* 17, no. 2 (1991): 228–45.

Lucero, Helen R., and Suzanne Baizerman. *Chimayó Weaving: The Transformation of a Tradition.* Albuquerque: University of New Mexico Press, 1999.

Lutz, Catherine A., and Jane L. Collins. *Reading National Geographic.* Chicago: University of Chicago Press, 1993.

Lyon, M. L., and J. M. Barbalet. "Society's Body: Emotion and the 'Somatization' of Social Theory." In *Embodiment and Experience: The Existential Ground of Culture and Self,* ed. Thomas J. Csordas, 48–66. New York: Cambridge University Press, 1994.

Malinowski, Bronislaw, and Julio de la Fuente. *Malinowski in Mexico: The Economy of a Mexican Market System.* Edited and with an introduction by S. Drucker-Brown. New York: Routledge and Kegan Paul, 1982.

Marcus, George. "Contemporary Problems of Ethnography in the Modern World System." In *Writing Culture: The Poetics and Politics of Ethnography,* ed. James Clifford and George E. Marcus, 165–93. Berkeley: University of California Press, 1986.

———. "Ethnography in/of the World System: The Emergence of Multi-sited Ethnography." *Annual Review of Anthropology* 24 (1995): 95–117.

———. "General Comments: Future Ethnographies." *Cultural Anthropology* 9, no. 3 (1994): 423–28.

———. "Imagining the Whole: Ethnography's Contemporary Efforts to Situate Itself." *Critique of Anthropology* 9, no. 3 (1989): 7–30.

Martí, José. *Our America: Writings on Latin America and the Struggle for Cuban Independence.* Trans. Elinor Randall. New York: Monthly Review Press, 1977.

Martin, Emily. "The End of the Body?" *American Ethnologist* 19, no. 1 (1992): 121–40.

Marx, Karl. *Capital: A Critique of Political Economy, Volume 1.* Trans. Ben Fowkes. New York: Vintage Books, 1977.

Mather, Christine, and Sharon Woods. *Santa Fe Style.* New York: Rizzoli, 1986.

Mauss, Marcel. "The Techniques of the Body." *Economy and Society* 2, no. 1 (1979): 70–88.

M'Closkey, Kathy. "Marketing Multiple Myths: The Hidden History of Navajo Weaving." *Journal of the Southwest* 36, no. 3 (1994): 185–220.

———. *Swept under the Rug: A Hidden History of Navajo Weaving.* Albuquerque: University of New Mexico Press, 2002.

McCormick, Dorothy, and Hubert Schmitz. *Manual for Value Chain Research on Homeworkers in the Garment Industry.* Brighton, U.K.: Institute for Development Studies, University of Sussex, 2002.

McIntyre, Kellen Kee. *Rio Grande Blankets: Late Nineteenth-Century Textiles in Transition.* Albuquerque, N.M.: Adobe Gallery, 1992.

Mehan, Hugh. "The Discourse of the Illegal Immigration Debate: A Case Study in the Politics of Representation." *Discourse and Society* 8, no. 2 (1997): 249–70.

Mexican Secretariat of Tourism. "Colonial Excursions: Oaxaca." 1997. http://mexico -travel.com/activities/colonial/col-515.htm/.

Meyn, Susan Labry. *More Than Curiosities: A Grassroots History of the Indian Arts and Crafts Board and Its Precursors, 1920–1942.* Lanham, Md.: Lexington Books, 2001.

Millman, Joel. "Can Tiny Red Bugs Mean Gold for Mexico?" *Wall Street Journal,* 7 October 1998, sect. B, p. 1, col. 3.

Minge, Ward Alan. "*Efectos del País:* A History of Weaving along the Rio Grande." In *Rio Grande Textiles,* ed. Nora Fisher, 5–21. Santa Fe: Museum of New Mexico Press, 1994.

Minick, Norris J. "The Development of Vygotsky's Thought: An Introduction." In *Thinking and Speech,* by Lev Vygotsky, 17–36. New York: Plenum, 1987.

Mintz, Sidney. "The Localization of Anthropological Practice: From Area Studies to Transnationalism." *Critique of Anthropology* 18, no. 2 (1998): 117–33.

Morris, Jan. *Locations.* New York: Oxford University Press, 1992.

Mudimbe-Boyi, Elisabeth, ed. *Beyond Dichotomies: Histories, Identities, Cultures, and the Challenge of Globalization.* Albany: State University of New York Press, 2002.

Mullin, Molly H. *Culture in the Marketplace: Gender, Art, and Value in the American Southwest.* Durham, N.C.: Duke University Press, 2001.

———. "The Patronage of Difference: Making Indian Art 'Art, Not Ethnology.'" In *The Traffic in Culture: Refiguring Art and Anthropology,* ed. George E. Marcus and Fred R. Myers, 395–424. Berkeley: University of California Press, 1995.

Myers, Fred R. *Painting Culture: The Making of an Aboriginal High Art.* Durham, N.C.: Duke University Press, 2002.

Nash, June, ed. *Crafts in the World Market: The Impact of Global Exchange on Middle American Artisans.* Albany: State University of New York Press, 1993.

Nash, June, and María Patricia Fernández-Kelly, eds. *Women, Men, and the International Division of Labor.* Albany: State University of New York Press, 1983.

Natural History Museum of Los Angeles County. Travel program, winter 2001.

Neizen, Ronald. *A World beyond Difference: Cultural Identity in the Age of Globalization.* London: Blackwell, 2004.

Newman, Fred, and Lois Holzman. *Lev Vygotsky: Revolutionary Scientist.* New York: Routledge, 1993.

Norris, Scott, ed. *Discovered Country: Tourism and Survival in the American West.* Albuquerque, N.M.: Stone Ladder, 1994.

Novelo, Victoria. *Artesanías y capitalismo en México.* Mexico City, Mexico: Instituto Nacional de Antropología e Historia, 1976.

Ober, Frederick A. *Travels in Mexico and Life among the Mexicans,* vol. 2, *Central and Southern Mexico.* Boston, Mass.: Estes and Lauriat, 1884.

Oglesby, Catherine. *Modern and Primitive Arts of Mexico, Guatemala, and the Southwest.* New York: McGraw-Hill, 1939.

Olwig, Karen Fog, and Kirsten Hastrup, eds. *Siting Culture: The Shifting Anthropological Object.* New York: Routledge, 1997.

Ong, Aihwa. *Flexible Citizenship: The Cultural Logics of Transnationality.* Durham, N.C.: Duke University Press, 1999.

Ortner, Sherry B. "Theory in Anthropology since the Sixties." In *Culture/Power/History: A Reader in Contemporary Social Theory,* ed. Nicholas B. Dirks, Geoff Eley, and Sherry B. Ortner, 372–411. Princeton, N.J.: Princeton University Press, 1994.

Parsons, Elsie Clews. *Mitla, Town of the Souls, and Other Zapoteco-Speaking Pueblos of Oaxaca, Mexico.* Chicago: University of Chicago Press, 1936.

Paz, Octavio. *The Labyrinth of Solitude: Life and Thought in Mexico.* Trans. Lysander Kempt. New York: Grove Press, 1961.

Pease Chock, Phyllis. "Ambiguity in Policy Discourse: Congressional Talk about Immigration." *Policy Sciences* 28 (1995): 165–84.

Peden, Margaret Sayers, and Carole Patterson. *Out of the Volcano: Portraits of Contemporary Mexican Artists.* Washington, D.C.: Smithsonian Institution Press, 1991.

Piaget, Jean. *Le langage et la pensée chez l'enfant.* Neuchatel, France: Delachaux et Niestlé, 1923.

Pilcher, Jeffrey M. *¡Que Vivan los Tamales! Food and the Making of Mexican Identity.* Albuquerque: University of New Mexico Press, 1998.

Poole, Deborah. "An Image of 'Our Indian': Type Photographs and Racial Sentiments in Oaxaca, 1920–1940." *Hispanic American Historical Review* 84, no. 1 (2004): 37–84.

Popelka, Cheryl Ann. "Profiles of Successful Textile Handicraft Entrepreneurs in Teotitlán del Valle, Oaxaca, Mexico." Ph.D. dissertation, Iowa State University, 1989.

Pratt, Mary Louise. *Imperial Eyes: Travel Writing and Transculturation.* New York: Routledge, 1992.

Reichard, Gladys A. *Navajo Shepherd and Weaver.* Glorieta, N.M.: Rio Grande Press, 1936.

Riley, Michael J. "Constituting the Southwest, Contesting the Southwest, Re-inventing the Southwest." *Journal of the Southwest* 36, no. 3 (1994): 221–41.

Rivera, Diego. "The Guild Spirit in Mexican Art: As Told to Katherine Anne Porter with Reproductions from His Murals." *Survey Graphic* 5, no. 2 (1924): 174–78.

Rodríguez, Sylvia. "Art, Tourism, and Race Relations in Taos: Toward a Sociology of the Art Colony." *Journal of Anthropological Research* 45, no. 1 (1989): 77–100.

———. "Ethnic Reconstruction in Contemporary Taos." *Journal of the Southwest* 32 (1990): 541–55.

———. "Tourism, Whiteness and the Vanishing Anglo." In *Seeing and Being Seen: Tourism in the American West,* ed. David M. Wrobel and Patrick T. Long, 194–210. Lawrence: Published for the Center of the American West University of Colorado at Boulder by the University Press of Kansas, 2001.

———. "The Tourist Gaze, Gentrification, and the Commodification of Subjectivity in Taos." In *Essays on the Changing Images of the Southwest,* ed. Richard Francaviglia and David Narrett, 105–26. College Station: Published for the University of Texas at Arlington by Texas A&M University Press, 1994.

Rojek, Chris, and John Urry. "Transformations of Travel and Theory." In *Touring Cultures: Transformations of Travel and Theory,* ed. Chris Rojek and John Urry, 1–19. New York: Routledge, 1997.

Roseberry, William. "Hegemony and the Language of Contention." In *Everyday Forms of State Formation: Revolution and the Negotiation of Rule in Modern Mexico,* ed. Gilbert M. Joseph and Daniel Nugent, 355–66. Durham, N.C.: Duke University Press, 1994.

———. "Images of the Peasant in the Consciousness of the Venezuelan Proletariat." In *Proletarians and Protest: The Roots of Class Formation in an Industrializing World,* ed.

Michael Hanagan and Charles Stephenson, 149–69. Westport, Conn.: Greenwood, 1986.

———. "Social Fields and Cultural Encounters." In *Close Encounters of Empire: Writing the Cultural History of U.S.-Latin American Relations,* ed. Gilbert M. Joseph, Catherine C. LeGrand, and Ricardo D. Salvatore, 515–24. Durham, N.C.: Duke University Press, 1998.

Ross, Gary. "A Blue Future for Mexican Indigo." *Americas* 39 (July–August 1987): 40–46.

———. "The Bug in the Rug." *Natural History* 95, no. 3 (1986): 66–73.

———. "Night of the Radishes." *Natural History* 95, no. 12 (1986): 61–64.

———. "Threads of Tradition." *Americas* 40 (July–August 1988): 16–21.

Rothstein, Arden Aibel, and Anya Leah Rothstein. *Mexican Folk Art from Oaxacan Artist Families.* Atglen, Pa.: Schiffer, 2002.

Rothstein, Frances A. "Flexible Accumulation, Youth Labor, and Schooling in a Rural Community in Mexico." *Critique of Anthropology* 16, no. 4 (1996): 361–79.

Sagar, Keith, ed. *D. H. Lawrence and New Mexico.* Salt Lake City, Utah: Peregrine Smith, 1982.

Santa Ana, Otto. " 'Like an animal I was treated': Anti-immigrant Metaphor in U.S. Public Discourse." *Discourse and Society* 10, no. 2 (1999): 191–224.

Santa Fe Interiors. *Oaxacan Weavers.* VHS video. Santa Fe, N.M.: Santa Fe Interiors, n.d.

———. "Santa Fe Interiors Online—Americana, Hearst Series." 2003. http://www .santafeinteriors.com/americana/hearst.html.

Saragoza, Alex. "The Selling of Mexico: Tourism and the State, 1929–1952." In *Fragments of a Golden Age: The Politics of Culture in Mexico since 1940,* ed. Gilbert M. Joseph, Anne Rubenstein, and Eric Zolov, 91–115. Durham, N.C.: Duke University Press, 2001.

Sarapes, Arte y Tradición. *Seenau Galvain/Sigue la Vida.* VHS video. Mexico: Centro de Video Indígena Oaxaca, n.d.

Schmidt, Henry C. *The Roots of Lo Mexicano: Self and Society in Mexican Thought, 1900–1934.* College Station: Texas A&M University Press, 1978.

Scott, James C. *Seeing Like a State: How Certain Schemes to Improve the Human Condition Have Failed.* New Haven, Conn.: Yale University Press, 1998.

Sheffield, Gail K. *The Arbitrary Indian: The Indian Arts and Crafts Act of 1990.* Norman: University of Oklahoma Press, 1997.

Simpson, David. "Raymond Williams: Feeling for Structures, Voicing 'History.' " In *Cultural Materialism: On Raymond Williams,* ed. Christopher Prendergast, 29–50. Minneapolis: University of Minnesota Press, 1995.

Skurski, Julie, and Fernando Coronil. "County and City in a Postcolonial Landscape: Double Discourse and the Geo-politics of Truth in Latin America." In *Views beyond the Border Country: Raymond Williams and Cultural Politics,* ed. Dennis L. Dworkin and Leslie G. Roman, 231–59. New York: Routledge, 1993.

Smith, Laurel C. "Mediating Indigenous Identity: Video, Advocacy, and Knowledge in Oaxaca, Mexico." Ph.D. dissertation, University of Kentucky, 2005.

————. "Mobilizing Indigenous Video: The Case of Mexico." *Journal of Latin American Geography* 5, no. 1 (2006): 113–28.

Spores, Ronald. "Differential Response to Colonial Control among the Mixtecs and Zapotecs of Oaxaca." In *Native Resistance and the Pax Colonial in New Spain,* ed. Susan Schroeder, 30–46. Lincoln: University of Nebraska Press, 1998.

Stephen, Lynn. "Export Markets and Their Effects on Indigenous Craft Production: The Case of the Weavers of Teotitlán del Valle, Mexico." In *Textile Traditions of Mesoamerica and the Andes: An Anthology,* ed. Margot Blom Schevill, Janet Catherine Berlo, and Edward B. Dwyer, 381–402. New York: Garland, 1991.

————. "Weaving Changes: Economic Development and Gender Roles in Zapotec Ritual and Production." Ph.D. dissertation, Brandeis University, 1987.

————. "Weaving in the Fast Lane: Class, Ethnicity, and Gender in Zapotec Craft Commercialization." In *Crafts in the World Market: The Impact of Global Exchange on Middle American Artisans,* ed. June Nash, 25–57. Albany: State University of New York Press, 1993.

————. "Zapotec Weavers of Oaxaca: Development and Community Control." *Cultural Survival Quarterly* 11, no. 1 (1987): 46–48.

————. *Zapotec Women.* Austin: University of Texas Press, 1991.

————. *Zapotec Women: Gender, Class, and Ethnicity in Globalized Oaxaca.* 2nd ed. Durham, N.C.: Duke University Press, 2005.

Taussig, Michael. *Shamanism, Colonialism, and the Wild Man: A Study in Terror and Healing.* Chicago: University of Chicago Press, 1987.

Taylor, Robert. "Teotitlán del Valle: A Typical Mesoamerican Community." Ph.D. dissertation, University of Oregon, 1960.

Taylor, William. *Landlord and Peasant in Colonial Oaxaca.* Palo Alto, Calif.: Stanford University Press, 1972.

————. "Town and Country in the Valley of Oaxaca, 1750–1812." In *Provinces of Early Mexico: Variants of Spanish-American Regional Evolution,* ed. Ida Altman and James Lockhart, 63–95. Los Angeles: UCLA Latin American Center Publications, University of California, 1976.

Teague, Lynn S. *Textiles in Southwestern Prehistory.* Albuquerque: University of New Mexico Press, 1998.

Tenorio-Trillo, Mauricio. *Mexico at the World's Fairs: Crafting a Modern Nation.* Berkeley: University of California Press, 1996.

Thomas, Nicholas. *Colonialism's Culture: Anthropology, Travel, and Government.* Princeton, N.J.: Princeton University Press, 1994.

Tiffany, Sharon. "Frame that Rug: Narratives of Zapotec Textiles as Art and Ethnic Commodity in the Global Marketplace." *Visual Anthropology* 17 (2004): 293–318.

Tomlinson, John. *Globalization and Culture.* Chicago: University of Chicago Press, 1999.

Tsing, Anna Lowenhaupt. *Friction: An Ethnography of Global Connection.* Princeton, N.J.: Princeton University Press, 2005.

Turner, Bryan S. *The Body and Society: Explorations in Social Theory.* London: Sage, 1996.

———. "Recent Developments in the Theory of the Body." In *The Body: Social Process and Cultural Theory,* ed. Mike Featherstone, Mike Hepworth, and Bryan S. Turner, 1–35. London: Sage, 1991.

Turner, Terence. "Bodies and Anti-bodies: Flesh and Fetish in Contemporary Social Theory." In *Embodiment and Experience: The Existential Ground of Culture and Self,* ed. Thomas J. Csordas, 27–47. New York: Cambridge University Press, 1994.

La Unica Cosa. "The Line of the Spirit Oaxaca Project." 2001. http://www.zapotec.com/aboutlos.html.

U.S. House of Representatives. *Indian Arts and Crafts Act of 1990.* 101st Congress, 2nd session, rept. 101-400, part 2. Washington, D.C.: U.S. Government Printing Office, 1990.

U.S. Senate. Committee on Indian Affairs. "Oversight Hearing on the Implementation of the American Indian Arts and Crafts Protection Act, Public Law 101–644." Testimony. Washington, D.C.: U.S. Government Printing Office, 2000.

Usner, Don J. *Sabino's Map: Life in Chimayó's Old Plaza.* Santa Fe: Museum of New Mexico Press, 1995.

van der Veer, René, and Jaan Valsiner. *Understanding Vygotsky: A Quest for Synthesis.* Oxford: Blackwell, 1991.

———, eds. *The Vygotsky Reader.* Oxford: Blackwell, 1994.

Vargas-Baron, Emily. "Development and Change in Rural Artisanry: Weaving Industries of the Oaxacan Valley, Mexico." Ph.D. dissertation, Stanford University, 1968.

Vasconcelos, José. *The Cosmic Race, A Bilingual Edition.* Trans. Didier T. Jaén. Baltimore, Md.: Johns Hopkins University Press, 1979.

Vásquez Valle, Irene. *La cultura popular vista por las elites.* Mexico City, Mexico: Universidad Nacional Autónoma de México, 1989.

Vila, Pablo. "Narrative Identities: The Employment of the Mexican on the U.S.-Mexican Border." *Sociological Quarterly* 38 (1997): 147–83.

von Humboldt, Alexander. *Political Essay on the Kingdom of New Spain,* vol. 3. Trans. John Black. London: I. Riley, 1811.

Vygotsky, Lev S. *Mind in Society: The Development of Higher Psychological Processes.* Edited by Michael Cole, Vera John-Steiner, Sylvia Scribner, and Ellen Souberman. Cambridge, Mass.: Harvard University Press, 1978.

———. "The Problem of the Environment." In *The Vygotsky Reader,* ed. René van der Veer and Jaan Valsiner, 338–54. Oxford: Blackwell, 1994.

———. *Thinking and Speech.* New York: Plenum, 1981.

———. *Thought and Language.* Edited and translated by Eugenia Hanfmann and Gertrude Vakar. Cambridge, Mass.: MIT Press, 1962.

Wade, Edwin L. "The Ethnic Art Market in the American Southwest, 1880–1980." In *Objects and Others: Essays on Museums and Material Culture,* ed. George Stocking, Jr., 167–91. Madison: University of Wisconsin Press, 1985.

Weigle, Marta. "From Desert to Disney World: The Santa Fe Railway and the Fred Harvey Company Display the Indian Southwest." *Journal of Anthropological Research* 45, no. 1 (1989): 115–37.

————. "Southwest Lures: Innocents Detoured, Incensed Determined." *Journal of the Southwest* 32 (1990): 499–540.

Weigle, Marta, and Barbara Babcock, eds. *The Great Southwest of the Fred Harvey Company and the Santa Fe Railway.* Phoenix, Ariz.: Heard Museum, 1996.

Wenger, Etienne. *Communities of Practice: Learning, Meaning, and Identity.* New York: Cambridge University Press, 1998.

Wertsch, James V. *Mind as Action.* New York: Oxford University Press, 1998.

————. *Voices of the Mind: A Sociocultural Approach to Mediated Action.* Cambridge, Mass.: Harvard University Press, 1991.

Wertsch, James V., Pablo del Río, and Amelia Alvarez, eds. *Sociocultural Studies of Mind.* New York: Cambridge University Press, 1995.

Wheat, Joe Ben. "Early Navajo Weaving." *Plateau* 52, no. 4 (1981): 2–9.

————. "Rio Grande, Pueblo, and Navajo Weavers: Cross-Cultural Influence." In *Rio Grande Textiles,* ed. Nora Fisher, 22–26. Santa Fe: Museum of New Mexico Press, 1994.

White, Hayden. *Tropics of Discourse: Essays in Cultural Criticism.* Baltimore, Md.: Johns Hopkins University Press, 1978.

Wilk, Richard. *Home Cooking in the Global Village: Caribbean Food from Buccaneers to Ecotourists.* London: Berg, 2006.

————. "Learning to Be Local in Belize: Global Systems of Common Difference." In *Worlds Apart: Modernity through the Prism of the Local,* ed. Daniel Miller, 110–33. New York: Routledge, 1995.

————. " 'Real Belizean Food': Building Local Identity in the Transnational Caribbean." *American Anthropologist* 101, no. 2 (1999): 244–55.

Williams, Raymond. *The Country and the City.* New York: Oxford University Press, 1973.

————. *Marxism and Literature.* New York: Oxford University Press, 1977.

————. *Problems in Materialism and Culture.* London: Verso, 1980.

Willis, Paul. *Learning to Labor: How Working-Class Kids Get Working-Class Jobs.* New York: Columbia University Press, 1977.

Wilson, Chris. *The Myth of Santa Fe: Creating a Modern Regional Tradition.* Albuquerque: University of New Mexico Press, 1997.

Wolf, Eric. "Closed Corporate Communities in Mesoamerica and Java." *Southwestern Journal of Anthropology* 13, no. 1 (1957): 1–18.

————. "The Vicissitudes of the Closed Corporate Peasant Community." *American Ethnologist* 13, no. 2 (1986): 325–29.

Wood, W. Warner. "Between Loom and Curio Cabinet: Locating Oaxacalifornia Craft Marketers." Paper presented at the annual meeting of the American Anthropological Association, New Orleans, Louisiana, November 20–24, 2002.

————. "Flexible Production, Households, and Fieldwork: Multisited Zapotec Weavers in the Era of Late Capitalism." *Ethnology* 39, no. 2 (2000): 133–48.

————. "The 'Invasion' of Zapotec Textiles: Indian Art 'Made in Mexico' and the Indian Arts and Crafts Act." In *Approaching Textiles, Varying Viewpoints: Proceedings of the*

Seventh Biennial Symposium of the Textile Society of America, Santa Fe, New Mexico, 2000,
272–81. Earlesville, Md.: Textile Society of America, 2001.

———. "Rapport Is Overrated: Southwestern Ethnic Art Dealers and Ethnographers
in the 'Field.' " *Qualitative Inquiry* 7, no. 4 (2001): 484–503.

———. "Stories from the Field, Handicraft Production, and Mexican National
Patrimony: A Lesson in Translocality from B. Traven." *Ethnology* 39, no. 3 (2000):
183–203.

———. "Textiles oaxaqueños, el arte indígena 'falso,' y la 'invasión' mexicana de la
Tierra del Encanto." *Cuadernos del sur* 9, no. 19 (2003): 19–33.

———. "To Learn Weaving below the Rock: Making Zapotec Textiles and Artisans in
Teotitlán del Valle, Mexico." Ph.D. dissertation, University of Illinois, Urbana-
Champaign, 1997.

———. "The Zapotec Textile Resource Pages." 1997. http://www.nhm.org/research/
anthropology/Zapotec/index.html.

Wortham, Erica Cusi. "Between State and Indigenous Autonomy: Unpacking Video
Indígena in Mexico." *American Anthropologist* 106, no. 2 (2004): 363–68.

Young, Kate. "Modes of Appropriation and the Sexual Division of Labour: A Case Study
from Oaxaca, Mexico." In *Feminism and Materialism: Women and Modes of Production,* ed.
Annette Kuhn and Ann Marie Wolpe, 124–54. London: Routledge, 1978.

Yúdice, George. *The Expediency of Culture: Uses of Culture in the Global Era.* Durham, N.C.:
Duke University Press, 2003.

Zimmerman, Jeremiah. "Hewers of Stone." *National Geographic Magazine* 21, no. 12
(1910): 1002–19.

Zolov, Erik. "Discovering a Land 'Mysterious and Obvious': The Renarrativizing of
Postrevolutionary Mexico." In *Fragments of a Golden Age: The Politics of Culture in Mexico
since 1940,* ed. Gilbert M. Joseph, Anne Rubenstein, and Eric Zolov, 234–72.
Durham, N.C.: Duke University Press, 2001.

Zumbühl, Hugo. *Manual de construcción de un telar de pedal y sus auxilares.* Huancayo, Peru:
S.E.P.A.S., 1981.

W. WARNER WOOD is Assistant Professor of Anthropology and Museum Studies at Central Washington University. He is also a research associate at the Natural History Museum of Los Angeles County, where he was formerly a curator.